APPEARANCE, OPINION, CHANGE:

EVALUATING THE LOOK OF PAINTINGS

Papers given at a conference held jointly by the United Kingdom Institute for Conservation and the Assocation of Art Historians, June 1990

Contents

ND 1630 .A6 1990

ISBN: 1 871656 09 5

Published by The United Kingdom Institute for Conservation of Historic and Artistic Works
6 Whitehorse Mews, Westminster Bridge Road, London SE1 7QD

Printed by Hobbs The Printers, Brunel Road, Totton, Hampshire SO40 3YS

Foreword

Too often art historians and conservators miss the opportunity to communicate with each other effectively. Pre-occupied with our own concerns we fail to address the issues where the two disciplines overlap, preferring instead to present our knowledge to those who already share the same assumptions.

The intention of this conference is to demonstrate how conservators and art historians can profit from each others' experience. We cannot presume there will be a meeting of minds but, by seeing issues from a variety of viewpoints, at least we should be able to make better sense of our own disciplines.

The subject chosen is of some importance. Paintings are frequently taken at their face value and unless we are very familiar with a particular work we may not realise how much it has changed or indeed which aspects have changed the most. An examination of its current state rarely allows us to reconstruct a painting's original appearance in its entirety. Fortunately many paintings have survived quite well, having changed in only minor and often predictable ways, so a technical study can be quite helpful.

Interpretations of an image will vary from one individual to another. Conservators increasingly aware of their own potential for misinterpretation and distortion of evidence turn to art historians for help. Together we need to decide what aspects of a painting are important to preserve. Clearly this is not simply a technical matter, it involves value judgements based on aesthetic and historical perspectives. To confront these issues we need to be very sure of our ground. For instance, how do our current assumptions and perceptions unconsciously restrict our understanding of the art of another epoch? Can we ever expect to know what was in an artist's mind? Such issues are raised in the following preprints which we hope will be a stimulating contribution to this subject, addressing some of our common concerns.

When Maurice Davies first suggested a joint meeting I was very keen to tackle this particular subject. Since its inception many people have been involved in the preparation of the conference and associated preprints. Above all I would like to thank Leslie Carlyle for her imagination, enthusiasm and determination in making both a reality. Throughout Maurice Davies and Nicola Kalinsky have coordinated on behalf of the Association of Art Historians.

I should also like to thank the Editorial Board. For the UKIC; Leslie Carlyle, Anna Southall, Joyce Townsend, Peter Booth and Victoria Todd with further assistance from Christine Leback Sitwell. Maurice Davies and Nicola Kalinsky for the AAH, and of course thanks too to the authors who have contributed papers.

None of this would have been possible without the support of the UKIC office, both in organising the conference and in publication of the preprints. Victoria Todd, assisted by Melanie Caldwell, has once again ensured a high standard of production.

Stephen Hackney
Chairman UKIC

UNITED KINGDOM INSTITUTE FOR CONSERVATION

Membership

Application for personal membership is subject to approval by the committee of UKIC. Institutional and subscribing membership applications should be sent to the Treasurer, who will provide an invoice on request.

A full member is entitled to one copy of the serial publications, *Conservation News, Grapevine* and *The Conservator*, as they are produced, receives concessionary rates for other publications and for conference fees, and has full voting rights. Student membership is open to those in full time education or in training posts, for a maximum of five years. Student members have similar rights to full members but may not vote at general meetings. Institutional members receive the serial publications and concessionary rates on two non-members of UKIC attending meetings. Institutional members have no voting rights. Subscribing members receive only the serial publications.

Full membership:	UK	£25.00
	Overseas	£28.00
Student membership:		£10.00
Institutional membership:		£40.00
Subscribing membership:		£28.00

Membership and all other enquiries should be sent to:-
UKIC Executive Officer, 37 Upper Addison Gardens, Holland Park, London W14 8AJ.

Publications
Back numbers

The Conservator Nos. 1 – 13	£3.50 members	
	£5.00 non-members	
Conservation News Nos. 1 – 10	£1.00 each	
11 – 20	£1.50 each	
21 – 30	£2.00 each	
31 – 40	£2.50 each	

Occasional Papers

No. 1	£1.50	No. 7	£6.50
No. 3	£5.00	No. 8	£7.50
No. 4	£3.50	No. 9	£6.50
No. 5	£6.50	No. 10	£8.50
No. 6	£5.00		

Miscellaneous

The conservation of modern paintings: introductory notes on papers from the 1983 symposium	£2.00
Conservation in Museums & Galleries: a survey (1974)	£2.50
Conservation in Museums & Galleries: a survey (1988) non-members	£10.00 £12.00
Lighting Preprints	£5.00

Reprint of the papers presented at the UKIC/MA/GDIM meeting in Bristol, April 1987

Preprints of UKIC 30th Anniversary Conference	£10.00
Training in Conservation, 1988	£2.00
Conservation of Ancient Egyptian Materials	£10.00
Modern Art: the Restoration and Techniques of Modern Paper and Paints, 1988	£6.50
Dirt and Pictures Separated, 1990	£7.00

Prices include postage, and are the same for members and non-members except where stated.
Publications available from UKIC Executive Officer, 37 Upper Addison Gardens, Holland Park, London W14 8AJ.

THE FIRST CLEANING CONTROVERSY AT THE NATIONAL GALLERY 1846-1853

Jaynie Anderson

Abstract
Evidence given by many leading figures in the Victorian Art world at the enquiry into picture cleaning at the National Gallery in 1852-3 provides a revealing case study of attitudes in restoration in mid nineteenth century England. Due to the emergence of national museums, a critical public, the appearance of European restoration manuals, and programs for the education and ethics of restorers a more modern concept of restoration gradually developed. The principal figure in the controversy was Sir Charles Eastlake, later to become the Gallery's first director, who, after his election, preferred to have his new acquisitions restored abroad, inhibited by criticism at home.

The first controversy concerning picture cleaning at the National Gallery took place at a time when a progressively more scientific concept of conservation was gradually and painfully emerging in European museums[1]. Restoration controversies were not a novelty in the history of art, for they had occurred with increasing frequency throughout the sixteenth and seventeenth centuries[2], but they were a new phenomenon within the public domain and within the context of a national museum, which was accountable to parliament. In the late 1840's and early 1850's, almost concurrently, the Louvre in Paris and the National Gallery in London, were faced with public concern and outrage at the way in which individual Old Master paintings had been cleaned. Both institutions dealt with the crisis in characteristically different ways. The French, who had experienced several revolutions, quietened public opinion by retiring the director of the Louvre Frédéric Villot[3] to a more important administrative position, whereas the English conducted a lengthy public enquiry into the management of the National Gallery, the outcome of which determined its future for many years. During the enquiry a select committee interviewed almost everyone of importance in the English art world, artists from the Royal Academy, museum curators, restorers and collectors, and, finally, published a lengthy report of about a thousand pages, which provides the material for a revealing case study of attitudes to restoration at mid-century[4]. The full and careful record of evidence taken in interviews demonstrates an alarming diversity of contradictory opinions, irreconcilable differences of taste, and how personal and political rivalries could affect the way in which even presumably well-informed individuals interpreted the appearance of paintings. What is equally apparent is the subjective nature of interventions by restorers in the nineteenth century and how highly interpretative they were in a period which might be called the prehistory of modern restoration as we know it.

When assessing the contradictory evidence given as to how a particular painting appeared before and after cleaning the commission could find no visual proof of the earlier appearance of the painting except in the form of occasional engravings and painted copies. Indeed there is an extraordinary lack of information concerning early photography at the National Gallery and Sir Charles Eastlake, the first director (Fig. 1)[5], appears not to have been interested in this new tool for recording the appearance of paintings in the collection, even though he was also the first President of the Royal Photographic Society. During his frequent trips abroad, Eastlake used photographs when considering works for acquisition and when wishing to photograph frescoes for comparative attribution purposes. The early catalogues of the gallery were not illustrated, and there is no visual record of the physical state of paintings before 1860 when pictures were gradually photographed for didactic purposes-to distribute to art schools-on the initiative of Henry Cole and Richard Redgrave from the South Kensington Museum[6]. It was only after the enquiry, and perhaps we may surmise because of it, that the earliest photographs were taken before and after restoration in 1857.

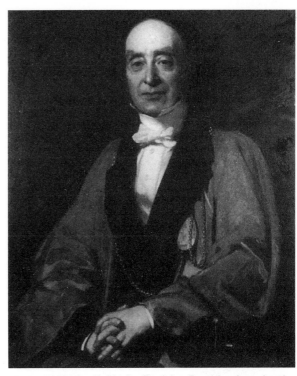

Fig 1. J P Knight. Sir Charles Eastlake. Royal Academy, London

The enquiry into the principles of picture cleaning was well timed, for the public museums that had been founded in the first decades of the nineteenth century had created a more professional context for restoration. Museum directors were forced to consider policies and theories of restoration including the education and ethics of professional restorers. The emphasis was on Italian Renaissance painting, for the new national galleries, whether in London or Berlin, despite their titles, had nothing to do with preserving the national heritage of their respective countries, but were competitively engaged in the purchase of Old Masters. At its beginnings the National Gallery acquired pictures by benefaction, but the situation changed dramatically in 1855, when as a result of the public enquiry, Eastlake was appointed the gallery's first director, and introduced a systematic acquisitions policy generously funded by Parliament and accountable to an ever-increasing and critical public. As Eastlake was only too well aware, the study of Renaissance art in the nineteenth century presented considerable difficulties for museum directors, dealers and the general public alike. Many pictures had been assigned legendary and inaccurate attributions when they were in private aristocratic collections in the seventeenth and eighteenth centuries which made their true authorship difficult to determine. Moreover, the condition of Italian Renaissance paintings was usually unsatisfactory, for they were often covered by filth, discoloured varnish and the overpainting of previous restorers, all of which often obscured the original surface. Despite problems of condition, the direct study of works of art and their stylistic analysis became of essential importance for the newly created and expanding public galleries of the nineteenth century. Indeed it could be argued that the new science of connoisseurship was stimulated by the demands of an international art market which supplied the new museums. Restoration often occurred before or after a picture was bought or auctioned and became an indispensable diagnostic aid for the collector, dealer or museum director, who wished to confirm an old attribution or propose a new one[7].

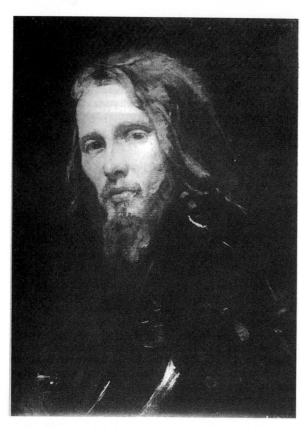

2. *Alfred Stevens. Morris Moore. Tate Gallery, London*

stances, pollution in the atmosphere and the notorious Gallery Varnish. The coal smoke in the London air led to a gradual darkening of works of art and was also believed to produce a bloom on the surface of pictures. Pollution was especially bad in the area around Trafalgar Square where a steam engine worked the fountains and where there were gasworks, factories, and wash houses. The other contributory factor to the darkening of pictures was the infamous Gallery Varnish, a mixture of boiled oil and mastic, invented by the first Keeper of the Gallery, William Seguier, and still applied to the paintings during Eastlake's keepership by William's brother John Seguier who acted as a restorer. Varnishes made with natural resins and oils will darken with time, and some may have been intentionally toned to a dark colour before being applied using a brown pigment, such as Cassel earth, or according to some restorers' manuals, liquorice, coffee grounds, cigar ends etc. Seguier's Gallery Varnish had a particular property; it remained tacky for a long time after its application, attracting dirt to the surface of the picture.

Between 1846, when the correspondence first appeared in *The Times* and 1853 when the enquiry began, many of the pictures were considered to have 'mellowed'-that is darkened-and were no longer a subject of concern. Following the correspondence in *The Times* Eastlake wrote a report to the Trustees in defence of his picture cleaning in January 1847, and in November of the same year resigned as Keeper, because he said the office occupied too much of his time; the post of Director at the gallery did not then exist. Although he never admitted publicly the difficulties he had experienced with the restoration controversy, it is clear that this was the principal reason behind his resignation. Eastlake himself became an influential trustee from November 1850, in which role, according to his own testimony, he uniformly opposed the cleaning of pictures. Indeed he emphasized at the enquiry that: 'I have been accused, both in Parliament and in the public papers, with being the sole advocate for cleaning, whereas I was utterly against it.' Eastlake realized that the pictures cleaned during his keepership had not suffered any damage to the original paint surface, but he became increasingly wary of undertaking further conservation for fear of provoking public censure, when even well informed visitors to the Gallery were capable of misinterpreting what they saw before them. He also seems to have distrusted the gallery restorer John Seguier.

Eastlake's book 'Materials for a History of Oil Painting' (1847), played a pioneering role in destroying the secrecy of artists' techniques and made such knowledge available to an English public for the first time. In his correspondence Eastlake reveals his awareness of how difficult it was for the public to understand newly cleaned pictures when they were hung next to other uncleaned works in the National Gallery. In a letter written to George Vivian, on 5 February 1847, he records the difficulties: 'Two pictures by Rubens-"The Judgement of Paris" and the "Brazen Serpent"-were cleaned under my superintendence in the N. Gallery in 1844. I was acquainted with the general nature of the great painter's mere materials, and on that occasion after due trials on unimportant parts to satisfy myself that these works were not exceptions to his usual practice (for there are exceptions) I allowed two different picture cleaners to remove everything which was unquestionably not applied by the master. The extreme change in the appearance of these works (particularly the "Brazen Serpent") was almost alarming when the eye wandered to the other pictures[9].'

Eastlake was also justifiably cynical about how his critics interpreted the appearance of pictures before and after restoration. At the enquiry in 1853 he drew attention to the fact that he himself had repainted an area the size of a sixpence on the small of Juno's back in the 'Judgement of Paris' (No194). In the year of the picture's acquisition, 1844, it had been cleaned by Thomas Boden Brown under Eastlake's supervision, when Eastlake offered to repaint the area where paint was completely missing in the small of Juno's back, which according to Brown was 'mended in a most exquisite manner; no living artist would have done it better.' When asked by the enquiry whether those repairs had ever been noticed by visitors to the Gallery, Brown replied that they had not. Eastlake in his testimony went even further. He stated that where the folds of the skin are rather complicated: 'I made two studies from nature from such models as I could find to assist me in that

As with many disputes the controversy concerning the National Gallery began with a letter to *The Times*, on 29 October 1846, signed by Verax, the pseudonym of Morris Moore (Fig. 2). Moore was a failed itinerant artist turned picture dealer, who became one of the most venomous critics of the gallery's cleaning and acquisition policies[8]. In several letters Moore expressed his indignation that four pictures had been subjected to 'a dreadful ordeal at the cleaner's hands', Rubens' 'Peace and war' (National Gallery No46), which he considered had been 'completely flayed', as had Cuyp's 'Cattle and figures' (No53), and 'Philip IV hunting wild boar' (No197), then attributed to Velazquez, while Titian's 'Bacchus and Ariadne' (No35) had been 'scraped raw' in parts and 'repainted' in others.

In the debate that followed in *The Times*, Ruskin, then aged 29, wrote in defence of Eastlake, and pronounced that the Cuyp was 'nearly uninjured', that Titian's 'Bacchus and Ariadne' had 'escaped scot-free', that the Velazquez was in perfect condition, but admitted one exception, a painting by an artist whom he intensely disliked, Rubens. Ruskin's testimony concerning Rubens' 'Peace and War' is a particularly revealing example of how a critic's taste may influence his judgement of a restoration. 'I have no hesitation,' Ruskin wrote, 'in asserting that for the present it is utterly, and for ever partially, destroyed....This was indisputably of all the pictures in the gallery that which least required and least could endure the process of cleaning. It was in the most advantageous condition under which a work of Rubens can be seen; mellowed by time into more perfect harmony than when it left the easel, enriched and warmed without losing any of its freshness or energy. The execution of the master is always so bold and frank as to be completely, perhaps, even most agreeably, seen under circumstances of obscurity, which would be injurious to pictures of greater refinement.'

Ruskin's judgement that it would be better to submerge the exuberance of Rubens' palette under a deliberate veil of patina was characteristic of the taste of his age, for it was stated by many witnesses at the enquiry that varnish applied to the surface of a picture often contributed an adventitious harmony and effect to a painting. The mellow effect of the patina produced by time which Ruskin found so charming was often the product of two circum-

operation...because the folds of the flesh were interrupted; I could not trace their terminations, and I thought it safer to have recourse to nature....I have frequently heard people point out that portion of the back as an admirable specimen of the master's work.' Eastlake's repaints in varnish were removed in 1940-41, when the picture was again restored and a number of other repaints removed, to reveal a large number of *pentimenti* which had previously been hidden under the varnish, and which had escaped comment during the restoration controversy, presumably because they were not visible.

In the early 1850's a few pictures were cleaned with the approval of the Board of Trustees, of whom Eastlake, then President of the Royal Academy was an *ex officio* member, and without causing controversy. From the minutes of the Trustees' meetings it appears that Eastlake's attitude to conservation had been already formed by his unpleasant experience as Keeper; he appears to have decided that although cleaning may have been in principle desirable it was inexpedient if it led to public criticism. There was also a very real possibility of moving the gallery from Trafalgar Square to a site where the atmosphere was less polluted. And in the words of another Trustee Sir William Russell, 'some persons thought,' and here Russell clearly meant Eastlake, 'that in a new National Gallery, if the pictures, after being cleaned, were arranged in some new order, the public would not feel the change which might be made in them.' Russell went on to say that these same persons considered it desirable to allow the pictures 'to remain for a protracted period in the condition in which they then were, and gradually to become more and more obscure, so that at last the public itself would be obliged to call upon us to perform these operations.' Eastlake's view, as defined by Russell, seems to have been either wait until a new installation on a new site would divert attention from any changes in the appearance of paintings after cleaning, or alternatively let the paintings become increasingly dirty until even the public realise that cleaning is necessary. Yet there can have been no doubt that some form of cleaning was desirable, for Russell drew attention at the enquiry to a report he had compiled with Eastlake in 1850-on the desirability of introducing glass to cover pictures. They commented on the dirty and obscure condition of most of the paintings in the gallery and the causes for the change in their appearance: 'Many of them present the appearance of being covered with a thick film, alike foreign in feature and in colour to the original character of the picture, detracting from its highest qualities, and depriving it for the time of clearness and brilliancy.'

At the time of the influx of visitors for the Great Exhibition of 1851 Russell proposed that more pictures should be cleaned to allow foreign visitors to see the paintings in a more favourable condition, but Eastlake was in favour of postponement. In 1852, the condition of the paintings had not improved, the move to the new site was uncertain, and John Seguier was asked by the Trustees to submit a list of pictures for cleaning during the summer recess when the gallery was closed for six weeks. Eastlake suggested several amendmentss in the instructions to Seguier, and the most informative source on this point is again Russell's evidence at the enquiry for he openly disagreed with Eastlake. The proposed instruction to Seguier was that he be requested to complete 'the necessary operations for putting in order those pictures which he has recently reported to the trustees as requiring fresh varnish'. There followed the instruction to which Eastlake objected: 'that Seguier be instructed in those operations in which, upon removing the old varnish, he shall ascertain that the effect of the picture is impaired by colouring matter, not original, which can be removed with ease, perfect safety, and benefit to the picture, to do so using of course, the greatest care and precaution.' Russell told the committee that Eastlake considered it opened 'too large a door', and suggested the wording: 'requiring the removal of varnish, and revarnishing'. He added that Eastlake, who had 'rather a strong recollection of what had passed on a former occasion, might be unwilling again to encounter the amount of attack that possibly might be made.' In his own evidence Eastlake confirmed this, when he explained why he had been reluctant to allow picture cleaning since he had become a Trustee in 1850, 'because the cleaning of pictures is a subject which admits of no proof, and it is one on which the public mind may be easily unsettled.'

Two criticisms of Eastlake's position may be made. Firstly, that he underestimated the need to arrest the physical deterioration of paintings by conservation work and, secondly, that he failed to understand that when the surface of a picture becomes obscure it is a public loss, and part of the business of a national gallery is to exhibit pictures in good condition. When the nine pictures were cleaned after the summer recess in 1852 a new and violent polemic opened, again beginning in the pages of *The Times* with the indefatigable and intemperate Morris Moore once again at the centre of the storm. Eastlake became even more adamant that whatever objections he had to the cleaning of pictures were 'very much confirmed.' The pictures involved were two Canalettos: the 'Stonemason's yard' (No127), and his view of San Simeone Piccolo (No163), three works by Claude: the 'Embarkation of the Queen of Sheba'(No14), 'Marriage of Isaac and Rebecca' (No12), 'Landscape with Hagar and the angel' (No61); Rubens' 'Conversion of St Bavo' (No57); Guercino's 'Angels weeping over the dead Christ' (No22); Veronese's 'Consecration of St Nicholas' (No26); and the early copy after Poussin's 'Plague at Ashdod' (No165), then believed to be an original.

During the enquiry the main point at issue was whether any glazing on the original surfaces of these paintings had been removed, and on this point Eastlake clearly believed that none had, though he considered that Seguier had overpassed his instructions, the very instructions that Eastlake had taken such pains to re-define. The conflicting views given by various witnesses tended to cancel each other out in the conclusions reached by the commissioners. Many testified that the appearance of the paintings had deteriorated, because the mellow tone of their surfaces had been removed during conservation, irrespective of whether they believed that mellow tone was due to the finish of the master or to the influence of time or to the application of varnish. The most discussed painting of all was Claude's 'Embarkation of the Queen of Sheba'(No14). Although Eastlake did not believe that any of the nine pictures had been injured, for him Claude's 'Queen of Sheba' had been 'tastelessly' and 'unequally cleaned', but which he considered 'time will make right' with a little dust rubbed over the surface of the picture. In reply to a question put by Mr Charteris (later Lord Elcho), Eastlake remarked that he thought dust would do the work great good, 'and much greater good than attempting to restore the softness of outlines which may have been destroyed in some of those pictures by over-cleaning. I believe that accidental and irregular stains, produced by time and dust, are more agreeable than any thing effected by the will of a picture cleaner.' Other witnesses, such as Edward Cheney, a collector who had his pictures restored abroad, testified that the glazing in many parts of the 'Queen of Sheba' had definitely been removed. John Nieuwenhuys, a picture dealer and amateur restorer from Brussels, was also firmly of the opinion that the painting had been 'over-cleaned', that is, 'some delicate tints cleaned away'. In some cases special blemishes were said to exist, which were imperceptible before cleaning. Predictably Morris Moore went further than anyone and claimed that injuries had occurred to glazes on the ropes, rigging and water, and that the inscription had lost its legibility. When asked somewhat sarcastically by the chairman Colonel Mure, why it was that a gentleman who had examined the picture with such extreme caution and accuracy had not noticed one peculiarity, a *pentimento* of a flag on the mast, Moore gave the unreassuring reply that no one else had either. Only Retra Bolton, a picture restorer, thought that no harm had been done to the 'Queen of Sheba' whatsoever, a view that has been endorsed by time[10]. In retrospect Bolton appears to have been a brave man of independent judgement. When this picture was subsequently cleaned, in 1946 and again in 1976, no evidence of damage was found.

Some of the confusion concerning the interpretation of what the witnesses saw was due, as Norman Bromelle has noted[11,12], to the fact that Seguier under-, rather than over-, cleaned the pictures. Morris Moore had complained that in Canaletto's 'Stonemason's yard' (No127) '...the effacement of half-tints and shadows has reduced them to unmeaning reliefless surfaces, similar in effect to the detached portions of a theatrical scene....The sky had a smudged appearance, such as I know, from experience, to be the result of an improper action of some strong solvent....There is an absence of that freshness and sharpness of execution which,

until the late cleaning, characterized this picture.' When the 'Stonemason's Yard' was cleaned in 1955 Bromelle observed that 'the shadows were indeed slightly rubbed, and there was considerable overpaint over a large portion of the sky.' This damage and overpaint probably occurred when the picture belonged to Sir George Beaumont and before it entered the national collection. Presumably Seguier's cleaning made the earlier damage and repaint more visible, without really addressing the problem; and Moore misinterpreted the appearance of what he had seen[11,12]. In his own evidence Eastlake expressed the difficulty involved in interpreting such evidence: 'If you saw one of Claude's trees rubbed out, every one would remember the original state of the picture, and would be able to compare it; but when you come to niceties, such as beams in shadows and so on, I very much doubt whether anybody distinctly remembers them, especially as they are obscure parts of the picture in question, which of course were still more obscure when the picture was covered in dirt.' The whole subject of restoration was relatively novel within an English context, and most witnesses, when questioned had only a vague acquaintance with the history of the subject as revealed by their quotations from a very few Italian literary sources, principally Vasari and Armeninini. Strangely no reference was made to the intelligent French manual of restoration, 'De la conservation et de la restauration des tableaux', published in 1851 by Horsin Déon, a conservateur at the Louvre. In the case of the artists, who gave evidence, including Eastlake and Ruskin, their own taste and activity as artists, precluded an objective judgment. For example, when Eastlake was giving evidence on glazing in relation to the paintings by Claude, he stated: 'I should say of Claude that if he was not a glazer he ought to have been one, for there is a certain equality in his touch which approaches to what painters call wooden, and that is now very apparent in the "Annunciation" [by Claude] and in the other pictures. The effect of glazing, or of dirt, would be to break the evenness of these touches, and to diversify the mere touch, independent of the colour. I should recommend that the "Annunciation" should be left without its glass for at least a twelvemonth, so that it might have the benefit of dirt.' Here we seem to be very far removed from the modern principle of conservation which respects the original intention of the artist, for Eastlake seems to be equating Claude's intentions with his own as an artist.

Among the precautions suggested by the committee for the future was the recommendations that no picture cleaner who is employed by the Gallery should fail to give a full and distinct explanation of the mode and materials of his procedure; that no varnish shall be used in the Gallery without the permission of the Director; that any picture to be cleaned shall be the subject of a previous written report from the Director to the Trustees; if necessary a painting will be examined by three experienced persons, one of whom will be a practical chemist.

One way of scientifically evaluating the evidence given at the enquiry which the committee considered was through the evidence of chemistry, particularly in relation to the effect of solvents, of which most restorers and artists were ignorant, remembering that the study of chemistry was a fairly primitive science at that date. Eastlake, in a letter to Sir Robert Peel of 1845, had recommended that those who supervise cleaning should 'put themselves in communication with some experienced chemists,who might be directed to render assistance when required.' Some restorers such as Thomas Brown agreed that it was necessary for a restorer to have a knowledge of chemistry, but only one picture restorer John Bentley stated that he had studied chemistry and that such knowledge played an important part in his business as a restorer. Much more common was the attitude of Sir Edwin Landseer, who when asked by Charteris: 'Do you think that a cleaner could make himself perfectly conversant with the vehicles used by the old masters, and their mode of painting, so as to know the strength with which he should apply his different solvents?', replied 'I am not chemist enough to tell'. We can now see Eastlake's suggestion as being the first step in a development that was gradually nurtured in the conservation and scientific departments of the National Gallery.

When Eastlake became Director of the National Gallery in 1855 he made the decision, which he kept to himself, to have his new acquisitions restored in Italy, before bringing them back to England, so that any changes in their appearance would not be open to public comment. In a report to the Trustees of 14 November 1857 he justified the expense of having a picture restored in Italy on the grounds that it was difficult to have early Italian pictures well restored in England. In order to assist him in his acquisitions he kept notebooks, as did his travelling agent Otto Mündler[13], which recorded the condition and location of works of art that might be offered for sale to the National Gallery. He was well aware that the pictures he was presented with were often retouched by earlier restorers. As Joyce Plesters and Sir Denis Mahon have remarked, Eastlake 'probably never overcame a certain personal distaste for cool tonality, a distaste which always carried with it the danger (when he admired the master concerned) of attributing that coolness to the activities of cleaners, who were presumed to have removed a glaze.' Although on one occasion during his first continental tour after becoming Director he did have a moment of perception when on 31 August 1855 he noted a Lorenzo di Credi in the Staatliche Kunsthalle at Karlsruhe (No409): 'In specimens of this kind by Lorenzo di Credi the colours are always crude. The question is whether this was the artist's taste at that period or whether such works have been overcleaned--This latter solution is not probable as the pictures in Lor. di Credi's later manner are always richer[14].'

Eastlake's preferred restorer abroad was Giuseppe Molteni, conservator at the Pincoteca di Brera, about whom I have written extensively elsewhere[15]. Pictures would await export in his atelier at Milan, where they were discussed by a group of early connoisseurs who frequented his studio, including Giovanni Morelli, the inventor of scientific connoisseurship. Here they were restored, repainted and re-attributed. It is clear that Eastlake would take previously unconsidered liberties in stripping away old varnish and previous restorers' repaints in Milan rather than in London. After restoration a painting's true character would be re-submerged under a veil of patina, a process of dirtying and toning that made the appearance of the new acquisitions harmonize with the appearance of those in the collection at home. When asked by one of his friends to define Molteni's undoubted abilities as a restorer, Morelli wrote: 'This Molteni is a strange chap. He is a truly outstanding restorer, endowed as he is, with a fine artistic sensibility and a passion for ancient art. But because he is a pupil of our Academies, he occasionally takes part, just as your excellent Director of the National Gallery [Eastlake] often does, in the battle the Academies wage to correct the naive inaccuracies of the Old Masters, which are almost always merely the result of their engaging easy going manner. The naive imprudence of genius will never be understood by the pedantry of our Academicians. But apart from that, Molteni is a good fellow and very conscientious.' In the 1850's during the emotional build up to the Risorgimento, Italian patriots such as Morelli and Molteni were reconsidering their national heritage, which was under threat because of the successful acquisition policies of the so-called national galleries abroad. They attempted to formulate new laws concerning cleaning and to look at the whole subject in a more broadly based spirit of empiricism, culminating in Count Giovanni Secco-Suardo's restoration manual of 1866[16]. Secco-Suardo's book, still in print in a revised version, was dedicated to Morelli and based on a public course for restorers held in Florence, the Renaissance pictures being supplied from Morelli's own collection now in Bergamo. Eastlake's knowledge of Italian Renaissance painting certainly profited from these Italian experiments.

Finally, it is possible to propose some general conclusions from this kind of study: it may promote an awareness of the different appearance of paintings in the nineteenth century that certainly affected the writers of some classic art historical texts that are still in use today; -similarly, it may promote an awareness of the cultural mentality of these early restorers whose imprints in the form of patina and repainting are still on some Renaissance pictures today; -the very responsible and fair-minded committee of enquiry in 1853 attempted to de-mystify the secrecy surrounding the cleaning of paintings in a pioneering spirit the consequences of which we benefit from today. After the second world war the Gallery again played an innovative part in de-dramatizing restoration with the famous exhibition of cleaned pictures in 1947 when many of the paintings which were the subject of controversy in the first enquiry were re-examined in a more scientific manner, principally by the use of radiography[17]. It was in 1940 that the Trustees

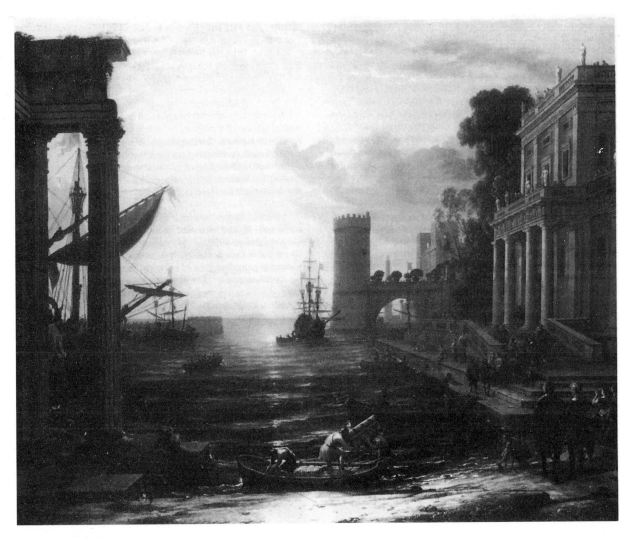

3. Claude. Seaport: the Embarkation of the Queen of Sheba. National Gallery, London (No14), 1.485 X 1.94

published the first book of X-radiographs, 'From the National Gallery Laboratory'[18], a primitive but charming forerunner of the Technical Bulletin, in which they made a claim prophetic of the future 'the connoisseur may find...a certain re-orientation of values; and the scientist a new vista of experimental philosophy.'

References and notes

1. My interest in this subject was stimulated by Joyce Plesters and Sir Denis Mahon, who have generously allowed me to consult their draft manuscript, **Picture cleaning and art literature. Observations on the relationship of the literature of art to the problems of picture cleaning,** Library of the National Gallery, London. I am grateful to Jill Dunkerton and David Bomford for a critical reading of the manuscript before it went to press.
2. Conti A, **Storia del restauro e della conservazione delle opere d'arte,** Electa (1988), passim.
3. On Villot, cf. de Chennevières P, **Souvenirs d'un directeur des Beaux-Arts,** Arthena Paris (1979), 84-9.
4. **Report from the select committee on the national gallery together with the proceedings of the committee, minutes of evidence,** the House of Commons (1853).
5. Robertson D, **Sir Charles Eastlake and the Victorian Art World,** Princeton University Press (1978).
6. For this information I acknowledge Anthony Hamber's forth-coming doctoral thesis, **The Photography of art 1839-1880,** for Birkbeck College.
7. Anderson J, Review of D Levi's monograph on Cavalcaselle, **The Burlington magazine,** 132 (1990), 43-44.
8. Haskell F, 'A Martyr of Attributionism: Morris Moore and the Louvre "Apollo and Marsyas", **Past and present in art and taste,** Yale University Press London (1987), 153-74.
9. Library of the National Gallery.
10. For a modern view of the dispute, cf. Wyld M, Mills J, and Plesters J, 'Some Observations on Blanching (with special reference to the paintings of Claude)', **National Gallery Technical Bulletin,** 4 (1980), 49-59.
11. Brommelle N, Controversy in 1846, **Museums Journal,** 56 (1957), 257-262.12.Brommelle, 'Material for a History of Conservation. The 1850 and 1853 Reports on the National Gallery', **Studies in Conservation,** 2 (1955), 176-86.
13. **The travel diaries of Otto Mündler 1855-1858,** edited by C T Dowd, introduction by J Anderson, **The Walpole Society,** 51 (1985).
14. Library of the National Gallery.
15. Anderson J, 'Layard and Morelli', Acts of the Symposium, **Austen Henry Layard tra l'Oriente e Venezia,** ed Fales F M and Hickey, at Venice in 1983, Rome 1987, pp. 109-37.
16. **Manuale ragionato per la parte meccanica dell'arte del ristauratore dei dipinti,** Milan (1866).
17. Hendy P, '**An exhibition of cleaned pictures (1936-1947)',** National Gallery (1947).
18. Bragg W and Rawlins I, **From the National Gallery Laboratory,** London (1940).

LONG LOST RELATIONS AND NEW FOUND RELATIVITIES: ISSUES IN THE CLEANING OF PAINTINGS

Gerry Hedley

Abstract

This paper seeks to enquire as to why it should be that, after nearly two centuries of cleaning controversy at major museums, we have reached a point where three different approaches to cleaning are widely employed. The fundamental problem of change in paintings--the long lost relations--forms the starting point of the discussion, with the recognition that old paintings simultaneously incorporate changes that are seen as loss, such as faded pigments, and changes that have come to be culturally valued as signifiers of the passage of time. We cannot return to the original intention and so must construct a new relationship between the artist's original intention, the present work, and the passage of time. But there can be no single--no absolute--solution to such a problem; rather, there are a number of new found relativities. Experience with the practice of cleaning has led to just three cleaning systems--complete, partial, and differential--finding favour. What they share in common, and what gives each a parallel validity, is that they establish a definably coherent relationship to aspects of the artist's intentions and the passage of time. Once cleaning is understood in these terms, it is possible both to accept the validity of all three different approaches, and to identify the critical points within any particular cleaning system at which the coherent relationship may be jeopardised. From this basis, conservator and curator can share responsibility for what is done during cleaning.

The problem of change in paintings

Old paintings are normally coated with varnish. In time, the varnish yellows and becomes covered with surface grime. The painting is progressively obscured. A point is reached where so much of the artist's image is lost that some kind of cleaning is widely felt to be necessary. But this act of cleaning is a matter of deep and enduring controversy. For as long as there have been national museums, there have been bitter disputes over the presentation of cleaned paintings.[1] The Louvre, the first public national art gallery, opened its doors in 1793 to the sound of criticism of its recently cleaned works. In 1796, in an attempt to answer its critics, it held an exhibition which included partially cleaned paintings. Fifty or so years later, arguments sprang up again at the Louvre, from 1848-1860, over the paintings cleaned under the direction of Villot. Almost at the same time, a fierce discussion broke out in London, about the cleaning of paintings in the National Gallery. As a result, a Select Committee was set up in 1853 to investigate the Gallery's cleaning policy. A few years later, in 1861, the approach of the Pinakothek in Munich was vigorously attacked and, this time, a Commission of Inquiry was given the task of adjudication. There followed a prolonged lull in the drama until, in London, the bold policy of complete removal of varnish and later accretions shocked a new resurgence of debate. When the cleaned Velazquez 'Philip IV in Brown and Silver' was shown at the National Gallery in 1936, the ensuing clamour proved to be just a foretaste of the international debate which would be engendered, by the same Gallery, in the late 1940s as the public saw, for the first time, the paintings cleaned during the war years. One consequence was that an exhibition of cleaned paintings was held in 1947, and another was the emergence of scholarly debate and comparison of the approaches of major museums. Inevitably, a committee was formed to investigate the affair. But the blandishments of the Weaver Commission failed to end the matter. In the early 1960s the same debate flared once more, though the Gallery was to remain resolved in its policy of complete cleaning.

By 1978, the focus of contention had shifted from Europe to North America. The policy of the National Gallery of Art in Washington, D.C. was challenged, particularly in regard to the once sombre 'The Mill' attributed to Rembrandt, and 'The Gerbier

Family' by Rubens. Investigative committees were called in, while a moratorium on cleaning was imposed. Presently, it is the cleaning of wall paintings that is causing most dispute: the Sistine Ceiling, the Brancacci Chapel and Leonardo's 'Last Supper' are all the subject of bitter and angry words.

And how angry the words of this long running cleaning controversy are--"flayed," "ruined," "destroyed," "ravished." These are the judgements which occur repeatedly across nearly two centuries of public debate. Intriguingly, at least in Britain, the cleaning of the same paintings, after roughly one hundred years has evoked, on each occasion, almost identical responses. The style of discussion is absolutist; a particular cleaning is either lauded or vilified. In the words of one perceptive correspondent to **The Times** in 1847 "Here is assertion for assertion."[2]

Can it be that we have learned nothing from such a prolonged period of discussion? Do we need to accept the view of **The Burlington Magazine** editorial that the cleaning controversy will " . . . run and run . . .,"[3] forever replaying the same tunes? Some believe so; the debate, they contend, is about aesthetics and therefore, they say, there can be no end to it. This paper challenges such views. It holds that, by understanding the nature of the aesthetic intervention made during cleaning, and of its relationship to the original painting, and what has happened with time, we can come to see that there cannot be one solution to the cleaning of paintings but, rather, a number of relatively valid possible presentations. These "new found relativities" present us with different, not right or wrong, ways of establishing a coherent relationship with a changed work of art.

One area, in which something has most definitely been learned, is that of the vulnerability of glazes and thin paint layers to removal during cleaning. This is specially true of works from around 1750 onwards. Trained conservators are aware of the need to identify such layers and have been warned against their removal. They should not, one hopes, "flay" paintings in the manner of some past restorers. Though this is a gain, it does not resolve our discussion, for the controversy has never been solely confined to the safety of the original paint and glazes. As a correspondent to **The Times** remarked in 1847, It is useless to allege that nothing but discoloured varnish has been withdrawn, for it is perfectly possible to alter the structure and continuity, and so destroy the aerial relations of colours of which no part has been removed.[4] To understand this, we need first to renew acquaintance with some long lost relations.

Hogarth is often cited in cleaning debates because of his etching 'Time Smoking the Picture'. This image, satirising the taste of contemporary connoisseurs, is frequently used to support complete cleaning. Yet, in fact, Hogarth was primarily concerned with how the effects of time could "dis-unite" and "untune" a painting in a much more profound sense than the simple obscuring caused by yellow varnish. In the **Analysis of Beauty,** published in 1753, he wrote about the consequences of colour shifts within paintings,

"let us now see in what manner time operates on the colours themselves; in order to discover if any changes in them can give a picture more union and harmony than has been in the power of a skilful Master, with all his rules of art, to do. When colours change at all, it must be somewhat in the manner following, for as they are made some of metal, some of earth, some of stone, and others of more perishable materials, time cannot operate on them otherwise than as by daily experience we find it doth, which is, that one changes darker, another lighter, one quite to a different colour, whilst another, as ultramarine, will keep its natural brightness . . . Therefore how is it possible that such

different materials, ever variously changing . . . should accidentally coincide with the artist's intention".[5]

In confronting an old painting, we frequently confront lost relations of this kind. Such changes can have serious consequences for the overall pictorial unity. For instance, Slive, comparing Hal's portraits of the Regentesses and Regents of the Haarlem Alms House, declares that,

"in the portrait of the men... the pictorial unity appears less successful than in earlier works. The intense light areas of the flesh tones, the great expanse of white linen, and the daringly broad red touch on the knee of the man on the right tend to jump and are not fully integrated into a coherent design. However when the painting was in its original state it probably created quite a different effect. A faithful . . . old copy of it shows that the portrait has darkened considerably during the course of more than three centuries. When the copyist first saw the group portrait the rich effects of light filtering over the figures were still apparent and the surfaces of the conference table were clearly defined. Today the clarity of the spatial relationships is lost and delicate adjustments in the surface animation of the black clothing . . . have virtually disappeared."[6]

So many examples of such changes could be cited but, for the present, it must suffice to say that amongst the most severe alterations are those which arise in dark clothing, as in the Hals, those that occur in the dark passages of paintings on red-toned grounds, and those that occur when brightly coloured lake pigments fade.

Loss and its perception are therefore at the very heart of the cleaning controversy. But not all change is regarded as loss, for a painting is both an aesthetic creation and an historically old object. Consequently, there are changes which occur which can be regarded as signifying the age of a painting, as marking it out as an object which has grown old naturally, and there is a tendency to value these changes. In this regard fashions do change. No longer do many people agree with Sir George Beaumont's dictum that "a good painting, like a good violin, should be brown"; but, equally, there is a widespread consensus that an old painting ought not to be made to look as if fresh from the easel. Our attitude to signs of age is nuanced and prone to fluctuation. There is, for instance, a tendency to accept the craquelure pattern on older works though, perhaps, rather less on paintings of the nineteenth century, and hardly at all in contemporary works. There is a tendency to tolerate a certain amount of wear on paintings though little acceptance of widespread losses, and there is a tendency to tolerate distortions of panel, and increasingly, canvas supports. Some also see an interaction of the varnish and the uppermost layer of paint as an attribute of ageing. Brandi proposed the notion of positive and negative changes introduced by time, seeing the role of the restorer as preserving the positive and eliminating the negative.[7] Generally, all valued changes with time tend to be grouped by the broadly encompassing term of "patina."

Thus, an old painting may simultaneously incorporate changes from the artist's original intention--loss--with other changes that have come to be culturally valued as signifiers of its age, and broadly can be called its patina. The cleaning of a painting is about establishing a new relationship with this duality. It must reconcile loss and adjust to the passage of time. Perhaps it is, in part, this closeness to a universal experience of human existence that renders it so prone to raising our emotions.

Some examples of significant change in paintings

Before we look at the ways in which these goals might be achieved, it is appropriate to examine two further examples of significant change from the artist's original work. The first is a 'Crucifixion' by Bernardo Daddi.[8] It is one of those examples where relatively well-preserved colours at the borders of the work alert us to the magnitude of the alterations which have taken place. The painting, as we now see it, has a pale tonality; we know now that this was not intended because, at the left and right edges, there are darker and more intensely coloured strips which have been protected by the barley sugar spiral columns which covered them. The changes not only alter the whole balance of tonal relationships of the painting, but also they influence the reading of it. The Virgin's robe is now a formless black, matched by the equally formless shape of Christ's robe. In addition, there is substantial darkening and blackening of the vermilion red of the soldiers. The original contrasts of colour would have been intended to stress symbolic relationships between the various figures. Now the group at the foot of the cross fails to cohere, and is not so clearly distinguished from the figure of Christ on the cross. Focus, drama, and pathos have all been lost with time.

A second example, this time from the seventeenth century, serves to show how ambiguous our relationship to change and the artist's intention can become. In the 'Self-Portrait' by Godfried Schalcken, we find again evidence of better preserved colour at the border of the painting. The background was originally a much more intense blue, and although it contains both indigo and smalt the loss of colour is, according to the report, because of "erosion of the medium causing chalking."[9] Originally, too, the red coat of Schalcken was a deeper, more intense colour. It was painted with an unstable organic red lake pigment. With time, just as in parts of the Bernardo Daddi, this pigment has faded.

But these changes are not the only things relevant to this painting. It is unusual in that it is a canvas painting which has never been lined, a rather rare occurrence for paintings of the seventeenth century. It has thus received somewhat less restoration treatment in the past than is normal. Such paintings tend to be valued, as examples of how paintings will age without the active "restorative" influence of man. Its relationship to the artist's original work is, however, somewhat remote. For, not only does it have the colour changes already alluded to, it also has extensive craquelure and raised paint in the form of cupping. Of course, this is a natural process of the ageing, but we should remember that Schalcken was a pupil of Dou, a master known for minuteness of detail and smoothness of surface which led to the style being described as *fijnschilders* - literally fine art - though its meaning then was rather more prosaic than its current application. Today, we are in a period of minimalist conservation, and a painting like this would normally receive as little treatment as possible. The work was treated at the Hamilton Kerr Institute where loose paint was consolidated, a strip lining was attached, and some moisture treatment was used to reduce the cupped surface a little. When we now look at such a painting, we do not, then, see much of the artist's original intention. We see, instead, the presentation of the originality of the painting; the fact that few hands, other than those of the artist, have been involved with the work. Given the enormous status attached to the hand of the individual artist in Western culture, this untampered originality assumes especial significance, even though the painting itself is dramatically different from how the artist intended.

These two examples illustrate, in their different ways, a central point in this discussion. **In paintings which have undergone significant changes, we cannot any longer have the artist's original intention.** Indeed, we may not even want it. Instead, we are going to be compelled to choose aspects of that intention, or to define some new relationship to the intention, through the restoration procedure. The processes of cleaning and of retouching need to be understood as part of the way in which the painting is represented to the viewer. But these choices are not limitless. In the course of the prolonged cleaning controversies, essentially just three different approaches to cleaning have gained acceptance. Although there are limitless nuances within each system, this still does not reduce the process of cleaning to a kind of tyranny of the subjective. They are nuances within an established framework. In broad terms, a curator should know roughly how the painting will look once a given approach to the cleaning has been selected.

Three approaches to cleaning

The three approaches to cleaning can conveniently be described as "complete cleaning," "partial cleaning," and "selective (or per-

haps balancing) cleaning." In complete cleaning, the aim of the technique is to remove all of the discoloured varnish and other accretions from the surface of the original paint. It is a technique best exemplified by the National Gallery in London, but is one that is also widespread in North America. In partial cleaning, the aim of the cleaner is to thin the varnish uniformly so that a still visible distinct yellow layer remains on the surface. This technique is common in continental Europe and is particularly highly theorised at the Louvre.[10] The third technique involves cleaning the painting differentially, removing more varnish from some areas and retaining more in others, with the intention of creating a visual balance. Its origins, too, are in continental Europe, though in recent years it has been most associated with practice at the Metropolitan Museum of Fine Art, New York.

The greatest advocate of complete cleaning was the German restorer Helmut Ruhemann who came to work at the National Gallery, London in the 1930s. The primary case for total cleaning rests on revealing the quality of the original paint, completely unobscured by yellow varnish. Ruhemann wrote,

"To bring out all these qualities to the full is far more important than to preserve accretions of dirt or varnish, ...[11]"

Why, he enquired,

"should any detail or shade be lost of the truest and most precious testimony of bygone ages that we possess?"[12]

This is a technique which gives primacy to the colour of the work and the truth of what remains of the original painting. From this stance the policy is entirely coherent. What is more, there can be no question that the kind of thorough cleaning advocated has immeasurably changed our appreciation of artists' use of colour in a way no less dramatic than is presently occurring to our view of Michelangelo and the Sistine Ceiling. Additionally, such close contact with the actual surface of the paint enables a more thorough grasp of painting techniques to be formed. It is no accident that, for more than thirty years, the National Gallery has been a major contributor in the elaboration of the techniques of the Old Masters.

In the partial cleaning of a painting, there is a different relationship to the artist's intention. Here, the surface of the original paint is not revealed, but remains covered by a thin layer of varnish. The restorer or curator may decide that the layer should be thicker or thinner, depending on their view of the painting. The role assigned to this thin yellow varnish remnant is suble.[13] It has the dual function of harmonising the relationships of colour and space within the painting, while acting as a signifier of the age, the antique character, of the work. These factors are also seen as inter-active since the pictorial unity of the work is felt to be enhanced by time, which is symbolised by the thin layer of varnish. Since there is evidently a choice as to how thin the varnish should be, there is a degree of critical interpretation of the work which must be made. The restorer is encouraged to determine,

"the equilibrium of the whole which is practicable at present and which, taking into account the *present state of the materials,* most faithfully restores the *original unity* of the *image* . . ." (original emphasis.)[14]

This technique recognises the fundamental problem of total cleaning, which is that a completely cleaned work may well reveal a set of changed colour and spatial relationships that has evolved with time to be very different from when first painted. Total cleaning does not,

"restore the work to its original state ... It simply reveals the *present state of the original materials.*" (original emphasis.)[15]

The dilemma of the original unity of the image is also confronted in the third technique of cleaning. Here, the restorer constantly seeks, during the cleaning, to establish a balanced set of relationships within the work. John Brealey explained his working technique as follows,

"You must be aware, for instance, that the contrast between the lights and the darks has often been paodied by time because the darks have darkened but the lights have not changed to the same extent and so the distance between them has become a grotesque caricature of their original relationship. The half tones where all the subtlety of expression lies, have become closer to the lights than the shadows If you are goinbg to do the right thing by the artist, you have to consider how, through the removal of oxidised layers of varnish, it is possible to bring back some semblance of the pictures original cohesion."[16]

The means to do this are relatively straightforward: the restorer cleans the painting more in some areas than others, using the residual varnish to tone and harmonise, as in the case of partial cleaning, but all the time,

"thinking of balance, balance, maintaining the pictures original unity. Everything ... tends toward that."[17]

An attempt is thus made, in this type of cleaning, to restore the relationship of values that, it is believed, would have existed in the original work. Quite apparently, the restorer has more leeway for variation when using this method than in either of the other methods. The restorer must decide where to leave varnish, and how much to leave, and must do so while being guided by a notion of a now lost original unity. In practice, this type of cleaning has tended, in recent years, to produce relatively clean looking paintings. Generally, the retained areas of varnish are very thin, and in other areas one sees an approach which is closer to complete cleaning than partial cleaning. Used in this way, the technique gives a primacy to harmony of the painting while revealing much of the remaining colour of the work.

The importance of neighbouring contrast relationships in human and animal vision has been stressed as a possible theoretical basis for such a technique. Gombrich argued that, in fact, the role of the restorer should be to preserve relationships rather than colour.[18] Some recent ideas in colour theory explore the link between the colours we see and the contrasting relationships which surround them. In seeking an explanation for the phenomenon of colour constancy in human vision, the view has been developed that our perception of a particular colour is not just a function of the detected instensity of the red, green and blue spectral zones to which the cones in our eyes respond, but is additionally supplemented by a reading of the reflectance relationships at the boundaries of the colour.[19] For instance, experiments have demonstrated that, given particular contrast relationships, the brain will "see" the same colour as a range of hues, and that, in certain circumstances, a shadow, on a white surface, illuminated with white light, can appear coloured. The theory claims that the colours we see are based "on a comparison of the lights from an object and its surroundings." It could be argued, then, that preserving surrounding relationships also preserves "truer" colours. At best, this kind of work remains tenuous and speculative. For our purposes, we need do no more than note that whatever the value of this particular theory, it is a widely held view that the appearance of the borders between contrasting colours influences our overall perception.

These, then, are the three approaches to cleaning which have gradually evolved over nearly 200 years. It can be seen that none of them reproduce the artist's original intention. Instead, they construct a relationship to that intention and to time: they are new found relativities. Undeniably, there is a tendency for them to be set one against the other. Ruhemann decried "the misguided prohets" of "part way," "semi," "artistic," or "nuance," cleaning. Partial cleaners claimed complete cleaners ignored "the very foundations of restoration" and "withdrew from the cultural commitment that restoration implies." Selective cleaners have spoken in personal terms of sensitive, "aesthetic" cleaners as opposed to insensitive, "scientific" cleaners.

The problem of the artist's intention

These kinds of pronouncements reflect an unwillingness to accept the relativistic aspects of cleaning. Indeed, the whole debate has been fatally flawed by the attempts of each school to gain credibility by claiming the greatest closeness to the artist's original intent.

Maclaren and Werner formulated most clearly the draconian aspiration:

> "... it is presumed beyond dispute that the aim of those entrusted with the care of paintings is to present them as nearly as possible in the state in which the artist intended them to be seen."[20]

But each school defends its practice in terms of closeness to the artist's intent. We have seen already the talk of doing "right by the artist," of "restoring the original unity of the work," and, in regard to complete cleaning, Ruhemann felt that the "restorer should be guided in everything by the master's intent." Everyone wishes to have God, or at least an Old Master, on his or her side. Elsewhere I have discussed at some length the fallacy of such claims.[21] I shall not take time rehearsing those arguments here; suffice it to say that if we have lost the original intention, only certain aspects of that intention may be preserved by each of these sophisticated approaches to cleaning. Because each approach gives different weight to the contributors to aesthetic experience, such as colour, harmony, and a sense of the passage of time, a claim by one technique over the others of being the most close results in a discussion of, for example, whether colour is more important than harmony, or whether a sense of the passage of time justifies a new imposed set of contrast relationships. These kinds of discussions are not merely fruitless, but are fallacious since the categories debated were all essential components of the original work. It is a little like trying to discuss whether in a wall it is the bricks or the mortar which are most important.

Much of the vehemence of the cleaning debates stems from this search for an impossible absolute. And that search for an absolute is motivated by the particular position which painting has in our culture. As a Fine Art, it is not only seen as the most sophisticated form of visual expression, but it is also crucially linked to the hands of particular individuals who are especially venerated. Yet, paintings change, intention is lost, time mellows and decays. In cleaning, the restorer is compelled to construct a new relationship between us and the work. It is hardly surprising, then, that restorers should fear to have any relationship other than one which can claim a direct link with the artist's intention, and even sometimes with the artist. In the face of alternative cleaning approaches, it becomes of the essence to lay claim to the greatest closeness to the artists"s intent. Gombrich's pungent remark that "one should have thought it is common ground that Titian is dead and that we cannot ask him what his intention was,"[22] is perhaps all that needs to be said.

What makes an approach to cleaning valid?

If there is no absolute, then there can only be new found relativities. I am suggesting that these three approaches to cleaning have equal validities; they are parallel ways of constructing a new relationship to the artist's intent and the passage of time. However, this does not mean that any approach to cleaning os equally valid; there are techniques which I would deem to be invalid. One such instance is the practice, which was once quite popular, of cleaning the lighter areas of a painting while leaving uncleaned the dark regions. The "porthole" effect could be quickly achieved and with relatively little risk, since lead white containing paint tends to be less soluble in cleaning solvents than many darker paints. I do not consider this to be a valid cleaning approach because it fails to satisfy what I believe to be essential test of validity—this is that, to be vlaid, a cleaning technique must establish a definably coherent relationship to aspects of the artist's intentions and the passage of time. The cleaning of the whiter regions only is simply an expedient adopted by the restorer for the sake of convenience. Further, though it has the saving grace of avoiding treating vulnerable areas, it actively distorts what remains of the painting by deliberately creating enhanced contrasts.

We are not then adrift in a sea of relativities. We have to deal only with a limited number of valid techniques. Essentially, it is the notion of the coherent relationship which has gradually been arrived at, through more than two hundred years of cleaning practice. The reality of this process has led to the emergence of not one kind, but three different kinds of coherent relationships. Perhaps there can be no better proof of this relativity than in the fact that, presently, the London National Gallery, the Lourvre, and the Metropolitan Museum can be taken as exemplars of the three different approaches. Yet, these museums are in complete agreement as to what constitutes fine art; they collect paintings essentially within the same canonical framework. That they display differently paintings by the same artist is *because* there can be no cleaning absolute. The interesting scholarly question then is not whether the Louvre is right and the National Gallery wrong, but why it is that the Louvre chooses one kind of cleaning approach and the National Gallery another. What does it tell us about the particular relationship of each museum to art and artists? Equally, none of the foregoing is meant to preclude the fact that we may individually prefer one technique over another; we may like one appearance better. But again the interesting aspect of this is not to assert that I am right and you are qrong, but to ask why it is that people come to value one kind of reconstruction over another.

Making judgements about cleaning and retouching

This does not mean that critical judgement of the cleaning process is entirely suspended, rather than it must be re-directed, for there are particular dangers within each of the cleaning systems; **there are points at which the coherent relationship is jeopardised**. Both curators and restorers need to be aware of the weaknesses of each system and address their critical visual faculties towards them; they must make judgements within each process.

The principal danger of complete cleaning is that it might reveal changed relationships that have become excessively jarring to the pictorial unity. Paintings on dark grounds are the most prone to show very dark and very light contrasting regions. The intensity of the shadows and half tones increase as medium darkens; and the paint becomes more transparent, so the influence of the dark ground is greater. The examples of change discussed earlier show that there can be many other such relationship altering shifts. In all cases, the restorere and curator must assess the degree of disjunction and decide whether to leave it visible, as a kind of patina, or to tone it down by glazing, during retouching.

The retouching phase of a completely cleaned painting also carries dangers. A very clean painting shows all its flaws and damages. If the work is fine, it inevitably calls for high quality, deceptive retouching if we are to see it as a whole image. Unlike the other techniques, it is actually in the retouching phase, rather than the cleaning phase, that a completely cleaned work is reconstructed to a pictorial unity. The difficulty is knowing at what point to stop retouching. There is a temptation to produce a highly finished work, with little remaining signs of wear or ageing. So, while the cleaning reveals the present state, with all its internal hue and contrast shifts, the retouching might tend to create the impression of a painting which has hardly altered at all with time. "Over finishing" needs to be consciously avoided, especially as it is almost an internal logic of the process. Conversely, poor quality retouchings on completely cleaned works hyave a particularly destructive effect on the pictorial unity, since they become apparent in a way which focuses attention on the retouching.

It is just as important to be aware of internal logic when it comes to safety of cleaning. Total cleaning encourages the restorer to come, in Ruhemann's words, "face to face with real original old masters' paint." [23] It is not conservative in its approach to the paint film and to my mind this is the central problem with the technique, so long as there are questions left unanswered as to the safest technical means of cleaning. Close contact must enhance the risks to the integrity of the uppermost layer of paint. Unfortunately, the other techniques are not able entirely to avoid the same kinds of risks, but at least they do not operate with the same injunction to approach the original paint surface. Here we should emphasise that, in many ways, the central problems of cleaning are technical. We do not have the precision of control which we should like in cleaning, nor do we know exactly how the paint film

is altered by the treatment. The most important recent developments in cleaning are the combination of the emergence of new methods to clean, employing water based gel formulations, and the undertaking of a number of studies to better comprehend the fundamental effects of both solvent and water based cleaning on oil paint films. The recently refined air abrasion cleaning techniques are also being used on paintings. Sadly, this is all long overdue. In the post war years, the heated cleaning polemics tended to discourage scientists from work in what was seen as a dangerously controversial area. Now it is essential that we take advantage of the possibility of a more balanced aesthetic discussion, to extend our material knowledge and practical control of cleaning.

With partial cleaning, we face a different, though no less intractable, set of problems. The main one is that it is, practically, very difficult to do. Organic solvents tend to dissolve through the whole depth of a layer of varnish at once, so making partial removal difficult. Alkaline reagents tend to remove the most acid components first and to leave less oxidised regions, so creating an irregular cleaning effect. Consequently, partial cleaning can often result in a patchy and uneven thinning. Sometimes the high points of raised paint will be completely clean whereas the troughs will still contain varnish. This kind of result can be very disturbing, and can result in the painting looking considerably more worn than before cleaning started, even though it may be in excellent condition. Evidently "patchy" and "peak" cleaning are examples of, what I would term, incoherent relationships to original intention. In my view they are not valid.

A second weakness is the determination of the basis as to how thin the varnish should be. A visitor to a museum which favours partial cleaning might be forgiven for not comprehending why some paintings are left with rather thick varnish and other with barely detectable remanats. Is the thick varnish necessary for the harmony of one but not of the other, or are we simply seeing different estimations of what harmony is? This does matter because I believe it to be of the essence that the viewer should be able to form some idea of how a painting is being re-presented as a result of cleaning. It ought not to be a matter of unfathomable mystery. There can, of course, be very good reasons for such variation, but such difficulties need consideration, particularly when relatively clean and relatively obscured paintings are displayed, side by side, introducing a further, spurious contrast relationship.

There are similar weaknesses with regard to selective or "balancing" cleaning. One of the problems is that the new unity is established during the cleaning and inevitably, must be the personal product of the restorer. Of course, the strength is that the restorer can attempt to clean so that a point is never reached where the work goes sharply out of balance. On the other hand, when painting is completely cleaned there is little ambiguity as to its present state and, if modulation is called for, it can be done with discussion and even several trials during retouching. With balancing cleaning, we are never quite sure what the state of the work actually is, or how it reached the point of its display.

The criticism tends to be met with the claim that the painting just looks right. Here, we need to be cautious, for we have seen already that there can be no absolute aesthetic in cleaning. We are entitled to ask what it is that looks right and why. As a cleaning system, it places pecular demands upon the restorer, who needs to establish a particular right to intervene in original works of art. There is no clear objective reference point in this cleaning ystem, as there is in the other two, and so the restorer might feel impelled to raise subjectivity to a pinnacle which is not quite warranted by what is being done. In practice, the most subtle practitioners have distinguished themselves by extremely restrained balancing, confining their intervention to only the most problematic areas. It is always fair to enquire of what has been done and so to avoid elevating the whole restoration to a mysterious plane.

Just as "over finishing" is an inherent weakness of complete cleaning, so it is likely that "over balancing" is an inherent weakness of selective cleaning. It is possible to become too obsessed

with contrasts and to set about a multiplicity of harmonisations, or to allow only the blandest of contrasts to remain. Again, the best practitioners steer clear of too excessive intervention which ultimately would become a denial of the age of the painting.

Sharing responsibility

"Shared responsibility" is an attractive notion, with its implication of a non hierarchical inter-relationship between the disciplines of curator and conservator. All too often, this does not occur. Some countries institutionalise the dominant role of the curator in deciding what should be done during cleaning; elsewhere, in reality, it is the conservator, the active partner, who, de facto, takes the decisions. This need not be the case; for, in the choice of a cleaning strategy, there is need for the knowledge of curator and conservator. The conservator will have an intimate knowledge of the condition of the painting and its technique, he or she will have an estimation of how difficult the cleaning will be practically. The curator can bring to bear the historical knowledge of the painting, the artist, and context. However, these truisms will mean nothing unless the curator and conservator have some comprehension of one another's disciplines. If the curator knows nothing of technique, and the conservator nothing of art history they will find it difficult to have a meaningful discussion.

How then might a shared decision be reached? The starting point must be an assessment of the condition of the painting and, particularly, of how it has changed with time - its lost relations. This will give some idea of the potential problems of cleaning. It is always the paintings that have suffered most which present the gravest problems in cleaning. **At this stage it may be wise in some cases to decide against cleaning altogether.** Next, assuming agreement is reached on the desirability and feasibility of cleaning, then the approach that is to be adopted can be considered. Should the work be completely, partially, or differentially cleaned? This decision will depend on the style and subject, the condition of the paitning, the vulnerability of the paint, the context of the work, the intended display conditions and so forth. Finally, having opted for a strategy, the curator and conservator can discuss the nuances of the cleaning and, together, ensure that the pitfalls of the chosen system are avoided. This, in essence, is how the curator and conservator might start from long lost relations and follow the road to the presentation of new found relativities within an old painting.

In burying the myth of absolutism—that there is only one right solution—I am hoping to ease the process of rapproachement between different approaches, that is, to encourage a more mature understanding of each other's relations. This essay is conciliatory because it recognises equal, though different, values within the varying approaches. Perhaps we will learn to rejoice in the diversity that seeing similar great paintings, presented in different ways, offers to our visual perception. It would be best if we could, for there can be no going back to the originals, and no single response to change.

It is also a good moment to attempt conciliation because, in practice, there is a certain tendency now for all the cleaning systems to arrive at much closer results. Partial cleaners seem to be leaving much thinner residual layers; complete cleaners seem to be trying to stop a little short of the paint film and to be prepared to tone down jarring discontinuities. Currently, the pragmatic guide to cleaning would probably stipulate just four requirements: the painting should appear as a unified whole; it should not display altered contrasts that are too jarring; it should not be made to look too new; and it should display as much of the remaining colour as possible, within the limitations imposed by the other requirements.

However, the cleaning of paintings is not best considered at the pragmatic level. What is done during cleaning is to change the work as an aesthetic object—to re-present it. It remains a duty of the conservator and curator to understand, as clearly as possible, how and why this is being done and what options are available. This essay has attempted to make sense of the methods that have historically evolved to clean paintings. If we can do that, we then

at least have a non mystifying basis on which to discuss the conservation and restoration of paintings, as both aesthetic and material objects. We have lost the old original relations. We did not even want them to stay unchanged, for the passage of time is important. Yet, we need to understand our new found relativities, not as a battleground of right and wrong, but as the varied strands which have come to connect our present view of art with the past.

References

1. Keck, S 'Some picture cleaning controversies: past and present'. **Journal of the American Institute for Conservation of Historic and Artistic Works**, vol 23, 1984, pp 73-87.
2. Letter to the editor of **The Times**, 4 January 1847
3. Editorial, **The Burlington Magazine**, vol 127, no 982 January 1985.
4. Letter to the editor of **The Times**, 7 January 1847.
5. Hogarth, W **The Analysis of Beauty**, ed Burke, J (Oxford: Clarendon Press, 1955) pp 130.
6. Slive, S **Frans Hals**, Volume 1 (London: Phaidon 1970) p 212.
7. Brandi, C **Teoria del restauro** (Rome: edizioni di storia e litterature 1963).
8. Villers, C and Hedley, G 'Evaluating colour change: intention, interpretation and lighting' in **Preprints of Lighting in Museums, Galleries and Historic houses,** (London: Museums Association 1987) pp 17-24.
9. Massing, A and Groen, K 'A self-portrait by Godfried Schalcken', **Bulletin of the Hamilton Kerr Institute**, no 1, pp 105-108.
10. Bergeon, S **Restauration des peintures**, Dossier du Department des Peintures, n 21, Paris, Reunion des Musees Nationaux, 1980.
11. Ruhemann, H **The Cleaning of Paintings** (London: Faber and Faber 1968) p 218.
12. Ibid, p 218.
13. Philippot, P 'La notion de patine et le nettoyage des peintures', **Bulletin, Institut Royal du Patrimoine Artistique**, vol 9 1966, p 138.
14. Mora, P, Mora, L and Philippot, P **Conservation of Wall Paintings** (London: Butterworths 1984) p 283.
15. Ibid, p 282.
16. Hill Stoner, J 'John Brealey's Trained and Sympathetic Eye,' **Museum News**, vol 59, no 7, July-August 1981, p 26.
17. Hochfield, S 'The Great National Gallery Cleaning Controversy,' **Art news**, October 1978, p 59.
18. Gombrich, E H **Art and Illusion**, 2nd printing (Princeton: Princeton University Press, 1972) pp 54-55.
19. Brou, P, Sciascia, R, Linden, L and Lettvin, J Y 'The Colors of Things,' **Scientific American**, vol 225, no 3, September 1986, pp 80-87.
20. MacLaren, N and Werner, A 'Some Factual Observations about Varnishes and Glazes,' **The Burlington Magazine**, vol 92, July 1950, p 189.
21. Hedley, G 'On Humanism, Aesthetics and the Cleaning of Paintings,' Ottawa 1985, mimeograph. Unpublished lecture text available from extension services, Canadian conservation institute, department of communications, Ottawa, Ottawa, Ontario, K1A OC8.
22. Gombrich, E H 'Dark Varnishes: Variations on a Theme from Pliny', **The Burlington Magazine**, vol 104, February 1962, p 54.
23. Ruhemann, H **The Cleaning of Paintings**, p 235.

LOOKING AT LEONARDO'S LAST SUPPER

Martin Kemp

The story of the deterioration of Leonardo da Vinci's mural painting of the 'Last Supper' in the refectory of S.Maria delle Grazie in Milan (Fig.1) has often been told, most recently in connection with the current campaign of restoration. The standard narrative is a cautionary tale - if not actually a horror story - involving a disastrous choice on Leonardo's part of an experimental technique, a catalogue of misfortunes ranging from assault by Napoleon's troops to modern bombing, a sequence of sadly misguided attempts to reconstitute the lost masterpiece on the basis of misconceptions about the nature of his medium, and the general ravages of dampness, atmospheric pollution and the tourist industry[1]. The climax of the story, in the recent accounts, involves the sweeping away of past errors, on the secure basis of scientific analysis and in keeping with the conviction that whole-scale repainting of lost features is fraudulent. The stated aim of the recent campaign is to recover what remains of the 'true Leonardo'.[2]

The aspiration to reconstitute Leonardo's 'original', albeit in fragmentary form, implies that our modern knowledge grants us immunity from the period-flavoured blunders of the past. From our standpoint of patronising superiority, we tend to deride Cavenaghi's work on the 'Last Supper' in the early years of this century, which is said to have resulted in the younger disciples looking suspiciously like the angels in the restorer's independent paintings[3]. We are both better-informed and more humble, acting with far greater respect, responsibility and integrity towards the handiwork of the past. Our sense of integrity towards what is considered authentic is much like the current fashion for performing music on period instruments - a parallel to which I will be returning.

I am aware that no historically-aware modern conservator would claim access to absolute certainty on all technical matters when striving to regain the authentic image, particularly in the case of a painting as complex as Leonardo's mural, and I would not expect a conservator to claim that the 'original' of any Renaissance painting can be precisely recovered in every respect. But the problems to my mind go beyond admissions of the technical limitations of even the best current procedures. The problems concern the nature of the perceptions of paintings within the continuous historical process of which we are still a part. The criteria of every age appear at the time to stand in a privileged position of objectivity with regard to past misconceptions, and there is no reason to think that the nature of our own judgement is essentially different in this respect. However, the scientific aura of unassailable objectivity that pervades the practice and above all the presentation of modern conservation makes it harder rather than easier to see the period-specific nature of the basic choices that are being made.

The choices of every age are embedded within a complex series of interlocking assumptions about the essential nature of the object with which we are confronted. Each viewer, past and present, brings a particular set of expectations, abilities and differential discernments to bear on the image. The 'Last Supper' can be looked at as 'a Leonardo', as a cult icon of modern culture, as an essential tourist experience, as the first High Renaissance narrative, as a moving work of art, as a religious image, as a demonstration of the pictorial language of gesture, as a supreme

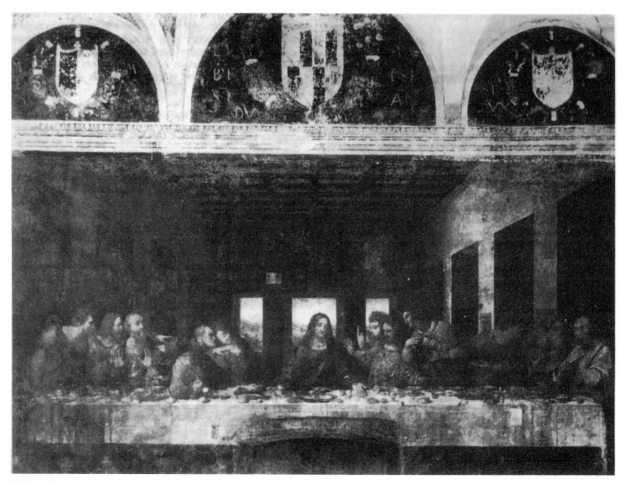

Fig.1 Leonardo da Vinci, 'Last Supper', c.1497, Milan, Refectory S.Maria delle Grazie (after Pellicoli's restoration and before Brambilla Barcilon's)

attempt to evoke natural appearances, as a realisation of Leonardo's theories, as a spatial conundrum, as an elaborate iconographical text, as an extraordinary example of mural painting technique, as the ultimate challenge (or nightmare) for a conservator, as an expression of the patron's authority, as the Soprintendenza's greatest treasure, as an extreme illustration of the behaviour of the 'disembodied eye' in the perception of perspectival images, and so on. Each of these ways of looking will make distinct demands on the surviving image, and not all of these demands will be compatible either with each other or with current conservation practice.

What I should like to attempt in this paper is not so much a criticism of modern practice as such, much of which is undoubtedly based on a far greater knowledge of the physical constitution and behaviour of the material objects than was available in the past, but rather to subject our assumptions to critical scrutiny in the historical contexts of the ways in which the 'Last Supper' has been viewed and the particular kinds of demand that we are now making on images from the past. I will conduct this investigation under three headings: 'the viewer in history'; 'the authentic Leonardo'; and 'the scientific answers'.

The viewer in history

In order to become more reflective about current practice we really need the as-yet unwritten history of conservation from the standpoint of how pictures have been viewed in past ages. Only by understanding the conceptual frameworks within which past procedures were devised can we gain a clearer perspective on our own choices. The story of the viewing of the 'Last Supper' cannot on its own substitute for this comprehensive history, but it might give some clues as to what such a history might be like. In particular, we may gain some idea of the changing criteria of what constitutes a 'ruined' painting and what should be done to reconstitute it.

The early deterioration of the 'Last Supper' is well attested. Although Pasquier le Moyne did not mention its condition when he

viewed it in 1515 during Francis I's Italian expedition - dwelling specifically upon the miraculous veracity of the still-life details on the table - two years later Antonio de Beatis described it as 'most excellent, though starting to become ruined [*incomincia ad guastarsi*], I do not know whether from dampness which affects the wall or some other mischance'[4]. The term *guasto* is one which recurs in early accounts in a way that suggests that sixteenth-century concepts of what constituted a 'ruined' painting were rather different from ours. The most discouraging of the assessments from the next century, by Scanelli in 1642, indicates that only confused 'vestiges' of the figures remained[5]. There are, however, early signs that the 'Last Supper' benefitted from a growing tolerance of imperfect images, whether the unfinished sculptures of Michelangelo, the underpainting of Leonardo's 'Adoration of the Kings', sketchy drawings or damaged masterpieces. Armenini in 1586 records that although the mural is 'half ruined [*mezzo guasto*], it appears to me even in this state to be a very great miracle'[6]. Lomazzo is also effusive in his praises, when discussing the portrayal of motions and emotions, although he records that the mural seems to be 'totally ruined' because of a problem with its '*imprimitura*'[7]. I suspect that the enthusiasm of Renaissance connoisseurs for fragments of sculpture from their beloved classical antiquity played a significant role in conditioning this willingness to delight in incomplete survivals.

Vasari's famous account of Leonardo's masterpiece is rather curious in this respect. In his life of Leonardo he does not mention its condition at all. Rather, he concentrates on its miraculous qualities, noting that 'every part of the work shows an incredible diligence; since even in the tablecloth the working of the fabric is counterfeited [*contraffatta*] in such a manner that actual linen could not be more true'[8]. He tells the story, also found in Lomazzo and Carducho, that Leonardo 'left the head of Christ unfinished, thinking that... it was possible to conceive in the imagination that beauty and celestial grace which ought to belong to divinity incarnate'[9]. This emphasis upon the artist's actual realisation falling short of his 'perfect ideas', with its Neoplatonic flavour, might be better applied to Michelangelo than Leonardo, and the evidence of notes and drawings by followers suggests that Vasari was incorrect in thinking that Christ's head was originally unfinished, but it does

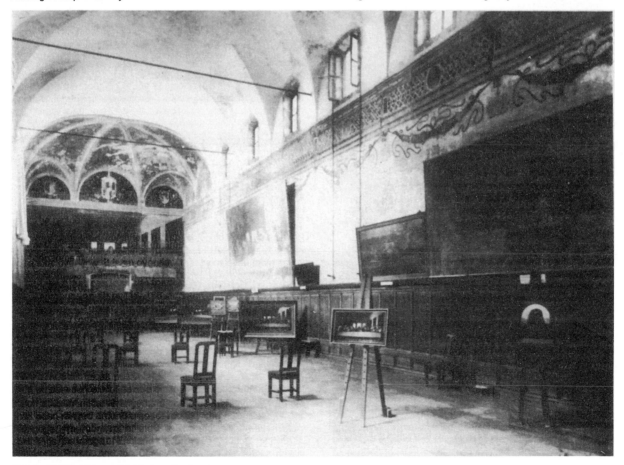

Fig. 2 The Refectory of S.Maria delle Grazie in 1900 (photo. Broggi)

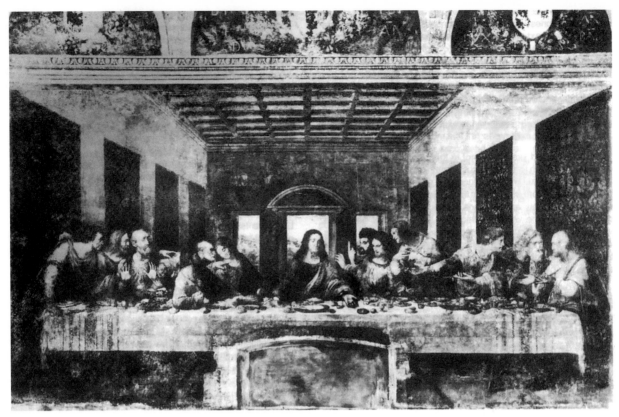

Fig. 3 The 'Last Supper' after Cavenaghi's restoration of 1907-8.

Fig. 4 The 'Last Supper', detail of Head of Christ during Brambilla Barcilon's restoration

Fig. 5 The 'Last Supper', detail of heads of St.Thomas and St.James the Greater during Brambilla Barcilon's restoration

have the merit of providing a precocious explanation for the *non finito*.[10] However, there were strict limits to Vasari's appreciation of imperfect survivals, as witnessed by his willingness to cover Leonardo's unfinished 'Battle of Anghiari' with his own murals.

Only when he is discussing a copy made by Gerolamo Bonsignori, in his notes on the 'Lives of Benvenuto Garofalo and Girolamo da Carpi, Ferrarese painters, and other Lombards', does Vasari record that the 'original by Leonardo is so badly executed that nothing more can be discerned than a blurred stain [*una macchia abbagliata*]'[11]. Buonsignori's copy, Vasari tells us, was undertaken as an act of 'devotion' to 'render lasting testimony on his behalf to the powers [*virtù*] of Leonardo'. Virtually from the first, there is evidence that the 'Last Supper' received homage as an exemplary 'work of art'. Giovio and Vasari both testify that Louis XII wished unavailingly to 'transport it to his kingdom' on account of its 'nobility, both for its composition and because of its incomparable diligence of finish'[12]. Vasari's stress upon the *nobilità* of the painter's work and the *nobilità* of the royal patron who was desirous of possessing it were part of the same promotional programme for artists and art[13]. The combined desires to pay homage to Leonardo's masterpiece and to rescue it from its self-destructive oblivion provide the motives behind many of the numerous early copies, particularly those commissioned by patrons such as Francis I. The copyists, as was typical in the earlier periods, all adopted various degrees of licence, particularly with respect to the architectural setting.

By the late eighteenth century, the reconstructive copying had assumed a more specifically historical flavour, involving research to determine the appearance of lost features of the original painting. Abbot Francesco Maria Gallarati, Giuseppe Bossi and André Dutertre undertook meticulous recreations of the damaged masterpiece using what visual and written evidence was available to them[14]. Bossi's superb reconstructive initiatives, which culminated in the making of a version in mosaic, a medium of unquestionable durability, provided the locus for Goethe's brilliant verbal recreation of the communicative force of Leonardo's invention[15]. Something of this atmosphere of studious copying, so redolent of nineteenth century art academies, survives in Broggi's 1900 photograph of the refectory (Fig.2).

It is in these successive contexts of creative re-realisation and historically reconstructive copying that the earlier conservation programmes need to be understood. The efforts of such restorers as Bellotti (1726) and Mazza (1770) were based on the conviction that Leonardo's painting could best be served by recreating the coherence which it had lost - though already in the eighteenth century questioning voices were beginning to be heard, including that of Goethe[16]. Even Barezzi's more archeological intervention in 1853-5, which uncovered the lunettes, resulted in significant amounts of recreative infilling and overpainting[17]. The shift in emphasis during the subsequent restorations (Müller-Walde in 1895-6, Cavenaghi in 1904 and 1907-8 [Fig.3], Silvestri in 1918 and 1924, and Pellicoli in 1947-9 and 1952-4) was progressively towards consolidation and removal of the later retouchings, aided by detailed photographs and accompanied by an increased use of scientific and analysis to determine the actual medium, which since Lomazzo's time had been thought to be oil[18]. Cavenaghi was the first to discern that the 'fresco' or 'oil painting' was actually executed in a form of tempera on a double layer of priming. It is in keeping with this change in emphasis that a 1936 photograph of the refectory shows that the smaller, easel-mounted copies in the earlier view have been replaced by detailed photographs of the disciple's heads, taken as part of Cavenaghi's campaign of restoration. These recent trends have culminated in the current campaign by Pinin Brambilla Barcilon, which is rigorously stripping the mural 'to recover all that remains of Leonardo's own painting', providing only a neutral, featureless infilling in the large areas devoid of surviving paint (Figs.4-5)[19].

The interpretative eyes which have accompanied the more archeological excavations of the battered strata of Leonardo's original have been more attuned to fragmentary works than the eyes of previous generations. Indeed, there has even been a kind of romantic 'plus' to be gained from the effects of the ravages of time on the legibility of the work. As a true successor to Pater,

Kenneth Clark followed his sober and accurate estimate of the repainted state of the picture, with a romantic evocation of its poignantly faded power:

'But in spite of the depressing insistence of these facts, some magic of the original remains, and gives the tragic ruin in Santa Maria delle Grazie a quality lacking in the dark, smooth copies of Leonardo's pupils... The fresco, perhaps from its very vagueness, has kept a certain atmospheric quality. As we look at them, these ghostly stains upon the wall, "faint as the shadows of autumnal leaves", gradually gain a power over us not due solely to the sentiment of association. Through the mists of repaint and decay we still catch sight of the superhuman forms of the original'[20].

It is rather like listening through a veil of surface noise to an early record of a great singer, which acquires a moving quality rather different from a re-mastered and electronically cleaned version. Clark's kind of appreciation not only relies upon a sensibility attuned to the evocative qualities of damaged remnants of past civilisations but also on the lessons taught by the Impressionists and their successors, who have shown us how to relish the very 'stains' and 'blots' (*macchie*) that Vasari found so incoherent. The Italian 'impressionists' were, after all, called the Macchiaioli.

More recent taste - for remastered recordings no less than for scientific restorations - would distance itself from the more romantic aspects of this response, while still relying upon our willingness to work with the fragmentary. This willingness is enhanced by our belief that we are closer to seeing what remains of the authentic Leonardo.

The authentic Leonardo

The declared aim of the present campaign is clear, unequivocal and pervaded by an apparently cast-iron logic: 'what we are bringing to light will truly be by Leonardo's own hand'[21]. Carlo Bertelli, the Soprintendente under whose administration much of the restoration has been conducted, entitled one of his articles, '*Verso il vero Leonardo*'[22]. Setting aside for the moment the technical problems with the recovery of 'all that remains of Leonardo's own painting' - I am thinking of such problems as the difficulty of determining which pigments are truly original, and the irreversible physical change in some of the materials used by Leonardo - we can legitimately ask a series of questions about the assumptions that lie behind the notion of the 'true' or 'real' Leonardo. Is the 'true' Leonardo to be identified with the scattered material remnants of his picture? Is the notion of recovering and retaining only that which is 'by Leonardo's own hand' identical to the reinstatement of the 'real' Leonardo? Is the concept of the artist's 'hand' one that should have a determining influence on how we conserve a Renaissance painting? How far can we identify a recovery of the fragmentary original with a respect for the artist's intentions, if such intentions are reconstructable at all? Does the artist, in some way, exercise posthumous rights over his creation? Are we aiming to recapture the authentic experience of the original? Is there such a thing as an 'authentic experience' to be reconstructed at all, either in terms of the viewing of the 'Last Supper' in 1498 or in terms of the circumstances of the present-day spectator? This set of more or less subversive questions are those of a historian rather than a conservator, but the conservator has explicitly, implicitly or totally inadvertently already given answers to them before he or she lays solvent to surface.

Let us begin with what is perhaps the least taxing of the queries, that is to say with the question of how far we can recapture the original experience. I think it will be generally accepted that even for a work that remains *in situ* like the 'Last Supper' the circumstances under which it is viewed will have irreversibly changed. The changes not only embrace the obvious physical alterations in the work and its setting - the re-building of much of the refectory after the bombing, changes in lighting, the absence of refectory tables, our entrance from a foyer through turnstiles etc. - but also involve the mental frameworks which control the viewer's perception of the work[23]. These mental frameworks for the present-day viewer will vary enormously - from those of a bored tourist with sore feet to those of a cynical art historian with a sore head -

but no one can escape all the associations which go with the huge exposure the painting has received as a cultural icon. The 'Renaissance experience' is no more reconstructable than is the original experience of a piece of music by Beethoven. Even the most archaeologically scrupulous performance of the Choral Symphony on period instruments in original settings, rigorously observing the composer's own markings, will not sound like the original in the ears of a modern listener. We simply cannot dismiss the intervening experiences of Beethoven performed by the massed ranks of post-Romantic orchestras. The sound of the authentic recording is not so much authentic as overtly concerned with what may be termed the 'sound of authenticity' - which represents a particular kind of experience for a modern listener.

If we accept that the authentic experience is not re-capturable in the final analysis, can we still say that it should nevertheless be reinstated as far as is possible? A positive answer to this question depends upon the possibility of identifying something we can call the original experience, which is itself predicated on notions of the artist's intentions and the attitudes of the original spectators. I am not someone who believes that the artist's intentions are either imponderable or irrelevant to the historian who wishes to understand the work and, by extension, to any spectator who wishes to enrich the potential of their viewing. In Leonardo's case we are fortunate in possessing a large body of notes to help us identify his 'intentions' - in the most obvious sense of this term. We can assess the requirements he placed on a painter with respect to such matters as light, colour, space, detailed naturalism, motion, gesture, physiognomy, expression, invention and narrative. We can also embrace the broader class of intentions left unstated by Leonardo, since they were part and parcel of the business of making functional religious art in particular settings under particular conditions of patronage etc.

Yet all this potential for defining original intentions should not lead us to believe that they are like a recipe for a cake, which, if mixed in the right proportions and properly cooked, will inevitably produce a product with a certain appearance and flavour. Any artist's intentions, and most especially during the deeply pondered and protracted execution of a work like the 'Last Supper', will be a complex and shifting compound of conscious and unconscious aspirations, adjustments, re-definitions, acts of chance and evasions. It is unlikely that there was ever a stable set of transparently accessible intentions.

The same kind of complex instabilities will come into play when we consider the original spectator. Is such a spectator to be identified with the Duke, who was impatient for Leonardo to finish, with the Prior (whether or not Leonardo actually used him as the model for Judas), with the humble monks dining in the refectory, with Loius XII, who wanted to carry it off to France, with Leonardo's fellow painters or even with Leonardo himself? For a northern spectator like Pasquier le Moyne, the 'Last Supper' was a miracle of verisimilitude, particularly with respect to the still life on the table. Italian observers paid relatively more attention to its qualities as a *historia*.

Any programme of restoration of a badly damaged and extensively repaired artefact which aims to reinstate some measure of the original experience has to make an implicit choice as to which of the artist's intentions or groups of intentions and which of the various spectators' criteria are to be satisfied. The present campaign might be said to satisfy Pasquier rather than those who would define the 'Last Supper' first and foremost as a history painting. The revelation of such details as the hooks suspending the tapestries and the reflections in the pewter plates have been underwritten by reference to Leonardo's own intentions:

'In recuperating the work of another painter such details might seem irrelevant; but in Leonardo's case we know from descriptions of his working methods that he placed the highest importance not only on the overall conception of the Last Supper but also on the perfect rendering of details. If Leonardo gave such importance to the smallest details in the painting of his pictures, should we not do the same in examining it?[24]' It is perhaps significant that David Allan Brown, the judicious author of this passage, refers to 'examining it' rather than the final presentation of the work after restoration.

In searching for the ravishing detail that will reveal the hand of the master, in terms both of mimetic skill and of his personal handwriting, we are indulging in a relatively modern quest. Although the Renaissance saw the birth of the concept of the individual artist's 'hand' - Dürer was precociously alert to this criterion - it was only with the rise of the historical connoisseur that it assumed prominent significance. The birth of the detailed photograph had much to do with its enhanced importance. Recent publications centering upon conservation, such as exhibition catalogues, exploit blown-up details to striking effect, and the widely illustrated photographs of rediscovered details of the 'Last Supper' during its cleaning provide a kind of visual argument in favour of the controversial 'restoration methodology'[25]. Indeed, I think it can be argued that the production of such documentation in lavishly illustrated publications provides an end in its own right, which inevitably exercises some influence over the choices of means and goals for the restorer. The publication and more general broadcasting of the results is, in its turn, related to the sponsorship of large-scale restorations and the kind of return that the sponsors expect on their investment. The sponsorship of the cleaning of Michelangelo's Sistine Ceiling presents the most blatant example of a sponsor's control over the public presentation of the results. Even the most hard-headed curators and conservators cannot but be affected by the political, institutional and financial requirements built into such sponsorship deals. The Ceiling's conservators have necessarily become media performers, displaying their alchemical magic in front of the television cameras.

In the case of the 'Last Supper' I believe that the aesthetic shift in successive restorers' priorities from the overall effect to the seductive fragment has been significantly facilitated by the available means for the presentation and dissemination of the resulting images. But the choice remains at heart an aesthetic one. We have lost a sense of the predominant importance of the 'story' in history painting, in favour of the 'work of art' as our authentic visual experience of what has been created by the master's hand. Even when we do turn our attention to the meaning of the image, we are more than likely to resort to a detailed hunt for iconographical clues which parallels the reading of a literary text - a form of piecemeal reading that would have repelled Leonardo, given his insistent emphasis on the simultaneity of the visual image. In this respect the 'science' of the Panofskian iconographer and the science of the conservator, armed with magnifying apparatuses and Polaroid cameras, are mutually reinforcing.

The scientific answers

The dilemmas of choice that face us now are not essentially different in kind or less period-specific than those which faced past restorers. Where our situation is different is that a vastly greater body of information is available to us, particularly the data of scientific analysis. But does this make our choices any easier?

Recent analysis has done much to clarify the materials used by Leonardo and to explain the rapid deterioration of the painting's surface. We know that his medium was a kind of *tempera grassa*, a technique similar to that used on panel paintings and probably incorporating oil as an accessory binder - though precise definition of the binding media remains elusive[26]. Microscopic examination and scientific analysis have revealed that the *intonaco* was covered by a fine layer of plaster incorporating oil, which was then primed with white lead. In at least one area where deeper colours were required, a coating of carbon black was added (Fig.6). The layers of pigment, one or more of Leonardo's, and those added by successive restorers, were built up on this base. The failure of some of the layers to maintain adhesion, resulting in extensive losses of pigment and priming, can be clearly discerned across the whole surface. We know that the wall is unusually thin for its height and that the atmospheres in the refectory and the small room on the other side of the wall are subject to unequal fluctuations in temperature and humidity. Leonardo's layered, *a secco* procedures, particularly his application of a skin of white lead, were asking for trouble.

Although some inevitable doubts remain about some of the intermediate layers of pigment - are they early overpaint or Le-

Fig. 6 Cross-section of the 'Last Supper' from Christ's right sleeve, showing the discoloured priming, white lead layer, carbon black underpaint, red pigment layer and discoloured red overpaint (Laboratorio Chimico, Fortezza da Basso, Florence).

Fig. 7 Photographs by O. Louis Mazzatena of Dr.Pinin Brambilla Barcilon on the scaffolding and at work, and by Victor R. Boswell, Jr. of a detail of a restored slice of lemon, as illustrated in the **National Geographic**, November, 1983

Fig. 8 The 'Last Supper', detail of the head of Simon during Brambilla Barcilon's restoration.

Fig. 9 Leonardo, study for St.Simon (or copy of a lost drawing), red chalk on red prepared paper, 189 x 150mm, Windsor, Royal Library, 12550.

onardo's modelling? - the aspiration to remove everything not added by Leonardo himself is at least realistic in the light of scientific examination. May we say that such a procedure can be described as a truly 'scientific restoration' and accorded a less questionable status than earlier attempts? There are two answers to these questions, a public one and a professional one.

The public perception resides in the more or less popular reporting of the great campaigns of conservation, supported by the kind of explanatory exhibitions which occur widely in Europe and America. When Signora Barcilon appears in the 'National Geographic' (Fig.7) it is as *donna universale*, a mistress of science, technology, archeology and art, transformed inexorably into a magician who performs on a public stage. Bertelli, author of the accompanying article, tells us that 'Dr.Pinin Brambilla Barcilon works at a microscope about the size of a dental X-ray machine... with a paintbrush along with a scalpel and a surgeon's skill... The current restoration is, in a sense, an excavation'. 'You have to think like an artist', she is quoted as saying on her own behalf[27]. Leaving aside the confusion of imagery, it is clear that the technological, medical and archaeological allusions give the procedures an aura of scientific legitimacy. Although the prowess of science and progress of technology are less subject to automatic public reverence than they were a few years ago, science still possesses a kind of mystique that gives it special authority - particularly if it is so technically complex as to be incomprehensible to the public at large. I would not deny that the graphs, charts, diagrams, lists of pigments and photomicrographs often accompanying the exhibition of newly-restored paintings are intended to be genuinely informative, but the actual role they perform for the majority of the spectators is a combination of mystification and legitimisation. Sometimes they seem to add very little that is useful to all but a few specialists, and are now routinely included as required components in the conventional language of such shows. Faced with such parades of scientific authority, the public may be misled into thinking that the rationale for the procedures is now beyond question.

The professional answer should be - but is not always - different from the public answer. Scientific techniques provide data in response to specific questions, and technology supplies tools to meet specific needs. Science can vastly improve the quality of the answers we can provide and technology can enormously increase our scope for informed action on the basis of these answers. But neither can ultimately determine the nature and the quality of the questions, nor do they supply the framework of assumptions which precede the asking of questions. Since science and technology have so increased our potential for action, the scrutiny of our assumptions is even more vital than it was. The assumptions underlying present campaigns of restoration are no different in nature from those which have pertained in the past. They concern the conception of what is essential in a work of art, which in turn determines what demands we make on visual images. The procedures being followed in the 'Last Supper' are founded on a set of contemporary beliefs, and the choices are very much those of our own time. This is not to say that they are wrong - indeed, I do not think it is possible to define right and wrong in any enduring sense in such matters.

Conclusion

After such a bout of relativistic breast-beating, it is probably only fair that I come clean and offer my best opinion about what should be done with a painting like the 'Last Supper'. Faced with such practical questions to whether repaints and infillings should be removed in whole or in part, and what degree of cosmetic retouching should be permitted, decisions have to be taken, with all the risks they entail. I do not wish at this late stage of my paper to become entangled in the question of the historical-cum-ethical status of later additions; that is to say whether they have a right to survive as integral components of the work as a historical artefact. Rather I am concerned with the more practical question of the legibility of the image with respect to the requirements we place upon it. Let us imagine a painting finished in 1500 which had lost one-fifth of its surface by 1600, and is retouched by a restorer who wishes

Fig. 10 The 'Last Supper', detail of the hair of St.Thomas during Brambilla Barcilon's restoration.

to retain the overall effect. By 1700, another fifth of the original is lost and painted in, and so on, until the 1900 restoration results in a picture that is one-fifth original and fourth-fifths repaint. Do we remove all the repaints, ending up with just one-fifth of the picture? I think the answer in this case is not to strip the picture down, not least because each of the repaints were undertaken on the authority of what survived. In the case of the 'Last Supper' - and probably in any other actual instance - the situation is more complicated, since the status, quality and physical condition of the repainting is far more variable, and may even be risking the actual survival of the surface. However, I would not be inclined to strip the disciples' and Christ's heads down to bare, vacuous silhouettes, even where external contours emerge that are recognisably those of Leonardo's drawings (Figs.8-9). We may gain some pleasure from a close-up photograph of some of the vivacious curls at the top of St.Thomas's head (Fig.10), but the loss of the bulk of the hair is destructive of the formal coherence of his head as a whole - which is how most spectators will have to read it from floor level.

If, however, the decision has been taken to strip away all the later additions - and I would not assert categorically that it is the wrong decision - what do we do with what remains? We could fairly say, 'this is what is left; we wish it were more coherent, but all we can do is to take pleasure in some gains in visual quality of the details and welcome a good deal of additional historical information, To add something that is not Leonardo's would be to perpetrate a forgery'. This is a logical and defensible position, but if the result is claimed to be the restitution of the 'true' or 'real' Leonardo a kind of deception is taking place, not least because the expression of the 'true' or 'real' Leonardo through a scattered series of archaeological fragments would have been meaningless to Leonardo himself. We should not be under any illusion that the 'true' and 'real' are defined other than in our terms.

In the case of the 'Last Supper' we are uniquely equipped with early, large-scale copies, which in combination provide us with a great deal of information about the lost areas of Leonardo's mural[28]. I would be inclined to find some way of using this information, even to the extent of a judicious but detectable infilling of general masses to tie the picture together. As an alternative, I think it would be worth using new technologies to provide a visual programme in which the surviving fragments are successively faded into the best of the copies and relevant drawings. Such a solution would of course be overtly modern and specific to our own period, but the transparency of the modern, technological forgery would be part of its merits. It would not claim the spurious authenticity of the 'real' Leonardo, but it would reconstitute particular aspects of the impact of the work in terms which would be effective for the present-day spectator. Leonardo, the great 'counterfeiter' of nature, might even nod in approval.

References

1. Amongst the more recent accounts, see Marani, P C, **Leonardo's Last Supper**, Electa (1986); Cecchi, R, and Mulazzani, G, **Il Cenacolo di Leonardo da Vinci**, Giunti (1985); Brambilla Barcilon, P, **Il Cenacolo di Leonardo in Santa Maria delle Grazie. Storia condizioni problemi**, Ivrea (1985); and Brown, D A, **Leonardo's Last Supper: the restoration, Leonardo's Last Supper: before and after**, National Gallery of Art, Washington (1984).
2. Bertelli, C, **Verso il vero Leonardo, Leonardo e Milano**, ed. Dell'Acqua,G A, Milan (1982) pp 83-8. For further reports on the campaign and the scientific analysis, see Matteini, M, and Moles, A, A Preliminary investigation of the unusual technique of Leonardo's mural 'The Last Supper', **Studies in Conservation**, 24 (1979) pp 125-33, and Il Cenacolo di Leonardo: considerazioni sulla tecnica pittorica e ulteriori studi analitici sulla preparazione, **Quaderni dell'Opificio delle Pietre Dure e Laboratori di Restauro di Firenze**, 1 (1986) pp 34-41; Bertelli, C, Il Cenacolo vinciano, **Santa Maria delle Grazie**, Milan (1983) pp 188-95, and Leonardo e l'Ultima Cena, **Tecnica e stile. Esempi di Pittura Murale del Rinascimento Italiano**, ed. Borsook, E, and Superbi Gioffredi, F, Florence (1986) pp 31-42; Travers Newton, H, Leonardo da Vinci as a mural painter: some observations on his materials and working methods, **Arte Lombarda**, 66 (1983) pp 71-88; Kühn, H, Naturwissenschaftliche Untersuchung von Leonardos 'Abendmahl' in Santa Maria delle Grazie in Mailand, **Maltechnik/Restauro**, 4 (1985) pp,14-51; and Marani, P, Leonardo's Last Supper: some problems of the restoration and new light on Leonardo's art, **Nine Lectures on Leonardo da Vinci**, ed. Ames-Lewis, F, Birkbeck College, London (1990) pp 46-51.
3. See Bertelli, C, preface to Pedretti, C, Studies for the Last Supper from the Royal Library at Windsor Castle, **Leonardo's Last Supper...**, National Gallery of Art, Washington (1983) p 14.
4. Pasquier le Moyne, **Le Couronnement du Roy Francois premier...**, Paris (1520) pp.204-5; see Snow-Smith, J, Pasquier le Moyne's 1515 account of art and war in Northern Italy: a translation of his diary from Le Couronnement, **Studies in Iconography**, 5 (1979) pp.173-234. Antonio de Beatis, Relazione del viaggio del cardinale Luigi Aragona, MS in Naples, Bibliotheca Nazionale, Codex XF 28 B and XIV E 35, ed. Pastor, L, **Die Riese des Kardinals Luigi d'Aragona**, Freiburg (1905) p 176.
5. Scanelli, F, **Il Microcosmo della Pittura**, Cesena (1657) pp 404, reporting his inspection of 1642.
6. Armenini, G B, **De Veri Precetti della Pittura**, Ravenna (1586) p 172.
7. Lomazzo, G P, **Trattato dell'arte della Pittura**, Milan (1584), p 50.
8. Vasari, G, **Le Vite de' più eccellenti pittori, scultori et architettori**, Florence, 1st ed. (l550) and 2nd ed. (1568), ed. Bettarini, R, and Barocchi, P, Sansoni (1966-87) vol 4 , p 25ff; also conveniently available with indications of additions to the 2nd. ed. in Pedretti (1983), p 145.
9. Vicente Carducho quoted by Pedretti (1983) p 30.
10. The famous drawing 'for' the head of Christ, now regarded as wholly or largely the work of a pupil, suggests that Leonardo had settled on an image for the features of Christ, perhaps based on the model mentioned on Forster II 3r: 'crissto. giova[nni] co[n]te quello del chardjinale del mortaro'. See Pedretti (1983), p 30; Brown, D A, Leonardo's Last Supper:

precedents and reflections, **Leonardo's Last Supper...**, Washington (1983) no.5; and Marani, P C, **Disegni lombardi del Cinque e Seicento della Pinacoteca di Brera e dell'Arcivescovado**, Florence (1986) pp 27-31.
11. Vasari (1568) in Pedretti (1983) pp145-6. For the Bonsignori copy, see Steinberg, L, Leonardo's Last Supper, **Art Quarterly**, 36 (1973) p 402.
12. Vasari, ed. Bettarini and Barocchi, vol.4, p 26. For the account by Paolo Giovio in his **Leonardi Vinci Vita**, see Beltrami, L, **Documenti e memorie riguardanti la vita e le opere di Leonardo da Vinci**, Milan (1919) doc. 258, and Barocchi, P (ed.), **Scritti d'arte del Cinquecento**, Turin (1977) vol 1, p.8
13. For this point and for Vasari on Leonardo more generally, see Rubin, P, What men saw: Vasari's life of Leonardo da Vinci and the image of the Renaissance artist, **Art History**, 13 (1990) pp.34-46.
14. For Gallarati, see Bertelli, Studies..., (1983) pp.12-13. G. Bossi, **Del Cenacolo di Leonardo da Vinci**, Milan, 1810. For Dutertre's copy, see Heydenreich, L, André Dutertres Kopie des Abendmahls von Leonardo da Vinci, **Leonardo-Studien**, ed. Passavant, G, Prestel-Verlag (1988) pp113-22; and Brown , ...Precedents and reflections (1983) no.21.
15. Goethe, J W, Observations on Leonardo da Vinci's Celebrated Picture of the 'Last Supper', in Gage J (ed.), **Goethe on art**, London (1980) pp166-95; originally in **Kunst und Altertum**, 3 (1817). The mosaic copy by Giacomo Raffaelli (1906-14) is in the Minoritkirche, Vienna.
16. For the various campaigns, see Cecchi and Mulazzani (1985) p 75ff, and for the early cricticism by Bianconi (1787), see p.78: 'is it not better to have a fragment, however ruined, by one of the foremost painters than something which, in the form of a fraudulent renovation, presents nothing other than a shamfeul daub, remote from the original?' For Goethe, see Gage (1980).
17. Cecchi and Mulazzani (1985) pp 80-5.
18. Cecchi and Mulazzani (1985) pp.85-100.
19. Marani (1986) p 29.
20. Clark, K, **Leonardo da Vinci**, ed. Kemp, M, Viking (1988) pp 148-9. The 'quotation' in Clark's text is actually a praphrase from Walter Pater's essay, Leonardo da Vinci (1869); see Pater, W, **The Renaissance**, ed. Hill, D, University of California Press (1980) p 95: '...ghosts through which you see the wall, faint as the shadows of leaves upon the wall on autumn afternoons'.
21. Pinin Brambilla Barcilon reported in Bertelli, C, Restoration reveals the Last Supper, **National Geographic**, 164 (1983) p 674.
22. Bertelli (1982).
23. For a subtle discussion of this and related matters, see Lowenthal, D, Forging the past, **Apollo**, 131 (1990) pp 152-7.
24. Brown,...the Restoration (1983) unpaginated.
25. Marani (1983) p 29.
26. See particularly Matteini and Moles (1986).
27. Bertelli (1983) pp 666-76
28. For the copies, see Steinberg (1973) pp .297-410; Alberici, C, and De Basi, M C, **Leonardo e l'incisione**, Electa (1984) pp 49-100; Brown,....Precedents and relections (1983); Shell, J, Brown, D A, and Brambilla Barcilon, **Giampetrino e una copia cinquecentesca dell'Ultima Cena**, Milan (1988); and Rossi, M, and Rovetta, A, **Il Cenacolo di Leonardo. cultura domenicana, iconografia eucaristica e tradizione lombarda** (Quaderini del restauro, 5) Olivetti (1988) pp 76-118.

This paper was received after the editorial deadline.

TEXTURE AND APPLICATION: PRESERVING THE EVIDENCE IN OIL PAINTINGS

Stephen Hackney

Abstract

The image created by an artist is only part of the message embodied in a painting. A painting is a three dimensional object with distinct and unique topographical features. Evidence of the act of painting is always preserved in the final image; typically this may be in the brushmarks, the impasto, drawn or scraped lines in the surface, or the texture of the support.

In the past the need to preserve the image has sometimes led restorers and liners to carry out treatments that have sacrificed some of the surface qualities of the painting, occasionally disastrously. Recently conservators have given the problem a great deal of attention and sought ways of alleviating it.

This paper considers the original and aged condition of some painting surfaces and attempts to define what it is we wish to preserve. It then describes some of the technical aspects of cleaning and lining which can cause distortion of the surface texture and considers alternatives for preserving the original surface and enhancing its appearance through lighting and display.

Introduction

It might be argued that the very property that distinguishes a painting from a print or reproduction is its surface appearance. Over the years much ingenuity has gone into the perfection of techniques to record a painting's image. The photographic and printing industries have devised excellent methods for the reproduction of images, the qualities and limitations of which are well understood. Our perception of paintings is strongly influenced by our exposure to photographic images. At best we use photographs to remind ourselves of a particular painting but frequently we know the work only by its reproduction. When we see such a painting for the first time we may be struck by the inadequacy of the reproduced image. The colours may be reasonably accurate, the tone and contrasts may be quite good, but when we see the real object we are drawn to other qualities that are not in the reproduction yet which sometimes, depending on the skill of the exhibition designer, add subtly to our appreciation.

What are the properties that tell us we are looking at an original painting? Most obviously, there is the evidence of the application of paint by the artist. The work of the abstract expressionist, Jackson Pollock, provides a dramatic example of the free application of fluid paint to an absorbent surface.

Expressionist artists have used their struggle with the application of paint to convey a message beyond their final image. Perhaps this is why reproductions of the paintings of Van Gogh often appear so inadequate. Unless we can see the thickly brushed impasto, the dabs of paint on a tight canvas texture, then even his intense yellows, blues and greens lose their strength.

Less obviously, all artists consciously or unconsciously leave evidence of the painting process. Some have exploited the properties of their paint to produce images that could not have been readily achieved by other means. The small dabs of colour applied by impressionists and pointillists to create an opaque optical mix on the canvas are readily apparent to the viewer. The texture is intrinsically concerned with the need to apply small areas of colour thickly enough to cover the ground. By contrast the Pre-Raphaelites used thin transparent glazes over a smooth white reflective ground to create intense colour. Absence of texture here is an essential quality of the painting.

Portrait painters in the 18th century used a variety of techniques to work quickly and accurately[1]. Both to make a living and also to rise to the challenge of Kneller, portraitists had to prove they could paint with facility. Sketching and painting of the sitter had to be carried out with confidence and style and in the best of such work the immediacy of execution is preserved in the final image. To speed painting, toned grounds were used for shadows, fluid white paint for lights and highlights, painterly shorthand was sufficient to represent features such as hair or material. Many other techniques and tricks of the trade were employed to out-strip their competitors, for instance, the use of interesting weaves such as twill for the canvas support. Each choice of material and technique is visible in the surface quality of the final painting providing the client and us with evidence of the artist's dexterity.

Paint film

However the artist chooses to exploit his or her medium, evidence of its rheological properties remain in the surface of the painting.

The medium must be applied in a liquid state, either straight from the tube or modified to alter its viscosity. For instance, it can be made stiffer by soaking some of the medium into a blotting paper. Such paint, although difficult to work, produces the greatest impasto. Conversely it can be diluted and applied in a thin wash like watercolour. Oil can be worked all day (wet in wet), colours can be merged, mixed or churned up on the surface, or it can be allowed to dry and further paint applied without disturbing the existing layers.

To obliterate an underlying colour the paint film needs to have high covering power but also needs to be relatively thick; thick enough to allow the creation of visible surface irregularities. Most paint films are not applied with sufficient thickness to cover a ground colour entirely, instead they rely on its reflective qualities to create translucency and overall tone.

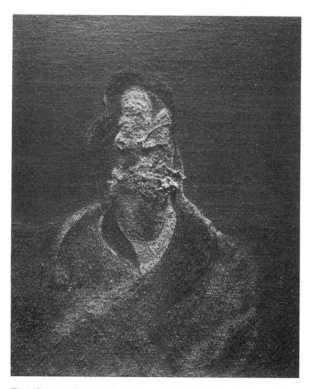

Fig 1 'Portrait of Isabel Rawsthorne' (1966) by Francis Bacon (Tate Gallery T00879) in raking light showing paint impasto and canvas texture.

Fig 2a 'Douarnenez, Brittany' (1930) by Christopher Wood (Tate Gallery T00545) during cleaning, showing dirt in brushmarks.

Fig 2b 'Douarnenez, Brittany' (1930) in raking light, showing the artist's brushed ground.

Oil, of course, can be modified by the addition of materials such as fillers, resins and waxes. Such additions to commercially formulated paint inevitably reduce its covering power and are associated with increased thickness and impasto in paintings. Fillers and extenders to the paint pigment may be added to create matt surfaces or improve translucency. Often they are there simply to allow the creation of impasto. Additions to the paint medium, such as resins, oils or waxes, are usually to alter the working properties of the wet paint for easier application but they may also be used to increase gloss and translucency. Frequently the modification of artists' materials in this way has led to serious problems. Injudicius choice of additives has caused cracking, darkening or paint loss soon after completion.

For example, Turner's oil paintings have suffered from his careless choice of materials and inconsistent use of additives. Many of his canvas paintings have been seriously damaged by lining, in part because of his use of water sensitive grounds[2], but fortunately his paintings on panel preserve their original texture. In 'The Opening of the Wallhalla' he evidently applied paint of a buttery consistency using a palette knife. This paint did not dry with clean crisp edges but sagged very slightly in a stiff gelatinous mass sometimes oozing excess medium.

Choice of support

Despite being hidden under layers of paint the support and priming are discernible in the final image, either directly or in their influence on subsequent layers. Canvas is frequently chosen for its lightness, texture and give during painting. Linen thread is uneven, containing slubs, and may be woven tightly as is popular in Britain or more loosely as in France. The canvas probably has a plain weave pattern but an artist may choose twill, herring bone, dogtooth or some other special weave.

In general, canvases are sized and then prepared with a lean ground. Commercial primings and grounds are evenly applied, partly covering the canvas texture, but sufficient texture shows through to give the surface a distinctive feel. Sometimes coarse particles such as sand may be added to the ground to give it extra 'tooth'. These too show in the final painting. Artists' grounds will not have the same uniformity, for example, some show distinct brushstrokes.

Of course the artist may choose a smooth support such as hardboard, wood or plywood, or add sufficient ground to fill and cover the texture of the support entirely. In addition a ground can be made smoother by scraping or abrasion. Such supports are more appropriate when the artist intends to paint thinly or use glazes.

Varnish

Surface reflection is another unique surface property that may be overlooked by the casual observer. There are a number of different ways of describing and measuring gloss[3]. Words such as sheen or distinctness of image are used to describe the way light is reflected from a surface. Essentially light may be reflected specularly or more diffusely, a proportion being scattered and absorbed by pigment thereby imparting colour. Clearly this is dependent on many factors including the nature of the incident light. The smoothness of the paint surface, its contraction on drying, the amount of medium, pigment size, refractive indices and absorption bands all influence the reflective quality of a surface.

The reflective property of a painting surface is usually a subject of some importance to the artist and he or she will have definite ideas or assumptions about it. For example, when oil paint dries it sometimes 'sinks', producing a matt surface, whereas in another part of the work, depending on the pigment to medium ratio, it may remain glossy. The artist may choose to preserve these effects, in which case the painting would not be varnished. A varnish protects the surface and it also imparts a smooth even gloss, saturating the colours fully. In the past many paintings have been varnished against the artist's intention; the works of the impressionists are well known examples. The desire to impose a glossy finish on such works must be resisted. If a protective film is required, in some cases a matt varnish can be applied. For example, Edward Wadsworth, who painted in egg tempera, specified that only wax varnishes should be applied to his paintings.

Ageing of paintings

In time a varnish will yellow, revealing any unevenness in its application, and eventually it will darken, obscuring the image. At this stage it is often removed and replaced by a new varnish. Sometimes the varnish is only partially removed. If the canvas texture is pronounced through the paint film, either intentionally or through unsuccessful lining in the past, the varnish residue will be left in the weave interstices giving the painting a freckled appearance that will gradually get worse as the varnish darkens. Similarly old varnish may be trapped in brushmarks and impasto, exaggerating and distorting the texture of the paint. Observers confronted by such a discoloured varnish, particularly when it has been coated with further layers to hide its unevenness, may have considerable difficulty reading the image and judging the degree of distortion. An uneven paint surface is one of the greatest obstacles to successful partial cleaning.

Varnishes, particularly when several layers have accumulated over the years, can be quite thick, submerging some of the surface texture. On removal of a thick yellowed varnish and its replacement by a thin layer of acrylic, unless sensitively applied, the surface texture can be significantly changed. This may not be desirable if the artist has deliberately attempted to produce an even gloss. The conservator may choose the acrylic varnish for its stability but may not be able to imitate the original varnish surface.

Craquelure is widely recognised as a consequence of the ageing of oil paintings. Drying cracks may occur soon after the painting is finished. Age cracks are usually the result of embrittlement of the paint, ground and canvas sizing and associated with certain conditions such as overstretching of a canvas, dry conditions, fluctuating humidity or impacts[4]. Both drying and brittle cracks have characteristic patterns and distribution. They can be identified with particular media or combinations of materials and are a unique form of fingerprint for a given painting.

Although craquelure is usually accepted as unavoidable and even as a sign of age and authenticity, its effects are frequently underestimated. Because on any particular painting the effect of craquelure is ubiquitous, like a yellowed varnish, we may not be aware of its extent. A fine web of craquelure is rarely perceived as a problem, yet incomplete or localised forms can be most disturbing. Cracks may be filled with dirt and darkened varnish residues, reducing the tone and contrast of a painting, or they may catch the light, making an obscuring film. Both effects tend to flatten an image.

A stretched canvas support also ages. Undulations and sagging indicate a loss of tension caused by relaxation of the canvas. Canvas corner draws or cracks in the paint corresponding with the inside edge of the bottom stretcher member are the effects first noticed. Tapping in the keys (wedges) to re-establish tension does not solve this problem and in the long term makes it much worse. A painting in this condition requires a more considered approach. It is at a crucial stage in its lifetime and can either be preserved from further deterioration or irreversibly interfered with.

A stretched and cracked painting will eventually start to suffer from cupping of the paint film and ground. Tension carried in the paint and ground is transmitted to the canvas at each crack. Stress realignment[5] causes the paint and ground to lift adjacent to the cracks causing the familiar cupping. Initially the canvas will follow the ground until crack propagation takes place between the ground and support, leading to cleavage and flaking of paint. At this stage the painting needs consolidation. Traditionally this has been achieved by glue/paste lining which has the added advantage of flattening the cupped paint. Cupped paint is most disturbing and can easily overwhelm other surface characteristics.

For display, although craquelure is accepted, cupping is not. So conservators attempt to flatten any raised crack edges lest they catch the light and become disturbing. Much damage has been caused in attempts to flatten cracks: successful flattening by glue lining has often caused serious damage to the paint surface.

Attitudes to lining

In 1974 the Greenwich Lining Conference drew attention to the problems caused by traditional lining practice[6,7]. Conservators had become aware of the extent of damage that had occurred in the past and the technical difficulties in preventing damage using current lining methods. It was an opportunity for conservators to compare experiences and put forward new solutions, but its main value was to identify the seriousness of the problem. Since then many museums have considerably reduced the number of linings undertaken, choosing to defer such treatment for an unspecified period.

Most obvious is the damage caused by badly executed glue linings, notably the flattening of surface features, "moating" around impasto, melting of glazes or the disruption of water soluble grounds. Other problems such as weave emphasis or shrinkage of the supporting canvas are also associated with the use of moisture and hot irons. These kinds of damage became evident to conservators and led to the adoption of wax lining which could be performed at lower temperatures and excluded moisture. The use of vacuum hot tables for wax lining created a new form of canvas weave emphasis whereby during lining under pressure the paint and ground partially collapse into the original canvas or are even impressed into the weave pattern of the lining canvas. Wax linings also fail to eliminate most cupping and surface distortion problems.

New adhesives such as EVA, PVA, wax resin formulations, dispersions, solutions and gels added to the conservators' choice but each brought their own particular problems. Many more were tried and rejected. What became apparent was the need to understand better the structure of paintings and how they deteriorate[8]. Was it better to line a painting on to linen canvas or a synthetic material such as glass fibre or polyester? Should a painting be marouflaged onto a solid support such as aluminium or glass fibre laminate? What means should be employed to reduce surface deformations without introducing new ones? Should we accept existing deformations provided the painting is not in immediate danger? Should we predict future deterioration and pre-empt it? How much interference is acceptable and can it really be reversible?

This raises enough questions to paralyse a conservator for a lifetime. A moratorium on lining had been proposed at the Greenwich lining conference and, although not generally adopted, a reduced rate of lining gave some breathing space to consider some of the questions. Since then more minimal structural conservation treatments have become the accepted practice and it has been found that lining can usually be deferred until some later date. When it cannot, the lining of a painting is approached on an individual basis with fewer assumptions and less reliance on traditonal solutions, each treatment providing an opporunity to learn more. As a consequence, those paintings remaining in good condition are now less likely to be damaged in lining.

Glazing and directional lighting for display

Unless we go to some lengths to display paintings so that we can see their surface characteristics, a wider audience will not be capable of appreciating the effects we wish to preserve. Until we do, painting surfaces will continue to be neglected or damaged during 'restoration'.

Much discussion and effort has gone into installing lighting in museums and galleries. For conservation and display, good illumination can simply be defined as that sufficent to see a painting but not enough to cause damage. In practice the requirements are much more demanding and less readily agreed.

All will acknowledge the need for good colour rendering, that is a continuous, even spectrum of the right colour temperature. Although rather cool, north light provides the most constant and safe light source and was the favourite for artists' studios. Daylight continues to be sought for its natural and varying qualities.

Preference is usually for a painting to be at the brightest point on the wall and for the illumination to be even across it. This is most easily achieved by a light source 20-30° from the vertical using sky-lights, fluorescent tubes or spotlights.

As well as for its poor colour rendering and flicker, early fluorescent lighting was despised for its bland, even, diffuse illumination, the elimination of shadows and the headaches it induced. By using thicker coats of fluorescing material, flicker and colour rendering can be substantially improved and new miniature tubes produce something closer to a point source of light. If carefully positioned, perhaps with reflectors behind, these can be used to produce directional lighting with a quality and colour similar to daylight.

By contrast architects want light to help create space within the building. Occasionally windows have to be included in walls to provide a glimpse of the exterior of the gallery. Such considerations are absolutely necessary but if carried to extreme can interfere with the viewing of the paintings. Windows and ambient light reflected off walls create reflections on the paintings. Although reflections can be distracting they do remind us of the painting surface. They become a nuisance only when it is impossible for the viewer to avoid them.

Frequently a framed painting is protected by a sheet of glass, acrylic or polycarbonate. This provides excellent protection but can interfere with our enjoyment of the painting and its surface. In general polycarbonate produces worse reflections than acrylic which in turn is worse than glass. However, low-reflecting glass is now affordable and overcomes reflection problems except in the worst lighting conditions. Well-lit low-reflecting glass is almost invisible and the lighting conditions necessary to make the most of low-reflecting glass tend to show the painting surface quite well.

The use of a slightly more raking light, as can be seen in the Clore Gallery, offers advantages to the viewing of surface texture. It mimics the directional quality of sunlight but at much lower intensities and without glare. Spotlights set at less than 10° to the vertical can also produce directional illumination to reveal the texture and surface of a painting. The disadvantage of such a system is the unevenness of distribution down the wall and the presence of broad bands of shadow at the top of the painting caused by the frame.

Conclusions

This paper is not an argument for dramatic or theatrical lighting but for a small increase in its directional quality to allow the viewer to detect more easily variations in the surface of paintings.

It is a request for curators and art historians to become more aware and knowledgeable about the surface character of paintings in their care. They should demand that the surface be protected and ask for evidence and records of its condition. Conservators will be glad of their interest and very willing to discuss the aesthetic and technical problems which they regularly confront. Then, perhaps, errors in interpretation and the physical damage described above will finally be overcome.

It has been argued elsewhere that lining is concerned only with the reverse of the painting[9]. The arguments have long since widened and indeed never were confined to merely structural matters. Such attitudes may linger where lining is considered a separate process from restoration, but most liners and conservators are now aware of the potential for damage during lining. They

also understand and value the surfaces of paintings better and are unwilling to interfere. As a result, more limited conservation treatments are adopted and are usually found sufficient to solve the structural problems of a painting.

References

1. Jones, R, 'The artist's training and techniques. Manners and Morals' pp 19-28. **Exhibition catalogue Tate Gallery** 1987.
2. Townsend, J, 'Turner's painting materials: a preliminary discussion'. **Turner Studies** 10 (1), 1990, pp11.
3. Eastaugh, N, 'Gloss'. **The Conservator**, No. 8, 1984 pp10-14. UKIC.
4. Hodge, S, **Cracking and crack networks.** Courtauld Institute of Art 1987 unpublished.
5. Mecklenburg. M, 'Some aspects of the mechanical behaviour of fabric-supported paintings'. **Report to the Smithsonian Institution**, February 1982.
6 Percival-Prescott, W 'The lining cycle'. **Preprints** to the conference on comparative lining techniques, National Maritime Museum 1974.
7. Mehra, V R, 'Comparative study of conventional relining methods and materials and research toward their improvement'. **Interim report to ICOM Committee**, Madrid 1972.
8 Hedley, G, 'Relative humidity and the stress/strain response of canvas paintings: uniaxial measurements of naturally aged samples'. **Studies in Conservation**, pp133-148. Vol. 33, No. 3, August 1988.
9. Walden, S, **The Ravished Image**, p148. Weidenfeld and Nicholson.

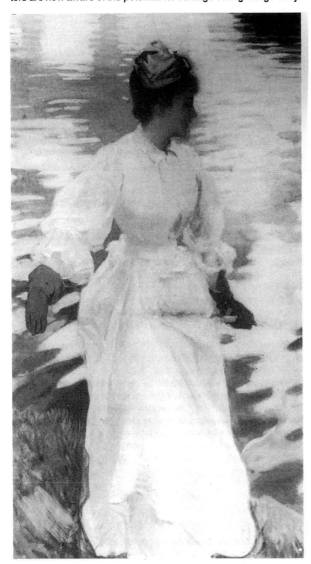

Fig 3a 'Lady fishing, Mrs Ormond' (1899) by J.S.Sargent (Tate Gallery N04466).

Fig 3b 'Lady fishing, Mrs Ormond' in raking light. The painting has been rolled, starting at the top, and tied or held at two pionts.

PAUL GAUGUIN'S PAINTINGS OF LATE 1888: RECONSTRUCTING THE ARTIST'S AIMS FROM TECHNICAL AND DOCUMENTARY EVIDENCE

Vojtech Jirat-Wasiutynski and Travers Newton

Abstract

Few of Paul Gauguin's paintings survive unrestored and present their original appearance. Identifying and documenting those that do and revealing the changes that have taken place in the altered and restored works is crucial to reconstructing Gauguin's aesthetic aims. This paper, the result of a collaboration between an art historian and a paintings restorer, examines paintings from the short period of Gauguin's most intense experimentation and closest interaction with fellow artists Emile Bernard and Vincent van Gogh in the autumn of 1888. Works selected range from virtually untouched to significantly restored, including one example of an intervention by the artist himself.

Paul Gauguin showed considerable concern for the appearance, presentation and preservation of his paintings from an early date; this was, no doubt, a result of his close association with Camille Pissarro and Edgar Degas in the Impressionist group, as well as his familiarity with the collectors who might acquire his works. Gauguin was a collector himself and entered the Impressionist group in that role as well, forming an extensive collection of their work as Merete Bodelsen has shown [1]. For instance, a Guillaumin landscape and a Cezanne still life from his collection appear in the background of two of his own paintings, from 1885 and 1890 respectively ('Still Life with Mandolin', Musee d'Orsay, Paris, and 'Portrait of a Woman', Chicago Art Institute). Both works are framed in versions of the white Impressionist frame propagated by Pissarro and others in the early 1880s: the latter may be fictional, given the enlarged scale of the Cezanne in the background [2].

Apparently concerned by the yellowing and deterioration of old master paintings, Gauguin followed Pissarro's practice in the 1880s in order to ensure the preservation of the appearance of his Impressionist paintings: he painted "lean" and, as far as we know did not varnish any of his paintings, in many instances preferring to put them behind glass [3]. His "Instructions to an Unknown Collector" (Mr and Mrs Alex Lewyt Collection, New York), from about 1896, reflect these concerns. He advises the future owner of his work to place the painting in a modest frame and to glaze it in order to finish or refine the image and thus protect the painting from the bad air of the apartment [4].

Gauguin sent the letter to France with a Dr Nolet to accompany a Tahitian painting from 1896, now in a private collection; the text, however, is ornamented with a drawing after 'Day of the God', 1894 (Chicago Art Institute). This Tahitian painting is well preserved and a good example of the durability of Gauguin's technique. It appears to retain in large measure the original intensity of its colour; it has not yellowed, nor is there any visible craquelure. Gauguin applied very lean paint, which can easily be rubbed off, to a fine canvas support with no visible ground. The 'Day of the God', which was purchased from the artist by Degas, was never varnished, although it may have been covered with a coating of wax, which has since been removed, to protect its friable surface [5].

By contrast, many of Gauguin's paintings have suffered a good deal from restoration, principally lining, and from inappropriate presentation, including varnishing and reframing. His mature painting style has usually been interpreted as a reaction to Impressionism and characterized, by reference to 'The Vision of the Sermon' (National Gallery of Scotland, Edinburgh), as the use of areas of flat, bold colour to create a decorative design. As we shall demonstrate, the Breton and Arlesian paintings of 1886-88, for instance, are characterized not only by such a colourful, decorative aesthetic, but also by dry chalky surfaces and subtly textured paint. They are, as a result, very fragile: aging and intervention by restorers has often compromised the aesthetic effect intended by the artist.

Our first example of an altered Gauguin is the 'Breton Bathers', 1888 (Kunsthalle, Hamburg). It was recently exhibited in the international retrospective "The Art of Paul Gauguin" without comment, although its appearance had been thoroughly transformed by a drastic restoration before it entered the museum collection [6]. The tacking margins were cut and the painting lined to a secondary canvas with lead white. The lining gives the painting a stiff, flat look, while the forcing of the texture of the canvas weave up through the compressed paint layers adds to the harshness of the effect. The restoration was completed by the application of a thick, glossy varnish: the high reflectance is quite at odds with the aims of Gauguin as documented by his statements and works which have come down to us largely unrestored. The glossy varnish makes the image very hard to read, as can be seen in a comparison of details with the relatively untouched 'Winter', 1888 (Ny Carlsberg Glyptothek, Copenhagen).

The second example of restoration, 'Farmhouse at Arles', 1888 (National Museum, Stockholm), hung recently in the "Vincent van Gogh in Arles" exhibition at the Metropolitan Museum of Art in 1984 [7]. It would seem to reflect a more sympathetic treatment in response to the more unusual and experimental painting technique of Gauguin in the autumn of 1888. The image is very thinly painted on what seems to be a coarse jute support. The painting has been glue lined to a supporting canvas and a light coating of matte varnish was applied to the surface at some point. The highly hygroscopic, loose-weave textile had become visibly stretched and this distortion around the edges is now permanently preserved through the lining. A detail of the centre foreground shows the present tight, flat appearance of the jute support. The slight variations in paint texture between washed, stained and thinly impastoed areas tend to be obscured by the present rigidity of the support, as a comparison with a detail from the unlined and unvarnished 'Portrait of Vincent van Gogh Painting Sunflowers', 1888 (Rijksmuseum Vincent van Gogh, Amsterdam) makes clear. The colours in the Stockholm picture have probably also darkened and sunk into the support as a result of the lining and varnishing.

It is, of course, not our intention to blame anyone for past mistakes: Gauguin himself engaged in rather dubious restoration practices in treating the work of Vincent van Gogh, as well as his own 'Vintage at Arles', 1888 (Ordrupgaard Collections, Copenhagen), as we have shown elsewhere [8]. We are using the contrast between restored and unrestored paintings to illustrate the need for closer investigation of Gauguin's aesthetic intentions and techniques; we will now follow with a closer study of several works to show what we have been able to learn in that respect.

Close examination of Gauguin's technical procedures is essential if we are to understand, appreciate and preserve his works in an historically responsible way. A number of paintings have survived relatively untouched, as our comparisons suggest, especially in Danish and Soviet collections and in the holdings of the Vincent van Gogh Foundation, displayed in the eponymous Rijksmuseum in Amsterdam. These works, and particularly those that we have been very generously allowed to study at length in Amsterdam, have allowed us to establish a small corpus of "original" works by Gauguin for reference. Examining them and documenting the artist's aims, with the help of contemporary texts, has revealed changes that have taken place in the altered and restored works. This investigation has been crucial to interpreting the original appearance of Gauguin's paintings, as well as for our understanding of the way in which they were to be seen.

We have already mentioned that the practice of the Impressionist group, Pissarro and Degas in particular, was the most significant source of Gauguin's painting techniques after 1879. On 26

July, 1879, Gauguin wrote to Pissarro that he was going to prepare his own canvas for painting [9]. We have found, nevertheless, that he was more likely to use commercially pre-primed supports in the first half of the 1880s. These were usually prepared with one or two layers of off-white ground, a light priming popular with the Impressionists [10]. These canvases, often pre-stretched, were sold by artists' colourmen such as Latouche, whose stamp is visible on the reverse of paintings from 1874 and 1883 [11].

Like Pissarro and other Impressionists, Gauguin probably did not intend to varnish these early paintings, preferring the "matte finish" with a "velvety tone" noted in a review of Pissarro's paintings at the sixth Impressionist exhibition in 1881 [12]. This antipathy to varnish continued in later years, as we have seen. The earliest surviving unvarnished painting by Gauguin, of which we are aware, is the 'Still life with Flower and Book', 1882 (Ny Carlsberg Glyptothek, Copenhagen), which is painted on a pre-primed tan canvas. From the same period, we have a record of the artist ordering a frame through Pissarro and having glass fitted in it [13]. The glass was to act, no doubt, to protect the fragile unvarnished surface and to finish (unify) the painting, as Gauguin was to point out in 1896, in the document cited above. Judging by the dimensions, he was probably framing 'La Petite Reve', 1881 (Ordrupgaard Collections, Copenhagen), painted on a pre-primed grey canvas, but unfortunately now lined and varnished. The thin, lean paint allows the ground to show in many places [14].

Finally, the painting was to be provided with an appropriate frame: not the traditional gold frame, carved or moulded in elaborate relief, but a simple frame that would set off the high-key palette and broken brushwork of the Impressionist. That he later claimed considerable credit for its invention suggests that Gauguin often adopted the white frame used by Pissarro [15]. None survive on his paintings but we can see them depicted in his paintings adorning works from his own collection, as we have already shown. Theo van Gogh exhibited Gauguin's recent work in "white frames of unpainted wood" at Boussod et Valadon's Montmartre gallery in November and December 1888 [16].

The artist's search for a personal technique after 1882, once he had decided to become a full-time painter, led to experimentation with supports, grounds and paint application. His increasingly straitened circumstances after the loss of his employment in January 1883, in the wake of the Paris stock market crash of the previous year, probably explains why he now often prepared his own canvas for painting [17]. By 1885-86, there are indications that Gauguin was responding increasingly to the textural quality of the underlying textile support and that he was beginning to look at paintings on canvas as objects with sculptural properties.

In the 'Four Breton Women', 1886 (Bavarian State Collections, Munich) (Fig. 1), Gauguin portrayed women from Pont-Aven in regional costume [18]. He used a medium-weight linen, to which he applied the ground after stretching the fabric. This may have been a cost-saving action, yet much of the image is rather thinly painted and the canvas acts as a prominent element, aiding in the "flattening-out" of the composition. Although there are passages of wet-on-wet impastoed brushwork, Gauguin is clearly reducing elements suggestive of perspectival depth by having no horizon line, by removing foreground shrubbery that was formerly present and by creating strong, outlined profiles [19]. At present, the painting surface has a rather glossy varnish which we doubt reflects the artist's original intentions, as a comparison with the matte effects of the unvarnished surface of 'Women Picking Fruit', Martinique, 1887 (Rijksmuseum Vincent van Gogh, Amsterdam), viewed in oblique light, shows [20].

The 'Women Picking Fruit', painted in Martinique in the late summer of 1887, has survived untouched in the van Gogh family collection since it was purchased by Theo van Gogh from the artist, whose dealer he had just become, in late December of that year [21]. Here the artist used a medium-weight linen again and, after stretching it, applied a ground that was rather thin and allowed paint medium to seep through to the reverse of the canvas, where the outline of the seated woman is now visible. It is not clear whether the ground allowed media to penetrate the canvas in a selective fashion or whether the stain is reflective of Gauguin's preparatory procedures (for example, he may have begun outlining the composition with oil colors on the canvas before applying

Fig. 1. Paul Gauguin, 'The Four Breton Women,' 1886, oil on canvas, 72 x 90 cm (Bavarian State Collections, Munich)

the ground layer). This is a rather flat painting as well, with little or no impasto, and when viewed in oblique light shows a selective use of media from somewhat glossy to matte effects. The outlines of the forms are generally more matte than the surrounding areas and add emphasis to their linearity. The underlying canvas weave provides an overall gridded effect.

Gauguin was not the only artist who was experimenting with manipulation of supports, grounds, paint and surfaces in an effort to achieve a "flat" image. In 1887 Emile Bernard and Louis Anquetin were developing Cloisonism and in mid-August, 1888 Bernard met Gauguin in Brittany [22]; shortly thereafter, Bernard painted 'Breton Women in a Meadow', 1888 (Denis family collection). The painting has remained unvarnished, is unlined, and is still framed in what seems to be an original white frame, probably in part because it was acquired early by the painter Maurice Denis and has remained in the family collection to this day [23]. It is painted on a medium weight linen in such a fashion that the perimeters of the various figures' outlines allow light to shine through the canvas. It is as if these outlines were painted in a trough or negative area of paint and the surrounding colors were painted up to that point. The transmitted light photograph of the seated woman in the lower left shows subtle variations in the density of the paint application which is not readily visible on the painted side. The areas where the light shines through reveals a very thin ground layer and since these areas do not appear unpainted on the front, it may be that Bernard built up the painted passages in layers beginning with a thin wash. In addition, it is likely that the outlines of the forms were painted on the canvas before the application of the ground layer. This is a practice which Gauguin may have used for his 'Women Picking Fruit' of 1887 [24].

Gauguin painted the 'Vision of the Sermon' in September 1888, after the arrival of Emile Bernard in Pont-Aven. He wrote to Emile Schuffenecker about it on 8 October, noting that this year "I have sacrificed everything - execution, color - for style" [25]. Gauguin's dramatic statement reflects the fact that that autumn every painting became a new technical experiment. In the Vision of the Sermon, Gauguin sought to suggest three-dimensional sculptural qualities and the play of light on forms without using illusionistic devices for modelling and atmosphere. As has often been pointed out, the historical models for this approach can be found in the work of the so-called "Primitives", Gothic stained glass, quattrocento (pre-Raphaelite) painting, Japanese prints and popular art.

The firm drawing of 'The Vision' suggests the existence of precise preparatory drawings, now lost, like those known for the 'Four Breton Women'. The outlines around the major compositional elements, which appear dark in the x-ray, correspond to areas of thin washes or bare canvas, for example in the border of the Breton hat, visible in the top center of the figure in the lower left. This suggests that Gauguin may have first sketched the outlines on the bare canvas before applying the ground and paint layers. Each paint layer, for example in the hat of the left foreground figure,

Fig. 2. Paul Gauguin, Self-Portrait "les miserables", 1888, oil on canvas, 45 x 55 cm (Rijksmuseum Vincent van Gogh, Amsterdam)

was carefully built up, usually over thin washes of color, to produce subtly varied tones and hues. He also created different textures, from a fine canvas-weave texture to smooth, luminous effects where he used thicker paint, with a suggestion of relief, possibly with the addition of wax to the medium. Unfortunately, some of the surface texture was altered by an early lining, possibly before 1911. The painting appears, however, never to have been varnished and, since it has been covered with glass since it entered the National Gallery of Scotland in 1925, it has remained remarkably clean [26].

In the fall of 1888, as part of an exchange of self-portraits among artist friends of Vincent van Gogh, Gauguin painted his own 'Self Portrait "les miserables"' (Rijksmuseum Vincent van Gogh, Amsterdam) (Fig.2) [27]. On October 8, 1888, Gauguin wrote to Schuffenecker about this picture: "I have done a self-portrait for Vincent van Gogh who asked me for it. I believe it is one of my best efforts: absolutely incomprehensible (upon my word) so abstract is it...The drawing is altogether special (complete abstraction)...The colour is a colour rather remote from nature; imagine a vague memory of my pottery twisted by the furnace! All the reds [and] violets streaked by the fiery flashes, like a furnace radiating from the eyes, the seat of the painter's mental struggles." [28] Given our one hundred years hindsight, it is difficult to see this work through Gauguin's eyes with the "shock of the new" (as it were) reflected in his use of the term "complete abstraction". He seems to have over-emphasized the brilliancy of the colours, particularly the "reds and violets streaked by fiery flashes". Was he exaggerating? Perhaps some of the colours have faded or sunken in, or perhaps our twentieth-century eyes have become jaded. Whatever the case, this letter communicates not only his cockiness because he had created a radical image, but also his concern that it would possibly not be understood because he had stepped beyond even the avant-garde boundaries established by Impressionism.

Gauguin's 'Self Portrait "les miserables"' is unlined and retains its original unvarnished surface, probably because it too was acquired by Theo van Gogh from the artist and has remained in the van Gogh family collection ever since [29]. Gauguin painted this composition on a plain, moderately fine weave cotton fabric without the use of a ground layer, although the presence of a glue sizing is suspected. The transmitted-light photograph shows that it is more thinly painted than the painting by Bernard, and, like the Bernard, shows some areas of negative space around the major outlines. The direct brushwork of the floral patterns on the green shadow which is blocked out around Gauguin's eyes and nose in a graphic, geometric pattern, reminds one of Cennino Cennini's recommendation to the fresco painter to render the deep shadows of a face first, often with terra verde, before proceeding to the midtones and the final highlights[30]. The transmitted light photograph here reveals Gauguin's Cloisonism not only as a function of strong outline and negative space, but as a further breakdown of

forms within spaces into graphically described blocks of light and dark. The underpainting of the flowers reflects an immediate brush technique, although the face itself would appear to have been painted more slowly, even methodically, beginning with a tonal, stained underpainting. The thinness of the final image, complemented by the soft, fluffed-up cotton fabric, results in a paint surface that is still extremely fresh and in excellent condition.

In October 1888, Gauguin joined van Gogh in Arles. Shortly after, he purchased twenty metres of "very strong canvas" [31]. This is presumably the inexpensive jute textile on which he and van Gogh painted some sixteen paintings in Arles. In addition to cost factors, there may have been practical reasons for Vincent's and Gauguin's use of jute: for example, the popular book by Bouvier, 'Manuel des Jeunes Artistes' (ca 1830) suggested that the rougher the fabric and ground layer [32]. Bouvier also discussed the selection of the weight of the canvas "according to the size and subject of the painting" [33]. This quote is usually interpreted to mean that a small picture should be painted on a delicate fabric and a larger composition on a rougher weave. One can also interpret his words in the sense that the delicacy or roughness of the subject portrayed could influence the fabric selected.

Vincent van Gogh used the roughly woven jute in the fall of 1888, although it seems likely that its adoption was Paul Gauguin's idea rather than his. In 1887-88, van Gogh had been using a medium weight, commercially pre-primed linen support in such paintings as the 'Self-portrait Dedicated to Gauguin' (Fogg Art Museum, Harvard University), from September 1888, and in the 'Sand Barges' (Museum Folkwang, Essen), from August 1888. A detail of the latter shows how he used the off-white priming as a type of mid-tone, a practice related to that of some Impressionists, which could be interpreted as a time-saving device [34]. In the spring of 1888, van Gogh expressed an interest in experimenting with "absorbent grounds" and in the priming of canvases for "absorbent effects", which implied an interest in producing matte, unvarnished pictures for certain subjects [35]. There is no indication, however, that he shared Gauguin's and Bernard's interest in translucent, thinly painted images. By 1888, Vincent showed an increasing preference for thickly impastoed, wet-on-wet surfaces.

Van Gogh used the jute, perhaps for the first time, for his view of the 'Falling Leaves in the Alyscamps' (Rijksmuseum Kroller-Muller, Otterlo), painted in early November 1888 when Gauguin was with him. The matte paint, applied sparingly over a thin ground, allows the texture of the coarse-weave fabric to show; brushwork plays no significant role in the painting as it had in earlier impastoed works by van Gogh. But whereas Gauguin used the texture of the jute to flatten out the image, van Gogh fights with it here to dig out as dramatic a perspectival device as possible with the abruptly receding trees and lane.

Although Gauguin's immediate motivation for the use of jute was monetary, he seems to have responded at once to the coarse support as "primitive" in his experimentation with technique and in his choice of subject matter. In a letter to Theo van Gogh, the artist wrote that 'Human Miseries: Vintage at Arles' (Ordrupgaard Collections, Copenhagen) and its pendant, 'Woman in the Hay with Pigs' (Niarchos Collection), were rather "coarse", referring no doubt principally to his treatment of the subject of female sexuality. Gauguin, nevertheless, went on to discuss the qualities of the coarse support in the very next sentence, which suggests that he saw a parallel between material and image [36].

'Human Miseries', painted on the fairly rough jute just mentioned, perversely depicts Breton peasant women harvesting grapes in an abstracted Arlesian setting. This is a rather thickly painted composition for Gauguin, with experimental application of paint that may reflect a use of palette knife and splatters, as well as a brush [37]. Gauguin described this painting to Emile Bernard in mid-November as "executed with a palette knife very thickly on coarse sacking in bold outline filled with colors that are almost undifferentiated" [38]. In this case, Gauguin may have used the jute as much for structural reasons (i.e. insuring a good bond between the thick paint, ground and canvas) and the durability that he supposed it to have since it resembled hemp, as for special effects

[39]. Nevertheless, he experienced problems with "flaking" in this work within a matter of weeks, as we shall see.

In some respects, 'Human Miseries' can be viewed as a concession to van Gogh's insistence on more thickly painted surfaces in his work. At the same time, it was a lesson from Gauguin to Vincent that pictures could be painted thickly without the obvious use of the brush, "the messing with brushwork" that he disliked [40]. As a result of such experimentation, Vincent noted in a letter to Theo: "You will see that some people will soon be reproaching Gauguin for no longer being an Impressionist" [41].

The experimental technique of 'Human Misery' was not repeated; Gauguin preferred to paint thinly on the coarse weave jute in subsequent paintings. The painting needed restoration in December, soon after it arrived in Paris for exhibition at the Montmartre gallery run for Boussod et Valadon by Theo van Gogh [42]. The flaking reported by Emile Schuffenecker may have been a result of poor adhesion of the ground, aggravated by its being rolled up for transportation from Arles to Paris, before the painting was fully dry; we will have to wait for the research of Henrik Bjerre at the conservation laboratories of the Statens Museum in Copenhagen for a full answer. The painting has suffered several restorations, including an early lining with the addition of a strip of canvas enlarging the image by some 3 cm on the left; the present gloss varnish coating is also not original, nor appropriate.

The earliest restoration was undertaken by Gauguin himself in January 1889, as he reported in a letter to Vincent. "The whole Vintage has flaked because of the white which has separated [from the canvas]." Gauguin then explained how to reattach the paint: "You stick newspapers on your canvas with flour paste. Once dry, you place your canvas on a smooth board and press down on it hard with a very hot iron. All your flakes of colour will remain, but they will have been flattened and you will have a very beautiful surface." [43] The commentary by the artist reflects the polemic with van Gogh about impasto and Gauguin's willingness to alter the appearance of a recent work to underline his artistic intentions. This position also reveals a relativistic attitude to the preservation of at least some of his paintings which might seem at odds with his general desire to guarantee the durability of his art; but, as an artist, Gauguin was clearly more concerned with aesthetic aims than historical preservation [44]. A relativism governed by his contemporary aesthetic aims might lead to Gauguin's reworking of a painting; this editing would not, however, include varnishing an unvarnished painting as far as we know.

In December, 1888, Gauguin combined thin, "flat" painting with the use of coarse-weave jute in his 'Portrait of Van Gogh Painting Sunflowers' (Fig.3). The lean paint was applied sparingly over a thin lead-white ground; the loose-weave structure is visible through the paint layer in some places. The matte, unvarnished paint surface shows no visible brushwork; it is characterized by a variety of subtle textures, ranging from smooth, semi-transparent areas that resemble washes of colour, to roughed up sections and some limited impasto. Large areas of solid colour dominate the image; the palette is Gauguin's characteristic selection of reds, greens, and blues, as well as their "muddy" combinations. The pale blue and yellow, however, strike an Arlesian note and reflect van Gogh's well-separated palette of primaries and complementaries.

Pronounced contours and even outlines in blue delimit the areas of colour. The transmitted light photograph shows the trough or negative space which corresponds to the outlines of the figure, much as in Bernard's 'Breton Women in the Meadow', and suggests that Gauguin worked out the composition on the jute before applying the thin lead white ground. This is supported by examination of the x-ray where one can see that Gauguin applied the ground selectively, anticipating the final layout of the painting in blocks of solid color. Two sketches for the 'Portrait' survive (Carnet, Israel Museum, Jerusalem) [45]. Given the careful design of the image and the minimal changes that can be detected in the painting, Gauguin may have used a large, finished preparatory drawing, now lost, for the figure as was the case for the major figures in 'Four Breton Women', 1886, and 'Women Picking Fruit', 1887.

Fig. 3. Paul Gauguin, Portrait of Vincent van Gogh Painting Sunflowers, 1888, oil on canvas, 73 x 92 cm (Rijksmuseum Vincent van Gogh, Amsterdam)

Gauguin's 'Portrait of Vincent van Gogh Painting Sunflowers' had been removed from exhibition several years ago due to its fragile condition. The artist's painting technique could not be faulted since the adhesion between paint and ground layers and support has remained excellent, but the jute has proved less durable than Gauguin assumed. The jute support, which is very hygroscopic, responds dramatically to changes in relative humidity; the resulting stresses on the oxydized and photodegraded fibres have produced some shearing of the brittle jute along the edges, particularly along the top, which was aggravated by a strip-lining attached with epoxy resin in 1980.

Conservation treatment was necessary in order to return the painting to exhibition in the Rijksmuseum Vincent van Gogh. The particular challenge lay in the need to preserve the aesthetic authenticity of the image, which is directly dependent on the subtle surface effects, which depend in turn on the original integrity of the complex of support, ground and paint layer. A full acount of the conservation of Gauguin's 'Portrait of Vincent van Gogh Painting Sunflowers' (a treatment which was undertaken in 1988 by Cornelia Peres, restorer, at the van Gogh Museum, and Travers Newton, visiting restorer, with Vojtech Jirat-Wasiutynski acting as consultant art historian) will be published by the Rijksmuseum Vincent van Gogh in the spring of 1990 [46]. It seemed particularly useful, however, to conclude our examination of Gauguin's concern for the preservation of his works by summarizing the decisions that were made and the way in which information was used in the process of determining an appropriate treatment and display for the painting.

Exhibiting the 'Portrait of Vincent van Gogh Painting Sunflowers' required relieving all tension on the upper edge of the jute support and reinforcing the weakened textile. The strip lining from the previous restoration was removed and any further lining was ruled out, due to the fragility and permeability of the support and the delicacy of the unvarnished paint layer. This precluded displaying the painting hung vertically on the wall. Clearly, exhibiting the picture flat in a case was not an acceptable option since it was meant to be viewed in relation to a wall and not from above, as an object on its back in a display case. A compromise was worked out in which the painting will be shown in a case, but tilted at an angle which reflects an appropriate viewpoint for the image.

A solid support was cut to fit the exact inner dimensions of the still-extant tacking margins (these margins had been repaired and rewoven with jute threads mixed with PVA, methylcellulose, and synthetic Japanese tissue). A piece of new fabric with directional threads, capable of engaging the jute, was stretched over the solid support. The painting was placed over this new fabric in such a fashion that it could be tilted in a half-vertical position and yet was still held in place by the hairs of the new fabric support. To give the picture further support, a new frame was constructed, to replace

the modern gold leaf frame, in such a fashion that it would rest its padded inner edges on the picture surface. The tacking margins were not fixed to the new support.

Given the hygroscopic nature of the jute, construction of a micro-climate controlled chamber proved necessary. Although the aesthetic drawbacks in exhibiting any picture behind a barrier are obvious, at least now the painting can be viewed by the public once again. It will be tilted up at an angle of about 80 degrees, somewhat like the picture on Vincent's easel and so as to set up a viewing angle implied in the image itself. It will be shown in a white frame, which is our best estimate of the original based on Gauguin's and Theo van Gogh's practice in 1888. The unvarnished surface will be protected by glass as Gauguin probably intended, since he requested collectors to do so a few years later.

Gauguin saw his pictures as principally targeted for friends and a small group of collectors in the 1880s. His increasing dilemma was how to differentiate himself from the Impressionists (many of whom, like Monet, were enjoying a great deal of economic success in the late 1880s), while at the same time selling his work. Documentary and technical evidence reveals a secretive, methodical approach to painting, and a concern for creating a carefully crafted, often delicate paint surface that would not yellow or crack. Gauguin experimented with various media and supports to this end. Although we cannot say that he avoided the use of varnish on all of his paintings, study of his oeuvre shows unvarnished pictures from the early 1880s and an increasing interest in matte effects by 1888. By studying historical documents and the condition of unrestored works, we have become convinced that Gauguin had precise concerns regarding the aging properties and the presentation of his paintings.

It is time for conservators and art historians to take stock of the subtleties of artists' intentions and to investigate how we have reinterpreted those aims by uninformed restoration and presentation of their paintings. Hopefully, future restrospectives such as "The Art of Paul Gauguin" will include symposia for conservators as well as historians, in order to promote better evaluation of the problems and solutions in the conservation of an artists' oeuvre.

Acknowledgements

The authors wish to thank Thea Burns and Melissa Newton for their assistance and support throughout this project; Victoria Todd and Leslie Carlyle for their editorial and organizational work; and the Social Sciences and Humanities Research Council of Canada, Queen's University at Kingston, the Samuel H. Kress Foundation, and the National Endowment for the Arts for funding various parts of the research.

References and notes

1 Bodelsen, M, Gauguin the Collector, **Burlington Magazine**, 104 (1967) pp217-27.

2 Isaacson,J, The painters called Impressionists, in **The New Painting: Impressionism**, 1874-86, catalogue of an exhibition, National Gallery of Art, Washington and the Fine Arts Museums of San Francisco (1986)p378.

3 Gauguin expressed concern about yellowing varnish and oil in a letter (Paris, 10 February, 1895) to the critic Arsene Alexandre in Malingue,M (ed), **Lettres de Gauguin a sa femme et a ses amis**, Grasset, Paris (1946) pp 264-65. Isaacson loc. cit. reports Pissaro's exhibiting unvarnished paintings under glass in 1882.

4 The text reads, in translation: "To the unknown amateur of my works, greetings. Let him excuse the barbarism of this small picture; a certain disposition of my soul is probably its cause. I recommend a modest frame and, if possible, a sheet of glass which, while finishing it, preserves its freshness by protecting it from the changes always produced by the bad air of the apartment." Reproduced in Pickvance, R, **The Drawings of Paul Gauguin**, Paul Hamlyn, London (1970) pl 83.

5 We would like to thank Inge Fiedler, conservation scientist at the Chicago Art Institute, for communicating the contents of a 1958 treatment report to us. In the letter to Alexandre loc. cit., Gauguin advocated the use of wax instead of varnish.

6 We would like to thank Dr Werner Hofmann, director, and Dr Helmut Leppien, curator of the Hamburg Kunsthalle, for supplying information about the Breton Bathers and for permitting examination of it in the atelier, with the kind assistance of Ms Heike Moeller, conservator.

7 We would like to thank Dr Pontus Grate, vice-director of the National Museum in Stockholm, for permission to examine the Farmhouse in Arles and the staff of the conservation studio for assistance in doing so.

8 Jirat-Wasiutynski, V, and Newton, T; Farrell, E, and Newman, R, **Vincent van Gogh's "Self-Portrait Dedicated to Paul Gauguin": an Historical and Technical Study,** Center for Conservation and Technical Studies, Harvard University Art Museums, Cambridge, Mass.(1984) pp 17-20.

9 Merlhes, V (ed), **Correspondence de Paul Gauguin,** I, Fondation Singer Polignac, Paris (1984) p 16 (no 11).

10 Callen, A, **Techniques of the Impressionists,** Chartwell Books, Secaucus, N.J. (1982) pp 60-61.

11 Merlhes, **Correspondence**, p 332 (note 24), points out that Gauguin bought the pre-stretched canvas used for the Musee d'Orleans 'Clearing', 1874, and his earliest surviving sketchbook (National Museum, Stockholm) at Latouche's shop. Louis Latouche participated in the first Impressionist exhibition in 1874. Travers Newton has documented a Latouche stamp on the 'Portrait of Aline and Clovis', 1883 (Private collection).

12 **The New Painting** (1986) p 367 (no 111): "The majority... are framed under glass in the English manner. Because of the absence of varnish, the painting is left with a matte finish. This gives it a velvety tone..." Ibid. p 330 (no 99): Pissarro's unvarnished paintings were also noted the previous year.

13 Merlhes, **Correspondance** p 31 (no 25, c. July 1882) and p 33 (no 27, c. August 1882).

14. We would like to thank Ms Hanne Finsen for allowing us to study this painting and 'Human Miseries: Vintage at Arles' as well, and Mr Henrik Bjerre for his assistance and observations during examination of the works at the conservation laboratory in the Statens Museum for Kunst, Copenhagen.

15 Van Gogh, V, **The Complete Letters of Vincent van Gogh,** New York Graphic Society, Greenwich, Conn. (1958), III p 104 (no 561) to Theo van Gogh, c. 12 November, 1888.

16 ibid. p 534 (no T3a), Theo van Gogh to Gauguin, 13 November, 1888.

17 Bodelsen, loc. cit. pp 597-601, established the chronology of Gauguin's employments. We have observed a proportional increase in artist prepared canvases starting in 1884-85.

18 We would like to thank Dr Christian Lenz, Director, Neue Pinakothek, Munich, and Dr Hubertus von Sonnenburg, then director of the Doerner Institute, for permission to examine the painting in the laboratory. We are most grateful to Dr A. Burmester and his assistants for undertaking the necesary technical procedures.

19 The four figures were prepared in four full-size chalk drawings; the contours were transferred to the canvas and probably underdrawn in charcoal. The x-radiograph of the Four Breton Women reveals these firm contours as negative gaps. Also visible is the pentimento of the foreground shrubbery on the left, in front of the woman seen from behind before the wall.

20 We would like to thank Mr Han van Crimpen, curator, and Dr Ronald de Leeuw, director, Rijksmuseum Vincent van Gogh, for facilitating in every way our study of this painting and two others by Gauguin, 'Self-Portrait "les miserables"' and 'Portrait of Vincent van Gogh Painting Sunflowers', on numerous occasions. Dr van Asperen de Boer provided his equipment and expertise in the examination of the first two paintings with an IR vidicon.

21 Cooper, D (ed), **Paul Gauguin: 45 Lettres a Vincent, Theo et Jo van Gogh,** Staatsuitgeverij/Bibliotheque des Arts, s'Gravenhage/Lausanne (1983) pp32-33, receipt, 4 January, 1888.

22 For a review of the term and the movement, see Jirat-Wasiutynski, V, Paul Gauguin's Paintings, 1886-91: Cloisonism, Synthetism, Symbolism, RACAR: Revue d'art canadi-

enne/Canadian Art Review, IX (1982) pp 36-38, with references to previous literature by Dr B Welsh-Ovcharov and Ms Mary Anne Stevens.

23 We would like to thank Dr Dominique Denis and Mme Claire Denis for the opportunity to study Bernard's 'Breton Women in a Meadow'. The painting was exchanged for Gauguin's 'Portrait of Madeleine Bernard', 1888 (Musee des Beaux-Arts, Grenoble), in September 1888. But it seems to have reverted to Bernard after his break with Gauguin in 1891 and was acquired by Maurice Denis from the dealer Ambroise Vollard in 1892, according to Welsh-Ovcharov, B, **Vincent van Gogh and the Birth of Cloisonism,** catalogue of an exhibition, Art Gallery of Ontario, Toronto (1981) p 301, note 11.

24 Gauguin had used unprimed canvas, as did Bernard here, on various earlier occasions, including in the early summer of 1888 for the **White River** (Musee des Beaux-Arts, Grenoble), the reverse of which he used for the Portrait of Madeleine Bernard already mentioned.

25 Merlhes, **Correspondence** pp 248-49 (no 168).

26 We would like to thank Mr Hugh Macandrew, Keeper, Mr John Clarke, Keeper, and Mr John Dick, restorer, for the rare opportunity to study the 'Vision of the Sermon' unframed and deglazed.

27 The exchange is discussed in Jirat-Wasiutynski and Newton, op cit, pp 6-9.

28 Merlhes, **Correspondence** p 249 (no 168).

29 See note 20.

30 Cennino Cennini's **Il Libro dell'arte**, translated into French by Victor Mottez as **Traite de la peinture** (1858), was discovered by Auguste Renoir in the mid-1880s, according to Bailly-Herzberg, J, (ed), **Correspondence de Camille Pissarro**, PUP (1980), I pp 299-300, note 2.

31 Van Gogh, **Complete Letters** p 100 (no 559), c. 6 November, 1888; also Gauguin to Bernard in Merlhes, Correspondence p 273 (no 177), early November, 1888, for van Gogh's use of it. The "coarse sacking" was also much cheaper than painter's canvas, as Gauguin noted in a letter to Theo van Gogh, in Cooper, op. cit., p 77 (no GAC 9), c. 4 December, 1888.

32 Pierre-Louis Bouvier, **Manuel des Jeunes Artistes,** Paris [n.d.]; in the American translation by A. Laughton, New York 1845, p 116, we read: " a canvas somewhat coarser is even preferable because it holds the paint better." We know that both van Gogh and Gauguin had problems with grounds not adhering to fabric supports while in Arles.

33 ibid.

34 Van Gogh, **Complete Letters,** III, p ; Callen, op cit p

35 See van Gogh, **Complete Letters**, II, p 529 (no 467), pp 542-43 (no 475), p 545 (no 477), and p 566 (no 488), all to Theo van Gogh, March/April 1888.

36 Cooper, op cit, p 75 (no GAC 9), c 4 December, 1888.

37 See note 14.

38 Merlhes, **Correspondence** p 275 (no 179)

39 For its supposed durability, see Cooper, op. cit., p 77 (no GAC 9), c. 4 December, 1888, and Merlhes, **Correspondence** p 273 (no 177), early November 1888; for the hemp analogy, see Bouvier, op. cit., p 116.

40 Merlhes, **Correspondence** p 284 (no 182), to Bernard, early Dcember 1888.

41 Van Gogh, **Complete Letters**, III. p 107 (no 563), c. 23 November, 1888.

42 Letter from Schuffenecker to Gauguin, 11 December, 1888 (Gauguin family collection), cited in Merlhes, **Correspondence** p 299 (no CI).

43 Cooper, op. cit., p 251 (no GAC 34).

44 Jirat-Wasiutynski and Newton, op. cit., documented Gauguin's restoration of van Gogh's **Self-Portrait Dedicated to Paul Gauguin**.

45 The Arles-Brittany sketchbook of 1888-90, now in the Israel Museum, Jerusalem, was published in facsimile as Huyghe, R (ed), **Carnet de Paul Gauguin,** Quatre Chemins/Editart, Paris (1952). A systematic study of the sketchbook can be found in Amishai-Maisels, Z, A Gauguin Sketchbook: Arles and Brittany, **Bulletin Israel Museum,** vol () pp 68-87.

46 The co-authored essays will appear in a special volume of Cahiers Vincent, Amsterdam. We would like to thank Dr Cornelia Peres for sharing the results of her research with us and permitting us to present our joint findings here. The Central Laboratory, Amsterdam, was also involved in the research for the treatment of the 'Portrait'.

This paper was received after the editorial deadline.

CONSTANCY AND CHANGE IN LATE NINETEENTH CENTURY FRENCH PAINTING

John Gage

My rather bland title hides what seems to me to be one of the most important developments in European painting in the nineteenth century: the end of naturalism as an option. This was, of course, to lead, in extreme cases, to the end of representation itself. This development has usually been attributed to the rise of Symbolism as a painterly movement, but I do not need to remind this audience that the history of art is not simply the history of artistic ideas. I want to show that the *cul-de-sac* in which naturalism found itself by the 1890's was equally the result of internal pressures and weaknesses. The two most important of these seem to me to be the newly popular interest in a sophisticated psychology of perception, and the ready availability of a new range of painting materials. Our knowledge of both these elements has increased markedly in recent years,[1] but they have rarely been looked at together. It will be one of my tasks to show that they are, in the context of style, inseparable. To do so I shall focus on a group of avant-garde painters working in France at the end of the nineteenth century: Monet, Cézanne and Van Gogh.

A comparison between Monet's voluminous, recently-published correspondence and that of Cézanne and Van Gogh makes us at once aware that he was a far less reflective artist. He was constantly frustrated as a landscape painter by the changing weather and the disturbing activities of man, but generally without much thought for the problematic nature of his own vision. Even the development of his cataract seems to have come as a sudden and unexpected shock in 1912.[2] Monet belongs to that long tradition of painters, reaching back at least as far as Leonardo, and represented in the early nineteenth century by the German Romantic, Phillip Otto Runge, for whom it was the task of the painter essentially to emulate nature by matching her appearances, and to do so by study directly in front of the motif, even if the results of this study were later to be reconstituted in the studio.[3]

When painting pictures before the subject had become *de rigeur* in late nineteenth century France, one of the requirements of this approach to nature was speed of execution; and Monet was to develop this faculty more than most. In the course of his long series of "Rouen Cathedral" he was clearly able to improve this speed. He reported that one day in 1893 he had worked on ten canvases, although he had hoped to work on twelve; and in the long run he increased his performance from nine to fourteen canvases a day.[4] Monet claimed at the end of his life that the "Poplar" series of 1891 had involved no more that seven minutes on each canvas, painted on in sequence each day before the motif.[5]

For Monet the problem was to arrest an effect of light. One of the earliest writers to recommend speed of execution and abandonment to the "première impression" to painters aiming to imitate nature, was the chemist, M E Chevreul, who had introduced a psycho-physiological dimension to the question, claiming that an overlong scrutiny of the motif would, through the workings of the successive contrast of colours (coloured after-images), distort the perception of colour itself.[6] Chevreul was one of the many contributors to the new experimental aesthetics of the mid-nineteenth century, developed in Germany by G T Fechner, and in France, notably, by Seurat's friend, Charles Henry. It was an aesthetics which paid increasing attention to the subjective responses of the spectator. Such an emphasis could only lead to a recognition that the effect of the natural scene on the viewer was of a quite different order from the effect of paintings and that, for the most part, the artist laboured under severe limitations *vis a vis* the visual impressions he was attempting to reproduce. This realisation was not entirely new as Aristotle had already in his discussion of the rainbow *(Meteorology 372a)* claimed that it was impossible for pigments to match the rainbow colours red, green and purple, since matching involved mixture, and these were unmixed colours. This was probably the origin of a remarkable passage in a commentary on Aristotle's *Parva Naturalia* by the twelfth century Spanish Moslem writer, Averroes, in which he argued that the artist is greatly inferior to nature because the colours of nature are infinite, but those of the artist only finite.[7]

But in the nineteenth century this humble attitude was given a new impetus by the growth of experimental psychology. The most sustained account of the gap between the perception and the representation of nature was in a series of lectures, **The Relation of Optics to Painting**, by the German physicist and physiologist, Hermann von Helmholtz, delivered in the 1850's and translated into french in 1878. Helmholtz was particularly concerned with the discrepancy between light in nature and light in pictures. White, for example, in a picture indoors will be from 1/20th to 1/40th of the lightness of the same white in sunlight; and black in sunlight is only half as bright as white in the shaded part of a room.[8] He also drew attention to the subjective phenomena of colour-contrast and irradiation (by which light objects seems to spread their light over their surroundings), both of which, he said, must be represented objectively in paintings because of the relative feebleness of the artist's means.[9] It is this objectification of subjective effects which is so noticeable in the Neo-Impressionist work of Seurat in the 1880's (although Seurat may not have derived the idea direct from Helmholtz, but rather via the Swiss aesthetician, David Sutter).[10] Helmholtz summarised his conclusions:

"The representation which the painter has to give of the lights and colours of his object I have described as a translation, and I have urged that, as a general rule, it cannot give a copy true in all its details. The altered scale of brightness which the artists must apply in many cases is opposed to this. It is not the colours of the objects, but the impression which they have given, or would give, which is to be imitated, so as to produce as distinct and vivid a conception as possible of those objects."[11]

As the relaxed tone of this conclusion suggests, Helmholtz was not at all disturbed by the artists' need for compromise. Indeed, he saw this as the guarantee of individuality, leading to painterly solutions as different as those of Rembrandt and Fra Angelico and "his modern imitators", by whom he meant, I suppose, the German Nazarenes.

French writers were not always so optimistic. In the late 1850's, even before Helmholtz's work had appeared in France, a critic, Jules Jamin, had been busy with his photometer both out of doors and in front of pictures, and had found that there could be little comparison between them. Jamin saw much to admire in modern painting, especially in the work of Decamps, but he concluded that art could never be a reproduction of nature, and that the realist school was chasing a chimera.[12] The theme of the inadequacy of the painters' means recurs in French aesthetic writing with a positivist orientation well into the 1890's,[13] and, not surprisingly, it affected the responses of avant-garde painters themselves. It took the experience of the Italian Riviera in the early 1880's to persuade Monet that his palette was quite inadequate. Characteristically, he took refuge in the rather rhetorical observation that he would really have needed precious stones rather than paints to do it justice.[14] Van Gogh, on the other hand, had a long struggle reconciling the demands of his perception of nature with the demands of art. As early as 1885 in Holland he had argued for the primacy of the "palette" over nature:

"...one loses that general harmony of tones in nature by painfully exact imitation; one keeps it by recreating in a parallel colour scale which may not be exactly, or even far from exactly, like the model."[15]

The immediate context of Vincent's idea is Delacroix's notion, recorded by Charles Blanc, of the avoidance of "local colour" through the manipulation of contrasts; but it is also curiously close to a remark attributed to Corot in the treatise on watercolour with the help of which Vincent had taught himself to paint several years earlier:

"We are too feeble to reach the tone of nature; and when we are in front of her, so as not to compromise ourselves, we transpose; in this way, even if the tone is three times more feeble than that which she presents, it will be harmonious."[16]

Vincent was also thinking of Delacroix when he wrote from Arles to Theo in August 1888 that he was trying to detach himself from what he understood as "Impressionism":

"...instead of trying to reproduce exactly what I have before my eyes, I use colour more arbitrarily, in order to express myself forcibly." (Letter 520)

The approach also reflects Vincent's close association with Gauguin since the Paris years. Later in 1888 Gauguin instructed the young Sérusier to paint the small landscape which came to be know as the "Talisman" according to these expressive principles. He told Sérusier that he must work a "belle transposition picturale", which would make his emotion quite plain; he must put yellow, blue and vermillion in their purest forms from his paintbox where he saw them represented by any nuance in his subject.[17] It is clear that, even allowing for the mellowing of the thin pigments on the dark cigar-box lid, the young painter, in front of nature, did not follow out this advice to the letter.

All these preoccupations came to a crucial focus in the career of Cézanne, who spent a lifetime trying to identify and to represent what we see. Cézanne's imperious way with his subject matter - the editing out of foliage in landscape, for example, and the laborious arrangement of his still-lives[18] - and his obsession with "theory", especially at the end of his life,[19] have led some commentators to emphasise the conceptual in his work; just as his daily struggle with the motif and his contemptuous dismissal of "literary" painters, who seemed to him to have turned their backs on nature, has led others to see him as remaining close to the ethos of Impressionism. But it is clear from Cézanne's language that he was familiar with elements in the contemporary psychology of perception. This helps us to locate some of the peculiarities of his style. His belief, for example, that seeing is a product of training, and that it is optics (l'optique) which provides this training[20], is very much in tune with Helmholtz's theory of perception as outlined in his **Physiological Optics,** translated into french in 1867 and much quoted in the positivist aesthetic literature to which I have referred.[21]

Helmholtz's essential argument was that perception is the mind's organisation of the visual world not as a result of Kant's innate characteristics, but through experience.[22] Many spectators have hardly known what to make of the patchwork of marks presented by so many of Cézanne's late paintings, although we have the testimony of at least one modern painter-critic that it is possible for us to learn to see nature in this way.[23] One of the French popularisers of Helmholtzian psychology, Hippolyte Taine, whose De L'Intelligence of 1870 had gone through ten reprintings by the time of Cézanne's death, used that painter's term, taches (patches), to link the experience of a woman whose sight had been restored late in life to the activity of painting:

"Colourist painters know this condition well, for they are always returning to it; their talent consists in seeing their model like a patch (tache) of which the sole element is colour more of less diversified, tempered, enlivened and mixed. Thus far no idea of distance and of the position of objects, except when an inference (induction) derived from touch places them all opposite the eye..."[24]

This is surely the understanding that lies behind Cézanne's well-known remark to Émile Bernard that "to read nature is to see her beneath the veil of interpretation as coloured patches (taches) following each other according to a law of harmony".[25]

Cézanne's taches may thus be direct representations of his sensations of colour before nature. His problem was essentially to identify the principle of this harmonic law and to find a painterly means adequate to it. In this brief paper I have no space to explore the complex implications of these notions for Cézanne's art; but it seems to me that we need, on the one hand, to extend the examination of the painter's verbal formulations begun by Gowing, Shiff and Strauss, and, on the other hand, to ask ourselves in front of his paintings quite simply what it is that we are looking at in them.

In a letter to his son shortly before his death, Cézanne wrote:

"...as a painter I am becoming more clear-sighted before nature, but...with me the realisation of my sensations is always painful. I cannot attain the intensity that is unfolded before my senses. I have not the magnificent richness of colouring that animates nature".[26]

"Magnificent richness of colouring" might be the product of an ample palette; and it is notable that by the end of his career Cézanne had expanded the rather limited range of pigments he had used in the 1870's and 1880's to a series of nineteen.[27] Bernard, who records this late palette, also recalled a telling episode during his visit to Cézanne in 1904, when the old painter wanted to use his (Bernard's) palette, which was set with only four colours: chrome yellow, vermilion, ultramarine and madder lake, plus white. "You paint with just these?", asked Cézanne, "Where is your Naples yellow? Where is your peach-black, where your sienna earth, your cobalt blue, your burnt lake?...It is impossible to paint without these colours."[28] I need hardly stress that a wide-ranging palette is the hallmark of a matcher.

What is most striking about Cézanne's late palette is its traditional character. It included five earth-colours, plus peach-black, and of the nine synthetic pigments, only one, viridian (vert emeraude) had been introduced later than the early years of the nineteenth century. Cézanne seems to have made no use, for example, of the mid-nineteenth century cadmium yellows or cerulean blue so favoured by Monet.[29] His choice of pigments was, in fact, closer to that other "classicist" among the Impressionists, Renoir.[30] Like Renoir, too, Cézanne is likely to have been preoccupied with the stability of his pigments;[31] nine of his nineteen colours were particularly known for their solidity, and of the other, only the chrome yellows, which had generally been replaced by cadmiums, had a poor reputation for it in late nineteenth century France.[32]

In France, as elsewhere, the stability of pigments and media was a matter of great concern throughout the second half of the century, when a growing number of synthetic and relatively untried products was appearing on the market. Just as the London Royal Academy had introduced instruction in chemistry in 1871, so a few years later the Ecole des Beaux-Arts appointed the genre-painter, J G Vibert, to give instruction in technique; and, as a traditionalist, Vibert felt obliged to evaluate the new pigments and media and to reject most of them on the grounds of their impermanence.[33] His lecture course, published in 1891 as **La Science de la Peinture,** became one of the most popular and most reprinted of french technical sources well into the 1920's.

The crucial question for modern painters was the character of the brightest pigments. In 1857 Jules Jamin was still arguing that naturalistic painting could only be achieved if the tonal-range of nature was transposed in the picture into a lower key,[34] but as peinture claire gained ground in the 1860's, and was given a more colouristic emphasis in Impressionism, there was inevitably a demand for greater range at the top end of the brightness scale. Cézanne in his later years was particularly in need of bright pigments for, as we know from the testimony of Bernard,[35] as well as from many canvases and watercolours abandoned in their earliest stages, he began with the darkest tones and proceeded to work up the scale into the lights. Since he was clearly not prepared to experiment with the newer bright pigments, Cézanne often found it impossible to find on his palette tones which would match his strongest sensations of luminosity, which were represented, as he wrote to Bernard, particularly by the reds and the yellows.[36] His palette included six reds, among them two earths, and five yellows, also including two earth colours and two bright chrome yellows; but, given his commitment to a scale of modulations based on hue rather than on value, as well as a reluctance to mix too liberally, and hence destroy the purity of his tones, perhaps he found in many cases that he had simply run out of matches.

That Cézanne worked on a white or lightly-toned canvases made it possible for the priming to stand more or less satisfactorily for the lightest points in the composition; and this has given rise to the modern debate about "finish" in the late works.[37] For us, the question is probably no longer resolvable in principle, and perhaps it was the occasion of great anxiety. As he wrote to Bernard in 1905:

"Now, being old - some 70 years - the colouring sensations which give the light are with me the cause of abstractions which do not allow me to cover my canvas, nor to follow the edges of objects when their points of contact are fine, delicate, which results in my image or picture *(tableau)* being incomplete."[38]

As might have been expected, the headstrong Van Gogh adopted a far less cautious attitude to his materials than Cézanne. Soon after his arrival in Arles in 1888 he sent to Theo for a large batch of a dozen pigments from Paris, all of them bright and several; malachite green (probably copper aceto-arsenite), geranium lake (an aniline colour), cinnabar green (a mixture of chrome yellow and prussian blue) and orange lead (?chrome orange) among the most fugitive then on the market, according to Vibert (Letter 475). In a subsequent letter Vincent showed that he was well aware of these failings, but he was not at all deterred, arguing that he would make allowances for them in his handling of these materials in his work:

"All the colours that the Impressionists have brought into fashion are unstable, so there is all the more reason not to be afraid to lay them on too crudely - time will tone them down only too much." (Letter 476)

This sounds like studio gossip, and since it seems clear that the Impressionists did pay attention to the stability of their materials, by "Impressionists" Vincent probably intended the Neo-Impressionists, with whom he had recently been in close contact in Paris. Seurat in particular had made use of fugitive pigments, noting as early as 1887 that they were fading (the revisions he made in the dotted manner on his earlier "Bathers" in the National Gallery that year were probably for this reason). Other commentators noticed the degradation of the colour in "Sunday afternoon on the Island of the Grande Jatte" only three years after it was painted in 1886.[39] As far as we are able to judge from the literary evidence, both Seurat and Signac, who were, of course, deeply implicated in the scientific aesthetic of the 1880's and anxious to find pigments which would approximate to the colours of the spectrum, made much use of the products of the most recent paint technology.[40]

But what is perhaps most remarkable about Vincent's observation is that it shows him prepared to allow a large place in the conception of his late colour compositions to the actions of time. Time had been regarded as a good painter at least since the seventeenth century, but in the earlier periods, when varnishing was seen to be the essential complement to a finished picture, it was natural that varnishes should for the most part be the place where he had showed his hand.[41] The history of varnishes is still very sketchy, but it seems that in the nineteenth century many painters were reluctant to employ them, and this was particularly so among the Impressionists, precisely because of the premium they placed on the purity and brilliance of the bright colours.[42] On the other hand, a letter form Van Gogh to the critic Aurier suggests that he had nothing against varnishing (Letter 626a), although it is at present impossible to say to what extent he used it. His idiosyncratic interpretation of the ageing problem could perhaps only have occurred to a painter whose urge to match his visual sensations was not very highly developed; and it raises the question of how far time can be seen to have done his work. Were Vincent's post-Paris paintings as much out of his contol as Cézanne's late unfinished canvases? Should we, indeed, look at them only through dark glasses? I hope my paper will suggest more work for the conservator to do.

References and notes

1. For psychology, Boring, E G, Sensation perceptions in the history of experimental psychology, New York (1942) especially Ch 3; N Pastore, **Selective History of Theories of Visual Perspective,** 1650-1950, (1971). For the late nineteenth century materials, Callen, A, Techniques of the Impressionists, London (1982).
2. Monet to Geffroy, 26 July 1912, in Wildenstein, D, **Claude Monet; Biograhie et Catalogue Raisonne,**Lausanne, IV, (1985), p386 No 2033.
3. For Leonardo se especially Leonardo da Vinci, **Treatise on Paintings,** ed. and trans., MacMahon, (1956), I, pp.291-2 872. For Runge, Runge, P D, Hinterlassene Schriften, Hamburg, I, (1840), pp 81, 180-1.
4. Monet to Alice Hoschede, 23 March 1893 (Wildenstein, op. cit.III, 1979, p.272 No.1196). On March 29 Monet reported that he had reached a peak of fourteen canvases that day (ib.p273); a year earlier the norm had been nine (ib. 18 March 1892, 2 April 1892)
5. Perry, L C, 'Reminiscences of Claude Monet, 1889-1909', **American Magazine of Art,** I8, (1927), p.121.
6. Chevreul, M E, de la Loi du Contraste Simultane des couleurs, Paris (1839) pp 215-6.
7. **Averrois Cordubensis Compendia Librorum Aristotellis qui Parva Naturalia Vocantur,** ed. Shields, A E, Cambridge MA (1949), p.20f. Averroes seems to be thinking less of painters than of dyers.
8. Hermann von Helmholtz, **Popular Lectures on Scientific Subjects,** trans. Atkinson, London (1900), II, pp 97-8
9. ibid. pp 113-21.
10. For Seurat's possible knowledge of Helholtz's essay, Homer, W I, **Seurat and the Science of Painting,** Cambridge MA (1964), p 289; also p 43 for the discussion of irradiation by Sutter in an article of 1880, which Seurat claimed to have read almost as soon as it appeared.
11. Helmholtz, op. cit. pp 121-2
12. Jamin, J, 'L'Optique de la peinture', **Revue des deux Mondes,** 2e per. 7 (1857) espec. pp 632ff;, 641-2.
13. For example: Laugel, A, **L'Optique et les Arts,** Paris (1869), pp 89-100; Brucke, E, **Principes Scientifiques des Beaux-Arts,** Paris (1878) p 105 (Helmholtz' essay on optics and painting was published as an appendix to this work); Gueroult, G, 'Formes, Couleurs, Mouvements', **Gazette des Beaux-Arts,** 2e per.25, (1882) p176; Vibert, J C, **La Science de la Peinture,** Paris (1891) (1902) pp 68-9 (this edition was reprinted in 1981).
14. See Monet to Alice Hoschede 26 January 1884 (Wildenstein II, (1979), p.233 No.394; 2 February 1884 to Duret (No.403); 25 March 1884 to an unknown correspondent (No.460); see also Renoir's report in House, J, **Monet; Nature into Art,** New Haven and London (1986), p235 n.35.
15. **The Complete Letters of Vincent van Gogh,** London (1958), No.429.
16. Cassagne, A, **Traite d'Aquarelle** (1875), 2nd ed. Paris (1886) p. 113. For Van Gogh's use of Cassagne, Letter 146.
17. For the fullest account, based on Emile Bernard's recollections, Guichetau, M, **Paul Serusier,** Paris (1976) pp 21ff.; also Boyle-Turner, C, 'Serusier's **Talisman, Gazette des Beaux-Arts,** 6e per. 105, (1985) pp.191ff.

18. The treatment of landscape is well illustrated in the subjects Cezanne painted side-by-side with Armand Guillaumin in the 1870s (Rewald, J, **Studies in Impressionism**, London (1985) pp 110-1, 114-5; these last in colour in Rewald, J, **Cezanne; a Biography**, London (1986) pp.132-3. For the still-lives see the account by Louis le Bail in the late 1890s in Rewald, **Cezanne**, cit. p.228.

19. See, for example the remarks made to Charles Camoin in 1905 (Camoin to Matisse in D. Giraudy) 'Correspondence Matisse-Camoin', **Revue de L'Art** 12 (1971) pp 9-10.

20. Cezanne to Bernard, 23 October 1905 in Doran, P M, (ed.) **Conversations avec Cezanne**, Paris (1978) p 47.

21. Se Pastore op. cit. pp 167ff.; also ibid. 'Helmholtz's Popular Scientific Lectures on Vision', **Journal of the History of the Behavioural Sciences** 9 (1973) p. 196.

22. The active role of the mind in organising sensations was one of the dominant themes of Laugel's very Helmholtzian '**Optique et les Arts**' (e.g. p.41).

23. Frankl, G J R, 'How Cezanne saw and used colour' (1951) in Wechsler, J, **Cezanne in Perspective**, Englewood Cliffs (1975) pp 125-30.

24. Taine, H, **De L' Intelligence**, Paris 2nd ed. (1870), II, p122. It is of interest that Monet at the end of his life spoke enviously of the blind man who saw the world afresh after his sight had been restored (Perry, loc cit p.120), although his source here was probably Ruskin's **Elements of Drawing** (London (1904) p.27): see Dewhurst, W, 'What is Impressionism?', **Contemporary Review**, 99 (1911) p.296.

25. Doran op. cit. p36. Lawrence Gowing's contention that in themselves Cezanne's patches do not represent anything, seems in this context to be wide of the mark

(Gowing, L, 'The Logic of Organised Sensations' in Rubin, W, (ed.) **Cezanne; The Late Works**, New York (1977) p66. Cezanne's remark also undermines the view of another painter-critic, Ernst Strauss, that his activity as a painter was essentially to interpret what he saw (Stauss, E, 'Nachbetrachtungen zur Pariser Cezanne-Retrospektive 1978', **Koloritgeschichliche Untersuchungen zur Malerei seit Giotto**, 2nd ed Munich & Berlin (1983) p173.

26. Rewald, J, (ed) **Paul Cezanne; Letters**, 4TH ed. Oxford (1976) p327

27. Bernard in Doran, op. cit. pp 72-3. Few technical analyses of works by Cezanne have been published, but the Louvre's **House of the Hanged Man** of 1873 used a palette of some nine pigments (Callen, op. cit. p74), and the **Chestnut Trees** of the mid 1880s in Minneapolis some eight (Butler, M, 'Pigments and Techniques in the Cezanne Painting "Chestnut Trees", **Bulletin of the American Institute for Conservation of Historic and Artistic Works**, 13 (1973) pp.77-85). The National Gallery's **Mountains in Provence** of c.1886 reveals the use of nine pigments (Roy, A, The Palettes of Three Impressionist Paintings', **National Gallery Technical Bulletin**, 9, (1985), p .17.

28. Doran, op. cit. p.61.

29. For Monet's palette, House, op. cit. p239 n.10

30. For Renoir's palette in the late 1870s, Renoir, J, **Renoir my Father,** London (1962) p342; for the 1890s, Tabarant, A, 'Couleurs', **Bulletin de la Vie Artistique,** 4, (14 July 1923) p289.

ART HISTORICAL AND TECHNICAL EVALUATION OF WORKS BY THREE NINE-TEENTH CENTURY ARTISTS: ALLSTON, WHISTLER AND RYDER

Joyce Hill Stoner

Abstract

Washington Allston used multiple glazes with fast driers, megilp and asphaltum, and a final toning called "Titian's Dirt." James McNeill Whistler had profound interests in surfaces and harmonies and orchestrated both permanent and impermanent materials into alternating patterns in 'Harmony in Blue and Gold': The Peacock Room, which has also been modified by imbalanced past restoration efforts. A.P. Ryder used unorthodox non-drying materials which have caused traction crackle and immutable browning, but may be the key to distinguishing numerous forgeries from original works. Examination of contemporary bibliographic sources in conjunction with technical examination by conservators and art historians working in tandem is seen as a promising method to evaluate original and current appearance of works by these artists.

Introduction

Washington Allston, James McNeill Whistler and Albert Pinkham Ryder have each left a "paper trail" of personal accounts and correspondence, and each had fond colleagues who reminisced volubly about the artists' personalities and technical practices. Conservators can rarely delve into these sources during the course of a treatment, whereas art historians regularly comb these materials but may not highlight technical observations which could influence the treatment, or could anticipate likely changes in current appearance. All three of these artists used techniques and combinations of materials which are more likely to alter with age than many of the works of their contemporaries. Knowledge of the likely consequences of the practices of these artists through documentary sources, the study of the works in their current state and examination of microscopic cross sections are all helpful in more accurately assessing the appearance and impact of the paintings at their moment of completion. Such an assessment can influence decisions concerning the conservation treatment.

As the art historian compares works by Allston to works by his contemporaries, such as Samuel F. B. Morse or John Vanderlyn, which tend not to have changed as radically in overall tonality, a conservator "at her elbow" can help explain misleading anomalies which may have intruded over the intervening years. As the curator tries to estimate the overall visual result of cleaning the varied surfaces of Whistler's "Peacock Room" before treatment begins, the conservator can try to provide clues about changed materials and past restorations to aid in a joint decision about both the original appearance and the wisest approach to restoration with current methodologies. And as both curators and art historians try to separate the forgeries from the genuine works by Albert Pinkham Ryder, their trained eyes can be assisted by the conservators' technical data provided by the "fingerprints" of stained cross sections taken from spurious and accepted works.

WASHINGTON ALLSTON (1779-1843)

Introduction

Washington Allston was called the "American Titian" by artists in Rome in the early 19th century. He used multiple layers of glazes with strong driers, incorporated soluble components into his paint films, and was known to apply a final toning layer which he called "Titian's Dirt." He went through early eclectic phases of imitating Old Master compositions, then in the 1830's, he painted small, visionary misty images of solitary women and wrote poems to accompany many of the pictures. For one such picture, 'The Spanish Maid', 1831, at the Metropolitan Museum of Art (Fig. 1), Allston noted that the conception of the poem and the picture had been simultaneous in his mind[1]. In the painting, Inez is sitting on

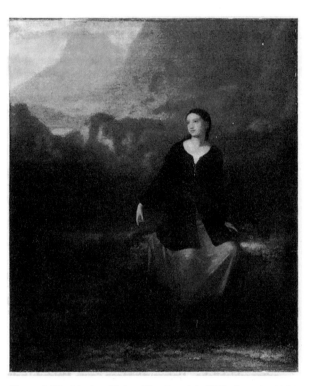

Figure 1. Washington Allston, The Spanish Girl in Reverie, 1831, oil on canvas, courtesy of The Metropolitan Museum of Art, Gift of Lyman G. Bloomingdale, 1901. (01.7.2).

an isolated grassy knoll, waiting for her lover to return from battle. The poem, "The Spanish Maid," contains phrases such as "the mountain's misty side," and the sun sinking "amid purple haze." The in-press catalogue entry at the Metropolitan Museum notes "through an extraordinary blend of blue, red, and green, the landscape is now a confusing blur, and one has trouble imagining its original appearance." However, comparison with other images of the same period, his use of multiple layers of glazes and the words chosen for the poem indicate that the current "blur" is probably intentional and not too far from the original appearance. Information on Allston's technique was provided by Henry Greenough, Allston's colleague and brother to the sculptor Horatio Greenough, who wrote that Allston told him that he painted over the mountains in this painting "at least twenty times, and that is the secret of the diaphanous effect which you mention."[2]

Allston's glazes and megilp

The "twenty" or more layers of glazing are likely to have contributed to the severe crackle pattern now markedly apparent throughout the painting. In order to carry out multiple glazings, Allston often added Japan gold size drier to his medium. One recipe for Japan gold size included a mixture of Kauri gum—a hard resin—and turpentine, boiled oil, litharge, red lead, and manganese dioxide. It was a strong drying agent often used by sign painters.[3] He also added megilp to his paints, a mixture of mastic, oil and turpentine. It has a buttery consistency enjoyable to paint with and maintains a "varnished" look for the oil paint as one is working. Megilp can also cause fissure cracks if used heavily and may darken with age.

When Allston saw the Venetian paintings in Napoleon's Louvre, he commented: "It was the poetry of color which I felt."

Titian, Tintoretto and Veronese "took away all sense of subject" for him with their "gorgeous concert of colors." [4] But what were the colors of the Titians that he saw? He may have seen the Venetian works covered with discolored brownish, "gallery varnish" which seeded the controversies in Paris and London thirty years later. The paintings were surely varnished at this time. Charles Leslie complained that his first history picture was not allowed in the British Institution's exhibit of 1814 on the grounds that it was not varnished and therefore looked "unfinished." Leslie also noted: "Allston first directed my attention to the Venetian school, particularly to the works of Paul Veronese, and taught me to see, through the accumulated dirt of the ages, the exquisite charm that lay beneath," [5] Thereby indicating that Allston was aware of discoloring surface layers. He had a keen fondness for the Old Masters, but his own paintings, even with multiple glazings, must have looked somewhat direct and opaque next to the aged translucencies of 16th century Masters with their accumulated grime and old varnishes. His use of a toned coating is therefore not surprising.

Allston's toned coatings

The use of toned coatings over the paint layer or over the final varnish would not have been unusual for Allston's time; Dunlap describes how Richard Wilson dispatched a porter for India Ink and Spanish licorice, which he then dissolved in water, and "washed half the pictures of the annual exhibition in Spring Gardens of the Society of Painters with the glaze considered 'as good as asphaltum.'" West comments "they were all the better for it." [6] Allston's "Titian's dirt," was made from a mixture of asphaltum, Indian red, ultramarine and megilp. Japan size is included with one recipe to make it dry faster, and so that he could work with it longer it is omitted from a second recipe. He told Greenough: "with this I go over the face, strong in the shadows and lighter in the half-tints; with a dry brush or rag, I wipe off the glazing or weaken it as I wish, and in this way, model up the general form and detail...very much like water-color painting...left moist." [7]

Allston had a great interest in unity and harmony, and it is likely that versions of "Titian's dirt" were used throughout most of his career. The Greenough reference above mentions this technique in connection with his early trip to Rome, so it is not just a later life phenomenon. Art historian William Gerdts notes that many artists used asphaltum unwisely which he says "gradually ruined many paintings." This would be true especially where it was used thickly.

Interpretation of Allston paintings

Unaware of Allston's technique, the first restorers who cleaned his paintings may have misinterpreted the intentionally toned surfaces. This could have resulted in the removal of readily soluble glazes and "Titian's dirt," thus significantly changing the appearance of the painting. Allston himself "in 1839, on seeing his heavily glazed 'Diana in the Chase', (1805), after a lapse of twenty-four years, disclaimed real authorship of the work, saying that the picture cleaner had totally destroyed his conception." Allston's 'Taming of the Shrew', (1809), was recently treated at the Philadelphia Museum of Art. [10] A study of a cross section of red drapery (Fig. 2) [11] suggested that reduction of the original varnish had been carried out with a scalpel rather than with solvents. In this particular case it is likely that the original toned paint surface had survived intact. A technical examination such as this can reveal much about the original appearance of a painting.

The interpretation of intended original color tonalities that may now be changed by cleaning or discoloration of media is somewhat aided by contemporary accounts. Allston's palettes and detailed recommendations for the use of color were extensively documented, by Nathaniel Jocelyn in August, 1823 [12]; by Thomas Sully during a visit to Allston in 1835 [13]; and by Henry Greenough's lengthy descriptions published by Flagg. [14] Although the number of pigments he used was limited, it still took him a half an hour to mix and meticulously spread them out on his palette each day. [15]

George Field, the color maker and color theorist, visited Allston's studio in London in 1815, because he had seen Allston's painting, 'The Sisters', which was painted in the tertiary colors

1. Later varnish
2. Original varnish
3. Interactive zone
4. Auto-fluorescence
5. Oil layer
6. Transparent glaze layer
7. Auto-fluorescent resin
8. Lighter oil paint
9. Non-oil layer (casein?)
10. Oil paint
11. Oil soaked into the ground
12. Ground

Figure 2. Diagram of cross section from Washington Allston, The Taming of the Shrew, 1809, oil on canvas, The Philadelphia Museum of Art, 018-1987-001, courtesy of Mark Aronson.

using the theories Field was about to publish. [16] Allston had arrived at the same theory independently. "For both Allston and Field, the significance of the tertiaries was that they alone on the color wheel contained all three primary colors and thus were a physical symbol of the ultimate harmony in the universe." [17]

Allston's use of tertiaries makes short color descriptions difficult; hyphenations become mandatory. (This concept is also operative while describing colors in Whistler's 'Peacock Room'.) The colors of 'The Spanish Maid', include: "A pinkish-beige hat," "dried-blood red velvet," or a "mustard-green belt." Art historian E. P. Richardson's color descriptions of Allston's 'The Sisters', include: "puce-colored dress," "cherry-brown blouse," and "brownish purple skirt." In describing Allston's 'Diana and her Nymphs in the Chase', the poet Coleridge listed "beautiful purple-crimson mosses" and "grey-blue faintly purplish" rock. For flesh, Allston aimed toward what he considered Titian's "luce di dentro" or "internal light" technique, which he compares to a purple silk woven of red and blue threads. The flesh tints are to be mingled lightly "with the brush only"..."twiddling them together instead of grinding them with a knife." A close examination of the face of the 'Spanish Maid' reveals a Seurat-like complexion composed of colors that blend best to the eye at a slight distance.

In fairness to an artist who clearly took great pains to select and employ certain color relationships and translucent effects as part of the meaning of his works, the treatment and interpretation of his paintings should be approached with as much supporting information as possible. Two promising sources for understanding are the plentiful documentary sources and technical examination of any extant untreated works. Both sources can be more richly mined if conservators and art historians work in tandem, as each profession has a different context for translating the information into tangible visual differences.

JAMES McNEILL WHISTLER (1834-1903)

Introduction

In the years before creation of 'Harmony in Blue and Gold, The Peacock Room', 1876-7, it was already apparent that James McNeill Whistler had profound interests in color harmonies and surfaces. In 1874, Whistler decorated The Flemish Gallery on 48 Pall Mall in grey, white and yellow to receive a selection of his paintings, which had entitled "Arrangements," "Symphonies" and "Harmonies"; detailed notes still exist on the numbers of the layers of distemper paint requested. Henry Blackburn wrote in Pictorial World:

> "The visitor is struck, on entering the Gallery, with a curious sense of harmony and fitness pervading it, and is more interested, perhaps in the general effect than in any one work. The Gallery and its contents are altogether in harmony—a 'symphony in colour,' carried out in every detail, even in the colour of the matted floor, the blue pots and flowering plants, and, above all, in the juxtaposition of the pictures. . . If anyone wishes to realise what is meant by true feeling for colour and harmony—born of the Japanese—let him sit down here some morning. . .A 'symphony' is usually defined as a 'harmony of sounds agreeable to the ear,' here, at 48 Pall Mall, is a harmony of colour agreeable to the eye."[20]

To achieve his surfaces, which were distressed diaphanous veils, he often scraped his portraits down again and again even after multiple sittings. Art historian David Curry compares Whistler's surfaces to Oriental surfaces in their ability to "pulsate with imprisoned colors."[21] To achieve this, he concocted a special dilute painting medium which he referred to as his "sauce," which was often used to the extent that the painting had to be "thrown flat on the floor to keep the whole thing from running off."[22] These multiple layerings with repeated partial removals could cause unusual changes in translucency with age, and the dilution of the oil medium could make the paint film unexpectedly soluble in the solvents normally used to remove discolored varnishes.

Whistler's harmony in blue and gold: the Peacock Room

In 1876, Whistler began consulting on the colors for the interior decoration of the recently completed dining room of one of his patrons, Frederick R. Leyland of 49 Princes Gate, London. The interior of the house had been transformed by Norman Shaw, and Thomas Jeckyll had placed gilded Spanish leather wall coverings and spindle shelving in the dining room to display Leyland's collection of Blue and White porcelain. Whistler began by making small adjustments: he added primrose yellow and blue to the embossed, silver-gilt leather wall coverings and cut off the red border of the rug. Both the adjustments were made in order to avoid color clashes with 'The Princess from the Land of Porcelain', which he painted in 1864 and was also to be displayed in the dining room. Small alterations evolved into more than six months of twelve-hour days repainting every surface detail of the room, from the moldings adjacent to the floor to complete patterns of peacock feathers on every square inch of the ceiling, and four stand-alone mural/panels of peacocks in various decorative and anecdotal poses (Fig. 3). Some of the areas sampled to date show at least eleven layers by the artist, including three layers of gilding (Figure 4).[23] The artist's mechanical distressing of top layers to reveal flickers of lower layers is evident even in some of the microscopic cross sections.

Whistler wrote a small broadside printed by Thomas Way in 1877, and distributed it to publicize the Room:

> "Harmony in Blue and Gold: The Peacock Room. The Peacock is taken as a means of carrying out this arrangement. A pattern, invented from the Eye of the Peacock, is seen in the ceiling spreading from the lamps. Between them is a pattern devised from the breast feathers. These two patterns are repeated throughout the room. In the cove, the Eye will be seen running along beneath the small breast or throat feathers. On the lowest shelf the Eye is again seen, and on the shelf above—these patterns are combined: the Eye, the Breast-feathers, and the Throat. Beginning again from the blue floor, on the dado is the

Figure 3. James McNeill Whistler, 'Harmony in Blue and Gold: The Peacock Room,' (northeast corner including the painting of The Princess, and two peacock shutter panels)1876-77, oil, resin and gold leaf on leather, wood and canvas, courtesy of The Freer Gallery of Art, Smithsonian Intitution, Washington, D. C., 04.61.

breast-work, Blue on Gold, while above, on the Blue wall, the pattern is reversed, Gold on Blue. Above the breast-work on the dado the Eye is again found, also reversed, that is Gold on Blue, as hitherto Blue on Gold. The arrangement is completed by the Blue Peacocks on the Gold shutters, and finally the gold Peacocks on the Blue wall."[24]

The patterned harmonies of both colors and materials were methodically conceived and carried out. The basic blue on gold/gold on blue patterns were executed by calculated alternation between powdered gold applied in painted designs, Prussian blue mixed with white[25] and Dutch metal leaf interlayered with copper resinate green.[26] Age has altered the harmonies. The Prussian blue and white paint color retains an opaque light blue hue, while the greener, translucent areas of copper resinate appear to have browned. The design areas using real gold still sparkle while the Dutch metal (a gold-toned alloy of copper and zinc) areas may have tarnished significantly on the surface. The possible impermanence of the Dutch metal gilding which Whistler had used on the staircase adjoining the dining room was already discussed in a letter (which Whistler ignored) of August 1876; Leyland wrote: "seeing the doubt there is of the gilding on the stairs standing you had better do no more."[27] Walter Greaves, one of two brothers who assisted Whistler with 'The Peacock Room' had supposedly also warned "The Master" that his materials "would not stand" but was disregarded.[28]

The Room was disassembled and relocated four times: twice in 1904, once in 1919, (when it was moved from Charles Freer's home in Detroit to the Freer Gallery of Art in Washington, D. C.) and again for restoration in 1947-50 by Freer staff and Boston conservators. It seems probable that some restoration was carried out at the time of each move, although it has not always been documented. 'The Peacock Room' is now closed to the public until 1992, while the Freer Gallery is undergoing renovation.[29] An examination and analysis is being carried out on cross sections taken throughout the room to understand as much as possible the original color harmonies. On the basis of this research, treatments will be developed to retrieve original color harmonies where solubilities of original materials, previous restoration materials and grime layers will permit.

1. Later restoration (protein)
2. Resin
3. Prussian blue
4. Gold gilding
5. Varnish
6. Prussian blue and white
7. Evidence of traction crackle
8. Varnish
9. Dutch metal
10. Copper resinate and yellow
11. White ground
12. Gold gilding
13. White ground
14. Copper resinate green (thin) (slightly "bled" into white ground)

Figure 4. Diagram of cross section from east wall of The Peacock Room lower dado panel below first peacock panel, courtesy Richard C. Wolbers.

Study of Whistler's own accounts and letters, in addition to contemporary descriptions of visits while the Room was in progress, indicates that the harmonies and patternings shimmered from floor to ceiling, outshining the more formal peacock panels on the window shutters and south wall. Subsequent restorations, which focused on the cleaning and inpainting of individual panels, have contributed to the distortion of the overall harmonies that must have existed in 1877. In the below-dado levels, the Prussian blue/gold-decorated wooden panels have thinner, slightly discolored greyish coatings and darkened blue daubs of retouchings. The adjacent framing moldings of the wainscoting have multiple layers of browned varnish and shellac films with generous repaintings. As these brown coatings are removed, shimmering greenish-yellow surfaces are revealed and the moldings vie energetically with their framed panels for visual attention. 'The Room', when cleaned overall, is likely to reveal a full range of blue, green and gold gradations which are analogous to the iridescent spectrum in actual peacock feathers. The cleaned areas of the Room seem to associate more clearly with the "greenery-yallery" tertiary colors of the Aesthetic Movement, and one could say that the recently revealed hyphenated, tertiary colors now show more kinship with the earlier 19th century colors used by Allston.

The question of retrieval of overall harmonies when confronted with possible discoloration of copper resinate and Dutch metal must be further investigated. The collaboration of conservators equipped with cross sections and art historians with contemporary accounts and other examples of period color harmonies will be essential. Fluorescent staining of cross sections[30] to date has indicated that some of Whistler's translucent underlying layers are more soluble than coatings and opaque repaints which were applied during the restoration treatment of the 1940's.

ALBERT PINKHAM RYDER (1847-1917)

Introduction

Ryder lived in a cluttered apartment on the lower West Side of New York City, slept in his clothes and worked surrounded by stacks of newspapers, unwashed dishes and unfinished meals. In an interview he said the artist should be "freed from the bondage of appearance" and remain "true to his dream."[31] As he "squeezed out big chunks of pure moist color," he said he saw nature springing to life on his small canvases or pieces of old furniture.[32] His working methods included: continuous reworking of many of his paintings, sometimes while the paint was still wet, or many years later; varnishing works in progress, and putting them away horizontally in drawers to dry; and mixing in candlewax[33] for translucent effects. A gentle, child-like man, Ryder made perfumes and wrote poetry for the friends who tried to care for him and to clean up around him. Some of these friends also were known to have "finished" Ryder's paintings for him at the end of his career.

Changes caused by Ryder's materials

Understanding of what may have been the original appearance of various works by Ryder at any of numerous times when each work was considered by the artist's patrons and friends to be "finished," truly requires the collaborative guesswork of conservator and art historian. Minor technical defects did not disturb the artist; the late 19th century art critic Sadikichi Hartmann noted that some of his paintings had "not only extensive crackings but regular varnish slides, moving lava-like through the surface." He also said that "Ryder apparently did not mind such trifles, perhaps he was so absorbed in the main issues of his work, that he could not concentrate on minor happenings and necessities."[35] To be able to continue working over the multiple layering of paint films and varnishes, like Allston, Ryder may have used fast drying agents, and extensive cracking has resulted. The cracking often took place while the paintings were still in Ryder's studio; Albert Groll described witnessing the artist using a red-hot iron to try to close the fissures on one of his paintings. Interpretation of the structure and condition of Ryder's works must therefore take into account the artist's own restoration attempts.

Figure 5. Albert Pinkham Ryder, 'The Curfew Hour', early 1880's, oil on wood panel, courtesy of The Metropolitan Museum of Art, New York City, Rogers Fund, 1909.

'The Curfew Hour' at the Metropolitan Museum of Art (Figure 5) exhibits one of the saddest scenarios of change in a painting. Cross sections (Figure 6) stained with fluorescent dyes were found to show the presence of a non-drying oil applied consistently between the paint film and the first application of varnish. One possible cause of this could be the artist's application of a rag charged with butter or perhaps the homemade perfume oils in his studio to the paintings in preparation for varnishing. Kenneth Hayes Miller noted that Ryder would go over pictures which were piled about his studio "with a wet cloth to bring out their depth and transparency" to show them to advantage to his visitors.[37] Either butter or perfume oils would leave a film of non-drying lipids on the surface before varnishing.

In the internal structure of the paint cross sections, proteins and sugar-based materials were also detected, which may have been materials used to increase the viscosity of the paint to create the meringue-like impasto visible in the cross sections and final paint surface. The traction crackle in many Ryder paintings has traditionally been attributed to the use of bitumen, but no bitumen was detected in the cross sections taken of three of his paintings at the Metropolitan Museum.[38] The translucent browning of many Ryder paintings, which is generally felt to be intrinsic and irreversible, may not be caused by the predictable alterations of paint film components such as Whistler's "sauces" or Allston's megilp, bitumens or "Titian's dirt," but from the "Maillard" effect[39]—the natural aging and browning of proteinaceous food materials.

Ryder attribution problems

Lloyd Goodrich believed there to be about a thousand Ryder forgeries;[40] some began to appear on the market even before the artist's death.[41] The new Lloyd Goodrich-Albert Pinkham Ryder Archive at the University of Delaware Library contains a number of forgeries detected by art historical analysis in conjunction with radiography. These paintings were sampled and compared to samples from three of the accepted works at the Metropolitan Museum. Cross sections of the accepted works show clear evidence of reworking and "whipping up" of the paint films and underlayers into convoluted wave forms. In addition, proteins and non-drying oils were identified as mentioned above. These cross sections are very different from those taken from the forgeries. The forgeries may superficially have convincing discolored and golden surfaces, but under the microscope cross sections reveal tidy horizontal bands of layered paint films with no sign of the other materials identified in the accepted works. Forgers may have successfully imitated the final appearance of his works, but apparently did not know enough of his true technique and materials to have imitated them fully. Furthermore, they would not have deemed it necessary; they could not have anticipated the methods of examination developed in the next century.

Conclusions

Art history has changed over the last twenty years, with new revisionist trends, emphasis on multicultural diversity and enhanced study of the cultural context of works of art. In the same period of time, art conservation has grown as a discipline, with the birth of new training programs, new professional associations and more interdisciplinary cooperation as represented by this joint United Kingdom Institute for Conservation/Association of Art Historians Conference. The study of the meaning and interpretation of works of art by art historians and conservators based on the joint investigation of the actual work and its technical dossier and the joint reading of contemporary documentary sources could carry both fields forward. Each professional brings a different body of core knowledge to the collaboration which can aid in the understanding of the significance of visible clues in the work, the reasons for certain components in a paint film, and the relevance of key phrases and concepts in the documentary sources. Art historians will be on firmer ground in visual diagnosis, and conservators can design treatments which are likely to be more sympathetic with original appearance. Both groups will have a stronger sense of the strengths and limitations of the knowledge in the complementary field to be able to insist on collaboration at crucial junctures of research.

1. Clear coating (penetrates into crack)
2. Original varnish + protein and unsaturated oils
3. Non-drying oil
4. Three layers of oil paint

Figure 6. Diagram of cross section from 'The Curfew Hour', courtesy Shelley Svoboda and Richard C. Wolbers.

Acknowledgements

The author wishes to thank art historians Wayne Craven, William Innes Homer, Patricia Leighten and Linda Merrill for their help with bibliographic source material and visual images, conservators Mark Aronson, Ruth Barach Cox and Irene Konefal for their help with access to information about paintings in other museums, and University of Delaware/Winterthur Art Conservation Program colleagues Wendy Samet and Richard Wolbers for analysis and interpretation of cross sections and Conservation Fellows Shelley Svoboda and Camilla Van Vooren for sharing the results of their research project on A.P. Ryder.

References

1. Dana, H W L, Allston at Harvard 1796-1800: Allston at Cambridgeport 1830-43. **Cambridge Historical Society Publications** 29 (1943) p 49.
2. Flagg, J B, **The Life and Letters of Washington Allston** (London: Richard Bentley and Son, 1893) pp 193-194.
3. Jones, E H, **Washington Allston's Painting Technique and his Place in the Coloristic Tradition,** unpublished typescript (Boston, Museum of Fine Arts, 1947) p 6 footnote 17.
4. Dunlap, W, **A History of the Rise and Progress of the Arts of Design in the United States** Vol. II (Boston: C. E. Goodspeed, 1918) p 306.
5. Leslie,C R, **Autobiographical Recollections**, Edited by Tom Taylor (Boston: Ticknor and Fields, 1860) p 22.
6. Dunlap, II p 306.
7. Flagg, p 187.
8. Gerdts, W H, Washington Allston and the German Romantic Classicists in Rome, **Art Quarterly** 32 (Summer 1969) p 184.
9. Johns, E, Washington Allston's Dead Man Revived, **Art Bulletin** 61 (March 1979) 70 footnote 79.
10. Treated by Mark Aronson, Conservation Fellow, 1988.
11. Aronson to Stoner, 12/23/88. The cross section of the red drapery was studied with fluorescent staining in collaboration with Richard Wolbers, Associate Professor of the University of Delaware/Winterthur Art Conservation Program; Aronson and Wolbers felt that the rough interface between the original varnish (which had an interactive zone with the original paint still present) and the later varnish suggested that varnish reduction had been carried out mechanically so there was little evidence of change of visual impact through solvent cleaning.
12. Morgan, J H, Nathaniel Jocelyn's Record of the Palettes of Gilbert Stuart and Washington Allston, **New-York Historical Society Quarterly Bulletin** (October, 1939) 131-134.
13. Sully, T, **Hints to Young Painters** (New York: Reinhold Publishing Corporation 1965) pp 32-35.
14. Flagg, pp 181-207.
15. Flagg, pp 242-243.
16. Johns, E, Washington Allston: Method, Imagination and Reality, **Winterthur Portfolio** 12 (1977) p 15.
17. Ibid.
18. Flagg, p 185-186.
19. Spencer, R, Whistler's First One-Man Exhibition, **The Documented Image: Visions in Art History,** (eds), Weisberg and Dixon (Syracuse: Syracuse University Press, 1987) pp 29-30.
20. Blackburn, H, A 'Symphony' in Pall Mall, **Pictorial World** (13 June 1874),quoted in Spencer 1987 pp 33-35.
21. Curry, D P, Whistler and Decoration, **Antiques Magazine** 126 (November 1984) p 1188.
22. Pennell, E R and J, **The Life of James McNeill Whistler** (Philadelphia: J B Lippincott Company, 1908) p 204.
23. Analyzed by Richard Wolbers, 1988.
24. David Park Curry, **James McNeill Whistler at the Freer Gallery of Art** (Wash., D.C.: Freer Gallery of Art, 1984), p. 94.
25. Winter, J, and FitzHugh, E W, Some Technical Notes on Whistler's Peacock Room, **Studies in Conservation** 30 (1985) p 151.
26. Ibid.
27. Whistler Letter L105, Glasgow Unviersity Library.
28. Pocock, T, **Chelsea Reach: The Brutal Friendship of Whistler and Walter Greaves** (London: Hodder and Stoughton, 1970) p 109. Greaves was referring to "Antwerp blue" in his disputes with Whistler, however, which has "stood" very well.
29. The author is collaborating with Wendy Samet and Richard Wolbers of the University of Delaware/Winterthur Art Conservation Program, W. Thomas Chase and Paul Jett of the Freer Technical Laboratory, and Linda Merrill, curator of American Art at the Freer, to examine and treat the Room.
30. Carried out by Richard Wolbers, 1988-90.
31. Ryder, A P, Paragraphs from the Studio of a Recluse, **Broadway Magazine** 14 (September 1905) pp 10-11.
32. Ibid.
33. Miller, K H, interview with Lloyd Goodrich, typescript, June 15, 1938, Lloyd Goodrich-Albert P Ryder Archive, University of Delaware Library, University of Delaware, Newark.
34. Homer, W I and Goodrich, L, **Albert P. Ryder: Painter of Dreams,** by Homer, W I, and Goodrich, L, (New York: Harry N Abrams, Inc, 1989) pp 134-5. Louise Fitzpatrick and Charles Melville Dewey, close friends of Ryder's, finished or otherwise altered paintings, apparently to approve their "salability," after the artist's death.
35. Hartmann, S, The Story of an American Painter, cited by Keck, S, in Albert P. Ryder: His Technical Procedures, **Albert P. Ryder: Painter of Dreams,** by Homer, W I, and Goodrich, L, pp 179-180.
36. The sections were taken by Delaware Art Conservation Fellow, Shelley Svoboda, and examined by her and Richard Wolbers. 2,7-dichlorofluorescein, .2% in ethanol, indicates the presence of unsaturated lipids. If the oil had dried, as would be expected particularly near the visible surface, these lipids would no longer be unsaturated.
37. Miller interview, cited above.
38. Sampling of these paintings was made possible by curator Dr. Doreen Bolger and the staff in the paintings conservation department.
39. A non-enzymatic reaction which gives food its color when aged; carbohydrates and proteins form a highly colored polymer, notes Richard Wolbers. For further information, he suggests **The Maillard Reaction in Foods and Nutrition** by G. R. Waller and M.S. Feather, American Chemical Society Symposium Series 215, Washington, D. C., 1983.
40. Homer, W I, and Goodrich, L, **Albert P. Ryder: Painter of Dreams,** (New York: Harry N Abrams, Inc, 1989) p 117.
41. Lewis, A, Frederic Newlin Price and the Problem of Ryder Forgeries, **Selections from the Lloyd Goodrich-Albert Pinkham Ryder Archive** (Newark, Del: Univ. of Del library, 1989) p 11.

GLUCK AND THE QUALITY OF ARTISTS' MATERIALS: THE SUEDE EFFECT

Christine Leback Sitwell

This symposium presents an interesting challenge as we are asked to consider the appearance of paintings in terms of our understanding of a particular artist or period of painting based on our experience as either art historians or conservators. This does not imply that we will have distinct and opposing views on the subject but rather that our perception of the appearance of paintings may be derived or influenced by different areas of study. Both disciplines must consider not only the artist's original intent in terms of his understanding and use of materials to create a particular visual appearance; but also the effect of any chemical or physical changes which may have occurred, thus altering its original appearance, and whether or not the artist anticipated these changes. Discussions related to the artist's intent may be influenced by our interpretation of artist's notebooks, letters and the writings of the artist's contemporaries as well as our subjective feelings and the varying fashionable perceptions of particular schools of artistic thought. The examination of artists colourmen's manuals and research notebooks as well as scientific analysis can provide valuable information regarding the various components of the paint and varnish layers, technological changes in their manufacture and the chemical and physical changes which occur, but the difficulty lies in the extrapolation of that information. For example, we know that certain pigments fade or change colour, oil mediums and resin varnishes darken but how do we use this information in our conservation treatments to recreate what we believe was the artist's original intent? How do we balance the information we have accumulated from historical documents and scientific research with our individual subjective feelings in light of what we believe the artist intended?

The purpose of this paper is to show the complex nature of this question in regard to 20th century oil painting materials by considering certain aspects of the archives of the British artist, Hannah Gluck (1895-1978).[1] I have chosen to concentrate on Gluck (she insisted on using her surname) because she was a traditional artist using a repetitive and documented painting technique which allows us to examine specific painting materials. In addition, she accumulated an enormous amount of information about the manufacture of painting materials so one is able to compare the technical and practical sides of the issue. Although she does not reflect the general trend or development of the 20th century artist's experimentation with incorporating a variety of materials within the paint layer, it would be more difficult to evaluate any changes in a painting by such artists as Jackson Pollock or Frank Stella as the incorporation of a variety of materials alters the behaviour and appearance of the paint layer to such an extent, that it is difficult to assess if the virgin paint layer has changed in any way.

As an artist, she gained recognition as a portrait and floral painter in the 1920's and 30's. However, by 1938 she began to notice changes in the nature and appearance of her painting materials. The changes were related to the priming of her commercially prepared canvases, the "sinking in" of certain paints and the "suede like" appearance of the paint layer. To understand the cause of these changes, she began a correspondence with Winsor and Newton which was to last until 1967 and to involve the other artists' colourmen firms of Rowney and Reeves as well as commercial oil and pigment manufacturers and technologists, art conservators, museum curators, representatives of art organisations, the British Standards Institution and other artists. The information which she accumulated from this lengthy correspondence and the numerous meetings and discussions she had with various individuals provides valuable information about the changes in the manufacture and production of artist's canvases and oil painting materials. In addition, it presents a fascinating insight into the discussions related to the appearance of paintings as the individuals involved were unable to agree about the composition of painting materials and their appearance.

Although Gluck's archives detail the various aspects of the manufacture and production of canvases, primings, pigments and oils, this paper will concentrate on pigments and oils as the paint manufacturing techniques were considered to be responsible for the changes in the appearance of the paint layer. As mentioned previously, Gluck was concerned about the sinking in of certain colours and the presence of what she termed "the suede effect". The suede effect was a difference in the tonal appearance of a colour which occurred when the brushstrokes were perpendicular to each other. In simplistic terms, it was similar to the visual effect of brushing suede in different directions. The first major disagreement among the various correspondents was whether or not the suede effect existed and, if it did, whether or not it was the result of Gluck's painting technique or the actual constituents of the paint. Initially, the artists' colourmen refused to accept the existence of the suede effect but contended that "the suede effect might exist in the sense that artists' paints were thixotropic in order to enable an artist to create impasto, and that a paint film of this nature might create thin corrugations on the surface which would influence the surface characteristics of the paint".[2] Gluck felt that the problem was caused by changes in the constituents and production method of the paint. She maintained that it was the result of changes in the processing of linseed oil, the reduction of pigment particle size, the method of dispersion in the oil and the incorporation of additives in the paint.

In order to understand the origin of the suede effect, we have to consider the types of linseed oil and pigments as well as changes in their manufacture. The processing of linseed oil as an industry was firmly established by the 18th century, but it was a rather elementary procedure which involved the grinding of the seed followed by the applications of pressure (crushing) in order to express the oil from the seed. This oil was referred to as "cold pressed" linseed oil. Prior to the 19th century, there are few references to the "tempering" or heating the seed prior to pressing. The application of heat and moisture had the advantage of increasing the yield of oil but at the same time increased the impurities or "foots" in the oil. In order to remove these impurities, the oil had to be "tanked" or allowed to stand so that the impurities would settle to the bottom. It was subsequently exposed to sunlight for long periods in order to bleach the oil and increase its viscosity.

By the beginning of the 19th century, hydraulic presses were introduced into the seed crushing industry and they generally incorporated steam kettles which subjected the seeds to higher temperatures. Hydraulic presses were more efficient in that the higher pressures and the increased heat in the tempering stage greatly increased the oil yields. This method produced a "hot pressed" oil, with a greater number of impurities, which had to be refined. This involved filtering, tanking and chemical treatment. In the twentieth century, this method was replaced by either the solvent extraction system or the expeller system. The former used solvents to extract the oil while the latter used a steel screw conveyor within a cylindrical barrel to expel the oil under very high pressure. Once again the problem of foots had to be eliminated by different refining techniques.

For Gluck, the crux of the matter was the existence of foots in modern linseed oils which were hot pressed rather than cold pressed. She believed that a traditional cold pressed oil would have a smaller percentage of foots than a hot pressed oil. The problem was whether or not artists' colourmen actually used cold or hot pressed linseed oil and when the change-over occurred. The artists' colourmen; Winsor and Newton, Rowney and Reeves, insisted that to their knowledge the use of cold pressed linseed oil in artist's materials had ceased prior to the 20th century and that they had only used refined expelled linseed oil (a hot pressed oil) since that date. However, there seems to be some confusion on

this point as there are references in artists' manuals to cold pressed linseed oil. One reference, "Painting Materials" by Gettens and Stout, states "artists' oils are generally obtained by cold expression".[3] Numerous chemical analyses were undertaken by Unilever, an industrial oil supplier, and the National Gallery of London to ascertain if it was possible to distinguish between cold pressed and hot pressed linseed oil on a chemcial basis. The results of their analyses showed that the differences in the percentages of impurities in either oil were too small to be of any significance in distinguishing the two oils. It was possible that the two oils might behave differently in a paint formulation on a purely rheological basis (flow characteristics) but that this would have to be determined by making paint samples and viewing them to see if a difference existed.

It was decided that prior to making the samples, it would be advantageous to consider the pigment with regard to pigment particle size, pigment to oil ratio and method of dispersion. It was felt that the pigment particle size might have some influence on the surface appearance of the paint. While the artist exploits the opacity and transparency of paints in order to obtain certain visual effects, the modern industrial pigment manufacturer is primarily interested in opacity. The reduction in pigment particle size increases opacity so modern manufacturers have concentrated on reducing the particle size. As most modern synthetic pigments are sieved, it is unusual to find coarse pigments - the finer pigments may form agglomerates but these may be broken down during the dispersion process. If they are not broken down, they tend to appear on the surface of the paint layer and this may cause a change in the surface appearance.

The pigment to oil ratio varies from pigment to pigment depending upon the oil absorption characteristic of the particular pigment. This influences the consistency of the paint. Modern artists' oil colours are formulated to a certain consistency which enables them to be tubed or packaged satisfactorily. This is achieved through the pigment to oil ratio as well as by the addition of various modifiers. In previous centuries, the consistency or "body" of a paint (consisting of oil and pigment only) was modified by the addition of either a boiled oil, an oil containing a drier, a stand oil or a sun-thickened oil. The artist could alter the flow characteristics and the appearance of the paint by using different oils.

The mixing of oil and pigment is called dispersion and is the process by which the pigment is "wetted" by the medium. Early methods of dispersion involved handgrinding the pigment and oil mixture on a marble slab. This method was superseded by mechanical dispersion which involved mixing the oil and pigment into a paste and then passing the mixture through a series of rollers. The degree of dispersion in handground paints was estimated at 20% whereas mechanically dispersed paints produced 80% dispersion. The modern dispersion methods in conjunction with the smaller pigment size could cause the pigments to agglomerate. As agglomeration is most noticeable on the surface of the paint layer, it might be another explanation of any change in the surface appearance.

As a result of these considerations, it was decided that the artists' colourmen would formulate a series of paint samples in different oil formulations which would be sent to six examiners who would assess their performance. In addition to Gluck, two artists and three conservators were selected as examiners. Each was asked to paint out samples in the vertical and horizontal direction as well as to paint a small still life. Paint samples were provided in unmarked tubes and the examiners were asked to provide their opinion in regard to the behaviour of the paints and whether or not the suede effect was present. The following pigments were selected - flake white, yellow ochre, light red, burnt umber, cobalt blue, ivory black, cadmium red and viridian. The pigments were selected on the basis of their differing pigment particle size and oil absorption ratios. They were prepared in the following oil formulations:

Series 1 - artists' oil colours as currently manufactured

Series 2 - Series 1 with the addition of stand oil

Series 3 - pigment and cold pressed linseed oil

Series 4 - Series 3 with the addition of stand oil

The conclusions of the examiners were fairly consistent. Although all four series had shown the suede effect, it was less noticeable in Series 2 and 4 because of the added medium but, as a result, the brushstrokes were not as crisp as in Series 1 and 3. Series 3 had obtained a higher rating in terms of appearance as two of the examiners noted that "there was a deep intensity of tonal value" and "the paint reflected the characteristics of both the oil and pigment".[4] During the discussion with the artists' colourmen, it became apparent that there were some basic misunderstandings in the formulation of the samples which made the results of the comparison unsatisfactory. Each colourmen had been allocated the same two colours for each series but there had been no attempt to standardise the pigment to oil ratios, the volume or viscosity of the stand oil and the method of dispersion. Although it was possible to compare identical colours within the four series, it was not possible to compare colours within the individual series.

Further discussions concerning the paint samples concentrated on the possibility of experimenting with different pigment particle sizes and the comparison of handground dispersion with mechanical ground dispersion methods. More sample tests were undertaken but the results were inconclusive as numerous factors appeared to influence the effectiveness of the dispersion method - these included the pigment size, the degree of mixing and the length of time the paint sample was exposed to the air during mixing (the viscosity of the paint increased as the length of the exposure time increased). In conclusion, the colourmen submitted a report which stated "the results we have obtained with these tests, coupled with those previously reported in connection with the comparison of cold and hot pressed linseed oil, provide an adequate explanation of the suede effect and indicate the futility of regarding paint pigment/oil mixtures as a superior variety of artists' colours. They demonstrate that some pigment oil pastes may exhibit practically no suede effect and yet be utterly unsatisfactory as a tube colour. There is no evidence to support the view that the suede effect is a fault which manufacturers can readily overcome by the use of coarsely ground pigments in combination with a particular type of linseed oil. Indeed, it must now be clear to everyone that properly ground mixtures of pigments and unpolymerized oils, having a consistency of artists' tube colours, will always exhibit the suede effect and that this property will tend to disappear if either polymerized oils are incorporated or produced artificially by leaving the colour on the slab in a thin layer for a period depending upon the nature of the pigment".[5]

With this report, the experimentation and interest in the formulation of a suede free paint eventually died a natural death. The artists' colourmen felt that they could not contribute any more time or information on the subject and the other participants had begun to lose interest. As an act of charity, the colourmen firm of Rowney produced, for Gluck, paints which were free of the suede effect but each colour was painstakingly prepared by either altering the dispersion method, incorporating additives or adjusting the pigment particle size. These paints were never offered commercially as the cost of making the paints on a large scale was prohibitive.

The significance or relevance of the suede effect with regard to the appearance of paintings is not diminished by the fact that the results were inconclusive. On the contrary, what appeared to be a rather insignificant problem experienced by one artist produced a wealth of information about paint manufacturing processes in the twentieth century. Instead of relying solely on documentary sources, as in the case of studying artists' materials of previous centuries, the discussions with the artists' colourmen revealed a considerable amount of information about their current materials and manufacturing methods as well as the difficulties they faced in obtaining traditional materials. By necessity, they had to obtain oils and pigments from larger industrial manufacturers whose interests were not always concerned with the very small market of artists' materials. The discussions also highlighted the fact that the formulation of a paint is highly complex and the alteration of any one of the constituents influences the behaviour or appearance of the paint. Although all the participants in these discussions were knowledgeable in their own particular field, whether as a manufacturer, conservator or artist, it was difficult to obtain a consensus in regard to the surface appearance of the paint as well as its behaviour during application.

The task which faces the art historian and the conservator in regard to the appearance of paintings of the 20th century is difficult because the pace of technological change is rapid; and the wide variety of materials which the artist may incorporate in his work may result in either physical or chemical changes within the painting which can not be readily identified as occurring because of one particular constituent. However, we do have the advantage that we can, at least, discuss our concerns with contemporary artists in order to record their views on the appearance of their works and also undertake photographic documentation to serve as a basis for future reference. Unfortunately, we will still be faced with the possibility that the painting's appearance may change.

References

1. Sitwell, Christine Leback, **The Dilemma of the Painter and Conservator in the Synthetic Age: the papers and correspondence of the artist, Gluck,** Elwick, Grover Aicken, Brighton, England, 1989.
2. Ibid, p 32.
3. Gettens, Rutherford J and Stout, George L. **Painting Materials,** Dover Publications Inc. New York, 1942.
4. Sitwell, op cit, pp 39-40.
5. Ibid, p 42-42.

RESTORING THE ENGLISH ICON: PORTRAITS BY WILLIAM LARKIN, 1610-1619.

Sarah Cove and Alan Cummings

"..relegated to backstairs and passages, darkened by varnish painted over, cut down to a smaller size, copied on canvas in the new manner and the originals thrown away or probably taken out into the courtyard and burnt. By the end of the 18th century the whole aesthetic of Elizabethan art was soutterly alien that a daughter of George III on seeing a Hilliard miniature could only exclaim in horror: 'Christ what a fright'. It has needed the revolution of aesthetic values effected by twentieth century abstractionism to make us understand the bizarre, lost loveliness, of the art of the court of Elizabeth and James I".[1]

Introduction

The paragraph above is quoted at length because it vividly illustrates the particular points to be made in this paper and the general issues with which this conference is concerned. Paintings are not made of inert materials which are immune to change. It is surprising how little the average visitor to a museum, gallery or country house appreciates that the pictures they see have substantially altered in structure and appearance since leaving the artist's studio. Conservators may be better qualified than art historians to identify and describe these physical changes. However, the training received by art historians should enable them to fully assess the significance of these alterations.

Physical change is not the only consideration. The way in which a work of art is perceived also depends on the context in which it is seen. A newly restored painting which appears gaudy when hanging next to a faded tapestry in its original setting, may look dull and lifeless to the same observer in a modern, brightly lit gallery.

Changes in taste also affect perception. The prevailing attitude towards a particular style or movement will vary with the social, economic and cultural *milieu*. The twentieth century "revolution of aesthetic values" has meant that previously neglected work has been given new status, sometimes even recognised as 'great art'. This has largely been the contribution of the art historian. The conservator may feel inadequate about making value judgements on the basis of style and content. Traditionally, it has been the art historian who has decided whether or not a painting is in itself worthy of a conservator's attention, and whether the changes that have taken place are of any consequence. Today, a joint approach is preferable with each discipline recognising the strengths and weaknesses of the other. As a result of such collaboration opinions regarding the quality, and sometimes even the attribution of paintings, may be radically altered.[2]

In the twenty one years since the Tate Gallery's 'The Elizabethan Image'[3] exhibition, art historical and technical research has accelerated the revival of interest in Tudor and Jacobean portraiture[4]. At the same time conservators and art historians have continued to address the problems of cleaning and restoration and how such paintings are to be presented to future generations. The aim of this paper is to illustrate this collaborative approach with reference to the on-going programme of conservation of the full-length portraits attributed to William Larkin (1610-1619) at Ranger's House, Blackheath.[5]

The English Icon

Before the sixteenth century there was little or no idea that a portrait should be other than an article of household furniture.

When, in 1537, Henry VIII commissioned Holbein to paint the Whitehall Palace wallpaintings the task was to "paint the surface with accuracy, losing none of the splendour of fur, brocade and jewel"[6] at the same time preserving the "power, magnificence and ruthlessness of the king"[7]. Holbein's portrait of Henry employed a pictorial formula that had already been used by Renaissance artists such as Titian to record the majesty of the European courts. His image of Henry is a consummate political icon. (Fig 1)

By the mid-sixteenth century patrons were eager to have their portraits painted 'in large' or in miniatures to decorate their newly built long galleries or their persons. As well as appealing to the painter's feeling for linear pattern, every feature of pose, costume and accoutrements had a symbolic purpose by "expressing rank in terms of dress, heraldry and inscription".[8]

Fig 1 Hans Holbein 'Henry VIII' c. 1536-37 2578 x 1371mm Black ink and watercolour on paper, laid on canvas. Cartoon for the Whitehall Palace Wall Paintings (now destroyed). A full-length copy in oil after Holbein is in the Walker Art Gallery, Liverpool. Courtesy of the National Portrait Gallery, London.

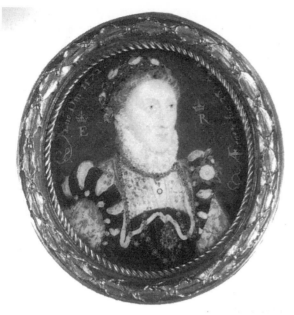

In 1572 the miniaturist Nicholas Hilliard was commissioned to paint the official portrait of the 'virgin queen' (Fig 2). The face of the ageing Elizabeth was not compatible with her image as a votive deity, so Hilliard depicted the mask-like features with no shadow, her identity revealed by the splendour of her costume. His distinctive style was taken from Holbein whose "manner of limning I have ever imitated and hold it for the best".[9] The flat arabesque design, brilliant colour, gold and silver leaf and the meticulous attention to every detail of features, jewellery, lace, and fabrics are reminiscent of the medieval manuscript illuminations from which many of the painting techniques were derived.[10]

The cult of royalist symbols was one of the most striking features of the Tudor age and accentuated these anti-naturalistic tendencies. The reproduction of Hilliard's ageless creation in the form of paintings, miniatures, medals and engravings ushered in a period of English "neo-gothicism" which lasted well into the reign of James I. The full-length portrait on canvas of 'Elizabeth I' at Hardwick Hall (Fig 3) is attributed to Hilliard's studio and dated c.1599.[11] It has an obvious similarity with the Ranger's House Larkins. In both we see the "full-blown costume piece, brilliant mosaics of jewel-like colour, bedizened icons enshrined in boxes with looped curtains, fringed and tasselled chairs with matting or turkey carpets on the floor".[12] In the portrait of Elizabeth, however, the face is a stock image, whereas the faces of Larkin's sitters are strikingly naturalistic, perched incongruously on 'cardboard cut-out' costumes.

The Larkin portraits at Ranger's House

The Suffolk Collection includes nine full-length oil paintings on canvas attributed to William Larkin by Roy Strong.[13] Seven of these are female portraits known as the Berkshire Marriage Set, dated c.1614. There are in addition the fine portraits of the 3rd and 4th Earls of Dorset. The portrait of the '3rd Earl' (Fig 4) was painted to commemorate the marriage of the Princess Elizabeth to the Prince Palatine in 1613. The '4th Earl' is a companion portrait presumed to be of the same date.[14] The paintings are likely to be those mentioned in the 1697 Inventory of Charlton Park, Wiltshire, built by Catharine Knevet, 1st Countess of Suffolk, whose portrait is included in the Berkshire Marriage Set. The paintings continued to hang in the Long gallery at Charlton until after the First World War when they were removed to Redlynch in Somerset. In 1974 descendants of the Countess of Suffolk gave the paintings to the Greater London Council.'

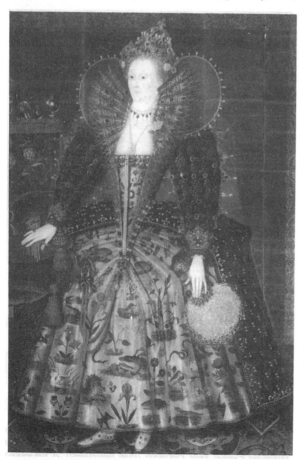

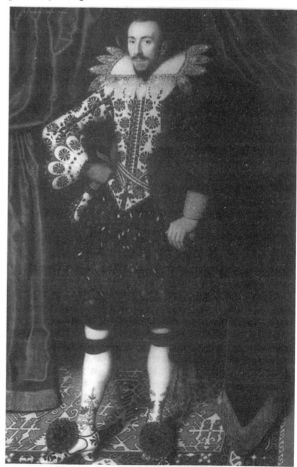

'Natural' change and past intervention

Canvas becomes weak and brittle in relatively few years. This, and the constant reaction of glue, oil and fabric to the damp and variable atmosphere of the country house, leads within decades to sagging and buckling. Paint and ground layers crack, lift and flake away from the support. At the same time fugitive pigments fade. Others change in hue. The varnish layer becomes discoloured and opaque giving a yellow veil over the whole composition.

Some time in the past the first stage in the cycle of major intervention will have taken place. A painting is 'lined' onto a new canvas and restretched. Though this sounds harmless enough the consequences are sometimes disastrous. Hot, heavy irons may have been used to flatten the old canvas onto the new. In the process, the wonderful original surface of a picture is forever lost. In Jacobean portraits the areas of lace, embroidery and metallic threads, meticulously depicted in tiny impasted dots, can be flattened and pressed into the surrounding areas. The combination of heat and moisture may cause the paint to blister or delaminate. Further damage may be done when the discoloured varnish layers are removed with abrasive or corrosive materials. A crude effort to repair the damaged areas with poorly matched colours inevitably follows. This cycle can be repeated many times in four hundred years. Sometimes a change in aesthetic values, for instance in the nineteenth century, has also inspired applications of tinted varnish and wholesale repainting of large areas, with more concern for the fashionable than the original style.

Though the Larkin portraits have avoided the ravages described by Roy Strong in the opening paragraph and remained at Charlton until seventy years ago, they exhibit all these symptoms of deterioration and unsophisticated intervention. Cupping and flaking of the paint is characteristic. There are numerous large and small areas of paint loss in all the portraits. They have all been lined, perhaps on several occasions, which has resulted in flattening and 'moating' of the impasto. Where an effort has been made to fill the losses with putty this is usually carelessly applied, covering large areas of intact original paint, with little attempt to recreate the surface texture.

The original use of fugitive or unstable pigment mixtures has led to striking examples of fading and colour change in the curtains, chairs and tablecloths. In the decorative details, for example the patterns on the carpets, fading of glazes and loss of colour in the blue and green areas makes them much less brightly coloured than was originally the case. Besides the extensive paint loss that has resulted from flaking there are also large areas which have suffered abrasion as a consequence of over-zealous cleaning and careless lining. Thin layers of dark and transparent paint are particularly susceptible. As a result the backgrounds of these portraits tend to have been damaged and much repainted. Other areas have probably been sanded to flatten the paint around damages.

To disguise the real condition of the pictures large areas have been repainted, often on more than one occasion. In general the repaint has none of the qualities of the original. Large brushes have been used to apply excessively smooth and buttery paint which is now seriously discoloured. Minute details of brocades, embroidery and lace have not been reconstructed with accuracy. Crisply painted curtain folds and slashed silk satin are blurred by loosely applied overpaint.

On top sits the discoloured and opaque varnish. The yellowed layer most affects the appearance of light areas, such as the white dresses of the Cecil Twins[15] (Fig 5), and cool colours such as lilac curtains. The opacity significantly alters the darks overall by reducing saturation and contrast. This particularly affects black drapery as in the '3rd Earl of Dorset'. Damage and layers of restoration are conveniently hidden beneath this deteriorated varnish. Unfortunately, the quality and character of the intact original paint are also lost to the average viewer.

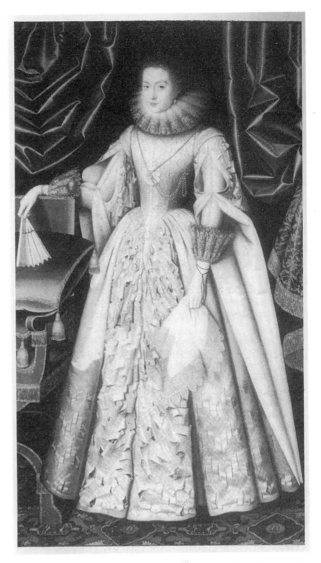

Fig 5 William Larkin 'Diana Cecil, Countess of Oxford' c.1615 2058 x 1200mm Oil on canvas. After conservation Courtesy of English Heritage. Photograph : Alan Cummings

The conservation policy

In 1978 the Greater London Council initiated a programme of conservation of the Larkins at Ranger's House. Its successor, English Heritage, has continued to support the venture.

It was a major decision on the part of the curatorial staff involved[16] to embark upon such a programme. Some of the portraits were in a fragile condition with areas of flaking paint. To deal with such specific problems is one thing. It is quite another to start a project which, to reach a satisfactory conclusion, will involve thousands of hours of work and considerable expense. The curators realised that cleaned paintings hanging next to dirty ones would be visually disturbing but that this temporary imbalance would have to be accepted. Once undertaken, it was also understood that to cancel the programme midway would be detrimental to the appearance of the set as a whole.

Initially two portraits were chosen for conservation: 'Lady Isabella Rich' and 'Lady Dorothy Cary'.[17] Each was given to a different conservator. In retrospect this decision was also a cause for concern. As there is no standard approach to conservation, paintings which hang together and are constantly compared should be restored by the same conservator whenever possible. Differences in the conservator's style and choice of materials may not be evident to the average viewer but they will be clearly visible on closer inspection or to the connoisseur. In the long term they also become more obvious due to the differential ageing of materials.

Having decided to go ahead with the project it was necessary to adopt or evolve a policy as to how the paintings should 'look' and a practical approach to achieve it. There are a wide variety of solutions. The 'archaeological' approach aims to methodically remove all discoloured varnish and non-original material. Damaged areas are simply subdued with an unobtrusive colour to 'reintegrate with the remaining original paint. Equally radical is the 'complete restoration' approach. After cleaning, areas of the painting considered to be too damaged, worn or faded are repainted wholesale. Neither of these extremes is usually adopted by the modern professional conservator but there are many intermediate courses of action.

There are also more subtle considerations. The skills of a conservator will improve over the years. Research into the materials and techniques of a particular artist's oeuvre can help the conservator both to understand the structure of a painting and to appreciate the artist's original intentions.[18] More prosaically, assistants with differing levels of ability may be employed for part of the treatment. Work may proceed at a relaxed pace or there may be pressure to meet a deadline or an estimate. These factors may seem trivial but it is not often appreciated that they can all affect the eventual appearance of a picture. The conservator responsible must ensure that they do so as little as possible.

The intention here is not to dwell on the general issues discussed above but to describe the approach adopted for the Larkin portraits. The original appearance can not be recovered or successfully restored. It is possible, however, to change the appearance of the pictures in a way which respects:
- the original requirements of Jacobean portraiture - the paintings should reflect the status, wealth and grandeur of the sitters.
- the aesthetic values of the period - the importance of pattern, colour and minute detail should be taken into consideration and re-established as far as possible.
- the craftsmanship of the artist, in a way that previous restoration has not.

Cleaning and restoration in practice

Discoloured and deteriorated varnish layers are removed entirely. Recent, soluble overpaint is removed with the varnish. However, in the case of these paintings thick layers of very old overpaint, often totally insoluble, remain. The process of revealing original paint for its own sake often receives automatic approval in the conservation field. In the Larkins the extent of overpaint and underlying damage is so serious that experience has shown this approach to be counter-productive. Without absolutely safe methods of removal it is often preferable to leave later paint in place. For example, large areas of the red curtains in the '3rd Earl of Dorset' were found to be crudely repainted.[19] However, the fragility of the original red glaze made removal of the overpaint unwise and little would have been achieved by 'excavating' the seriously damaged underlying paint. Insoluble accretions of discoloured varnish and dirt surrounding the impasted dots in the embroidered areas are very disturbing because they destroy the three-dimensional quality of the raised gold thread. Although it is very time-consuming they are mechanically removed.

For subsequent retouching and varnishing, synthetic media have been used. Providing they are properly formulated and skillfully employed their performance is comparable with traditional materials and they will survive longer without visible deterioration. In colour matching there is no attempt to use the same pigments as the artist. Modern synthetic artist's pigments are in general more permanent. A limited palette of opaque and transparent pigments can be used successfully to imitate seventeenth century colours and to efficiently cover large areas of damage.

For discrete losses of paint the term "inpainting" can genuinely be used where the paint applied by the conservator is strictly limited to the area of loss. The nature of the damage and the extent of overpaint in the Larkins, however, necessitates large areas of what is more accurately called "retouching". Even in this case, however, the aim is to minimise what is done, to make it accurate and sympathetic. In areas where pattern and detail are vital and the original design is clear, such as lace, embroidery and carpets, complete reconstruction is justified. A meticulous approach is essential in order to recreate the "sparkling" quality of the original. In areas where overpaint is not removed 'corrective' retouching is necessary. In general, no attempt is made to off-set the fading and discolouration of pigments, age craquelure and other qualities which paint 'naturally' acquires over four hundred years. It is, however, thought appropriate to suppress to an acceptable level loss of paint caused by flaking and the various changes brought about by previous intervention such as abrasion, mechanical damage and overpaint. To eradicate them entirely is not possible. For example, sometimes areas of design have been lost and the original intention is not clear. In such cases the area is 'reintegrated' without invention on the part of the conservator.

This approach does not entirely re-establish "pictorial unity" either within individual paintings or within the set as a whole. Controversies over cleaning and restoration have always emphasised the lack of harmony in paintings that are cleaned without compensating for the changes wrought by time upon artists' materials.[20] In the Larkins the intensity of colours and the relationship between them was originally of great importance, both to the artist and to the sitters. Indeed, in Elizabethan and Jacobean portraiture in general, colours such as lilac, green, gold and azure had symbolic as well as decorative significance.[21] Despite their importance, it is still felt that any attempt to fully re-establish the artist's colouristic intentions would be inappropriate.

It is not possible to fully illustrate these points without extensive reference to coloured images which unfortunately cannot be provided in this paper. However, it may be useful to mention two contrasting examples. A significant change has occured in the appearance of the curtains in three of the female portraits. In 'Lady Isabella Rich' cross-sections have shown that the mixture of the pigments smalt (blue) and red lake used in the curtains and tablecloth would have originally given a deeply saturated reddish purple. They now appear a pale lilac due to the discolouration of the blue smalt, fading of the red lake and discolouration of the oil medium.[22] An indication of the original colour is visible at the edges of the painting where the paint has been protected from light by the frame rebate.[23] After removal of the discoloured varnish and smeary overpaint, every attempt was made to preserve the crisp metallic appearance of the folds by careful inpainting of losses and abrasion. However, curator and conservator both agreed that to reglaze the entire area was not appropriate. This would logically have obliged the conservator to recolour faded or discoloured details all over the painting. Intervention on this scale to correct changes caused by 'natural' ageing would inevitably be approximate and subjective and therefore is considered to be unethical.

The curtains and chairs in the portraits of 'Anne' and 'Diana Cecil' have also changed considerably. On cleaning they were found to have suffered spectacular loss of the original green paint. Presumably the pigment[24] had deteriorated to such an extent that it was methodically removed (revealing a monochrome underpainting).[25] In consultation with the curators it was agreed that in this case the stripped areas should be restored to their original appearance despite the size of the area that had to be repainted. A transparent green, as close in hue as possible to the remaining original green pigment, was prepared using modern pigments and a synthetic resin medium. It was first applied to a masked area using large varnish brushes. Over this layer subtly modulated greens were air-brushed over highlights and shadows. The final effect was achieved using small brushes to break up the surface in imitation of 'natural' ageing by adding cracks and small blemishes.

Conclusion

Variations in approach to cleaning and restoration inevitably lead to ethical and aesthetic controversy. As there is no standard terminology to describe the appearance of paintings and what can be done to them, there is no mechanism for real communication. Terms such as 'partial' and 'selective' cleaning, 'overcleaning', 'patina', 'original paint' and 'artist's original intention' are expressions which may mean different things to different people. This frequently results in the pseudo-science, mystique and pretence which is even now associated with the conservation of paintings.

As there is no 'correct' appearance for paintings with a history of change and intervention stretching over four hundred years, no rigorous rules can be applied to their conservation. In the case of the Larkin portraits, there has been general agreement beween curator and conservator that the changes described as 'natural' are acceptable, whereas those arising from earlier intervention are not. However, in cleaning, there has been no methodical attempt to reveal original paint for its own sake. Though the 'artist's original intention' is a useful concept it cannot be consistently applied. The decisions as to what to do and what to leave undone have been made jointly by conservator and curator. In making these decisions, the Larkin portraits have been considered individually, as a set, and in the context in which they are displayed.

To date six of the nine portraits have been cleaned and restored, while one is undergoing conservation at present.[26] Reactions to the paintings have varied. Initially, when only two were cleaned and restored, visitors commented on how "bright" and "new" they looked. As has been shown they would have originally appeared much brighter when they left the artist's studio. Now that the majority of the paintings have been treated the two unrestored paintings look subdued and neglected. Visitors now comment on the "fabulous detail" and "vivid colour" that they have noticed for the first time since the paintings were hung at Ranger's House.[27]

Larkin's intention and his responsibility, was to convey the status and the character of his sitters. His tools were exquisite craftsmanship and rich colour. When the conservation programme is complete, the set of portraits at Ranger's House will reflect these values and truly justify their description as ".....the last, most brilliant instances of a style about to go into total eclipse".[28] Larkin died in 1619 and in the following year Van Dyck made his first visit to England.

Acknowledgements

We would like to thank the curators John Jacob, Jacob Simon, Anne French, Sheila O'Connell and lately Julius Bryant for their commitment to the conservation programme at Ranger's House. Their initial vision and tenacious support has ensured the survival of the project until now. We would also like to thank the National Portrait Gallery, the National Trust and English Heritage for permission to reproduce their paintings.

References

1 Strong R, **The English Icon: Elizabethan and Jacobean Portraiture**, Paul Mellon Foundation for British Art (1969) p 57
2 Before cleaning the portrait of 'Anne Cecil, Countess of Stamford' from The Suffolk Collection at Ranger's House, Blackheath, was thought to be of inferior quality to its companion portrait 'Diana Cecil, Countess of Oxford' After cleaning it was found that the portrait of Anne was the more severely damaged of the two. After restoration it can be seen that the portraits are identical in quality and it was the extent of the overpaint that made them initially appear dissimilar.
 - Jacob J and Simon J, **The Suffolk Collection, Cata logue of Paintings**, Greater London Council (Greater London Council, 1974) Nos 10 and 11,
 - Cummings AJ, unpublished Conservation Reports for 'Anne Cecil' and 'Diana Cecil', English Heritage, The Iveagh Bequest, Kenwood (1987)
3 Strong R, **The Elizabethan Image, Painting in England 1540-1620**, The Tate Gallery (1969)
4 - Edmond M, New Light on Jacobean Painters, **The Burlington Magazine**, CXVIII, No 875 (1976)
 - Edmond M., **Hilliard and Oliver: the lives and works of two great miniaturists**, Robert Hale, London (1983)
 - Strong R and Murrell VJ, **Artists of the Tudor Court: The Portrait Miniature Rediscovered**, Victoria & Albert Museum (1983)
 - Murrell VJ, **The Way Howe to Lymne**, V&A Publictions (1983)
 - Cove S, The Materials and Techniques of Painting attributed to William Larkin, 1610-1619, unpublished thesis for the Diploma in Conservation of Paintings, Courtauld Institute of Art (1985)
 - Woudhuysen-Keller R, McClure I, Thirkettle S, The Examination and Restoration of 'Henry, Prince of Wales on horseback' by Robert Peake, c.1610 The First Ten Years, **Hamilton Kerr Institute, Bulletin** No.1 (1988) p15
 - O'Connell S, **William Larkin and the 3rd Earl of Dorset: A Portrait in Focus**, Catalogue to the exhibition at Ranger's House, English Hertitage (1989)
5 Jacob J and Simon J, op cit
6 Piper D, **The English Face**, National Portrait Gallery Publications (1978) p 49
7 Ibid
8 Ibid
9 Hilliard N, **A Treatise Concerning the Arte of Limning**, Walpole Society, I, (1912) p 19
10 Murrell VJ, op cit
11 Girouard M, **Hardwick Hall, A History and a Guide**, The National Trust (1976) illustrated in colour p 79
12 Strong R, **The English Icon**, p 13
13 Jacob J and Simon J, op cit. Nos 3,4,8-14
14 Ibid, Nos 3 and 4
15 Cummings AJ, op cit
16 John Jacob, Curator, Jacob Simon, Mrs Anne French of the GLC, The Iveagh Bequest, Kenwood
17 Jacob J and Simon J, op cit. Nos 13 and 14
18 Cove S, op cit
19 Cummings AJ, unpublished Conservation Report on the '3rd Earl of Dorset' (1983), English Heritage, The Iveagh Bequest, Kenwood.
20 Hedley G, **On Humanism, aesthetics and the cleaning of paintings** Reprint of two lectures given at the Canadian Conservation Institute (1985)
21 Strong R, **The English Icon** p 34
22 Cove S, op cit, Technical Examination Report No RH/9, cross-section X2537
23 Ibid
24 Ibid, Technical Examination Report No RH/5, cross-sections X2489-92. Samples of the green pigment from the tacking edges of the curtains were examined by Karin Groen at the Hamilton Kerr Institute using laser microprobe and micro-chemical analysis. It was found to be a transparent copper green, possibly copper resinate.
25 Cummings AJ, Conservation Reports for 'Anne' and 'Diana Cecil'
26 Alan Cummings originally cleaned and restored 'Lady Isabella Rich '(No 14) in 1978. He has subsequently treated the 3rd and 4th Earls of Dorset (Nos 3,4) the Cecil Twins (Nos 10,11) and is currently working on 'Catherine Knevet, Countess of Suffolk' (No 8). Colour transparencies illustrating the points made in this paper, from the cleaning and restoration of all six paintings, will be used in the lecture.
27 Comments made after a lecture by Alan Cummings on the cleaning of the paintings to the Friends of Ranger's House, Summer 1988
28 Strong R, op cit, p 21.

DRYING CRACKLE IN EARLY AND MID EIGHTEENTH CENTURY BRITISH PAINTING

Rica Jones

Abstract

A technical study of British paintings from about 1700 to 1760 has established that more than half of them suffer from an unusual type of drying-crackle which, largely because of its small dimensional scale, has not been properly documented. It is called micro-cissing. After a brief explanation of drying crackle in general, the paper discusses micro-cissing in terms of its characteristic forms, its incidence in the work of the period and how it affects our appreciation of the paintings.

Introduction

British paintings from the last three decades of the eighteenth century and a good part of the nineteenth often exhibit a condition known as bitumen shrinkage, which is recognised by restorers and art historians alike as an inbuilt, irreversible problem for which mental compensation has to be made when viewing the picture. Much less well recognised is a different but equally prevalent form of shrinkage found in British paintings from the earlier part of the eighteenth century. A survey of fifty four paintings from between 1700 and 1760 produced thirty two with at least one instance of it and in some of them the whole picture was affected[1]. Yet in the few studies that have been made of cracking in paintings, it has been classified neither in a generic sense nor specifically in relation to this period. What then is this shrinkage, why does it occur and how does it affect our reading of the paintings?

An investigation of these questions is in progress at the Tate Gallery and results will be given during the lecture that accompanies this paper and in further publications. This paper deals with the observed form and occurrence of the problem and its effect on the artist's original intention, preceded by a summary explanation of shrinkage in general.

The nature and causes of drying-crackle

Both bitumen shrinkage and the much smaller form under discussion are examples of drying-cracks, which are known also as 'early', 'modern', 'immature', 'contraction' or 'ductile' cracks. Although found in a variety of patterns or networks, they are characterised by wavy, irregular edges, which are rounded in profile, and in most instances by a visible substrate at the bottom of each crack. This substrate is either a lower layer of paint which has remained intact or the ground or priming layer. Drying-cracks are quite distinct from age cracks, otherwise known as 'brittle' or 'mechanical' cracks, which penetrate both the paint and ground layers. They are sharp-edged and have no visible substrate[2]. In cross-section diagrams the difference is as follows:

It would be most unusual to find an eighteenth-century painting without age cracks, because they are largely the result of an embrittled structure failing to cope with externally induced forces, such as stress related to atmospheric change. Drying cracks, on the other hand, need not be general in either a painting or a period. This is because they are formed during the complex drying of the oil paint film, the composition of which varies not only at different periods but also within a single picture.

The drying of oil occurs in two phases, the first and simpler being the evaporation of the diluent or thinner, such as turpentine. The real drying, however, is a chemical process and it happens over a longer period as the paint absorbs oxygen from the air, thereby altering its chemical structure ('cross-linking') and becoming harder and more dense. Effectively it shrinks down, and whether it maintains a continuous film or develops drying-cracks during this loss of volume depends on a number of factors, most of them relating to its physical structure. If, for example, the ground layer is 'fat' (that is it contains as much or more oil as the paint on top of it), or if it has been polished smooth, or if it is not fully dry, then the paint may shrink into islands or blobs for simple lack of purchase on its surface. The same would be true of two or more layers of paint if the lower were fatter than the upper. Similarly a quick-drying layer (for example one which contained a resin as well as oil) laid on top of a slower-drying layer would develop shrinkage cracks. Yet other factors, such as the proportion of diluent to binding medium, the thickness of the paint or the addition of driers to the oil may all affect the paint's ability to form a continuous film. Finally the presence of a varnish, particularly if applied before the paint is sufficiently dry, adds to the complexity of the drying structure, since as it dries the varnish exerts a degree of traction on the layers beneath it.

Drying-crackle c 1700-1760

The types of drying-crackle found in the paintings of the period are illustrated in Figs 3 to 7, which show the surface of the picture viewed through a binocular microscope. For Figs 3 to 6 the magnification was x15 and the actual size of the area depicted is 2mm x 5mm. In Fig 7 the magnification was x40 and the surface area 1.20mm x 2mm.

The first thing to note is the microscopic size of the drying-cracks. Their average width is less than a third of a millimetre; indeed as discrete elements some of them are barely visible to the naked eye. Nevertheless in a network they can significantly distort the original appearance of the paint and the ways in which they do so are discussed later.

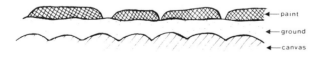

Fig. 1 Drying cracks

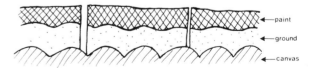

Fig. 2 Age cracks

Fig. 3 Drying-cracks and islands of dark paint in the curtain behind the figure in Hogarth's 'Archbishop Herring' (Tate Gallery T01971). Photographed at x15 mag. Reproduced at x33 mag.

Fig. 6 Craters containing varnish residues from the white cap of the woman in the top left of Hogarth's 'Heads of Servants'. The craters are found mainly in the furrows of the brushstrokes. Photographed at x15 mag. Reproduced at x33 mag.

Fig. 4 A very fine network of drying-cracks in Hogarth's 'Heads of Servants' (Tate Gallery N01374), the area being a shadow under the collar of the woman in the top left corner. The sharp branching line is age cracking. Photographed at x15 mag. Reproduced at x33 mag.

Fig. 7 Tiny craters in white paint from Ramsay's 'Portrait of Anne Bayne' c. 1740 National Galleries of Scotland, Edinburgh. They occur in the furrows of the brushstrokes. The sharp line is an age crack. Photographed at x40 mag. Reproduced at x88 mag.

The second characteristic of this drying defect is the different behaviour of light and dark areas. Figs 3, 4 and 5 represent dark or medium dark areas. As a general rule dark pigments from this period require more oil than light-coloured ones to make a workable paint, and the resulting film is thinner and weaker than one containing a high proportion of pigment. The dark areas contract into islands of paint each separated by a lighter-coloured crack aperture (lighter because it is the ground which is visible and in this period grounds are almost always shades of pale grey, buff or cream). In contrast the stronger, light-coloured paint can resist a complete breaking-up of the film. Instead it develops limited and very small networks of sharp, circular cracks, within which the paint usually contracts to form tiny craters (Figs 6 & 7). These craters originate in and usually remain confined to the furrows made by the brush or the hollows made by the canvas weave. Sometimes but less frequently they extend to the rest of the film. Departing from the general rule, the cracks surrounding each crater do not always penetrate the whole thickness of the paint. As a result the substrate is not necessarily visible, though the crack is often emphasised by a build-up of dirt and varnish within its

Fig. 5 Shrunken dark grey paint from the jacket of the man in the centre of Hogarth's 'Heads of Servants'. Photographed at x15 mag. Reproduced at x33 mag.

aperture, and each tiny crater often contains a pool of discoloured varnish. An industrial paint manual defines these two forms of drying-deformation under one term, cissing: "...the partial creeping back or contraction of the wet paint into 'beads', craters (usually with raised rims), islands or pinholes whereby the substrate becomes visible"[3]. Perhaps this microscopic version might be termed micro-cissing.

When and where micro-cissing occurs

As mentioned above, over half the examined paintings from this period suffered from micro-cissing. It is particularly prevalent in paintings done between about 1730 and 1755.

Painters whose work or some of whose works exhibit micro-cissing are as follows: Beare; Devis; Gainsborough (Sudbury - Ipswich period); Gravelot (very slight in glaze work and pentimenti); Hayman (very slight in thick light tones only); Haytley (one whole picture affected); Highmore (thick lights and some flesh tones); Hoare; Hogarth (more than half the examined pictures); Hudson (some lights and dark passages. Mid-tones unaffected); Mercier (very slight); Nebot; Penny; Ramsay (very slight in light passages of flesh); Scott; Vanderbank (very slight); Wale; Wright of Derby (in early work only); Zoffany (only very slight).

Painters whose examined work did not exhibit micro-cissing are: Amiconi; Angellis; Chéron; Kneller; Latham; Richardson; Slaughter; Thornhill; Van Heemskirk.

It is almost exclusively a British phenomenon. As far as the author has been able to ascertain it does not occur in anything but very isolated patches in paintings by British artists from the seventeenth century and it seems not to be a problem in pictures by their contemporaries from Europe, whether painted here or abroad. In the eighteenth century it seems to be absent from the work of continental artists who remained on their native soil; those who came to England, on the other hand, make interesting study. Mercier's early British work, for example, appears free from shrinkage, whereas his later paintings exhibit it slightly here and there, though compared to the work of some of his British contemporaries, it is negligable. With Angellis, however, who does not appear to have altered his materials and technique during his stay in England, there is no apparent difference in the condition of his British and continental work.

So this drying-crackle appears early in the eighteenth century, becomes very common in works from the third to the fifth decades and then, round about the seventeen-sixties, it seems to disappear as suddenly as it developed, being replaced by other forms of drying-crackle such as the bitumen shrinkage mentioned above or by fine shrinkage lines on a much larger network, as in some of Gainsborough's later work.

The effect of micro-cissing on the appearance of the painting

How then does a microscopic distortion affect our viewing of the painting? Is it possible that something so hard to discern as an intrinsic element can have a significant effect on our viewing of the picture? The answer is yes, through subtle alterations of tones, hues, depth and clarity. For example, a dark area broken up with a fine network of light cracks looks lighter, and the resulting reduction of contrast between light and dark areas lessens the sense of depth in the picture. This effect may be worsened by loss or reduction of translucency in the darks, because the slightly shrunken paint reflects light in a different way from a continuous film. Hogarth's 'Archbishop Herring' (Tate Gallery T01971) is badly affected in these ways.

In mid-tones, including thin applications of sky paint, a network of cracks revealing the substrate can at normal viewing distance alter the intended hue and make the whole area appear thin. Very

bad shrinkage in the left hand sky of Gainsborough's 'Rev John Chafy playing the violoncello' (Tate Gallery T03895) makes it look much less vibrant than it would have originally, in tone, handling and by contrast with the lighter sky on the right.

In the lights, particularly when the micro-craters follow the furrows of the brushstrokes and trap old varnish in them, the effect of vigorous brushwork is reduced. Hogarth's 'Heads of Servants' (Tate Gallery N01374) is an illustration of this. All the faces are affected. The sense of form is reduced, as can also be seen in 'Archbishop Herring's' hands. In small paintings, such as the conversation pieces of the period, facial expression may be distorted. Some of Gainsborough's 'portraits in little' from the Sudbury - Ipswich period suffer in this respect.

It is certain that this 'invisible' drying-crackle is partly to blame for the thin and sketchy appearance that has brought British early eighteenth-century painting a good deal of criticism. The reasons why they should be affected in this way, why the shrinkage takes the form it does and the ways in which it has been restored will be discussed in the accompanying lecture.

Acknowledgements

The author would like to thank the following people for their help with this project: Anna Southall, Roy Perry, Jennie Pilc, Anne Baxter, Samantha Hodge, Jo Crook, Joyce Townsend and Leslie Carlyle.

Notes

1. These paintings are mainly in the Tate Gallery and were examined during a technical survey by the author and Anna Southall. Others are from the National Portrait Gallery, Marble Hill House and the Yale Center for British Art at New Haven.

2. The following publications deal with the nature and cause of cracking:

 Keck, S, Mechanical alteration of the paint film, **Studies in Conservation**, 14 (1969) pp 9-30.

 Hamburg, H R, and Morgans, W M, (eds) **Hess's Paint Film Defects**, London (1979) pp 61-63 et passim.

 Mayer, R, **The Artist's Handbook**, London (1973) pp 172-173, 458-460.

 A very useful, unpublished work is: Hodge, S, **Cracking and Crack Networks in Paintings, a Survey**, a project for the Courtauld Institute of Art Conservation Diploma. I am grateful to Ms Hodge for some valuable suggestions.

3. Hamburg, op cit p 61.

 The origin of the word cissing is obscure. In nineteenth-century literature it occurs as 'cessing', as in J.B. Pyne's 'On the preservation of pictures painted in oil colours' in **The Art Journal**, January 1, 1864: "Repeat this process [of washing]...[until] the water, when even applied cold, will go over the surface without "cessing"."

 The Oxford English dictionary does not list the work under either spelling but Webster's does: "Cissing (origin unknown). The gathering of a wet film (as of varnish) into drops or streaks leaving parts of the surface bare or imperfectly covered." **(Webster's Third New International Dictionary**, Springfield 1971, vol 1 p 411.)

 Possible origins are the Latin 'cedo, cessi, cessum' meaning to retreat or yield, as in 'cessible' (easy to give way) or 'scindo, scisi, scissum', to tear, read, split or break, as in 'scissible' or 'scissile' (capable of being divided smoothly by a sharp edge.)

TURNER'S OIL PAINTINGS: CHANGES IN APPEARANCE

Joyce H Townsend

Abstract

The changes in appearance of Turner's oil paintings have been studied, as part of a project to investigate the materials and techniques which he used. Not all paintings show evidence of faded organic pigments, or loss of colour in newly-manufactured, unstable ones, though this is responsible for the greatest alterations when it does occur. Less widely-recognised factors, such as the darkening of the priming, sinking-in of paint, darkening of the paint medium and other optical changes, and better-known ones such as the effects of yellow varnish and the consequences of lining or past overcleaning make important contributions too. The effects and relative magnitudes of these factors will be discussed, and little-altered paintings will be identified.

Introduction

One of the aims of my research on the materials and techniques of J M W Turner, now in its third year, is to clarify the changes in appearance of Turner's oil paintings, by examining a range of works of varying degrees of finish and states of preservation. At the time of writing, about thirty-five paintings, mostly housed in the Clore Gallery for the Turner Bequest, at the Tate Gallery, London, have been examined, and work is continuing on the difficult problem of identifying the paint medium of each layer in heavily-glazed works. Brief overviews of the research project have been presented elsewhere[1,2] and a fairly complete summary of Turner's use of pigments, with a section on the findings for paint media to date, is being published[3].

Despite the changes attributable to impermanent materials or unsound techniques, the inevitable effects of the ageing of materials, and the intervention of restorers, many of Turner's paintings retain a force of expression which commands our attention today. An understanding of the alterations in their appearance should enhance our appreciation of his art, and shed some light on the "fragments" which form such an important component of the Turner bequest. Some of these remain untouched since Turner painted them, and their eventual cleaning may give us images which better reveal his techniques than his highly-finished works, displayed for decades, conserved many times, and intrinsically more subject to alteration that the unfinished works.

The appearance of all paintings in oil changes with time. Today, critical study of any aged painting ought to take into account the work's original appearance: however, it is impossible to recognise all areas of altered appearance without close examination of the work in question. A comparison with other works of similar age or history might also be necessary. Other authors[4] have discussed some false conclusions which have been drawn from the study of early Italian paintings, assumed not to have changed in appearance.

Ruskin bemoaned the sad and swift alteration in Turner's works, which he attributed to unsound technical methods, and implored Turner in print and possibly in person to produce even one painting which would survive unaltered for the edification of future generations. There is no record of Turner's response to Ruskin on this point, but various remarks attributed to him throughout his life testify to his lack of concern about alterations in his unfinished works, or in sketches which had served their purpose. Of 'Crossing the brook' (B&J[5] 130), an exhibited work, he said 'the only use of the thing is to recall the impression'[6]. Turner's friend Trimmer[7] noted that the paintings in Turner's studio were flaking severely, which had not worried Turner when it was pointed out to him. Trimmer wrote, 'During...1851..his gallery was in a most dilapidated state; the wet was running down some of his best pictures, through the leaks I had noted twenty years before and pointed out to him.'

Turner knew the colourman George Field [8,9] and Michael Faraday the physicist[10]. Field carried out systematic testing on the permanence of artists' materials, and sought ways of improving them. Faraday encouraged Turner to put aside canvases with new materials painted out, to expose similar materials to sunlight, and to observe their behaviour, even while he was using the new materials. Presumably, this fell on deaf ears. Turner himself used to say that he would be dead before the shortcomings of new materials and techniques would be discovered[11]. His use of pigments soon after their date of introduction[3] and his known improvisations in materials when travelling (such as the use of tobacco water to prepare brown-washed paper for the sketches LVIII now known as 'the Scottish pencils') support this assertion. It can be assumed that he would have used new combinations and ways of applying paint mediums[12] whenever they occurred to him. It would appear from Ruskin's accounts in "Modern Painters"[13] that Turner's paintings of the 1830's and 1840's were clearly changing for the worse within the artist's lifetime. It was at this period that Turner painted Academy works from a rudimentary state now described as a "colour beginning", during the Varnishing Days which immediately preceded the annual exhibition. Thus, they would have been wet and unvarnished, or else the varnish would still have been drying. On occasion he altered the tone of a whole sky (in 'Dido building Carthage' (B&J 131)), or added brightly-coloured details on these days. The latter was sometimes done in friendly rivalry, or to outshine a friend's work which was hung nearby, for example 'Bridge of Sighs, Canaletti painting' (B&J 349) in 1832 and 'Undine giving the Ring to Massaniello' (B&J 424) in 1846[5].

The changes in the appearance of Turner's finished oil paintings can be discussed under six causes. Working outwards from the support to the surface, they are:

- predictable changes in optical properties of the priming, paint, etc which are common to all works executed in these media, but which are responsible for quite noticeable effects in consequence of Turner's techniques;

- "sinking-in" after painting;

- loss of colour or alteration in colour of pigments in the surface layers, both in materials which were "new" in Turner's time and in longer-established ones;

- alterations and deterioration in the paint mediums specific to Turner's technique, which result in changed optical properties and the formation of obtrusive drying cracks in the paint layers;

- the obscuring effects of deteriorated (yellowed, browned or crazed) varnish, and the effects of past overcleaning which had the aim of removing such varnishes. Such effects are being discussed by other authors, in these preprints;

- alterations in surface texture, caused by unsympathetic lining treatments in the past.

Some paintings have altered less than most, whether through chance avoidance of the worst environmental conditions, or because they are less finished than exhibited works, and therefore simpler in construction, or because Turner employed unusually sound technical methods in their creation. Some of these will be discussed and illustrated.

Visual effects of the priming and support

There exists a great deal of information in the Tate's conservation files on the type of support and the colour of the priming for the three hundred-odd paintings in the Turner bequest. This information has been abstracted in the course of my research. Pigment

sampling may be limited sometimes by the excellent preservation of the image, even in Turner's works, but it is always possible to take a representative sample of priming from one edge or another. This enables a clear picture of Turner's use of supports and primings to emerge.

Particularly in his youth, Turner used a variety of supports for sketches and even for exhibited works: medium-weight canvas, generally loosely-woven and primed either commercially or by his father; very loosely-woven canvas primed by his father; panels prepared by a colourman; and pieces of previously-painted and varnished panel from furniture or wall-panelling, either subsequently primed in the studio or even used unprimed. A few later paintings are on panel or coarse canvas, but for the bulk of those painted after his father's death in 1829 he purchased canvases, already primed, stretched, and fitted with a backing canvas. Those with a backing canvas (a primed canvas glued to the back of the stretcher) were bought from Brown of 163 High Holborn, London, and their date of manufacture can be deduced from the stamp in many cases[14]. All such supports deteriorated quite rapidly, and many were lined in the nineteenth century. A few others were supplied by J Sherborn, sometime of 121 Oxford Street, about whom little is known[15]. Both companies styled themselves as 'artists' colourmen'. Of the works produced in his father's lifetime, the great majority have thin primings which were originally white, and which do not now conceal the texture of the canvas or the wood beneath. A very few of the earliest oils, dated to c1797 but not exhibited, such as his 'Self-portrait' (B&J 25) and 'Morning amongst the Coniston Fells, Northumberland' (B&J 5) have warm reddish grounds, and will be largely exempt from the colour changes discussed below.

The commercial primings consisted of lead white in linseed oil, usually applied over a lead white/chalk/linseed oil underlayer, on a glue-sized canvas. Therefore, they were white and opaque initially. It is exceptional to see a dirt layer over the priming when it is examined in cross-section, and in view of atmospheric pollution in the nineteenth century, the canvases must have been protected, at least before painting. Thornbury quotes[16] a contemporary description of shrouded canvases stored in Turner's dining-room. There was severe, subsequent darkening of the tacking margins, primed but never painted, on many canvases, for example 'Landscape composition' (B&J 257), 'A lady in Van Dyck costume' (B&J 444) and 'Seascape with a yacht' (B&J 274). This may have been due to the effects of hydrogen sulphide pollution[17], and some late nineteenth century authors wrote[17] that the same effect proceeded after painting, and resulted in a loss of luminosity whenever a lead white priming was employed.

Independently of this, the medium of oil-based primings will yellow (which is effectively a darkening in tone) when protected from the light. This is most obvious in white primings. Many of the conservation records now include the descriptions "buff" or "biscuit" to describe the colour of a darkened priming which in fact contains only white pigments.

Darkened primings covered by the thin, partly-transparent paint layers which Turner used, would make the surface much less luminous. These layers depended on a white substrate to confer luminosity and depth, especially in highly-glazed areas. A substrate which is in effect coloured would alter the tonality of the entire work, making it warmer and reducing contrasts everywhere. Such yellowing of the priming would have begun long before the lifetime of present viewers of Turner's works, and will be progressing very slowly now, if at all. The principal problem is, that we cannot reverse the effect or visualise clearly how strong it is. Paintings worked directly onto a varnished panel, as in the case of 'The garreteer's petition' (B&J 100), will also have suffered from the same problem, since the oil-and-resin varnishes used for furnishing or carriage panels would also turn very yellow when protected from light by later painting. The lightest passages, such as clouds, pale blue skies and pale yellow sunsets, and white waves or spray, would show the greatest changes, if they were thinly-painted, as happens in Turner's sketches and unfinished works. Darker passages such as vegetation and stormclouds will show this effect less; the net result is a reduction in contrast between such light and dark areas. Turner's paintings, once criticised for being too luminous, must now resemble more closely works by his contem-

poraries, since the latter may sometimes have used thicker primings which continue to conceal the colour of the support, while the same problem, the darkening of the priming, will have had less optical effect on their thicker, more opaque paint.

Some of the non-commercial primings presumably applied by Turner's father consist of lead white in egg. They have not darkened to any extent where they are covered by paint, and would have been white and crisp originally, as a modern recreation of a contemporary recipe[18] showed. Lead/oil primings would have looked less crisply white when new, since the oil medium would always have been slightly yellow. These primings are always thin, and would not have concealed completely the brown panel or the darkening, ageing canvas beneath, though this would have been a minor effect compared to some other colour changes in Turner's works. In a few cases, such as 'The field of Waterloo' (B&J 138), the topmost priming layer was toned with ochres to a pinkish buff, sometimes with linseed oil medium. The yellowing of the medium would be less noticeable in such a layer.

The egg-based primings were brittle, however, and probably soon lost adhesion with the canvas. Some contemporaries, and Turner himself, knew that his paintings were sensitive to water, and we know now that such primings would be very prone to crack when kept in damp or fluctuating environmental conditions. (Turner's house seemingly had both these failings, as Ruskin noted.) Some of the paintings with the worst history of flaking have this type of priming, and were glue-lined in the nineteenth century to stabilise them. The consequences for the appearance of such damaged paintings are worse than those caused by a priming of decreasing luminosity. This will be discussed later, under 'lining'.

When linseed oil paint is protected from the light the oil medium darkens considerably, as it does in primings. Its tendency to yellow more than other drying oils has been known for centuries. On present evidence, Turner used linseed oil exclusively. He does not appear to have used a less yellowing oil for the lighter colours. This gives rise to a more considerable change in appearance than the effect of a darkening ground, of course, for the paint layers form the image while reflection from the priming modifies it to a lesser degree. The effect will be more important in the paint layers in Turner's works since his paint tends to be rich in medium, whereas his commercially prepared primings are lean. The darkening can be reversed when a painting is exposed to light again[19], in contrast to light-induced yellowing of paint films, which cannot be reversed, and which has the potential to cause a greater change in appearance. This aspect will be discussed later.

Even cleaning of a substantial and protective dirt layer could lead to oil paint lightening towards its original tonality, once it is re-exposed to light. Attempts are currently being made at the Tate Gallery to detect this process in Turner oil sketches undergoing conservation, such as 'Seascape with a yacht?' (B&J 274).

The yellowing can be seen most clearly when the frame protects some of the painted surface from the light, as has happened to the sides of 'Waves breaking against the wind' (B&J 457). It is particularly noticeable where the paint of the waves is white or grey, and gives some insight into the colour change which can occur in a white priming. Were the painting to be reframed in a frame of more suitable size, the darkened paint would lighten to a considerable degree, perhaps completely[19].

Sinking-in of new paint

Some artists may have used semi-absorbent primings to prevent the oil medium of the paint being absorbed excessively by the priming soon after application. Many of Turner's primings, however, are absorbent. There is no evidence that his primings were ever sized with glue or coated with oil or varnish before paint was applied, whatever their composition, except in a few cases. The unusual composition of some of the primings (about a third of those analysed to date) which consist of thin layers of lead white (or occasionally chalk or gypsum) in whole egg, without oil, would provide a very absorbent surface for painting. These primings were used during his father's lifetime and slightly beyond, ie into the early 1830's. Turner's alternative, commercial, primings of

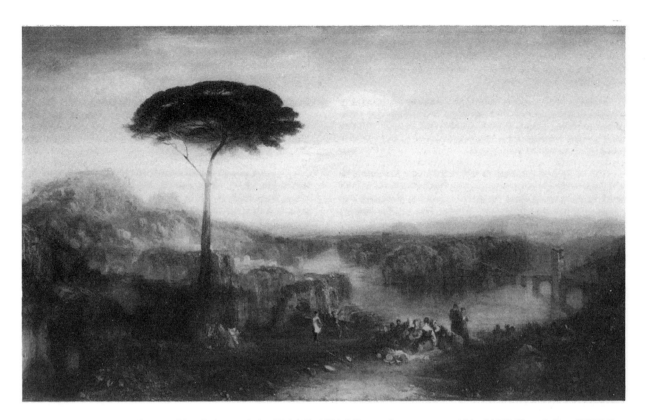

Fig 1 J M W Turner, 'Childe Harold's pilgrimage, Italy', B&J 342, 142 * 248 cm, oil on canvas, exhibited 1832 (Tate Gallery N00516)

lead white in linseed oil, with some chalk and glue size added, would have been slightly absorbent. Had it been Turner's habit to finish paintings in the studio well before they were exhibited, he might have repainted areas which had sunk into the priming before sending the works to the Academy, or might have modified his techniques to overcome the problem, but in fact the paintings displayed each year were still wet, and still subject to sinking in while on exhibition. As these drastic changes in the appearance of the exhibited paintings would have occurred over a short time, just a few days in fact, it is difficult for us now to imagine how the works looked when newly painted. There is no anecdotal evidence that works which were sold were repainted to compensate for sinking in before being sent on to the purchaser, though Turner or his father did varnish them first, at least in the earlier years[20]. However, the few exhibited works examined to date do show evidence of artist's retouchings, so he most likely did. 'The festival upon the opening of the vintage at Macon' (B&J 47), and 'Dido and Aeneas' (B&J 129) have been cited as examples[21,22] of paintings which sank badly when exhibited. In the former case, a contemporary judged the paint to have been applied to an unprimed canvas. The author has not had an opportunity to examine it. Unprimed canvases were certainly used for 'Jessica' (B&J 333), which was not entirely a serious composition, and for 'Judith with the head of Holofernes' (B&J 152, formerly known as 'The procuress?'), recently reattributed[23], which was a sketch. In the first two examples, paint may have sunk into earlier layers of paint too. A critic[5] discussing 'Keelmen heaving in coals by night' (B&J 360) wrote that the scene was too reminiscent of daylight when first displayed, but surmised that it would grow to resemble a night scene in 'a year or two more', so such effects would appear to have been understood and expected by Turner's contemporaries. Turner is known to have modified 'Dido and Aeneas' extensively during the Varnishing Days[5], and paint applied in the manner of a retouch is particularly prone to sinking-in.

Colour changes in pigments

More writers have remarked on loss of colour in Turner's oils than on any other shortcoming. Ruskin referred non-specifically to the widespread disappearance of whole areas of colour in the later paintings, and to loss of detail in the rest of the image. He cited 'The

Bay of Baiae' (B&J 230) as an example of browning and loss of blue and rose, in 1856, and wrote that 'The "Sun of Venice" going to sea' (B7J 402) had lost transparency, while the sky had become darkened and spotted. The paintings which he thought had suffered the most are the later Italian ones. He described at length the alterations in 'Childe Harold's pilgrimage, Italy' (B&J 342)[5]:

"It was, once quite the loveliest work of the second period, but is now a mere wreck. This 'Childe Harold' is a ghost only. What amount of change has passed upon it may be seen by examining the bridge over the river on the right. There either was, or was intended to be, a drawbridge or wooden bridge over the gaps between the two ruined piers. But either the intention of bridge was painted over, and has penetrated again through the disappearing upper colour; or (which I rather think) the realisation of bridge was once there, and is disappearing itself. Either way, the change is fatal, and there is hardly a single passage of colour throughout the cool tones of the picture which has not lost nearly as much. It would be less baneful if all the colours faded together amicably, but they are in a state of perpetual revolution; one staying as it was, and the others blackening or fading about it, and falling out with it, in irregular degrees, never more by any reparation to be reconciled.

(It would seem that these changes could be attributed to sinking-in of the paint as well as fading of pigment.) He said that 'Juliet and her Nurse' (B&J 141) lost colour soon after it was painted, as had the 'Walhalla'. The colours in 'Lucy, Countess of Carlisle...(B&J 338) were said to be "bright" and "extraordinary" in 1831 when it was exhibited{B&J}, yet they seem little brighter than in other paintings of that date now. Church[24] remarked that organic reds in the sunset of 'Chichester Canal' (B&J 285) had disappeared completely, leaving only yellow stains.

It is certainly true that some sunsets in both oil and watercolour have faded very considerably. One approach to the recognition of completely-faded colour could be to compare engravings after paintings with the original work. Turner reserved the right to touch proofs up to the final production stage however, and he is known[25] to have modified the final image on the plate, sometimes adding or omitting details in the process. The engravers, when they were reproducing works after his death, felt their reproductions to be the poorer without Turner's guidance: by implication they were more accurate than those supervised and modified by

Turner himself. Comparisons could be misleading in consequence in the case of watercolours, and probably oils as well. Engravings made after Turner's death might offer more accurate comparisons - but they may have recorded the appearance of already-faded works.

More information can be gained by a detailed examination of a representative number of oil paintings, and in particular those which are known to have altered, or which look altered. This has been a major criterion in the selection of works for examination. Some conclusions are given below.

The earliest oil paintings in fact include very few pigments which are subject to colour change, nor does their present tonality seem to leave much place for glazes consisting of organic pigments. For example, 'Dolbadern Castle' (B&J 12), the diploma work of 1802 has delicate yellow and pink clouds painted in stable pigments (lead white, Naples yellow, and various shades of ochre), while the face in Turner's 'Self-portrait' has been built up in scumbles of ochres[26], most likely overlain with glazes of the same pigments. Many of the inorganic pigments which he used in the early paintings are stable, for example ochres, Mars red[27], Mars orange[27], Naples yellow, ultramarine, azurite and lamp black. Others have occasionally been observed to change colour in paintings of such comparatively recent date as Turner's, for example vermilion[4,28,29], smalt[30] and orpiment[4]. No obvious instances of such changes have yet been seen in Turner's works, though they have been sought. Chrome yellow, used for large areas of most of Turner's paintings after 1814, had (and may still have) a bad reputation for blackening or moving towards a greenish tone, in the later nineteenth century. However, no trace of such alteration has been found as yet: any "greening" is in fact due to the optical effect of surface dirt overlying the pale yellow surface, often separated from it by a layer of varnish, and is clearly reversible.

Prussian blue, not quite as stable as the other inorganic pigments, does not appear to have faded. Indigo, used quite extensively by Turner for skies even after the introduction of the more stable cobalt blue, is more likely to have faded. In many watercolours this is very obvious, and not unexpected. Frequently it survives only as a brown wash on paper, where edges protected by mounts give a good indication of the loss. However no such loss of colour has been found in 'Aeneas and the Sibyl, Lake Avernus' (B&J 34) or 'River Scene with Cattle' (B&J 84), both of which have indigo in the sky, and small borders of paint protected by the frame to provide a comparison, or in other paintings which include indigo. Turner's tendency to use paint rich in medium, and the later application of natural resin varnishes which would have yellowed in a decade or so, thus reducing the amount of light reaching the paint, have both served to protect the indigo against fading.

The effects of light on organic pigments and media are very well documented in the scientific and industrial literature, but much less so in the conservation or art historical literature. Michalski[31] gives a brief, but comprehensive and recent, review of the damage caused to a range of materials, as reported in the conservation literature. For pigments in paintings, organic reds and yellows are generally the most prone to fading (they fade more rapidly than organic blues, in many cases).

Turner appears to have used rather few organic pigments in oil before the 1830's, since few can be recognised now, even at edges protected from light by a frame. Unless the uppermost paint layer is a very transparent, clear glaze, it would be expected to protect all the layers beneath to a considerable degree: thus, one would expect to see in cross-sections fugitive red organic pigments in the layers below the surface if they had been used, from which one could infer fading of the same pigment on the immediate surface. They are not in fact found in any layers. Madder and one other type of red can be identified in the earliest works, in various layers, but again there is no evidence for loss of colour. Organic yellows are not apparent now, but they may have faded completely, been obscured by other glaze layers which have darkened to the same tone, or turned brown during lining[32]. Or, they may have been cleaned off long ago because they were difficult to see and preserve. Certainly the residues of warm-toned glazes can be seen in the sky of the 'Walhalla'. It is not possible to guess their original shade, since they occur only in the middle of the image, and have all been exposed to light. The now-yellowed glazes in 'Chichester Canal' look so out of balance that one guesses them to have been pink or red, as Church reported.

The oil sketch 'Waves breaking against the wind' illustrates very well the fading of a red organic pigment used in the uppermost, ie surface, layer. As noted above, the frame has protected strips of paint at both sides. At the right edge, an area of pink corresponding to a sunset is visible. In the exposed portion of the painting, it is impossible to estimate its original extent by close visual examination. It can be traced on the surface with a stereo microscope, and was quite slight in extent. Interestingly, two glazes were present. The lower one consisted of Mars orange applied so thinly that it is not visible under normal viewing conditions, overlain with a similarly thin glaze of a reddish organic pigment with a wide range of particle sizes. On the exposed side, only the largest grains are still coloured since small particles of a dye or pigment always fade first[33]. Had Turner used a very fine-grained pigment, there might have been none left by now for

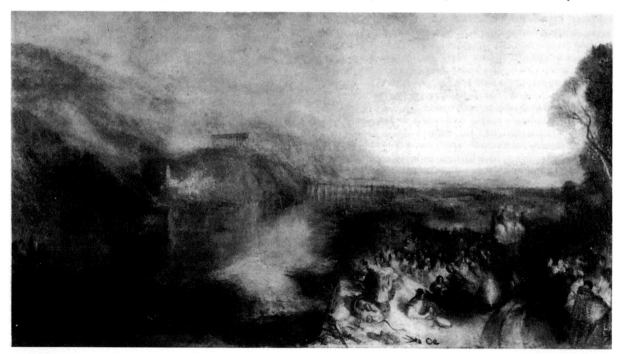

Fig 2. J M W Turner, 'The opening of the Wallhalla, 1842' (sic), B&J 401, 112.5 * 200.5 cm, oil on panel, exhibited 1843, (Tate Gallery N00533)

detection on the exposed side, without recourse to cross-sectional analysis. This is worth bearing in mind when one examines a painting whose sky appears out of balance, even though no trace of red or pink pigment can be seen in its apparently well-preserved surface. Thornbury[5] noted in 1862 that the sky of 'Rain, steam and speed' (B&J 409) 'has become sadly discoloured', which could be an instance of the rapid fading of fugitive pigments.

Most of Turner's glazes are very lightly pigmented. Red ones over the sun in sunsets are the exception, however. 'Sunset' (B&J 525) has such a deep red glaze, over red pigment. In such cases only, another optical effect described by Johnston-Feller[34] could occur. Glazes with pigment loading above a certain critical amount, which varies with the pigment type, painted over a light layer, can in fact show enhanced chroma (greater 'brightness') as light-induced degradation begins to take effect. Later, as more pigment is destroyed, they take on a pronounced yellow tone, then subsequently lose yellowness and all semblance of colour, unless the paint medium is darkening by then. The glaze in question in 'Sunset' has a rather intense shade and has certainly not faded to yellow as yet.

Where a pigment has changed in tone, or lost colour, its effect on the overall tonality is considerable, and would outweigh all other changes. Certainly among both early and unfinished works, such alterations are rare, and the ageing of the paint mediums used so frequently by Turner make a major contribution to the work's present appearance.

Ageing of the paint medium and surface cracking

As linseed oil dries fully and then ages, its refractive index increases, from about 1.48 to 1.57[35]. Organic pigments, which have a low refractive index (about 1.50) remain transparent in such a medium, as the refractive index of the oil matches theirs rather closely throughout the drying process. The traditional organic reds and yellows, and the newly-introduced ones which Turner used after the 1830's are of this type. However, in oils, he often added them to an abundance of lead white whose optical effects then predominate. In the case of lead white, areas of underpaint gradually become visible as the transparency of the white layer increases. Such *pentimenti* can be seen in small areas of Turner's seas on occasion, for example in 'Shipping by a breakwater' (B&J 33), and occur more commonly on highly-finished works.

Trees, foliage and indeed all of the foreground in Turner's landscapes are composed of thin, medium-rich layers, varied in pigment loading to give a range of opacities, and generally consisting of two to four pigments selected from ochres of up to five different shades, black, lead white, Mars colours, and on occasion Naples yellow, orpiment, azurite or terre verte. These 'glazes and scumbles' were applied over a 'colour beginning' which defined the main tones of the composition, in highly-diluted oil paint. Thus, brown areas of landscape have in effect a mid-brown underpainting, thin enough to reveal the texture of the priming, yet of moderate covering power. Skies have a light- to mid-blue blue underpainting, shading down to an area without underpainting where a yellow sunset would later be developed. In the first few years of oil painting, Turner used a fairly orderly method of construction, consisting of colour beginning, (linseed) oil glazes and finally a resinous glaze or two, followed at an appropriate time after painting by a resinous varnish. Towards the end of the decade 1800-09, he began to alternate, more or less, glaze-like layers either of moderate opacity or of great transparency, and to apply layers with oil, oil/resin and pure resin in a less orderly fashion, to achieve a variety of colour effects over small sections of the composition. The superposition of layers of modified mediums over oil, sometimes with oil on top of these, is very characteristic of his technique in all the later finished paintings. After his death, many of his later works were varnished for the first time, while earlier works were given additional coats of varnish.

These modified oil layers, easily distinguishable in cross-section in ultraviolet light, are likely to have yellowed at least as much as the pure oil layers. Indeed, the high reflectance of the initially-white priming would have served to make light available to the lower layers as well as the upper layers, so that all layers had the opportunity to darken. Individual layers can now be seen *via* cross-sections to have a mid-brown tone in most cases, where presumably they would have been straw-coloured or even lighter when first painted. Thick darkened glazes affect the surface appearance in several ways: they obscure the brown, yellow and orange pigments within or underlying them, cause blue areas to look greener than they should, and green areas browner. In some cases the gradations between green/brown leaves and brown shadowed areas, always subtle, disappear completely, initially to the viewer at normal distance, and eventually even to the viewer equipped with a strong light or a stereo microscope too. The greatest alterations in Turner's paintings are often attributable to these effects.

Further to confuse the viewer, the complex sequence of modified and pure oil layers is very liable to crack during drying, and light scattered off a surface of close cracks (spaced by a few millimetres, often) reduces the saturation of the surface. As the surface layer will most likely have grown brown as well, the impression is of a lighter brown instead of the more intense, greener, original colour. There is scarcely an exhibited painting whose landscape could justly be described as green today.

However, it has been pointed out[36] that such landscapes were built up by Turner in terms of warm/cold and light/dark contrasts, which leaves no theoretical requirement for the use of pure green: it is difficult to judge just how green these landscapes may once have been, while it is obvious that discernable changes have taken place. Only those paintings in the Turner bequest which had light, vernal tones originally, such as 'Crossing the brook', appear today to have a truly green appearance. This painting was described by a contemporary critic, Sir George Beaumont, as having 'a pea-green insipidity'[5]. This indicates that the light tonality was intentional, and was not universally found in Turner's work at that time, rather than being due now to fortuitously good preservation. The trees in 'Aeneas and the Sibyl', 'The garden of the Hesperides' (B&J 57), 'The Bay of Baiae' and 'Childe Harold's pilgrimage', to name but a few, serve as illustrations of browned landscapes. They have lost a great deal of luminosity, and the darkening of the landscape has swallowed up details of colour and form where they include small-scale figures. For example, the figures in 'Dolbadern Castle' are disappearing altogether into a brown gloom. In addition, similar pigments and media were used for different areas in these paintings, where variations in the sequence and the opacity of the glaze-like layers gave subtle contrast to adjacent areas. Because they are built up from similar materials, areas which were once distinguishable tonally tend to move towards a common brown appearance as the medium turns brown with age.

Effects of varnish

The optical effect of a yellow varnish and a yellowed or now-brown glaze are identical. Since the varnish covers the paint surface, its effect is both all-pervasive and difficult to assess, since no comparison with a varnish-free area is available to the viewer. The loss of contrast between dark and light areas, and the reduced distinction among blue, blue/green and green tones (until they cannot be named accurately at all in some cases), due to such a varnish, are effects well known to conservators as they clean such paintings. The effect of the discoloured varnish on an uncleaned painting, or the difference which would be wrought by cleaning, are much more difficult to envisage before or after the cleaning, since we tend to perceive any figurative or naturalistic scene as having a credible tonality, until the objective evidence of a partially-cleaned painting convinces us otherwise. Very few of Turner's paintings have an original varnish now, and it would undoubtedly be very discoloured where it had survived, though many paintings have varnishes which are old enough to be severely discoloured.

The changes attributable to yellow varnish are reversible, in principle, by cleaning. Turner's paintings are particularly hazardous to clean though, since thin, subtle, warm-toned resinous glazes which would have been just visible when newly-applied, are so well concealed by varnish now that they could have been unrecognised, and cleaned off. Previous generations of restorers and no access to microscopes for surface examination, of course,

hence it was more difficult for them to seek such glazes. Turner's use of wax[37] added to linseed oil has rendered some such glazes soluble in White Spirit, which is a 'safe' solvent for most other paintings, and his tendency to apply highly-diluted oil paint which formed discontinuous, underbound films which are removable by abrasion, have both pre-disposed the paint surface to over-cleaning. We cannot always tell how much has been lost, and it may be more profitable to consider a well-preserved surface. For example, the flesh painting of the 'Lady in Van Dyck costume' consists of thin glazes and semi-opaque layers over a thicker base layer which was lighter and yellower than the desired tonality. These well-preserved glazing layers show an effect exploited by Turner from the 1830's onwards, which we now call simultaneous contrast. Thin scumbles of vermilion used for the lips and flesh modelling have been heightened with thin, localised scumbles of ultramarine in lead white, applied with one stroke of a small brush. A yellowed varnish would destroy this contrast, by making the blue appear more green. Such subtle effects could have been missed by early restorers, and removed, since the technique is generally visible only at closer-than-normal viewing distance. Many of Turner's works, restored in the nineteenth century, have been overcleaned. 'The Vision of Medea' (B&J 293) has three figures in the foreground whose flesh paint now consists of thick, uncoloured white paint only. Again, such loss of colour is more easily perceived in a figurative painting. Even so it can be difficult to decide whether a painting is unfinished or has been overcleaned. The faces of the two figures in 'Landscape: Christ and the woman of Samaria?' (B&J 433) illustrate the problem. The author has concluded after microscopical examination that they are as Turner left them, that is, unfinished.

Obvious foci in the composition, such as figures, the lightest area of a river, or a building, were sitting targets for selective cleaning, and some have become over-emphasised and turned into spurious highlights by the process. Comparison with works at different stages of completion such as 'Richmond Hill with girls carrying corn' (B&J 227) and 'View from Richmond Hill' T.B. CXCVII-B of 1820 (watercolour on paper), and conservators' more recent experience in cleaning river subjects such as the 'Walhalla' suggest that the brightest highlights of rivers were glazed very lightly if at all, and have therefore suffered less than we might assume at first.

Recent conservation[38] of the 'Walhalla', and analysis[38] of the grey modern varnish (an early polyvinyl acetate one applied in the 1930's, which had adsorbed dirt) has shown that the loss of simultaneous contrast (perceived as a confusing absence of depth in the scene) among pink, blue and yellow scumbles is equally serious when the varnish goes grey instead of yellowing in the more usual fashion. Removal of the varnish has restored legibility to the image, while revealing more extensive discoloured retouchings and more damaged and lost glazes than had been suspected initially.

Turner's sketches and non-exhibited works were kept in his studio, and were finally given to the nation as the Turner bequest after his will and various codicils had been disputed (see the paper by Vaughan). In this century, the sketches were unrolled after decades of neglect, and some were cleaned, glue-lined, varnished and framed. Those treated more recently were wax-lined but not varnished. Turner had not varnished such unfinished works, still less framed or permanently stretched them. These, and oil paintings on paper, give the best clues to the original appearance of Turner's unfinished works. 'Waves breaking against the wind' is a good example. Whites of different degrees of brilliancy can be discerned in spray and more solid masses of water; the delicate surface texture (the impasto is not as high as in most finished paintings) and numerous gradations of grey in sea and storm-clouds can be seen. The image is largely a tonal study, employing grey/yellow, ie cold/warm contrast in addition, balanced by a warm ochreous foreground and a now-faded pale blush of sunset on the upper right (as discussed earlier). The drying of highly-diluted paint in little droplets is very expressive for the spray and foam: in other paintings it might have been lost through abrasion during cleaning[39]. The same technique was used in 'Manby apparatus' (which will be discussed later) for the rope being fired at the distressed vessel: it renders very successfully the idea that the rope

is barely visible through the spray. As in other unfinished paintings of the 1830's, Turner used opaque and semi-opaque scumbles in 'Waves breaking against the wind' almost to the exclusion of glazes, so the cracking and discolouration associated with such glazed areas in other paintings is absent.

Effects of lining and impregnation of the canvas

'Sun setting over a lake' (illustrated in Vaughan's paper) has a deceptively similar surface appearance to 'Waves breaking against the wind', and is still free of varnish. However, the lake is difficult to discern, though originally it was more obvious: it was formed from a series of transparent glazes, and contrasted with more opaque areas of the surface. A very thorough wax impregnation of the paint (done to prevent it flaking entirely from the priming and canvas), in addition to wax/resin lining, has brought the glazed areas close in appearance to the opaque areas. Other adverse effects of such treatments have been discussed elsewhere[40].

The glue-linings carried out within a few decades of Turner's death, and well into the twentieth century, have led to the greatest changes in appearance. The changes to the surface, as discussed in this volume[41], include:

- flattening of the light-coloured impasted areas, which occur in all Turner's finished oils, into the paint or ground;

- the formation of "moats" where a "hill" of paint has been impressed till it is surrounded by a "valley"; retention of brushmarks does serve to indicate where impasto was, however;

- enhancement of the canvas texture, which might be further emphasised by a glossy varnish;

- occasional melting of discoloured varnish into such white impasto during the lining process, to give a flat expanse of white flecked with brown which obscures the brushmarks;

- occasional visible melting of one glaze into another, when Turner had added wax to the medium.

However not all the gentle gradations of surface texture, which we see now on every finished painting, and which have every appearance of being flattened, have altered greatly from the original. The 'Walhalla', painted on panel, includes substantial areas of a soft impasto which sagged after application. Had this painting been on canvas, and lined, the soft outlines to the impasto could have been misinterpreted as an effect of heat treatment.

There are further consequences of lining a painting which has a thin priming on a loosely-woven, darkened, now-brown, canvas support. The adhesive fills the interstices of the canvas, previously filled with air and priming, with a translucent, amber material which effectively darkens the priming, since less light is scattered from the lined support than before, so that it has a more saturated appearance. This effect is at least comparable to the effects of darkening of the priming: it has been measured on canvases lined for the first time[42], and was shown to produce visible changes in appearance in test samples where primed and painted canvases could be compared before and after lining[42].

Concluding remarks

Today one of the best-preserved of all Turner's oil paintings is 'Venice from the canale della Guidecca, chiesa Santa Maria della Salute' (B&J 384), exhibited in 1840. In 1893, it was considered to be in very poor condition, compared to the other four Turners which comprise the Sheepshanks bequest at the Victoria and Albert Museum, London. Reports state that the surface was yellowed and that the cracks over most of the surface were disfiguring to the image. In that year, a glass-fronted Simpson case[43] was built to enclose the painting, a vacuum was applied and the case was sealed. It has not been reopened since, though doubtless air has diffused in until the interior has reached atmospheric pressure. The painting has nonetheless been protected from dust, atmospheric pollutants, and the attentions of restorers, after the initial

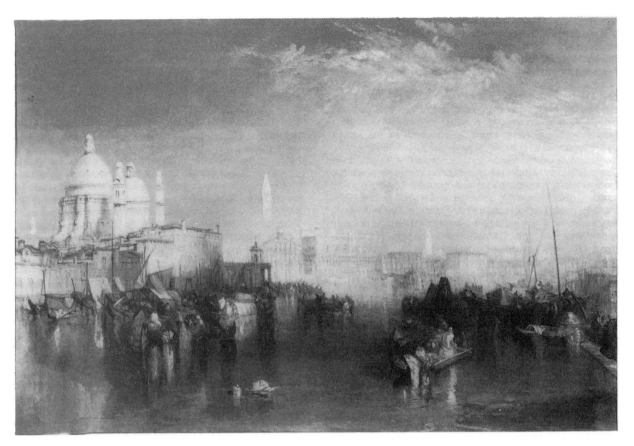

Fig 3 J M W Turner, 'Venice, from the Canale della Guidecca, Chiesa di S. Maria della Salute', B&J 384, 61 * 91.4 cm, oil on canvas, exhibited 1840 (reproduced courtesy of the Trustees of the Victoria and Albert Museum)

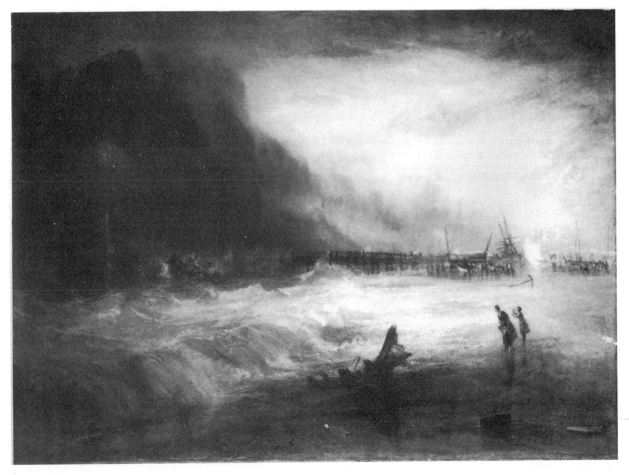

Fig 4 J M W Turner, 'Lifeboat and Manby Apparatus going off to a stranded vessel', B&J 336, 91.4 * 122 cm, oil on canvas, exhibited 1831 (reproduced courtesy of the Trustees of the Victoria and Albert Museum)

treatment and glue-lining which preceded the sealing of the case. The painting now appears to be in excellent condition for any nineteenth-century work, especially when one examines the other Sheepshanks paintings. 'Lifeboat and Manby apparatus going off to a stranded vessel...' (B&J 336) can be used as a comparison. 'Venice' has very shallow hairline cracks over the surface, visible only in white areas at normal viewing distance. The paint is scarcely deformed round the cracks, and is well-adhered to the canvas, so far as one can judge through glass. 'Manby apparatus', exhibited ten years earlier, has wider cracks made more obvious by the accumulation of a dark yellow varnish in them. Even without the varnish, one could not now imagine it glowing as 'Venice' does. The buildings in 'Venice' are of a dazzling whiteness which few modern viewers would associate with the areas of white pigment found in other, varnished, paintings by Turner. In these later paintings, ultraviolet fluorescence of the medium of the white paint, which includes wax[37], could be making a contribution to its bright appearance in daylight. The reflections of the water in the buildings can be seen as localised, pale yellow areas of glaze, easily distinguishable from the unglazed portions. The water is shot through with green, blue, and shadowy pinkish tones, whose gradations can be appreciated even at normal viewing distance. Although the water in 'Manby apparatus' is stormy, and is seen by night, it is very obvious that such delicate gradations of colour in that painting would be swamped by yellow varnish, darkening of the medium under the varnish, and decreased luminosity of the white priming. As a result of a preventive conservation measure, 'Venice' is now in excellent condition, and closer to its original appearance, than other paintings which were once considered to have survived better.

All the paintings exhibited in the Royal Academy, which is to say all the highly-finished works, are considerably altered in appearance. Ageing and darkening of the medium, and the formation of surface cracks, have caused the worst changes in appearance and tonality. It is necessary to examine unfinished paintings or oils on paper in order to see surfaces which are close to Turner's

original intentions. The unfinished paintings from the 1830's approach them the most closely, since scumbles predominate in the works of that decade. 'The arch of Constantine' (B&J 438) is another good illustration of such a little-altered painting. The foliage retains a green tonality and a slightly unsaturated appearance, and the sky, though it has fine cracks, does not have islands of paint outlined by dark varnish, as happens in many works with wider drying cracks. Interestingly, there is evidence from cross-sections for oiling-out layers over the ground and between some paint layers. This practice was recommended by some nineteenth century writers of artists' manuals[44] to make the later application of wet paint possible. Such layers are absent from the greater number of Turner's works which I have examined. Brush and palette knife work, and marks made by the end of the brush are clearly visible at close viewing distance. Twentieth century critics[45] have bemoaned the loss of excellent ideas under too much finish, but in this exceptional case, the idea has survived well. Sadly, in most other cases, Ruskin's remarks[46] on the alteration of Turner's paintings, though perhaps overstated at the time, are now all too apt:

"The fates by which Turner's later pictures perish are as various as they are cruel; and the greater number, whatever care be taken of them, fade into strange consumption and pallid shadowing of their former selves. Their effects were either attained by so light glazing of one colour over another, that the upper colour, in a year or two, sank entirely into its ground, and was seen no more; or else, by the stirring or kneading together of colours chemically discordant, which gathered into angry spots; or else, by laying on liquid tints with too much vehicle in them, which cracked as they dried; or solid tints, with too little vehicle in them, which dried into powder and fell off; or paintng the whole on an ill-prepared canvas, from which the picture peeled like the bark of a birch-tree; or using a wrong white, which turned black, or a wrong red, which turned grey, or a wrong yellow, which turned brown. But, one way or another, all but eight or ten of his later pictures have gone to pieces, or worse than pieces - ghosts, which are supposed to be representations of their living presence."

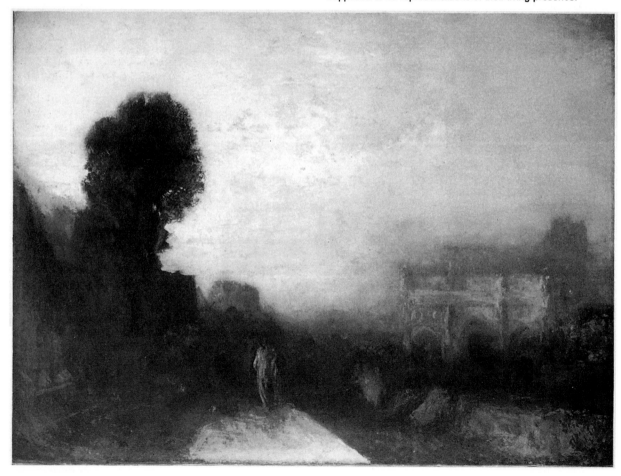

Fig 5 J M W Turner, 'The Arch of Constantine, Rome', B&J 438, 91 X 12 cm, oil sketch on canvas, c1835 (Tate Gallery N02066)

Acknowledgements

I am grateful to all members of the conservation department, to the staff of the Turner Collection at the Tate Gallery, and to Leslie Carlyle, Courtauld Institute of Art, for discussions during this project. The Leverhulme Trust has generously provided funding (administered by the Tate conservation department) for four years full-time study of the materials and techniques of J M W Turner, in the department.

References

1. Townsend, J H, 'Turner's materials and techniques', **Turner society news** 54 (1990) pp 5-7.
2. Townsend, J H, 'Turner research project', **Conservation news** 41 (1990) pp13-15.
3. Townsend, J H, 'Turner's painting materials: a preliminary discussion', **Turner studies** 10 (1990), in the press.
4. Villers, C and Hedley, G, 'Evaluating colour change: intention, interpretation and lighting', preprints, **Lighting**, UKIC/MA/ Group of Interpreters and Designers in Museums (1987) pp17-24.
5. Butlin, M and Joll, E, '**The paintings of J M W Turner**', Yale University Press, London and New Haven, 1st edn 1977, and 2nd edn 1985. These authors quote Ruskin's[13] and Thornbury's[6] remarks on specific paintings.
6. Thornbury, W, '**The life of J M W Turner R A**', Ward Lock reprints, 1970, quoted in[5]. Thornbury's book is not indexed, so I have included page numbers with each subsequent reference.
7. Thornbury, op cit p362 et seq.
8. Harley, R D, 'Field's manuscripts: early nineteenth century colour samples and fading tests', **Studies in conservation** 24 (1979) pp75-84.
9. Gage, J, **George Field and his circle: from Romanticism to the Pre-Raphaelite Brotherhood**, Fitzwilliam Museum, Cambridge, UK, 1989.
10. Leslie Carlyle has pointed out a reference to this in Jones, B, 'Life of Faraday', vol I, p419.
11. Thornbury op cit p124.
12. I am following the nineteenth century convention that paint 'media' are broad classes such as oil, tempera,..., whereas sub-divisions of type such as oil, oil modified with resin,.. are referred to as 'mediums'.
13. Cook, E T and Wedderburn, A (eds), '**Modern Painters**' I-V, '**The works of John Ruskin**' vols III-VII, Library Edition, George Allen, 1903.
14. Butlin, M, 'Turner's late unfinished oils. Some new evidence for their late date,' **Turner studies** 1 (2) (1981) pp43-5.
15. His business supplied some materials to Turner, as related in **Connoisseur** LXXXVIII (1931) p198.
16. Thornbury op cit p278.
17. Carlyle, L and Townsend, J H, 'An investigation of lead sulphide darkening of nineteenth century painting materials', preprints **Dirt and pictures separated**, UKIC (1990) pp40-43.
18. The recipe was provided by Leslie Carlyle from her research on nineteenth century artists' manuals, and was made up and applied as a priming by Tim Green of the Tate conservation department.
19. Levison, H R, 'Yellowing and bleaching of paint films', **Journal of the American institute for conservation** (1985) pp69-76.
20. Thornbury op cit pp116, 166, 175.
21. Lindsay, J, **Turner, the man and his art**, Granada Publishing, London (1985) pp40-41.
22. Finberg, A J, **The life of J M W Turner**, 2nd ed, Clarendon Press (1961) p210.
23. Wilton, A, 'The "Keepsake" convention: "Jessica" and some related pictures', **Turner studies** 9 (2) (1989) pp14-33.
24. Church, A H, **The chemistry of paints and painting**, Seeley, London (1901).
25. Lyles, A and Perkin, D, **Colour into line. Turner and the art of engraving**, Tate Gallery, London (1989).
26. From limited analysis by Dr Ashok Roy, National Gallery, London, and comparison with my analyses.
27. The term 'Mars' is used here to describe manufactured iron oxides, as discussed in a previous paper[3]. They are distinguishable from the natural ochres by colour (sometimes) and more clearly by their fine particle size. The orange and red ones used regularly by Turner are particularly bright.
28. Daniels, V, 'The blackening of vermilion', **Recent advances in the conservation and analysis of artifacts**, Institute of Archaeology (1987) pp280-282.
29. Feller, R L, 'Studies on the darkening of vermilion by light', **National Gallery of Art, Washington, Studies in the history of art** (1967) pp99-111.
30. Plesters, J, 'A preliminary note on the incidence of discolouration of smalt in oil media', **Studies in conservation** 14 (1969) pp62-74.
31. Michalski, S, 'Damage to museum objects by visible radiation (light) and ultraviolet radiation (UV)', preprints **Lighting op cit**[4] pp1-16.
32. One yellow, presumably organic, from 'Procession of boats with distant smoke, Venice' (B&J 505), turned out to be heat-sensitive, and turned brown when a pigment mount was being prepared on the hotplate. Nearly all pigments remain unaffected by this procedure.
33. It has been shown in one study of alizarin lake (the modern descendent of some of the organic reds used by Turner) that the finely-ground material with one-tenth the average particle diameter of the coarsely-ground material can fade in one-tenth of the time taken for the coarser material to lose all colour. Johnston-Feller, R M, **Journal of coatings technology** 58 (1986) pp33-50.
34. Johnston-Feller, R and Baillie, C, 'Analysis of the optics of paint glazes: fading', preprints **Science and technology in the service of conservation**, Brommelle, N S and Thomson, G (eds), IIC, (1982) pp180-185.
35. de la Rie, E R, **Stable varnishes for old master paintings**, doctoral thesis, University of Amsterdam (1988) p14.
36. Cox, W G D, 'The changing colour space of nineteenth century painters', **3rd congress of the International Colour Association at Rensselaar Polytechnic Institute** (1977). Published Adam Hilger (1978).
37. Ultraviolet microscopy, solubility of the paint surface in White Spirit, and temperature sensitivity of the paint medium indicate that wax is present. Analysis of specific waxes will be carried out in the future.
38. The painting has been treated by Stephen Hackney. Gas chromatographic analysis of the varnish was carried out by Raymond White of the National Gallery Scientific Department.
39. This is the type of surface film which has been described as watercolour in the past.
40. Berger, G A and Zeliger, H I, 'Detrimental and irreversible effects of wax impregnation of easel paintings', **ICOM-CC** (1975) 75/11/2/1-16.
41. See Stephen Hackney's paper in this volume.
42. Bomford, D and Staniforth, S, 'Wax-resin lining and colour change', **National Gallery technical bulletin** 5 (1981) pp58-65.
43. British patent no 6556, 1892.
44. Carlyle, L, 'British nineteenth century oil painting instruction books: a survey of their recommendations for vehicles, varnishes and materials of paint application', preprints, **Cleaning, retouching and coatings**, IIC (1990), in the press.
45. Gage, J, in **Turner 1775-1975**, Royal Academy of Arts, London (1975).
46. Quoted by Butlin and Joll[5] under 'Childe Harold's pilgrimage, Italy' (B7J 342).

THE ARTISTS ANTICIPATION OF CHANGE AS DISCUSSED IN BRITISH NINETEENTH CENTURY INSTRUCTION BOOKS ON OIL PAINTING

Leslie Carlyle

Abstract

Since *alla prima* painting has become the norm and we are consequently no longer conversant with the smallest details of the academic technique, the possibility that academic painters may have altered aspects of their technique to anticipate future changes in their materials has generally been overlooked. Although some nineteenth century artists may have favoured "the touch of time" which would mellow their work, according to most writers on British oil painting technique during the nineteenth century, future alterations were not welcomed. Rather, artists were offered practical advice on methods to circumvent changes such as ways to account for the yellowing of the medium or to allow for shifts in colour from the fading or darkening of pigments.

Introduction

"I would caution every young collector against the buying [of] dark and obscure pictures...It is not to be supposed, that these pictures came as they now appear, originally from the easel:no painter could be pleased with obscurity and indistinctness." (Anon.1782 102-104)

Indeed from the earliest days of the nineteenth century to the last, authors writing on oil painting technique, were uniformly concerned with the issue of change in the appearance of paintings. Efforts were consistently directed at avoiding the use of vehicles and pigments which were not considered durable, and where their use was held to be unavoidable, at methods to obviate their predictable decay.

One of the reasons why this subject dominated the literature is found in the repeated assertion that contemporary paintings were not enduring well,

"an evil report is gone abroad and propagated by the dealers in oil paintings...that the modern pictures will not stand- have not stood -but departed before their models: that there is some foundation to this assertion I am well aware of, having more than once lamented over designs..which will not be handed down to the next generation..."(Williams (1787) p.15)

Ruskin's well known remarks on the changes in Turner's works supported this view, "No picture of Turner's is seen in perfection a month after it is painted; and when all the colours get hard in a year or two, a painful deadness and opacity comes over them, the whites especially becoming lifeless."[1]. Other reports on the state of contemporary works often concentrated on the inability of modern paintings to survive in as good condition as the works of the "old masters". This view was not restricted to the early part of the century, nor even to Britain:

"It is only necessary to take a walk in the Louvre to see that the preservation of the picture is in direct ratio to its antiquity:... in approaching our own time the painting deteriorates more and more, those paintings which are in the worst state of preservation are not many years old."(Vibert (1892) p.16)

Causes of decay

The vehicle

Initially, the view was held that modern painters no longer had the same pigments available to them as the ancients, and that the knowledge of certain colours must have been "lost". This argument was effectively settled by research carried out on pigments excavated in Pompeii by Davy[2] who found the same materials as were used in modern colours. This left authors with the next logical assumption, that if it was not the pigments which were lost, it must be the vehicle. The search for the ideal vehicle was aided by another consideration aside from durability. Old masters' paintings were held to have qualities desired by contemporary artists, which were variously referred to as translucence, transparency, force, freshness, and enamel-like finish. Vehicles which would not cause decay in the colours and would provide an appearance similar to paintings from previous ages were sought after as the answer to all technical problems.

Various alternatives to oil were proposed: some involved reducing the oil content by the use of preparation layers on the canvas designed to absorb the oil from the paint (absorbent grounds); some by replacing the oil with other materials such as wax and gums (Miss Greenland's Grecian method[3]); and others by substituting varnish for oil (Kingstonian dry method) or by adding varnish to the oil medium. The latter became by far the most popular method and its use was supported by research into the old masters' methods such as that carried out by Merimee and Eastlake.

The role of oil

One of the reasons that early references to durability were directed to a reduction of the oil content in the paint was due to the observation that the oils used in painting grow dark with time. This was also held to occur when paintings were excluded from light and exposed to "foul air".

In fact, oils, in various degrees according to their nature and method of preparation, were coloured to begin with. Instruction books, particularly the earliest, advised artists to use the most coloured medium, linseed oil, with dark colours, reserving the less coloured oils, poppy and nut for light colours. According to George Field, one of the nineteenth century's foremost authorities on artists pigments, it was of no use to choose oils which were lighter initially, or even to bleach them prior to use because, "there is not any known process for preventing the discolourment.. sequent to its drying" (Field 1835 p.205).

Field reasoned that painters might anticipate this inevitable darkening of their vehicle by tinging it with "a fugitive transparent brown colour" before painting so that it "should posses that colour at the time of using to which it subsequently tends," this way, "the original disposition of the oil to acquire colour by age would be compensated by the disappearance of the brown tinge given to it, so as to preserve the original freshness of the painting" (p.205). Field then went on to point out that deliberately colouring the oil would not be necessary, since linseed oil boiled with litharge actually does acquire "such a fugitive colour" and diluted with oil of turpentine, "affords one of the more eligible vehicles for the painter"(p.205). Field also pointed out that the tendency of oil to grow darker is in proportion to their "natural power of drying"(p.201). Linseed oil was known to dry more quickly than poppy oil, and nut oil to be the slowest of the three. However, the advantage conferred by the less coloured oils was held to be offset by the weaker and less durable films formed by these oils in comparison with linseed oil.

Some sources felt that problems with discolouration caused by the oil could also be exacerbated by application techniques. One of the leading authors (Merimee) warned that colours should not be mixed too much on the palette with the brush as the oil will then rise to the surface "and the performance will turn relatively yellow in consequence"(1839 p.337)

Glazing and scumbling

This distrust of the vehicle led to repeated warnings by the authors against changes engendered by "excessive" glazing. Merimee noted that sometimes these glazed areas become altered in just a few years, and that "colourists of the second age" in anticipation of this, "only glazed those parts which, from their natural colour and tone, had nothing to fear from the bistre-like tint which they must acquire with time" (p.17). Like Field, Merimee suggested that the inevitable change, in this case described as the formation of a yellow tinge, should be taken into account by the artist. The first remedy was to use only a small amount of oil where "even a slight tinge of yellow would be a disadvantage", and the other was to "allow for the alteration which this yellow tone will produce in the original colour". Merimee gave an example, "if we wish to glaze a grey shadow upon white, it is better that the violet should predominate than the red, for a mixture of yellow and violet produces the true tint required" (p.90).

Another author found the deliberate use of a fugitive yellow pigment of some advantage: "Indian yellow gives very fine colour in mixture. It can be used occasionally in strong 'body', as though it fades it does not change its tint, and the yellowness of the medium in old pictures will greatly make up for its deficiency in depth" (Ellis 1887 p.55-56).

Adjusting technical practices in anticipation of the changes in medium was perhaps more prevalent than one might have thought. In recommending a specific vehicle recipe, one author wrote that this mixture "never changes but for the better, and the use of it removes the necessity of allowing for the colours changing or getting lower in tone, which must be done in using the above mentioned megelps"(Cawse 1822 p.8). According to one source this advice had been adopted by Sir Martin Arthur Shee, president of the Royal Academy (P.R.A. 1830-1850). The author wrote that Shee "observed to me that as colors were liable to change to a yellow or brown hue, due allowance should be made for this in the first instance." The author added, "For the sake of durability, he thinks that glazing should be sparingly used" (Sully 1873 p.40).

Causes of darkening in the medium

That the darkening of the materials, often referred to as the effect of time or age, may also have involved the intervention of picture cleaners was recognised. One author, explained that the "forcible effect" due to the exaggeration of light and dark seen in the best old masters works, was due to the fact that while the lights tended to receive "the most attention from the cleaners of pictures," the shadows being more vulnerable, "and not so able to bear much cleaning and rubbing, &c., have without doubt been more frequently neglected..". However, despite the fact that this added "considerable brilliancy to the lighter parts of the painting", he continued,

"it cannot be recommended that the artist of the present day, particularly if using colours with much vehicle, should paint their shadows with all the power and depth of the older masters' works in the state in which we now have them, rather to leave something to the deepening of time." (Fielding 1839 p.5)

Light

Less prosaic reasons than "time" for the darkening of the medium were also cited. It was observed that paintings which were stored away from light and air had a tendency to grow dark. The popular story of Rubens instructing that his paintings be exposed to sun if the whites have grown yellow from being kept in the dark was often repeated[4]. The truth of this phenomenon was supported by first hand accounts and even by experimental evidence. Merimee described experiments where layers of oil, as well as copal and mastic resin on various substrates (white lead, glass, or white pottery) were stored both in the dark and where "the circulation of the air is confined", as well as in a light and airy situation. Merimee stated, "in a few years...the combined influence of the air and light retards very much the yellowish tendency of the oils and varnishes, and that copal varnish...preserves its original brightness

much longer than the others" (1839 p.91-92). This led Merimee to recommend that paintings be placed in well ventilated halls lighted from the north (p.227).

Some authors felt that restricting light and air to freshly painted works would encourage the development of an oily layer which under ordinary circumstances, "where the picture is constantly exposed to the light,...is bleached and dried up as it comes to the surface"(Holyoake 1879 p.40). The presence of this layer was held to be the source of the unsightly yellowing of freshly painted works which did not receive enough light. But fully dried films were also held to darken, by the action of the air, either by oxidation, or by the presence of pollutants.

Foul air

Merimee and other early writers did not distinguish between the effects of light and air in their explanations for the darkening of oil paintings. Later in the century, however, authors became concerned with the effects of air alone. The presence of high levels of "sulphuretted hydrogen" (hydrogen sulphide) due to the combustion of coal and gas for heating and lighting, as well as from open sewers, was held to result in a chemical reaction with lead compounds used in oil painting materials. This reaction product, lead sulphide, a brown to blackish coloured material, was thought to cause darkening at the surface of paintings (from the presence of lead driers in vehicle, or in the oil-varnish), and in the ground (due to the presence of lead based pigments and driers in the ground). Artists were advised to take measures to avoid discolouration due to this cause. The use of lead based driers in the preparation of the medium and in oil-varnishes was proscribed and manganese driers recommended instead. Whereas no other pigment offered the covering power and body of white lead, bright whites could still be ensured by covering white lead with a top-coat of zinc white which would not react to foul air. Artists were also advised to coat lead white oil grounds with a layer of zinc white to guarantee their continued whiteness. As well, as a final step against the influx of hydrogen sulphide from behind the painting, the back of the canvas was to be protected[5].

Only one source actually recommended measures to lessen the presence of pollutants in the air where paintings would be on display[6]. For the most part, it was left up to the artists to anticipate the possible effects of foul air and to alter their technical practices accordingly.

The role of varnish

Throughout the sources consulted, any clear medium used in oil painting could be referred to as a "varnish", including materials clearly intended as vehicles such as "megilp" or other proprietary mediums. Because of the lack of a clear distinction between the terms varnish and medium, it is often difficult to determine whether the discolouration of the final varnish layer was being distinguished from the darkening of the medium alone.

In observing changes in oil pictures by the old masters one author stated that the colours had changed: "the original greys having become green by the varnishes over them having turned yellow" (Day 1856 p.32). In this context "varnishes" could have referred to the glazes, or, as the term is used today, to a final varnish layer.

However, there is ample evidence that the discolouring effects of varnish alone were well understood by some authors. De Burtin (1845) wrote of a painter-picture cleaner who was also "the principle inspector of the..electoral gallery at Dresden":

"..he removed the varnish that had grown old and yellow upon them [the pictures] during half a century, [and] he took care in doing so to leave it remaining on the whitest and lightest part of the picture, which places thus became an ugly stain that shocked every person.."(p.292-293)

That the final varnish coat would be likely to discolour, and require removal was also well understood, and recommendations for final varnishing took this into account. Despite the dangers of

varnish removal, varnishing was looked upon as necessary, not only to even out the gloss and saturate the colours, but to protect the vulnerable paint surface from atmospheric pollution. The main concern was to find ways of protecting the glazes and delicate finishing touches immediately underneath when the varnish layer required removal.

One source recommended that six or more coats of copal varnish (a very hard resin) be applied to the surface "until it resembles a sheet of plate glass." Then the picture will be "tolerably safe from every attack of the cleaners, short of actual destruction" (Martel 1859 p.57).

Despite its obvious merits for protection, the aesthetic for thick high-gloss coating appears not to have been adopted as the more usual recommendation was, "do not allow the work to be varnished so that you can see your face in it as in a looking-glass"(Redgrave 1866 p.609)

Another solution, was to recommend two coats of varnish using two separate resins. This system of varnishing was described by Merimee (1839):

"the best way of preserving pictures would be to varnish them lightly with copal at first, and when this layer is perfectly dry, to lay over them a couch of mastic. In a few years this will become yellow or chilled, and then it may be removed. The copal varnish, being extremely hard, will not suffer by the removal of this covering, but will preserve the picture so well, that even the glazing cannot be endangered in the cleaning" (p.91-92)

This became a popular approach and was recommended repeatedly (eg. Field 1835 p.379, Ellis 1883 p.49).

Several attempts were made to introduce materials which would solve the varnishing problem altogether. Field developed a method for decolourising shellac in order to provide a clear hard varnish, that was thought to remain colourless. Another author, later in the century, recommended that the use of copal and amber resins would provide long-lasting varnishes. He noted that since so many supplies of these varnishes were not made with the authentic resins, he would superintend their commercial production (Muckley 1882 p.45). Finally near the end of the century an alternative resin was proposed which would provide a colourless varnish removable in such mild solvents that the oil painting would not be at risk (Vibert 1892 p.95).

There were only two sources which mentioned that a painter may choose not to apply a final varnish. In 1861, one author described the fresco-like quality of an unvarnished sky, and remarked that, "Indeed, many of our best landscape painters..leave the bright lights of their skies and buildings unvarnished, using the varnish in finishing more as a glaze, from its giving a darker appearance, the unvarnished parts having more of the absorbent quality of fresco painting" (Burnet 1861 p.17-18). The only other reference was in 1898, "If you do not intend to varnish the picture, keep the colour as near as the pure tones as you can. The grayer the colour, the more "dead" or "flat" drying will make it look colourless" (Parkhurst p.63).

Changes due to pigments

The role of the artist

Although the gradual darkening of the resins and oils used in painting were considered inevitable, this was not held to be true for the colours. If only the correct pigments were used, changes in the colours would be largely avoidable. In the early part of the century, the onus for the use of non-durable pigments fell on the shoulders of the artist, with authors like Field maintaining that since colourmakers are no longer disreputable (as they might have been in the past): "the odium of employing bad materials attaches to the artist" (1835 p.xi). As Field stated in the preface to his book on pigments,

"The principle object of the present Treatise is,..by pointing out the true character and powers of colours of pigments, to enable the student to choose and employ judiciously those which are best adapted to his purpose" (p.x-xi).

Field's aim in presenting this information was to protect the artist's intentions, to "prevent the too frequent disappointment of his hopes and endeavors by a failure at the very foundation of his work" (p.x-xi).

Later in the century, the artist's responsibility to those who purchase his work was brought into the argument, "yet the reasonable demand on the part of the picture buyer for permanency in pictures necessitates a certain amount of chemical knowledge on the part of the artist concerning the materials he employs" (Standage 1886 p.7).

By the end of the century, the emphasis on providing durable pigments (and materials) had shifted somewhat to the artists' colourmen. Since Holman Hunt's well publicised paper, presented to the Society of Arts in 1880, on the poor quality of artists materials[7], authors focused their attention on helping artists identify permanent pigments and allowing for changes in those which were impermanent. Emphasis was placed on the adulteration of pigments and how the artist might determine their purity (viz. Standage see bibliography). This information had been automatically incorporated in eighteenth and early nineteenth century texts, but had received less direct attention in the middle years of the nineteenth century.

Anticipating change through technique

With regard to changes in the medium, artists were asked to observe examples of darkening in older pictures, and thereby to gauge this change in their own work - a demanding task in both imagination and perception. It can be argued that allowing for change in colours would have been significantly less difficult. The anticipation of future shifts and changes in colours was inherent in the very process of painting as practised throughout the century.

Instruction books prescribed a formula which usually involved three separate paintings of the subject where colours were gradually developed from the beginning through to the finishing. With this system, in the first painting or "dead colouring", the forms were laid in paler than intended; in the second painting, colours were strengthened; and in the third or last painting, also referred to as the "finishing", final glazes, scumbles and the last touches were applied. Colours were initially painted lighter than intended to allow for further enrichment in the following layers.

This advice is found regularly throughout the century, the painter being told to be "always working with a view to the finishing glaze, that is, keeping the tone of the whole some degrees higher than it is intended to be when finished" (Murray 1851 p.58). What this actually meant is made more explicit by another author who describes the first painting,

"The first time over in colour, flesh should be throughout cooler than required when finished, lighter and softer in the shades, markings (especially the pearly and blue greys) and the deep shadows, which are ultimately to be rich..the orange and red tints are to be all kept comparatively cool this first time over in colour, hence this stage is called, 'dead colour'" (Haynes 1887 p.20).

Painters were also warned to keep their colours lighter than intended not only in anticipation of the changes they may make, but also because as colours dried, there was a tendency for them to darken,

"It must be remembered that the colors drying as you proceed, the tone is no longer at the pitch you set it; so that in this gradual work you may be embarrassed to keep up the absolute harmony of the entire piece. It is one of those inconveniences...which your own observation will direct you to counterbalance or compensate" (Osborn 1845 p.236).

In conjunction with this, the colour of the paint below also influenced the top layers. This was felt to be the case particularly with whites: "It is the nature of whites to sink into whatever ground they are laid on" (Bardwell 1756 p.7). To obviate this, artists were advised to ensure either that they were painted over a white ground, "or, a considerable body of the colour should be laid on to allow for sinking in" (Compendium 1808 p.121). This was not only restricted to white paint:

"Remember too that every colour in drying will sink, and that it will partake, in proportion to its body, of the colour upon which it is laid; hence all tints, if not laid upon a light clear under-painting will change, and will, in drying lose a little of their power and brilliancy. It is necessary, therefore, that some allowance, in preparing tints, should be made for this change" (Edwards 1856 p.46-47).

Colours modifying each other

Artists would also be familiar with another subtle issue of colour change made apparent during the execution of a painting: that colours are modified by their juxtaposition. One author in defining the term "tone", appealed to the reader to remember, "one of the very first observations he must have made in his very first work, viz., of the change of appearance which took place, in a color already laid, on his placing another next to it: the color, tint, hue, or shade, was just the same, but its neighbor had either brought down or raised its tone" (Osborn 1845 p.394-395).

Artists, then, would have been familiar with viewing modifications in colour as the work itself progressed, not only by the addition of glazing and scumbling layers, but also by the influence of colours side by side. The phenomenon of juxtaposition of colours also had implications beyond the actual execution of the work. It would be necessary to take this into consideration for its final presentation:

"A tint, which, near, appears disjoined, and of one colour, may look of another at a distance, and to be confounded in the mass it belongs to. If you would have your work, therefore, to produce a good effect in the place where it is to hang, both the colour and the lights must be a little loaded.." (De Piles 1743 p.15-166).

Anticipation of change in pigments with time

"...the attention of the artist, in the course of his colouring, should be directed to the employment of such colours and pigments as are prone to adapt themselves in changing to the intended key of his colouring and the right effect of his picture" (Field 1835 p.50-51).

Since the very process of painting involved anticipating changes in the colours, the next step, to anticipate changes beyond the completion of the work, followed somewhat naturally. Observations that "time" created an increase in the transparency of colours in old paintings led to this advice for painting skies: "with heavy thunder, or other dense clouds, never let your blue sky be previously painted under the place where they are to go, for it will inevitably shine through in time" (Ellis, 1883 p.106).

Chemical changes in individual pigments were also to be considered, "I find by experience the greens will fade, and grow darker; therefore it is highly necessary to improve and force them, by exaggerating the lights, and making an allowance in using them so much the lighter" (Bardwell 1756 p.40 repeated in later versions eg. 1824 p.38).

As this quotation makes clear, certain pigments were recognized as unstable and likely to darken, fade, or shift from their original hue (eg. cobalt blue which was reported to shift towards green). Others, although considered stable on their own, were held to undergo chemical reaction in combination with other pigments: for example most vegetable-based (organic) pigments were thought to be destroyed by combination with white lead (Field 1835 p.68-70). Generally readers were warned away from using fugitive pigments, and from using others in mixtures thought to cause change. However, sometimes, advice was directed to ways of employing problem pigments by anticipating these changes.

As was seen with vehicles and mediums, occasionally a yellow colour may be introduced because of its fugitiveness,

"in shadows such vegetable colours as brown pink[6] are sometimes of advantage...if mixed with pigments which have a tendency to darken, they mitigate it very much. This last, indeed, is the most legitimate purpose to which semi-stable pigments whose colour fades on exposure can be put" (Salter, 1869 p.313).

In another example, umber was said to grow darker by time, but the author noted, "this is not a reason for setting it aside: this disadvantage may be obviated by mixing it with colours which grow paler by the action of light" (Merimee 1839 p.186). Alternatively, with colours which were said to darken, such as burnt sienna earth, the advice was to "employ rather less than the object on which we use it, or the part, would seem to require" (Osborn 1845 p.28).

It was noted that when semi-stable pigments were used in "full body", that is, where they were present in relatively large amounts, rather than diluted in a tint with another colour, "alteration made by time..is not so observable" (Salter 1869 p.313). This led to the advice that such colours (eg. carmine, or Prussian blue) could be relatively safely employed if they were used alone and in concentrated amounts (Salter p.134, Ellis 1883 p.62).

Another method for preserving the less permanent colours was to "lock" them up in varnish: "Yellow Lake..will not shew much of its beauty a hundred years hence, unless well secured by varnish"(Williams 1787 p.45). Similarly a coating of varnish was often recommended over lead white in oil to protect against blackening due to "sulphuretted hydrogen" (Merimee 1839 p.212). This advice was taken to its extreme late in the century by one author who recommended that all "semi-permanent" pigments be mixed with copal varnish as they are used, and that a thin coat of copal varnish should be placed over them when they are dry. He identified twenty-four separate pigments in this category (Muckley 1882 p.28,34).

Other sources attempted to give artists alternatives to changeable pigments. For example, although scarlet lake was not recommended, one source wrote, "Its colour can be very well imitated by Rose Madder, and a little Orange Cadmium, or Aureolin, all of which are stable" (Muckley 1882 p.31). Finally, questionable pigments could be relegated to unimportant positions, as one source wrote for chrome yellows:"They should be used in draperies, where the changing would not greatly matter" (Standage 1886 p.37).

Permanent pigments

Even pigments which did not change, but were celebrated for their immutability, had to be considered.

Of genuine ultramarine it was remarked,

"considering the permanency of its character,it will in general be necessary to break its brilliancy by some admixture, because, where used pure,the other colors that neighbor it changing in time their character, the harmony of the fresh picture will no longer be preserved, but a discordancy of tone be apparent" (Osborn 1845 p. 24-25).

Lighting conditions

The appearance of certain pigments was known to alter dramatically under some artificial light sources used to illuminate galleries. This was true of blues, and of cerulean blue in particular. However, cerulean blue's tendency to change in different lighting conditions was not necessarily seen as a disadvantage. One source wrote that under gas light,

"it has the distinctive property of appearing pure blue...This advantage, added to its permanence, has conferred a popularity upon coeruleum which its mere colour would scarcely have gained for it..A light and pleasing blue, with a greenish cast by day..It is in oil, and as a night colour, that coeruleum becomes of service.."(Salter 1869 p.191).

Just as cerulean blue was seen to advantage in these conditions, another writer stated that "A badly coloured picture will always look fairly well by gas or lamp light. This is a consequence of the rays of light from these sources being yellow. The effect is that of a yellow coat of varnish over the work" (Muckley 1882 p.85-86).

There are many indications that artists were well aware of the influence of different lighting conditions and did account for it in their work. One author listed colours designed to be used for painting under lamp light which had been suggested to him by the professor of painting at the Royal Academy, "Mr. Barry". The author reported that before adopting this palette he had "experienced some difficulties arising from my picture appearing very dirty in the flesh tints, when viewed by day-light", but after employing the colours listed for use under lamp light, he found that "the flesh tints which are painted with it have a very slight difference in appearance when seen by day-light" (Cawse 1822 p.19).

Another author warned that:

"The artist should bear in mind the destination of his picture when finished, and not be misguided by the striking effect of a too confined light in his darkened study, which will give to his shadows and all the darks of his picture an intensity that must greatly diminish when it is hung in a well lighted room or gallery"(Osborn 1845 p.128).

In portrait painting, the artist was advised to organise sittings at the same time each day so that the light would be the same, and the artist would not be misled into changing his colours to accommodate changes in lighting conditions (Hundertpfund 1849 p.83). Equally, artists were warned of the disappointing effects of bringing a painting executed out of doors inside, as a work painted on a bright day will "look much colder and greyer than it did out of doors" (Collier 1882 p.52-53). A well-lined painter's umbrella was recommended, and some artists were reported to have had a room constructed at the site so that they painted their outdoor scene through a window (Ellis 1883 p.2). Other authors were less pragmatic in their advice. One remarked, "You must learn to make allowance for that. You must learn by experience how much the colour will go down when you take it into the house" (Parkhurst 1898 p.402-403).

Discussion

The study of nineteenth century instruction books on oil painting reveals that the authors were advocating a number of techniques designed to anticipate changes in their materials. That painters may have deliberately made allowances for the yellowing of the medium, or for the shifting of hues has not been made a point of study, and yet the possibility of such practices has significant implications for the interpretation of these works as they are cleaned, and viewed.

Perhaps the lack of attention paid to this issue can be accounted for because of a change in oil painting technique which began to occur in the last half of the century and has continued to dominate in the twentieth.

As the taste for painting alla prima developed, and artists sought for immediate effect in their paintings, the anticipation of future changes to their work was no longer inherent in the very method of its execution.

In addition, as glazing and effects of tranparency gave way to matt unvarnished surfaces of solid colour, past lessons were no longer directly relevant. The break away from the academic style meant that there were no longer many examples illustrating how the artists intentions could be subverted by his materials. Nor was this concern for enduring effect in emulation of past achievement of the same relevance.

Now, our own lack of familiarity with the subtle interventions engendered by the academic technique leaves us less receptive to the argument that these painters may well have allowed for changes in their materials. That such ideas were discussed in the nineteenth century, and may have been incorporated into working pratice requires our attention, not only in cleaning these works, but in reconstructing the image as the artists intended.

References

1. Quoted in: Scott Taylor J, **Modes of Painting Described and Classified,...** London: Winsor & Newton Limited (1890).
2. "In a very interesting and important paper, written by Sir H. Davy, on the composition of certain pigments, then recently excavated at Pompeii, he proved, by analysis, that those of the mineral kingdom were chemically the same as the pigments now in use by the moderns; and as many of the paintings taken from the ruins, and also those which cannot be removed, bear a freshness and vividness of colour scarcely less so than when first executed, a question naturally forces itself upon the mind, as to how this durability was maintained? ..I cannot help thinking that it mainly depended upon the fitness of the vehicle employed and I much fear very little positive benefit can be expected until some improvement in the latter is effected." Bachhoffner, George H, **Chemistry as Applied to The Fine Arts,** London, J. Carpenter and Co. (1837) pp. xv-xvi.
3. Miss Greenland's "Grecian" encaustic method called for gum arabic, water, mastic resin, and white wax mixed with powdered pigment. Instructions for preparing Miss Greenland's encaustic medium, were first published in 'The Transactions of the Society Instituted at London for the Encouragement of Arts Manufactures, and Commerce', Vol.X (1792).They were transcribed in Hayter, C, **An Introduction to Perspective...** London (1825) p.289-298.
4. Rubens' letters were cited in Gullick and Timbs (1859) p.207 and Holyoake (1870) p.80-81.
5. A more complete discussion of this can be found in Carlyle, L and Townsend, J H, 'An investigation of lead sulphide darkening of nineteenth century painting materials' preprints **Dirt and Pictures Separated**, UKIC, (1990) pp.40-43.
6. "It has been stated that the destruction of the bindings of books in libraries lighted by gas is due to the slow action of sulphuric acid derived from its combustion. The employment of electric light in picture galleries, recommended..from purely optical considerations, is thus doubly advantageous." Scott Taylor Field's **Chromatography**..(1885) p.88.
7. Hunt, H, 'The present system of obtaining materials in use by artist painters, as compared with that of the old masters', **Journal of the Society of Arts,** April 23, (1880) pp.485-499.
8. Field wrote, "Brown Pink is a vegetal lake precipitated from the decoction of French berries, and dyeing woods, and is sometimes the residuum of the dyer's vat...It is of a fine rich transparent colour, rarely of a true brown; but being in general of an orange broken by green, it falls into the class of citrine colours, sometimes inclining to greeness, and sometimes toward the warmth of orange..." (1835 p.142).

Selected bibliography

Works referred to in the text.

Anon, **An Essay on Landscape Painting. With Remarks General and Critical, on the Different Schools and Masters, Ancient or Modern,** London, Printed for J Johnson, No.72, St Paul's Church-Yard (1782)

Bardwell, Thomas **The Practice of Painting and Perspective Made Easy..** London, Printed by S. Richardson; for the Author; and Sold by Him, at the Golden Lamp in Lower Brook-Street, Grosvenor-Square, 1st edition (1756)

Burnet, John **Landscape Painting in Oil Colours, Explained in Letters on the Theory and Practice of the Art, and Illustrated by Examples from the Several Schools** Re-edited with an Appendix, by Henry Murray, F.S.A. London, James S Virtue (1861)

Cawse, J **Introduction to the Art of Painting in Oil Colours. With plates, Explanatory of the Different Palettes Used in the Progress of Painting a Portrait or Landscape,** London, Printed for R Ackermann & Co, 101, Strand, by J Diggens, Saint Ann's Lane (1822)

Day, Charles William **The Art of Miniature Painting, Comprising Instructions Necessary for the Acquirement of that Art,** London, Winsor & Newton, (1856)

De Burtin, Francois Xavier **Treatise on the Knowledge Necessary to Amateurs in Pictures,** London, Longman, Brown, Green, and Longmans, Paternoster-Row. Edinburgh: A and C Black (original French edition 1808) (in English 1845)

Eastlake Sir Charles **Materials for a History of Oil Painting,** London, Longman, Brown, Green, and Longmans (1847)

Edwards, J **The Art of Landscape Painting in Oil Colours,** London, Winsor and Newton, 11th edition (1856)

Ellis, Tristram J **Sketching from Nature, A Handbook for Students and Amateurs,** London, Macmillan and Co, 1st edition (1883)

Field, George **Chromatography; or, A Treatise on Colours and Pigments, and of their Powers in Painting, &c,** London, Charles Tilt, Fleet Street. Sold by Booksellers, Print sellers and Artists' Colourmen,(1835)

Fielding, T H **On Painting in Oil and Water Colours, for Landscape and Portraits; including the Preparation of Colours, Vehicles, Oils, &c., Method of Painting in Wax, or Encaustic; also on the Chemical Properties and Permanency of colours, and on the best Methods of Cleaning and Repairing Old Paintings, etc.** London, Published for the author, by Ackermann & Co, Strand (1839)

Gullick, T J, and Timbs, J **Painting Popularly Explained: including Fresco, Tempera, Encaustic, Miniature, Oil, Mosaic, Water-Colour, Missal, Painting on Pottery, Porcelain, Enamel, Glass, &c. with Historical Sketches of the Progress of the Art,** London, Kent and Co (late Bogue), Fleet Street, (1859)

Haynes, F **A Treatise on Portrait Painting from Life. Also, Instructions for Painting Upon Photographs and Painting From Photographs...,**London, G. Rowney & Co, (1887)

Holyoake, Manfred **The Conservation of Pictures,** London, Dalton & Lucy, (1870)

Kingston, William **The Kingstonian System of Painting in Dry Colours, After the Ancient Grecian Method; A Descriptive Account is Also Given of the Materials, and Where They May be Purchased,** Weymouth, Printed and Sold for the Author, by B Benson; and Simpkin and Marshall, London (1835)

Merimee, M J F L **The Art of Painting in Oil, and in Fresco: Being a History of the Various Processes and Materials Employed, from its Discovery, by Hubert and John Van Eyck, To the Present Time: Translated from the Original French Treatise of M.J.F.L. Merimee, Secretary to the Royal Academy of Fine Arts, in Paris...,**London, Whittaker & Co. Ave Maria Lane. (French edition 1830) (English Translation by W Sarsfield Taylor 1839)

Muckley, William J **A Handbook for Painters and Art Students on the Character, Nature and Use of Colours, Their Permanent or Fugitive Qualities, and the Vehicles Proper to Employ.**

Also Short Remarks on the Practice of Painting in Oil and Watercolours, London, Bailliere, Tindall, and Cox, 20, King William Street, Strand, 2nd edition (1882)

Murray, Henry **The Art of Portrait Painting in Oil Colours, with Observations on Setting and Painting the Figure,** London, Winsor & Newton, (1851)

[Osborn, Laughton] An American Artist, **Handbook of Young Artists and Amateurs in Oil Painting Being Chiefly a Condensed Compilation from the Celebrated Manual of Bouvier, with additional matter selected from the Labors of Merimee, De Montabert and other Distinguished Continental Writers in the Art, in Seven Parts...** New York, Wiley and Putnam, 1st edition (1845)

Parkhurst, Daniel Burleigh **The Painter in Oil, A Complete Treatise on The Principles and Technique Necessary to The Painting of Pictures in Oil Colours,** Boston, Lothrop, Lee & Shepard Co, (1898)

Redgrave, Richard & Samuel **A Century of Painters of the English School; with Critical Notices of Their Works, and an Account of the Progress of Art in England,** London, Smith, Elder and Co, 1st edition (1866)

Salter, T (ed) **George Field's Chromatography; or, A Treatise on Colours and Pigments, as used by Artists. An Entirely New and Practical Edition: Revised, Rewritten, and Brought Down to the Present Time,** London, Winsor and Newton, (1869)

Scott Taylor, J (ed) **George Field's Chromatography. A Treatise on Colours and Pigments for the Use of Artists, Modernized by J. Scott Taylor, B.A. Cantab.,** London, Winsor and Newton Limited, (1885)

Standage, H C **The Artists' Table of Pigments. Showing Their Comnposition, Conditions of Permanency, Non-permanency, and Adulterations, Effects in Combination with Other Pigments and Vehicles, and Giving the Most Reliable Tests for Purity,** London, Wells Gardner, Darton & Co, Paternoster Buildings, Etc: The Manager of "The Artist," 22 Cursitor Street,E.C.; & Wm. Reeves, (1883)

Standage, H C **The Use and Abuse of Colours and Mediums in Oil Painting. A Handbook for Artists and Art Students,** London, Reeves & Sons Limited, (1886)

Standage, H C **The Artist's Manual of Pigments. Showing their Composition, Conditions of Permanency, and Non-Permanency, and Adulterations; Effects in Combination with each other and with Vehicles; and the most Reliable Tests of Purity. Together with the Science and Arts Department's Examination Questions on Painting,** London, Crosby Lockwood and Co., 1st edition (1886)

Sully, Thomas **Hints to Young Painters, and the Process of Portrait Painting as Practiced by the Late Thoman Sully,** Philadelphia, J M Stoddart & Co, (1873)

Williams, W **An Essay on the Mechanic of Oil Colours, considered under these heads, Oils, Varnishes, and Pigments, with respect to their Durability, Transparency, and Force, In which is communicated some valuable Secrets, particularly, A Method of preparing the Oils, so as to give them a strong drying Quality, perfectly Limpid, and Colourless.,** Bath, Printed by S Hazard. To be had only of the Author, W Williams,..No.2 Westgate-Buildings, Bath (1787)

DETECTING AND MEASURING COLOUR CHANGES IN PAINTINGS AT THE NATIONAL GALLERY

David Saunders

Introduction

There is mounting evidence that previous misinterpretation of the significance of individual colours or of the overall tonality of paintings is due not to a lack of understanding but to the alteration of colours either by irreversible physical or chemical change or by obscuration by yellowed or dirty varnishes.

As the number of cleaned paintings hanging in major galleries steadily increases and we become more familiar with the sometimes dramatic alteration in appearance wrought by the removal of discoloured layers, it is important to remember that not all colour changes may be reversed.

There are two categories of colour change which we should consider. First, there are reversible or largely reversible changes as varnishes yellow or become matt, or as dirt accumulates on a painting surface. Second, there are irreversible changes caused by physical or chemical alteration of certain pigments or of the medium into which they have been mixed to form the original paint.

Reversible colour changes

The cleaning of a great number of important painted works on panel, canvas and plaster has, whatever the rights and wrongs of each individual treatment, unveiled a wealth of brilliant colours and has often led to a reappraisal of an artist's colouring practice. This revelation is, perhaps, no better exemplified than by the transformation of the Sistine Chapel ceiling after its recent restoration.

In this light, there may seem little merit in making measurements of reversible changes. A failure to record or to measure the colour before the removal of discoloured varnish layers from a painting is, however, to deny the historical fact that at a particular time that painting may have had an entirely different appearance to that which it has now. It may be that a misconception emanates from the former appearance and that a record of the colours at that time may help to explain how such an interpretation arose. For instance, interpretations of the significance of the Virgin's white robe in the Courtauld Institute's 'Coronation of the Virgin' by Lorenzo Monaco must be reassessed in the light of the discovery that the robe may originally have been a purple-mauve colour[1].

Irreversible colour changes

To catalogue all the possible sources of irreversible colour change observed in paintings is outside the scope of this article. Some of the more familiar changes are listed below. Sound technique based upon workshop traditions and the limited use of certain pigments which were observed to possess poor permanence may have reduced the number of fugitive pigments used, but before the introduction of new synthetic pigments in the nineteenth century there was often little choice of colorant if a particular hue, that is for example a blue-green as opposed to a yellowish green, was desired.

Alteration in the colour of the painted surface may arise from numerous sources; the examples which follow are by no means comprehensive.

The first potential source for colour change is the paint medium. As the medium ages, so its optical properties may change. One common result is that a previously opaque layer can become partially transparent and so reveal lower layers of paint of a different colour. The colour of the medium may also change, a yellowing with time being a common example of this effect. Most varnishes are also prone to yellowing with age. Since it is usually possible to remove old varnish layers, we need not consider these last changes to be irreversible.

A second category of colour alteration arises from a loss of colour in the pigment materials. This type of change can be separated from the category discussed below in that here the hue is unaltered, whilst the chroma or 'colourfulness' (ie. saturation), of the colour decreases. Colour loss, or fading, is responsible for some quite spectacular changes in appearance. This type of change is exemplified by the fading of red or yellow lake pigments or by the loss of colour from the blue pigments indigo and smalt. In mixtures of pigments, the fading of one component may produce a change in hue as the colour of a second pigment becomes predominant. This type of change is exemplified by loss of the yellow colour from greens which were created by combining a fugitive yellow lake pigment with a stable blue mineral pigment: the colour seen on the painting today is far bluer than it would have appeared originally. Another way in which fading within a single layer may affect the overall tonality arises when a fugitive pigment is used in a glaze over a light-stable paint layer of another hue, for instance a crimson glaze over orange-red.

Thirdly, there are changes in the hue of the pigment, for instance from purplish-red to brownish-red. Examples of this type of change are the browning of copper resinate green, a paint which was produced by combining a copper salt, usually verdigris, with a resinous substance such as Venice turpentine and the blackening of the red pigment vermilion and of lead white, particularly in wall painting.

Many of these colour changes are believed to be catalysed by light, with sources containing a high proportion of ultra-violet radiation being the most detrimental. The loss or change of colour is frequently confined to pigment particles in the upper part of a paint layer. Such a surface effect is in keeping with light-induced fading. Cross-sections of paint samples taken from areas of faded lake pigment typically exhibit a virtually colourless layer at the upper surface with much of the colour retained deeper in the paint layer. The extent of fading with depth will depend upon the transparency of the upper (faded) portion, the thickness of the unfaded portion and the colour of any underlying layer.

To prevent completely any light-induced colour change, it would be best to store paintings in the dark. This is hardly compatible with public exhibition, so in practice a compromise is reached between the need to exhibit the work to the public of today and the need to preserve the work for the public of the future.

Detecting colour change

As indicated in the previous section, lighting levels within galleries are necessarily a compromise between those ideal for conservation purposes and those best for viewing. Within the gallery daylight is admitted to the rooms only after passing through glazing materials which absorb a majority of the harmful ultra-violet radiation. Light sources are selected to give good colour rendering with minimal ultra-violet emission. The level of illumination is controlled by dimming artificial lights and using adjustable louvres to restrict daylight.

In order to judge the success of such a regime, it is necessary to monitor any change in colour of the paintings with time. To this end, there are a number of methods available for detecting changes in colour.

Human colour vision

Under certain circumstances, the human eye is sensitive to subtle changes in colour. If two slightly different coloured samples are placed alongside each other, the eye can distinguish between them, given sufficient appropriate illumination. If, however, two samples rather more different in colour from each other are seen individually and consecutively, rather than simultaneously, the eye, or more precisely the signal processing portion of the brain, may well be unable to distinguish between them. As a result, human observation is not a good method of colour measurement, particularly since many of the irreversible changes are small and may occur over a considerable time.

Despite this, the eye can be used to make an indirect colour measurement by matching the object colour to one of a comprehensive set of coloured chips before and after a change has occurred. If the match is performed under the same illuminant by an observer with 'normal' colour vision and the chips are assumed to be permanent, then a colour difference may be measured empirically. The method has the disadvantage that it will be necessary to select a set of points on the painting to be monitored at the outset; it would not be feasible to make a match for every area! One final drawback of the technique is that the match for a particular colour depends upon the surrounding colour. If the surrounding colour alters, a false match may be obtained for the colour under study, indicating a change where none has occurred.

Colour photography

Colour photography is routinely used to record the condition of paintings. Theoretically, two colour photographs taken under identical conditions before and after a cleaning or taken prior to and after an irreversible change has occurred will show a difference in colour when viewed simultaneously under identical lighting. Unfortunately, there are two major problems. First, it is virtually impossible to obtain identical conditions for photography. It is just possible, if consecutive exposures on film from the same batch are processed together and printed, in the case of negative film, on the same paper. The nature of the experiment dictates, however, that the photographs be 'before' and 'after' exposures, and that a period of time must elapse between events, even if this is relatively short; a visit to the conservation studio for a cleaning test perhaps. When the second exposure is made the lighting may be different, the film may come from a different batch and the developing will vary slightly. If the colour change is great, it will probably still be obvious, otherwise it may well be lost. The second problem with photographic comparison is that a photograph is not a permanent record. The moment a film is manufactured, it begins to deteriorate and its characteristics alter[2,3]. After processing these changes continue; even when kept at low temperatures, the dyes in the negative or transparency alter and the support begins to disintegrate.

Spectrophotometry

The other methods of detecting colour covered by this paper rely upon objective measurement of colour before and after a change. Since it is the surface colour of the object which gives it a particular appearance, it is the measurement of reflected light that will be considered. The sensation of colour arises because objects illuminated with 'white' light, (tungsten light, fluorescent light and daylight may all be considered as white lights), do not reflect all the light which reaches them. Thus a green object reflects more light in the green region of the spectrum than in the red or blue. When this reflected light reaches the eye, the photosensitive elements,

cones, in the retina which are more sensitive to light in the green portion of the spectrum are more stimulated than those sensitive to the blue and red wavelengths. The resulting stimulation is interpreted by the brain as corresponding to "green". Of course, not all greens are identical since the visible spectrum does not comprise discrete red, green and blue light but a continuum from red to violet; thus a green which reflects more light in the blue region of the spectrum appears bluer than a green which reflects little light in this region.

Using instrumentation, it is possible to measure the quantity of light reflected in different regions of the visible spectrum. The visible region is considered to be light with wavelengths from around 400nm (violet) to around 750nm (red); measurements are typically made at 5 or 10nm intervals. The resulting data may be represented graphically in the form of a reflectance spectrum. A reflectance spectrum shows reflectance, as a percentage of the light reflected by a pure white reference sample, against wavelength.

To measure colour from the painting surface in this way it is necessary to have equipment capable of measuring reflectance at a range of wavelengths. At the National Gallery two distinct pieces of equipment have been used.

Reflectance spectrophotometer

The technique of reflectance spectrophotometry, as applied to paintings, has been described in greater detail elsewhere[4],[5]. To summarise, light from a tungsten ribbon-filament lamp is focused onto the entry slit of a monochromator. Light of the selected wavelength is then focused through a system of lenses onto the surface of the painting at a right angle (ie normal) to the plane of the painting surface. A proportion of the light reflected at 45° to the painting surface is focused onto a photomultiplier. The system of normal incidence and 45° measurement is one of the geometries recommended by the CIE (Commission Internationale de l'Éclairage). The quantity of light reflected by the painting at each wavelength is compared with the amount of light reflected by a standard of known reflectance.

The first step in measuring a spectrum is the accurate positioning of the painting with respect to the measuring head of the apparatus. If the point has not previously been measured then a photographic record is made of the area; if a repeat measurement is being made then the head must be repositioned in the same place as for the original measurement.

Before determining the reflectance at the first wavelength, the dark current from the photomultiplier is determined (the dark current is the residual signal generated by the photomultiplier when only stray light from the ambient surroundings is incident upon it). To minimize the dark current, the room lighting is switched off throughout the experimental procedure.

The signal generated for the sample is then compared to that for the standard at each wavelength in the visible region of the spectrum to give an absolute reflectance at each wavelength.

$$R\lambda = [(S\lambda - D) / (Ss\lambda - D)] \times Rs\lambda \qquad (1)$$

$R\lambda$ = Absolute reflectance for sample at wavelength λ
$S\lambda$ = Signal for sample at wavelength λ
$Rs\lambda$ = Absolute reflectance for standard at wavelength λ
$Ss\lambda$ = Signal for standard at wavelength λ
D = Dark signal

The absolute reflectance values are calculated and stored by a computer. The data may be presented as a reflectance spectrum or converted into a standard set of colour co-ordinates, for instance one of the CIE colour co-ordinate systems described below.

Image processing

Again the technique has been described elsewhere[6],[7]. To summarize, a standard TV camera or, preferably, a solid-state camera is used to make an image of the painting. A standard TV picture is made up of 625 bands (525 in America). Each band is transmitted in turn by the camera as a continuously varying voltage, termed an analogue signal, which is then converted to a digital signal prior to processing by computer.

The digitizing procedure is carried out by an analogue to digital converter (A-D converter) which periodically samples the incoming analogue signal and converts this to a numerical (digital) value. The time interval between samples will determine the number of picture elements (pixels) in each of the bands which make up the image. The greater the number of pixels, the greater the resolution of the digitized image. The analogue signal entering the A-D converter can have any value between zero and the maximum output voltage of the camera; the digitized signal generally has values between 0 and 255, that is 256 (2^8) different levels.

In a solid-state camera (CCD or CID camera), the image is focused onto a silicon chip which is divided into a large number of rectangular photodetector elements, each of which accumulates a charge proportional to the number of photons which fall upon its surface during the measurement period. The nature of the silicon chip ensures that the image is not subject to geometric instability, that is changes in the dimensions of the area imaged; this is one of the major drawbacks of using a tube type TV camera. The signal is treated in the same manner as a signal from a TV camera, except that the digital value for each pixel may be obtained directly from the signal generated by each of the photosensitive elements in the array.

Image processing for colour detection

Adapting a monochrome solid-state camera to measure colour is not straightforward. In commercial colour CCD cameras, the sensitivity of the photodetector is modified to produce red, green and blue images using internal filters. For colorimetric studies, the precision of these internal filters is insufficient, so we have elected to use external filters, the properties of which may be checked regularly by independent measurement. A number of alternatives are available. It would be theoretically possible to illuminate the painting with light of every wavelength in the visible region and thereby to obtain a reflectance spectrum for each pixel which will exactly define its colour. This method has been rejected because the volume of data that would be generated for each painting would be too great. At the other extreme, the photodetector in the camera can be made to simulate the response of the human eye by using appropriate red, green and blue filters. Whilst this approach minimizes the volume of data to be stored and analyzed and has been used with some success to detect certain colour changes[7], we have now found that the colour information acquired by this method is not sufficiently detailed to detect small colour differences[8]. A compromise, which gives accurate colour information without increasing the data storage requirements beyond an acceptable level is to use a set of so-called 'bandpass' filters. A set of seven filters which have maximum transmittances at 400, 450, 500, 550, 600, 650, 700nm and a bandwidth of 50nm have been found to give good colour difference detection when used in conjunction with a solid-state camera[8].

Quantifying colour change

Having obtained a measurement of colour using one of the above methods, it is necessary to have some means of quantifying any changes that have occurred.

Reflectance spectrophotometry

It is difficult to calculate the magnitude of a colour change directly from spectral information. The data is usually converted into tristimulus values. As the name implies, the tristimulus values express colour in terms of three stimuli, those thought to be generated by the three different types of colour-sensitive photoreceptor in the human eye, that is the red-, green- and blue-sensitive cones. The tristimulus system is thus an attempt to classify colour according to the way in which we believe it will be perceived by the human eye under a specific light source. In order to express colour information in this way, a knowledge of the response characteristics of the human photoreceptors is necessary. Experimentation over a number of decades means that these spectral responses are well documented[9],[10].

The first stage in the calculation is to adjust the human colour response curves, known as the x, y and z curves, to allow for the particular illuminant. The illuminant is usually one of the CIE reference illuminants; in the calculations which follow reference illuminant D65 is used throughout. CIE reference illuminant D65 represents a typical daylight illuminant. The adjusted x, y and z curves for each illuminant are also tabulated and are referred to as \bar{x}, \bar{y} and \bar{z} curves.

The theoretical responses of each of the three photoreceptors in the eye (X, Y and Z, which correspond approximately to red, green and blue respectively) are then given by the following relationship:

$$X = \int_{\lambda min}^{\lambda max} R\lambda \; \bar{x} \lambda \; . \; d\lambda \qquad (2)$$

Y and Z are derived from \bar{y} and \bar{z} in the same way. The values of X, Y and Z give an indication of the 'shape' of the reflectance curve of a colour under investigation.

In the most widely currently used colour system, the values of X, Y and Z are treated in a way believed to be analogous with the signal processing performed on the photoreceptor signals in the eye. The result is a set of three attributes which define a colour as seen under a particular light source. These attributes are given the labels L^*, a^* and b^*, and correspond to lightness, 'redness-greenness' and 'blueness-yellowness' respectively. Thus, a positive value of a^* implies 'redness' whilst a negative value suggests 'greenness'. The values of L^*, a^* and b^* are the three colour co-ordinates in the CIE 1976 colour system[11] and are derived from X, Y and Z as follows:

$$L^* = 116(Y / Yn)^{1/3} - 16 \qquad (3)$$

$$a^* = 500[(X / Xn)^{1/3} - (Y / Yn)^{1/3}] \qquad (4)$$

$$b^* = 200[(Y / Yn)^{1/3} - (Z / Zn)^{1/3}] \qquad (5)$$

Where Xn, Yn and Zn are constants which depend upon the light source for which the calculation is being made.

Once the results of a pair of colour measurements made before and after a period of time or a conservation treatment have been converted into values of L^*, a^* and b^*, it is possible to calculate the colour difference between them using the equation:

$$\Delta E^*_{ab} = (\Delta L^{*2} + \Delta a^{*2} + \Delta b^{*2})^{1/2} \qquad (6)$$

If the colour difference, ΔE^*_{ab}, is greater than one, it is theoretically possible for the eye to discriminate between the two colours. A ΔE^*_{ab} of one is described as a 'just perceptible difference'.

Image processing

With a non-spectral colour measurement system, such as is generally employed with a solid-state sensor, it is not possible to derive values of X, Y and Z directly from equation (2). The data obtained from a set of n filters may be converted into X, Y and Z data by matrix calculation. Thus for a set of seven filters, the camera response values through the seven filters are expressed as a 1 x 7 matrix. This matrix is multiplied by a 7 x 3 matrix to give a 3 x 1 matrix which will then contain the required values of X, Y and Z.

Once the values of X, Y and Z are known, L^*, a^* and b^* are calculated according to equations (3), (4) and (5) and the colour difference, ΔE^*_{ab}, may be calculated from equation (6)

Conclusions

Whilst there are a number of methods available for measuring the colour directly from the surface of a painting, an accurate measurement of colour difference with time is more problematic.

The main problem is to ensure that before and after measurements are made at exactly the same point. If the time between the measurements is great, there is also the problem of deterioration or alteration of the measuring equipment. Finally, the sensitivity of the measuring technique may well limit the magnitude of colour change it is possible to detect. Thus small changes in colour which are only just perceptible by the eye may not be detected.

Image processing techniques seem to represent the best compromise. By using appropriate filters, the technique allows colour measurements to be made over the entire surface of a painting. Repositioning of the object can be made using the stored image itself as a reference. In addition, positional adjustments can be made by software manipulation of the image. The accuracy of colour measurement afforded by the technique appears to be sufficient to detect just perceptible changes of colour.

References

1. Villers, C and Hedley G, 'Evaluating Colour Change: Intention, Interpretation and lighting', in Preprints, **Lighting** UKIC/MA/Group of Interpreters and Designers in Museums (1987) pp 17-24.
2. Hamber, A, 'Electronic Digital Imaging Systems and Art History : Advantages and Desirability', in **Colour Imaging Systems**, Pointer, M R (ed), The Royal Photographic Society of Great Britain (1987) pp 188-90.
3. Townsend, J H and Tennent, N H, 'The Photochemical and Thermal Stability of Colour Transparencies', in **Colour Imaging Systems**, Pointer, M R (ed), The Royal Photographic Society of Great Britain (1987) pp 117-23.
4. Bullock, L J, 'Reflectance Spectrophotometry for the Measurement of Colour Change', **National Gallery Technical Bulletin**, 2 (1978) pp 49-55.
5. Saunders D R, 'The Measurement of Colour Change in Paintings', **European Spectroscopy News**, 67 (1986) pp 10-18.
6. Thomson, G, and Staniforth, S. 'Identification and Measurement of Change in Appearance by Image Processing, in **Science and Technology in the Service of Conservation**, Brommelle, N S and Thomson, G (eds), preprints of the IIC Washington Congress (1982) pp 159-61.
7. Saunders D R, 'Colour Change Measurement by Digital Image Processing', **National Gallery Technical Bulletin**, 12 (1988) pp 66-77.
8. Hamber, A and Saunders, D R, 'From Pigments to Pixels : Measurement and Display of the Colour Gamut of Paintings', **Proceedings of the Society of Photo-Optical Instrumentation Engineers**, 1250 (1990) in press.
9. Hunt, R W G, **Measuring Colour**, Ellis Horwood (1986).
10. Wyszecki, G and Stiles, W S, **Colour Science, 2nd Edition**, John Wiley & Sons (1982).
11. Commission Internationale de l'Éclairage, 'Recommendations on uniform color spaces, color difference equations, psychometric color terms', supplement No.2 to **CIE Publication No. 15** (E-2.3.1), 1971/(TC-1.3) (1978).

CHANGES IN THE APPEARANCE OF PAINTINGS BY JOHN CONSTABLE

Charles S Rhyne

Introduction

The purpose of this paper is to review the remarkable diversity of changes in the appearance of paintings by a single artist to see what questions these raise and how the varying answers we give to them might affect our work as conservators, scientists, curators, and historians[1]. My intention is not simply to describe changes in the appearance of paintings by John Constable but to suggest a framework that I hope will be helpful in considering changes in the paintings of any artist and to illustrate comparisons among artists. To this end, I have selected examples and formulated my discussion of them less to present unpublished material on Constable (though there is a fair amount of this along the way) than to further discussion among conservators, conservation scientists, curators, and art historians on the complex and overlapping questions of this symposium.

As a first stage in designing a framework for considering the diverse types of changes that have taken place in the appearance of paintings, I have followed the useful suggestion in the call for papers by dividing the types of changes in the appearance of Constable's paintings into three categories: first, physical changes in the paintings themselves; second, changes in the physical conditions under which the paintings have been viewed; and third, changes in the cultural and psychological contexts in which Constable's paintings have been understood and interpretated.

As I shall argue in the conclusion, these three types of changes are interdependent. All three are involved in every judgment we make about the appearance of paintings and every action we take as a result. In this paper, however, I shall examine separately only the physical changes, the first two types, incorporating the cultural and psychological contexts from time to time rather than treating them separately.

Physical changes in paintings

In thinking about changes in the appearance of paintings, we may be inclined to think exclusively of later changes, changes following the completion of a painting by the original artist and his workshop. But I should like to draw attention to the facts that, firstly, the most important changes in the appearance of paintings take place during their original creation, secondly, that there may be several different stages at which a painting may be said to have been finished by the original artist, and, third, that some of the physical changes following the so-called "completion" by the original artist may have been anticipated, accomodated for, even intended by the original artist.

Changes made by the original artist

Let us consider certain aspects of Constable's working procedure. Taken to the extreme, of course, every new stroke of paint constitutes a change in the appearance of a painting, and it should be one of the *leitmotifs* of this symposium that relatively minor physical changes can be among the most important aesthetically or as documentation. When Constable added the tiny windmill, no more than one-half inch tall, at the far right edge of his 'Double Rainbow, East Bergholt Common' (Victoria and Albert Museum R117), he not only established tremendous depth in the landscape but identified the scene[2]. If that small detail were somehow lost, let us say accidentally damaged or covered by a frame, much of the space and personal meaning of the sketch would collapse.

But let us begin with examples of major alterations by the original artist. Probably the most famous compositional changes within Constable's *oeuvre* are the changes in his six-foot, 1825 R.A. exhibition piece, 'The Leaping Horse' (Royal Academy GR25.1); most famous because the painting, its full-size sketch and two brilliant preparatory wash drawings[3] have all been available in London from the turn of the century, and because Constable's own description of at least one of these changes, documented in his correspondence[4], was published in Leslie's famous **Life**[5] shortly after Constable's death, and in this century was more fully developed and popularized by Kenneth Clark[6]. In comparing Constable's full-size sketch, at the V&A, with the finished painting, we see that, in the final painting, he has removed the willow tree at the right, the cow drinking, the right side of the prow of the main barge, the figure poling the main barge, and the entire prow of a second barge just entering the picture at the extreme left of the painting. All of these changes were made not, as we might suppose, between the sketch and painting, but in the finished painting itself, where each of these *pentimenti* can be seen today with the naked eye under good lighting. More important for my point here, at least some, perhaps all, of these changes had not yet been made when the painting was exhibited in April 1825 at the Royal Academy. Constable's journal entry of September 7th, following the R.A. exhibition, records: "set to work on my large picture. Took out the willow stump by my horse, which has improved the picture much—almost finished—made one or two other alterations"[7].

One of the things I should most like to know about 'The Leaping Horse' is whether or not Constable allowed the evidence of those changes to be visible when he showed the painting to fellow artists and prospective clients. Although Constable increasingly retained evidence of the creative process in his paintings, my guess is that he never wished major compositional pentimenti to show in any finished painting, a point which we shall return to when considering changes wrought by time and conservation. It seems at least possible, however, that Constable never considered this painting, and perhaps others, quite finished. If true, the rejected prow of the barge at the extreme left may never have been fully obliterated.

Conveniently, 'The Leaping Horse' also provides evidence for two other types of changes in Constable's work[8]. If we look carefully at the extreme right of the canvas, we see a vertical crease just to the right of the tower of Dedham Church, marking the previous edge of the painted area before Constable enlarged the painting slightly by unfolding the strip of canvas folded around the stretcher bar at the right. A similar strip of unfolded canvas is visible along the left side. This unfolding of both sides of the canvas would have required restretching on a new, larger stretcher. In addition, Constable added a separate, 64 mm strip of canvas across the entire top of the painting. In a surprising number of cases, Constable followed a similar precedure, either unable to contain his original conception within the size canvas he had provided himself or else unable to resist expanding the scene itself as he worked.

A year previously, Constable had made similar but more dramatic changes to the size and shape of the full-size sketch for his vertical, 1824 R.A. exhibition piece, 'The Lock', in the collection of the Philadelphia Museum of Art (M'28-1-2, GR24.2), where over the years I have received extensive help and advice from Marigene Butler and her staff[9]. In comparing the canvas now folded over the left edge of the stretcher with that folded over the right edge, we discover that there is no paint on the left edge, whereas the canvas now folded over the right edge retains green paint similar to that immediately next to it on the face of the canvas, suggesting that the left edge is original but that the strip of canvas now folded over the stretcher bar at the right was previously part of the surface of the painting. Presumably, at least a small additional portion of canvas farther to the right was removed at the same time[10]. This is the only instance of which I am aware in which

there is evidence that Constable reduced the size of a canvas; and even here the intention seems to have been to convert a horizontal format into a vertical, possibly larger, sketch, because Constable has added a strip of canvas across the top, extending the painting surface about 286 mm. Most revealing, however, is the way in which Constable has done this. After unfolding the top edge of the original canvas, he added the new horizontal strip of coarser canvas, gluing it under the top edge of the original canvas. No stitch marks are visible in the clear x-radiographs, indicating that Constable was here working on a large oil sketch on canvas as if with paper.

For a clear example on paper, we may look at Constable's 1834 watercolor sketch of 'Cowdray House' (British Museum 1888-2-15-31, GR34.32), where the paint and pencil drawing on either side of the vertical division are clearly discontinuous, and the 70 mm vertical strip at the right therefore added, though not overlapped as in the full-size sketch for 'The Lock' discussed above.

One other aspect of his working procedure, which we have seen documented for 'The Leaping Horse', seems to have been common procedure for Constable. The evidence from his correspondence confirms that he continued to work on major canvases, even after their initial exhibition at the Royal Academy. Given the importance of the annual R.A. exhibitions for his reputation and advancement within the Royal Academy and the fact that he rested his reputation on his six-foot landscapes, one might have expected Constable to have brought his major exhibits each year to a state as near full realization as he could achieve. But he was notoriously slow in starting, laborious in his preparation, experimental in his approach to each problem; therefore continuously equivocal about matters of composition, finish, and effect; and he demanded of himself the ongoing discovery of effects seen in nature but never before on the canvas of any painter in the world. For these reasons, he found it especially difficult to bring his major six-foot landscapes to completion in time for the Royal Academy exhibitions or, in some cases, perhaps ever.

Immediatetly after submitting 'The Leaping Horse' to the Academy, Constable wrote to Fisher:

I have worked very hard—and my large picture went last week to the Academy—but I must say that no one picture ever departed from my easil with more anxiety on my part with it. It is a lovely subject, of the canal kind, lively—& soothing—calm and exhilarating, fresh—& blowing, but it should have been on my easil a few weeks longer.[11]

As we have already seen, within the year Constable did return the picture to his easel and, as it turned out, for more than a few finishing touches.

This practice of continuing to paint on his six-foot exhibition pieces is documented beginning with his first, the 1819 'White Horse'. In a letter to Fisher of July 2nd that year, Constable wrote of 'The White Horse' : "It has served a good apprenticeship in the Academy and I shall avail myself of it by working a good deal upon it before it goes on a second to the British Gallery"[12].

Constable's major exhibit the next year, the six-foot 'Stratford Mill' (National Gallery GR20.1), was also returned to his easel, even though, in this case, it was already owned by and hanging on the wall of a private collector. In a letter of October 2nd 1823, Fisher wrote to Constable that its owner, John Pern Tinney, was willing to lend Constable the painting to be worked on further, but that:

He dreads your touching the picture. This of course is not his own thought . . . But it is the suggestion of Lewis the engraver. "There is a look of nature about the picture,' says Lewis," which seems as if introduced by magic. This, when Constable gets it on his easil, he may in an unlucky moment destroy".[13]

The documentary evidence suggests that Constable may have had something of a reputation for this practice. Another collector, John Sheepshanks, wrote to Constable in March 1833, referring

probably to his version of 'Hampstead Heath: Branch Hill Pond' (Victoria and Albert Museum R301, GR28.2)[14]:

"The Picture you will not be sorry to hear grows upon me, since I got it—and I am already forming excuses, whenever you shall ask for it back, either to touch upon, or varnish—having resolved, that it must neither be the one, or the other—".[15]

The most specific technical description of Constable's retouching appeared six decades after Constable's death in Robert Leslie's generally reliable introduction to his 1896 edition of his father's Life of Constable.

Constable, no doubt, in certain of his later works employed the palette knife freely, but it was never used until he had secured the drawing, tone, and effect of the picture with the brush. During the last years of his life he, at times, also touched upon some of his earlier pictures in this way as they hung on the walls of his studio, leaving for a moment a work on his easel to do so[16].

We cannot be certain which works Robert Leslie is referring to, but Constable's inscription on the back of a watercolor of 'Old Houses on Harnham Bridge, Salisbury' (Fig.1, Victoria and Albert Museum R240, GR21.72), does provide one documented example of his retouching a work ten years later. It reads: "Old Houses on Harnham Bridge. Salisbury Novr. 14 1821." and "retouch at Hampstd. the day after the Coronation. of Wm. 4th, at which I was present—being eleven hours in the Abbey". Since the coronation of William IV and Queen Adelaide took place in Westminster Abbey September 8th, 1831, the watercolor must have been retouched almost ten years after first drawn. Martin Hardie, who first published this information, suggested that the original drawing was probably only a pencil beginning[17], but the watercolor is consistent with Constable's handling of other watercolors and oils of 1821, and the retouching, though probably over refreshed watercolor, is most notable for the bravura scratching out. For a somewhat parallel situation among Constable's oils, I would suggest that Constable returned to his six-foot sketch for 'Stratford Mill' (Yale Center for British Art B1983.18 GR20.2), sometime after having been elected a full academician in February 1829, and touched up the entire canvas, after which he felt justified in signing the painting boldly in reddish paint "John Constable RA/London". Reynolds considers the signature probably false, but it seems to me very much in character and the finishing of the sketch too advanced for 1820, the date he exhibited the finished version (National Gallery GR20.1). On several occasions, Constable attempted to borrow the exhibited version back from its owner. It seems reasonable that he might have worked up the sketch partly as an alternative for himself and visitors to his studio, if not for public exhibition.

Constable's careful pencil drawings and detailed oil studies from nature served him as something of a naturalist's notebook, the quarry from which he drew when developing his landscapes

Fig 1 John Constable, 'Old Houses on Harnham Bridge, Salisbury', 1821/1831, showing retouching ten years after original watercolor.

and filling them with human incident and staffage. It is doubtful that he would have altered any of these detailed records of his native scenes. Some of his freer drawings, watercolors, and oil sketches, seem to have been valued in the same way, as records of, for example, specific weather effects, and therefore would not have been altered by the artist. Others, however, seem to have been thought of more as compositional studies for possible paintings, and these seem more likely to have been altered in the process of developing exhibition pieces in his studio. Moreover, the evidence suggests that Constable increasingly thought of his finished paintings as part of an ongoing attempt to embody his full experience of nature. Thus they constituted something of a continuing experiment in which density of experience was increasingly valued. Repeatedly painting scenes from his childhood and youth, often returning to scenes first sketched over twenty years before, Constable was continuously reviewing his own experience, reinterpreting his favorite landscapes from increasingly mature and reflective perspectives. It is understandable that such an artist, especially one who preferred to keep most of his sketches and studies around him and who sold relatively few of his finished paintings, might think of his earlier work as an active participant in his current projects and might return to it with his brush as well as his mind.

What does this mean for us in practical terms? As historians (and I believe we are all to some extent historians), when we stand in front of a painting by Constable, we must be prepared for the possibility of two different paintings on the same canvas. We must be prepared to visualize an earlier painting, begun and finished in a single campaign of painting, representing a single, coherent stage in Constable's earlier career; though to see this painting we may have to imaginatively remove later retouching by Constable himself. And we must be prepared to see the painting as we have it today (excepting of course natural deterioration) as possibly a later interpretation by Constable of his earlier subject. In cases such as the 'Harnham Bridge' watercolor and, in my view, the 'Stratford Mill' sketch, this later reworking could transform an entire picture.

My chief concern here, however, is that we must be prepared to see occasional sketches and paintings that are not "finished" statements but rather records of ongoing experiments that have come down to us not necessarily at a "unified" stage. For example, the palette knife work in the lower-left of Constable's oil sketch of 'Dedham Vale from the Coombs' (private collection)[18], seems likely, to me at least, to be a later addition by Constable himself, possibly applied when he was struggling with the lower-left corner of his first six-foot landscape, which we shall turn to shortly. We are fortunate indeed that this palette knife work, admittedly different in character from the rest of the sketch, has never been removed, because during the seventies when the sketch was having difficulty finding a buyer, the palette knife work was frequently described in salesrooms as an addition by a later artist. Apart from the unlikelihood of anyone other than the original artist attempting to add to the sketch in this way, the palette knife work is fully characteristic of Constable's hand. As curators and conservators, then, we must be careful not to remove later touches, even if on top of varnish, unless they are clearly not in the original artist's hand, even though the painting may appear to us initially discordant, unlike our general conception of the artist's work. One of the themes of this paper, to which I shall return, is that the more unexpected some aspect of a Constable painting is the more it may convey a unique artistic experience and the more valuable it may be for our view of the artist and, therefore, the more important for us to understand as historians and to preserve as conservators.

In addition to changes made as part of his normal working procedure, Constable occasionally painted one image completely over a previous image on the same canvas. In this view of 'The Thames Valley from Hampstead Heath' (Yale Center for British Art B1976.7.17, GR25.35), we see the ghost-like, unrelated image of 'Salisbury Cathedral from the Close' beneath (the composition familiar from Constable's painting, dated 1820, at the V&A)[19]. Vastly more important are two examples that I have published recently, both of which present serious cleaning problems which have yet to be addressed.

The earlier of the two, Constable's first six-foot sketch, at the National Gallery of Art, Washington (605, GR19.2), for his 1819 'White Horse' (Frick Collection GR19.1), completely covers an unrelated image. X-radiographs made for me in 1984 at the National Gallery of Art revealed for the first time that the 'White Horse' sketch was painted over a previously unsuspected image of 'Dedham Vale from the Coombs'. The highly detailed bridge and buildings at the center of the Dedham Vale image, nearly identical to those in Constable's well-known, early study of the scene (Victoria and Albert Museum R63), are convincing evidence that the Dedham Vale image was not intended to be a six-foot sketch but rather was the beginning of a six-foot landscape painting, Constable's first attempt at the type of painting on which he later said he rested his reputation. Since the x-radiographs suggest that this was a promising beginning, it is difficult to understand Constable's decision to cover the unfinished 'Dedham Vale' painting with an unrelated sketch instead of retaining it for study and perhaps completion later. His financial situation at the time would not seem to have made one canvas and stretcher of such value if he had wished to save the unfinished painting. Completely covered by his own 'White Horse' sketch, the 'Dedham Vale' painting may now be seen only in x-radiographs and other types of laboratory images.

Given the importance of the 'White Horse' sketch, it is unthinkable that it will ever be cleaned off to reveal the unfinished 'Dedham Vale' painting beneath. Indeed, I cannot think of any instance in which I should advise removing any overpainting or later retouching by Constable in order to reveal an earlier image or earlier stage of the same image. But one can easily hypothesize cases (indeed they surely exist or have existed for other artists) where the painting beneath is so important and the painting on top seemingly so incidental that we might be tempted to remove the overpainting, even though convincingly in the artist's own hand. With the exception of extreme cases where an artist may have gone insane late in life or had fits of drunkenness in which he splashed whitewash on his paintings, I should like to lend my support (partly to see if there are counter examples with which other participants in this symposium may be familiar) to the general principle that no overpainting or later retouching convincingly by the original artist should ever be removed, no matter how seemingly incidental or "out-of-character" the overpainting or retouching and no matter how important the image covered. This would mean that we would have to be prepared to preserve, and I hope display, if such a picture existed, a major six-foot sketch by Constable over which he had sketched a few prominent, unrelated and seemingly crude lines.

The 'White Horse' sketch covering the 'Dedham Vale' image is itself an image of exceptional importance, Constable's first six-foot sketch and, as far as I can tell, the first example in the history of art of a large, full-size oil sketch on one surface done in preparation for a finished painting of the same size on another surface. In a recent article[20], I argued that the layering of these two images on this one canvas proves that the 'White Horse' sketch was not, as we might suspect, the beginning of another painting, later aborted, but rather was consciously begun by Constable as a full-size sketch in preparation for a finished painting of the same scene on a separate canvas of the same size. The lack of any intermediate ground, that is, a ground over the Dedham Vale image in preparation for the 'White Horse' sketch[21], and the considerable impasto of the unfinished 'Dedham Vale' painting underneath would have made it impossible for Constable to have achieved the kind of thin development of foliage, with brown ground showing through in areas, that he realized in his finished painting of 'The White Horse' at the Frick Collection.

As such, the Washington sketch for 'The White Horse' becomes the key object for understanding the origin of Constable's unique and justly famous "six-foot" sketches. There is no need to summarize that portion of the article here, but we may note that the unusually severe compression of impasto resulting from previous relinings (confirmed by the severe moating), the possibility of extensive repainting, and the unusually heavy coat of discolored varnish, make it impossible to do a close reading of one of the key canvases in Constable's career and indeed in the history of oil sketching. In its present condition I do not consider the 'White Horse' sketch a displayable object and indeed I do not believe it

Fig 2 John Constable, 'A Wooded Bank with an Open Book and Distant View of Water', 1829-c.1836.

has been on display since it was removed for examination in 1984. Tests done for me in the Paintings Conservation Department at the National Gallery of Art reveal that beneath the heavily discolored varnish is a lovely, light blue sky, similar to that in Constable's beautifully preserved six foot sketch for 'Stratford Mill' (Yale Center for British Art B1983.18, GR20.2) the next year. I believe there is still much to be learned from this picture and hope very much that David Bull will soon take the picture in hand for a slow, studious cleaning.

The last example I should like to discuss of physical changes made to a painting by the original artist embodies an unusual complex of changes. In the 1988 catalogue of the Constable exhibition at the Salander-O'Reilly Galleries in New York, I described the physical history of the painting in a vertical format, 'A Wooded Bank with an Open Book and Distant View of Water' (Fig. 2, Beaverbrook Art Gallery, Frederickton, New Brunswick No59.353)[22]; aided by x-radiographs (Fig. 3) made at the Owens Art Gallery, Sackville, New Brunswick, and by the detailed examination report prepared by Cathy Stewart at the Canadian Conservation Institute, Ottawa[23]. Previous to technical examination, however, one could already see on the surface of the painting, or for that matter even in good black and white photographs, that the present image covers an earlier portrait of 'Simcox Lea', known from a finished painting in a private collection (Fig. 4, GR30.18). This is clearer of course in the x-radiographs, which I believe have convinced those who previously questioned the attribution to Constable. The x-radiographs along with laboratory examination establish that the present canvas is composed of five pieces, butt-joined and then stitched together. The large central panel, on which most of the now ghost-like image of Simcox Lea fits, corresponds exactly to the size of the finished 'Simcox Lea' portrait. Without here reviewing the entire argument, available in the 1988 catalogue, it seems likely that Constable added the vertical strips along both sides in order to accomodate the full figure, having again allowed the development of his composition to outgrow the size of his original canvas (though why Constable, in this case, cut off the tacking edges of the original canvas rather than unfolding them, according to his usual practice, is unclear).

Since Lea seems already to have paid for the frame, it is possible that this was cause enough for Constable to take up a new canvas for the final portrait. A more decisive explanation may be provided by Lea's granddaughter, who recorded the story that Lea questioned Constable: "Why did you paint me, a careful family man, sitting under a tree in a thunder-storm?" "Sir", replied Constable, "when everybody has entirely forgotten you , this picture will be valuable for my thunder-storm"[24]. It seems clear that Lea was here describing his portrait on the Beaverbrook canvas, which indeed has a thunderstorm, perhaps more terrrible as a result of Lea's rejection. In addition, the x-radiographs show that the figure has largely been scraped down before being overpainted. Constable obviously elected to remove Simcox Lea rather than his thunderstorm from the Beaverbrook picture and to take up a new canvas for the final portrait, which obligingly has a lovely background all sunshine and light.

It is not necessary here to describe the final image painted over the Beaverbrook portrait, but we should note first that whatever the meaning of this unique and emotionally charged image, it could provide an important opening for understanding the psychology of Constable's late work, and secondly that the painting has suffered greatly from previous restoration and possibly from extensive overpainting by other hands, making it difficult to read the interplay of the two images with confidence. There is extensive damage to the paint layer including serious compression of impasto during previous relining, and the present coat of yellowed varnish is exceptionally thick and glossy. When, previous to the 1988 exhibition, the painting was examined in the Paintings Conservation Center at the Metropolitan Museum of Art, Dorothy Mahon and John Brealey, who kindly examined the painting for us, recommended against even a light cleaning. If I understood them correctly, they felt that previous restoration was so extensive that the painting would fall apart if cleaning were attempted. However, given the fact that the painting is clearly a sketch and was probably left in an uneven state by Constable, it seems reasonable to ask why the painting should hang together. Why would it not be wise to remove the heavy coat of yellowed varnish, the build-up of dirt and old varnish in the paint crevices, the awkwardly applied and poorly matched overpainting, and to see more nearly the picture as Constable left it?

Fig 3 Composite x-radiograph of central section of 'A Wooded Bank', showing image of portrait of 'Thomas Simcox Lea' covered over by present landscape. X-radiograph by Owens Art Gallery, Sackville, New Brunswick.

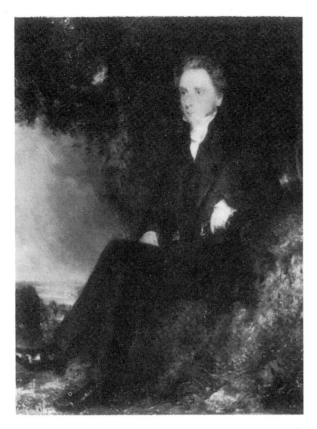

Fig 4 John Constable, 'Thomas Simcox Lea', 1830. Photo provided by owner.

Changes made by others

Turning now from changes made by the original artist to changes in the appearance of Constable's paintings made by others, let us look first at examples of changes by patrons, dealers, other artists, and past restorers. Then, on a more positive note, we shall consider several examples of changes by recent conservators.

Changes made to satisfy the wishes of a patron while a painting is in process would normally have been made to show the patron's person or possessions in a more flattering light. Thus, Constable substituted deer for offending cattle (still visible in the foreground of his country house portrait of 'Englefield House, Berkshire' (private collection GR33.1) for Benyon de Beauvoir, and almost certainly lightened and opened the sky in his painting of 'Salisbury Cathedral from the Bishop's Grounds' (Frick Collection GR26.18) for Bishop Fisher. Once a painting is finished, however, the owner of a painting often treats the picture as private furniture and may employ other artists to make changes without the knowledge, much less the approval, of the original artist. In the well-documented case of Constable's 1814 R.A. exhibition piece, 'A Summerland' (private collection H.193), the purchaser, John Alnutt, later hired John Linnell to repaint Constable's sky. Then, astonishing as it may seem to us today, ten years after the original purchase, Alnutt took the painting back to Constable requesting that he cut down the height to match a landscape he had recently purchased by Augustus Callcott, requesting that he also repaint his sky. The reduction never took place because Constable painted an entirely new picture (Yale Center for British Art B1977.14.41, GR24.81) the requested size as a substitute. Since Constable reclaimed his earlier version (which is about 90mm taller than his second, substitute version), it seems likely that Constable would have repainted the sky for himself, so that what we see now is probably the third sky on the same canvas.

Among the many changes in the appearance of Constable's paintings that must have been made by picture dealers, the following incident is recorded by Constable's close friend and biographer, C. R. Leslie, describing Constable's over 7 foot 1832 R.A. exhibition picture, 'Waterloo Bridge, from Whitehall Stairs, June 18th, 1817' (Tate Gallery GR32.1).

What would [Constable] have felt, could he foresee that, in little more than a year after his death, its silvery brightness was doomed to be clouded by a coat of blacking, laid on by the hand of a picture dealer! Yet that this was done, by way of giving tone to the picture, I know from the best authority, the lips of the operator, who gravely assured me that several noblemen considered it to be greatly improved by the process. The blacking was laid on with water, and secured by a coat of mastic varnish.
[25]

Among works on paper altered by dealers and past owners, includinin years past even distinguished museums, less valued drawings verso have suffered especially. On the verso of a sketchbook page, the sensitive drawing of 'Two Views of a Countyman Lying Down' (Yale Center for British Art B1977.14.6125 verso)[26] was marked through to indicate that the page was to be matted showing the drawing on the other side. In another verso drawing, perhaps undervalued because the scene had not been identified, one of Constable's earliest drawings of 'Dedham Vale from the Coombs' (Fig. 5, Hornby Library, Liverpool B62-18 verso)[27] was partially covered by hinged tape and marked by two ink stamps. For many years, of course, it was common practice to paste drawings down in the process of matting, thereby completely obscuring drawings on the back. Happily, many Constable drawings' have been lifted in recent years, often revealing drawings which have suffered surprisingly little damage. Where museum stamps have unfortunately been used in the past, small ink stamps (as in an example at the Louvre)[28], have obviously been less damaging than larger punches (for example from Exeter)[29].

Fig 5 John Constable, 'Dedham Vale from the Coombs', c.1808-12.

As conservators frequently point out, many of the most devastating and irreversible changes in the appearance of paintings have been caused by previous restoration. In a distressing number of cases, Constable's brilliant impasto has been compressed by previous relining, transforming the heightened touches, that would have conveyed the artist's most intense response to a dramatic sunset or the break of a wave, into flattened blobs. We need to look at those examples which somehow escaped the ruthless relining, so common in earlier times, to see what the quality of Constable's impasto can be in a well-preserved oil sketch, such as this lush 'Hampstead' example (Fig. 6, Yale Center for British Art B1976.7.103, GR21.64).

Fig 6 John Constable, detail of 'Hampstead Heath, looking towards Harrow, 1821, showing unflattened impasto brushstrokes.

One of the proposals that I hope will result from this symposium is the recommendation that a systematic record be kept of those works by each major artist which display what certain types of sketches and paintings looked like, as closely as we can tell, during the years immediately following their creation. I am aware that, among conservators and curators, there is some sharing of information along these lines so that, at least in major museums, conservators often travel to study closely related works in other museums before treating works in their own collections. It would benefit all of us if this information were recorded not only by conservators but also by art historians, who often have privileged access to private collections which sometimes house paintings that have survived in remarkably fine condition. If works, or aspects of works, in especially fine condition or displaying distinctive physical problems were recorded and if possible photographed by both conservators and art historians and this information made available to everyone conserving or doing research on works by the artist, surely we would all benefit.

As with relatively minor changes made by the original artist, so seemingly minor physical changes made by previous restorers can be among the most influential aesthetically or for documentation. What appears at first to be a threatening sky toward the right in this emotionally charged sketch of 'East Bergholt Common' (private collection H133) [30] may well be instead, as Simon Parkes, the private New York conservator, has suggested to me, the result of overcleaning of the upper-right quarter in the past so that the black ground in that portion may show through more than Constable intended. The vertical transition just to the left of center, which makes no [31] sense as part of a Constable cloudscape, supports this idea. If we compare this 1983 slide with one taken following the cleaning a few years ago, we see that the right hand portion of the sky has been slightly retouched in order to suppress this distinction. Happily, the sketch has also been reframed so that we now see nearly all of the sketch at both sides and along the bottom. More of this when we discuss changes in the appearance of paintings resulting from changes in the conditions under which paintings have been viewed.

With this last example we turn to changes made by recent conservators. I realize, from conversations with my friends in painting conservation departments, that the very phrase "changes by recent conservators" may sound offensive to some. But every physical modification we make to a painting changes it, even when

our aim is conservation with the least possible intervention. Surely we should acknowledge this and recognize ourselves as participants in the ongoing process of changing the appearance of paintings. Properly practiced, this is a noble undertaking, of which conservators can be justly proud. Another *leitmotif* that I hope will play through this symposium is the realization that we are not simply looking at the subject of changes in the appearance of paintings from a position of academic reserve but are instead active participants in the process, from which we cannot escape, nor should we wish to.

In those rare cases where paintings seem to have escaped the attention of previous restorers, recent cleanings have revealed paintings which seem very close to our understanding of how an artist's paintings would have appeared, let us say, a few years after completion. The dramatic rediscovery and cleaning of Constable's 1812 Royal Academy exhibition picture, 'A Water-mill', or, as we should now title it, 'Flatford Mill from the Lock' (private collection H124) [32], has returned to us not only something very close to Constable's vivid color, but more importantly the complexity and subtlety of his paint surface, barely visible through the badly discolored varnish before the sensitive 1979 cleaning by Robert Scott Wiles at the Corcoran Gallery, Washington. We see now Constable's increasingly fluid use of rich pigment and the subtle variation of his touch, evoking the moist atmosphere of the river valley. We shall return to this picture later when considering changes in the materials of paintings.

Another more recent cleaning, in 1984 by David Kolch, then at the Los Angeles County Museum of Art, has revealed the original colors and tonal coherency of 'A Farmhouse near the Water's Edge' (Frederick S. Wright Art Gallery, University of California, Los Angeles, on loan to the Los Angeles County Museum of Art GR34.77) [33] and has, I hope, finally put to rest the doubts that have so often been published regarding the authenticity of this very late sketch. The important role of conservation in affecting judgments of authenticity is not, I suspect, fully appreciated.

I would like now to consider another splendid cleaning by David Kolch, the 1985 cleaning of Constable's late, five-and-a-half-foot 'Stoke-by-Nayland' (Chicago Art Institute GR36.19) [34], which raises the important issue of interpretive cleaning. I was privileged to study the painting for several days toward the end of the cleaning, in the Paintings Conservation Department of the Art Institute, in the company of Rick Brettell, William Leisher, Timothy Lennon, and Inge Fiedler, who helpfully analysed several paint samples for me. In the process of a more extensive cleaning than the painting had received at least since 1922, the brilliant colors and brushwork of the painting were revealed more fully than at any time during the three decades I had admired the picture. However, one rather jarring tonal juxtaposition had surfaced during the course of the cleaning. Just to the left of the dark tree mass was a large, fairly bright, white cloud. Because this tonal juxtaposition seemed out of balance with the overall tonal coherency of the painting, the decision was made to clean the white cloud mass less fully than the rest of the painting, thereby establishing a more harmonious tonal order. This does agree with our sense of what a late Constable painting should look like. However, although the picture has always been published as an unfinished painting, I have been convinced for many years that it is a late sketch, in fact the last of Constable's famous and revolutionary, large, full-size sketches. If this is so, the juxtaposition of the bright cloud and dark tree mass would be less surprising and we might be inclined to clean the painting less selectively. Our concept of what a painting should look like cannot help but influence our cleaning of it.

Normal changes in the materials used

Painting materials naturally change in various ways, altering the appearance of paintings. Some of these changes were understood and welcomed by Constable; others were feared but chanced anyway. About other changes we cannot be sure; they seem not to have been anticipated.

Two quotes document Constable's expectation that time would improve his paintings in certain ways. Because the quotes presuppose that he had already observed such changes in his

paintings, he was obviously describing changes that take place in the "short time" he mentions. In a draft of a letter, which seems to be dated March 8th 1834, probably to a prospective client, Constable wrote from Hampstead:

It was with the greatest pleasure I heard of your visit to my painting room. . . . It is much to my advantage that several of my pictures should be seen together, as it displays to advantage their varieties of composition and also of execution, and what they gain by the mellowing hand of time, which should not be forced or anticipated. Thus my pictures, when first coming forth have a comparative harshness which at the time acts to my disadvantage.[35]

The second quote comes from a book published forty-five years after Constable's death, but recording the reminiscences of one of Constable's fellow artists, his younger contemporary, Solomon Alexander Hart. Hart wrote:

Calling upon Constable, one day, I found him with a palette-knife, on which was some white, mixed with a viscous vehicle, and with which he touched the surface of a beautiful picture he was painting. Upon expressing my surprise, he said, "Oh! my dear Hart, I'm giving my picture the dewy freshness of nature, and he contended that the apparent crudeness would readily subside, and that the chemical change which would ensue in a short time would assume the truthful aspect of nature.[36]

On the other hand, Constable surely feared the potential changes resulting from bitumen, of which he would have been well aware because of the well-known deterioration of Sir Joshua Reynolds' paintings resulting from his extensive use of bitumen. It seemed unlikely that Constable, an exemplary craftsman, would have risked use of such a substance. I had been concerned for some years with the discrepancy between Constable's enthusiastic descriptions of his vertical 1835 R.A. exhibition piece, 'The Valley Farm' (Tate Gallery 327, P41, GR35.1), and modern criticism of the painting. Typical is John Walker's description in his 1978 monograph:

What lovely words, "silver, ivory, and a little gold"! Alas, there is in the painting itself very little of any of these. Perhaps so much reworking has dimmed the brightness of the colors, which now seem somewhat drab. The beautiful pigmentation, which distinguished his masterpieces of the 1820s, has been replaced by a granular surface, rough and pitted. [37]

There is no mention of bitumen in the six page entry for 'The Valley Farm' in the 1981 catalogue of **The Tate Gallery Constable Collection**[38], nor any mention of the discrepancy between Constable's description and the picture's present appearance.

As you have guessed, Constable's descriptions of the painting are quite different. We take time for only one quote. In a letter of December 10th 1835 to Robert Vernon, the owner of the painting, Constable wrote:

I beg to apologize for keeping the picture, but I venture to do so . . . as I work on it every day and much for the better. . . . I cannot but feel obliged, by your allowing it so long to remain with me, as it has enabled me to carry my style as far as it is [possible] at least [in] my hands at present. . . . This picture is in all respects my best and will give me the fairest chance of doing so. Certainly the "Lock" is a striking "composition" but cannot compete at all with your picture, in color, brightness or richness, of the chiaroscuro—nor in finish and delicacy of execution. [39]

As far as I can tell, no one had considered the possibility that Constable and modern critics were looking at two quite different paintings,[40] one glowing with the brilliant, translucent effects of fresh bitumen, the other depressed with the dull, dark, wrinkled effects of deteriorated bitumen. Exactly those areas which Constable most wanted to bring to life are now deeply depressed.

We should all have recognized that bitumen was most likely the problem simply by looking at the painting, but it was then very difficult to see under highly reflective glass, and I think we must all have supposed that Constable used only the most reliable pigments. Two sources led me to reconsider the possibility of bitumen. Anna Southall, who has helped me on a number of

occasions in examining paintings in the Tate Collection, drew to my attention a 1960 technical examination report of 'The Valley Farm' in the files of the Conservation Department, which noted that "A heavy bitumen glaze has wrinkled and contracted" the surface[41]. Secondly, I reread a passage in Leslie's Life of Constable, in which he described an event in front of Constable's 1829 R.A. painting, 'Hadleigh Castle' (Yale Center for British Art B1977.14.42, GR29.1):

I witnessed an amusing scene before this picture at the Academy on one of the varnishing days. Chantrey told Constable its foreground was too cold, and taking his palette from him he passed a strong glazing of asphaltum all over that part of the picture, and while this was going on, Constable, who stood behind him in some degree of alarm, said to me "there goes all my dew". He held in great respect Chantrey's judgment in most matters, but this did not prevent his carefully taking from the picture all that the great sculptor had done for it[42].

Although I had read this quote many times, it had never before struck me that if Leslie's account was correct, this established that Constable had bitumen (asphaltum) on his palette in 1829, at least for finishing touches. A year later, Leslie Parris kindly arranged for us to study 'The Valley Farm', in the company of Anna Southall and two other conservators from the conservation department, with the heavy glass removed and a movable flood light. It was clear that all of the dark brown areas were completely mat and cracked, as we had expected, but that the painting as a whole was much richer than one would have guessed. It is now possible at least to guess what the painting must have looked like on Constable's easel, very much I believe as Constable described it. This process of mental reconstruction was aided also by Richard Wolbers, who allowed me to have a sample of his bitumen, which Carol Christensen, at the National Gallery of Art, mixed in various ways so that we could try painting with it to see the effect of fresh bitumen. When thin it is very transparent, disperses well in oil, has excellent tinting strength, and a most ravishing tone. It is easy to understand why Constable would have been willing to risk its use. Moreover, Wolber's research has established that commercial bitumen, which became available about 1815, flows more easily and is less likely to crack, and that bitumen behaves differently depending on the medium with which it is mixed[43]. Constable may have thought that by using the new product, not mixing it with wax, and spreading it thinly, he could avoid any problem. Regrettably, in 'The Valley Farm', his use of bitumen caused a partial reversal in the effect he seems originally to have achieved.

In some cases, Constable seems not to have anticipated a potential problem with his materials. His 'Landscape with Goatherds and Goats' (Art Gallery of New South Wales, Sydney GR23.36), a remarkably exact copy after Claude, made in 1823 while Constable was staying with Sir George Beaumont at Coleorton, contains what appear to be black ink or oil lines, most notably outlining the knees of the main figure (Fig. 7). No such lines are

Fig 7 John Constable, detail of copy after Claude's 'Landscape with Goathers and Goats', 1823, showing black transfer lines outlining knees.

Fig 8 John Constable, detail of 'Flatford Mill from the Lock', 1812, showing pentimenti before 1979 cleaning.

Fig 9 John Constable, detail of 'Flatford Mill from the Lock', 1812, showing pentimenti after 1979 cleaning.

visible in the original Claude, and given Constable's attempt to make as near a facsimile as possible, we may be reasonably sure that these black lines did not show when he finished his copy. They seem almost certain to be transfer lines which have come through over the years.

Likewise, the visible *pentimenti* of chimney and roof lines above their present position in Constable's 1812 R.A. exhibition picture, 'Flatford Mill from the Lock', discussed earlier, is unlikely to have been anticipated by Constable. Although we may wonder about the pentimento of the barge prow at the extreme left of the later and more loosely painted 'Leaping Horse', discussed at the beginning of this paper, there can be little doubt that in 1812 Constable would have completely covered the earlier, higher position of chimney and the mill roof when he exhibited this highly finished painting at the Royal Academy. When the painting was cleaned at the Corcoran Gallery in 1979, the *pentimenti* of chimney and roofs were suppressed, but, in keeping with standard practice at many museums, the earlier position was allowed to show slightly (Figs. 8 and 9). It is a fair question for this symposium whether we should so value the physical object in its present condition, recording as it does a stage in the creation of the painting, that we should allow the *pentimenti* to show in a painting such as this even though we can be nearly certain that the artist would have painted them out. The appearance of the painting has changed and so, it seems, have our values.

Changes in the physical conditions under which paintings have been viewed

We turn now from considering physical changes in the paintings themselves to changes in the physical conditions under which they have been viewed. Again, our first concern is with the artist and with the conditions under which his paintings were viewed at the time. Whether we wish to recreate, as closely as possible, the original conditions under which Constable's paintings were viewed or to compare our own changed conditions to them, it is the original conditions that provide the basis for judgment. Happily, there is considerable evidence available in Constable's correspondence, especially in his letters to his wife, Maria, and to his closest friend, John Fisher.

Lighting

Among the various features of the physical environment for his paintings, Constable wrote most often and most revealingly about lighting conditions. With the exception of a few rare moonlight sketches from nature[44], Constable seems to have painted landscapes only by daylight, turning to drawing by candlelight in the evening or on rainy days[45]. Any hour or any season would do, so long as the daylight was adequate. His studio painting of landscapes also seems to have been limited to daylight hours. In a

journal entry for Maria written in London, December 12th 1825, Constable wrote: "So dark that we had a candle on the table at 10. In the morning could not paint, but it does not signify as we are on the intricate outline of the Waterloo"[46].

Constable seems to have been equally concerned that his paintings be seen by good daylight by friends and potential clients, though over this he had less control. In another letter to James Carpenter also written from London in 1826, Constable wrote: "You see my little picture to a disadvantage, as the day is dark and I have by no means done my last to it"[47]. And in a letter of December 1st 1835 to his close friend, Charles Leslie, Constable wrote: "Will you be so kind as to call for me on your way, tomorrow at 11 or 12, so that we go to the R.A. together—and this will give a fair opportunity of begging you to look at Mr. Vernon's picture by daylight"[48], that is, to see Constable's painting in his studio by late morning light

Letters from his friend, John Fisher, probably provide further evidence of Constable's views on the preferred lighting for his pictures, because Fisher was clearly Constable's protege in art and anxious to please his elder friend. In two letters, he described in glowing terms the light on two of Constable large landscapes as Fisher had installed them in his home in Salisbury. On April 27th 1820, Fisher wrote:

Constable's 'White Horse' has arrived safe. It is hung on a level with the eye, the lower frame resting on the ogee: in a western light, right for the light of the picture, opposite the fire place. It looks magnificently.[49]

Six years later, Fisher wrote, probably from the same room:

The Cathedral [Constable's 'Salisbury Cathedral from the Bishop's Close', Victoria and Albert Museum R254, GR23.1] looks splendidly over the chimney piece. The picture requires a room full of light. Its internal splendor comes out in all its power, the spire sails away with the thunder-clouds. The only criticism I pass on it, is, that it does not go out well with the day. The light is of an unpleasant shape by dusk. I am aware how severe a remark I have made.[50]

Describing 'Stratford Mill' (National Gallery GR20.1), which Fisher had given to John Pern Tinney and perhaps helped him install in his home in Salisbury, Fisher wrote on February 16th 1822:

The light on your picture is excellent. It receives the South sun standing on the Western wall." In a sketch of the room, Fisher showed Constable's six-foot painting "hanging on a level with the spectator's head below a Venetian picture.[51]

The importance of viewing Constable landscapes by daylight was brought home to me dramatically in 1973 when I examined the Constable sketches in storage at the Louvre for the second time. In 1963, when I had first studied them, I had indicated that one of the little sketches, unframed, lying face up on a shelf, catalogued as "Constable genre," clearly represented 'Old Bridge and Bridge

Cottage from Flatford Lock' (Louvre RF1937-23, H172; although you may well be skeptical, the bridge and cottage are indicated in the center of the sketch). Moreover, I noted that this sketch was almost certainly an authentic Constable, though the dim, artificial light made it impossible to be sure. Perhaps still looking too much the student, I was unable to convince my curator-guide that we should take the sketch to daylight. For my visit in 1973, therefore, I arranged ahead of time to examine the sketches by daylight. The transformation was amazing; the sketch came together tonally, coloristically, spatially, and technically, and was clearly authentic. As you might guess, the other "Constable genre" sketches fell apart and looked even less convincing than they had in storage.

In the years since, I have made a point of examining Constable sketches and paintings by daylight whenever possible and must admit now to feeling terribly constrained when I am unable to examine a doubtful sketch in my hands, out of its frame, turning it in the sun, as Constable would have done. An example is a sketch that emerged from the Widener collection in 1988, representing the same stretch of land as the Louvre sketch, but here looking the opposite direction, 'Flatford Mill and Lock from the Towpath by Old Bridge' (private collection H617).[52] Although difficult to judge from the old photograph and doubted even after its reappearance, when seen in the sun it is clearly an authentic Constable, the open air sketch for Constable's 1817 R.A. exhibition piece, 'Flatford Mill' (Tate Gallery No1273, P14, GR17.1). Of course, there is no single, correct lighting condition for any Constable painting. In addition to the conditions under which it was painted, we must consider the studio conditions under which the artist viewed the sketch when using it to develop an exhibition piece, the conditons under which Constable showed it to friends, and any hopes or expectations he may have had, however vague, for its later life. Even considering only the lighting conditions under which the sketch was painted, we must allow for the possibility that the sketch may have been in full sun and in shade at different times while the artist was working. For finished paintings, even those painted entirely in the open air, Constable would have known that they would be exhibited by indirect, indoor light. The conclusion that we cannot assume a single lighting condition, should not, it seems to me, lead us to accept all lighting conditions as equally appropriate. The evidence allows us to establish a limited range of possibilities and to develop a sense of how the artist himself would have evaluated each. Any other types of lighting conditions can then be seen in a specific relationship to those under which Constable made his decisions and those in which he intended his paintings to be exhibited.

There is of course the additional, difficult question of how our viewing of Constable's paintings is affected by the relatively low, artificial lighting conditions, under which we, quite rightly, are normally obliged to look at Constable's paintings today. We cannot know how the artist would have responded to any forms of , but the comments in his correspondence suggest that even fairly strong artificial illumination would not have provided the quality of light he felt necessary for his paintings. My own experience is that the difference between artificial lighting at the low levels appropriate to galleries today, even when mixed with filtered daylight, and, on the other hand, reasonably full indirect daylight, is much greater than most people who do not have the opportunity to experience the difference first-hand would suppose. Seen under good indirect daylight in the conservation studio of the Nelson-Atkins Museum of Art, Kansas City, Constable's 1830 'Helmingham Dell' (55.39, GR30.1) leaps to life, revealing its monumental form and vibrant surface. [53]

An overall understanding of Constable's art suggests that Constable's landscape paintings seem especially artificial under flat, low-level, electric light, and that the 'chiaroscuro of nature', so essential to his view of landscape, is most deeply felt when we, as viewers, even inside a gallery, have a sense of the gradually shifting light overhead and are occasionally treated to a view of his landscapes under fairly full natural light. Unacceptable as it may be from the point of view of preservation, I have no doubt that our experience of Constable's landscape paintings is greatly heightened by an occasional burst of intense daylight.

As we are all aware, these differences in the appearance of paintings under different lighting conditions pose questions not only for what light should be used for research and display but also for conservation. When we inpaint a Constable open air painting, for example, should we do this by the reasonably full daylight under which it was painted, by the good indirect daylight under which he wished to exhibit it, under artificial lighting conditions similar to those in our gallery, or by the excellent, clinical lighting available in our laboratories?

I pose one final moral question for us. Many of us would accept the restriction imposed if an artist were to write on the back of his or her painting: "I realize that my painting is vulnerable and will deteriorate without varnish, but I prefer that this painting be destroyed rather than varnished." But what if this artist were to write instead: "I have painted this landscape partly to cover the earlier image on the same canvas. The privacy of this earlier image is part of the artistic integrity of this painting. I wish the painting to be destroyed rather than viewed with imaging technques, such as infra-red reflectography, which would reveal the earlier image, even if seen by only one other person." Would we respect the artist's restriction on imaging techniques?

Hanging, etc.

Constable's correspondence provides evidence for other types of changes in the physical conditions under which his paintings were viewed. In one fascinating letter of June 30th 1813 from London to his then future wife, Maria, Constable described the colors he has chosen for the drawing room and studio of his house in Charlotte Street.

> We are now repairing the house here with a thorough painting, and I shall leave orders about the back drawing room. The paper will be a sort of salmon color and the sofa & chairs crimson (by Lady Heathcote's advice). I think they will suit pictures but I am indifferent about show—though all insist upon it. . . . My front room where I paint shall be done with a sort of purple brown from the floor to the ceiling—not sparing even the doors or doorposts, for white is disagreeable to a painter's eyes, near pictures".[54]

Most of Constable's comments on the hanging of his paintings in the company of others concern the standard complaints of crowding and being hung in inferior positions at the Royal Academy, but three letters are especially revealing. In addition to the draft of a letter quoted earlier, in which Constable wrote probably to a prospective client, pointing out that his paintings were best seen together because "it displays to advantage their varieties of conception and also of execution, and what they gain from the mellowing hand of time":[55] Constable mentions details of hanging in two letters to Fisher, the first written about July 10th 1823:

> You have made an excellent purchase of a most delightful work. It is a pearly picture but its tone is so deep & mellow that it plays the very devil with my landscapes. It makes them look speckled & frost bitten, but I shall make my account of it, as I am now working for <u>tone</u>.[56]

In another letter to Fisher, written December 17th 1824, Constable reported on the reception of two of his six-foot landscapes ('The Hay Wain' [National Gallery GR21.1] and 'View on the Stour near Dedham' [Henry E. Huntington Library and Art Gallery, San Marino GR22.1]) when exhibited at the Louvre earlier that year. In this revealing quote, he described a change in the appearance of his painting during the first few weeks of the exhibition resulting from their rehanging, commenting especially on the viewing distance for his paintings:

> My Paris affairs go on very well. The pictures in the Louvre did not keep the ground they first took-but though the director (the Count Forbain) gave them very respectable situations in the first instance—yet on their being exhibited a few weeks, they so greatly advanced in reputation that they were removed from their original situations to a post of honor—the two prime places near the line in the principal room. I am much indebted to the artists for this alarum in my praise—but I will do justice to the Count. He is no artist (I believe) and he thought "as the colors were rough, they must be seen at a distance"—they found their

mistake as they then acknowledged the richness of the texture—and the attention to the surface of objects in these pictures.[57]

We value too little, I suspect, the opportunity of seeing the same paintings in different hangings, and pay too little attention to what can be learned from the changing appearance of paintings under different lighting conditions, against different colors, in the company of different paintings, and viewed from different distances. Happily, the increasing number of *in situ* studies and frame studies, etc., are beginning to correct this situation, but most art history writing still treats paintings as if they, or perhaps their photographs, exist in an environmental void.

Changes in cultural and psychological contexts in which paintings have been understood and interpreted

A comprehensive review of changes in the appearance of Constable's paintings requires attention to the changing contexts in which they have been painted, collected, bought and sold, preserved and restored, exhibited, and studied; for example in symposia such as this.[58] The fact that the cultural and psychological contexts for Constable's paintings are not discussed separately in this paper will not suggest, I hope, that they are in any way peripheral to the technical work of conservation. Quite the contrary; all technology serves human values. What we preserve and how is largely a result of what we value, as I have attempted to demonstrate in the body of this paper.

Conclusions

Even in the relatively few examples we have examined, we have observed an extraordinary diversity in the types of changes that have taken place in the appearance of paintings by one artist, John Constable. Along the way, we have noted how some of these changes relate to others within the work of the same artist; how, for example, darkened bitumen might affect our changing critical response to 'The Valley Farm', or how twentieth century values might persuade us to retain visible evidence of the roof lines in 'Flatford Mill from the Lock', even though the artist had deliberately painted them out. In addition, we may wonder what might be learned by comparing changes in the appearance of paintings by one artist with those in paintings by other artists; to see, for example, if the physical changes in Constable's 'Opening of Waterloo Bridge' and Turner's 'Helvoetsluys' (private collection)[59], which hung beside each other at the 1832 Royal Academy exhibition, are comparable enough, especially in the reds, that we can re-experience the famous competition between the two pictures.[60] Or we may wish to compare the different ways in which art historians, curators, conservators, and conservation scientists evaluate a certain type of change; to see if we can understand why a curator or conservator might have had 'Stoke-by-Nayland' cleaned as a displayable example of Constable's late painting while an art historian might value the same object, cleaned somewhat differently, as a document of Constable's working procedure. As a framework for stimulating such comparisons, let us look now at the draft outline I have been following.

I. Physical changes in paintings
 A. Made by the original artist
 1. Original working procedure
 a. Seemingly minor changes
 b. Significant alterations in composition, etc.
 c. Slightly enlarging canvases by unfolding and restretching
 d. Significant changes in the size and shape of canvases through cutting, stitching and pasting
 e. Finishing, pulling together tonally, etc.
 f. Varnishing
 2. Continuing work on paintings following exhibition and/or sale
 3. Significantly later development of paintings
 4. Scraping down, covering paintings with a new ground,

or overpainting with a new image.
 5. Destruction of entire canvases
 B. Made for/by others
 1. For patrons
 2. For dealers
 3. By other artists
 4. Through accident or vandalism
 5. By past restorers
 6. By recent conservators
 C. Normal changes in the materials used
 1. Anticipated and provided for by artist
 2. Feared by artist
 3. Not anticipated by artist
 D. Natural catastrophe, war, etc.
II. Changes in the physical conditions under which paintings have been viewed
 A. Under different lighting conditions
 1. By sunlight
 a. With the painting
 (1) In full sun
 (2) In mixed sun/shade
 (3) In shade
 b. Time of day
 2. By mixed daylight/artificial light
 3. By artificial light
 a. Candles
 b. Gas
 c. Electric (varying color temperature, etc.)
 (1) Incandescent
 (2) Floods and spots
 (3) Fluorescent
 (4) Quartz
 (5) Ultraviolet
 (6) Infra-red
 B. Viewed through an optical device or not
 C. How framed or not framed
 D. Hung at different heights, angles, etc.
 E. Displayed against different colored backgrounds
 F. Displayed beside other paintings, etc.
 G. Location
 1. Out-of-doors
 2. In the artist's studio
 3. First exhibitions at the R.A. and B.I.
 4. In private collections
 5. At auction
 6. In permanent museum collections
 a. On display
 b. In storage
 7. In later temporary exhibitions
 8. In conservation laboratories
III. Changes in the cultural and psychological contexts in which paintings are understood, interpreted, displayed and treated (Because this subject is so vast and permeates all aspects of changes in the appearance of paintings, it is not separately outlined here.)

This list is drawn almost entirely from Constable's work, though we have had time to consider only a sampling of examples here. I have no illusion that this would be an adequate outline for every artist or situation. The very fact that some portions of such an outline would be superfluous for certain artists but would require expansion for other artists points up the variety in the types of changes paintings by different artists have undergone.

This outline, which may at first appear excessively detailed, could of course be more so. Its intent is to help us think about these changes in an orderly, even systematic way. The cosmos of culture is in many ways parallel to the cosmos of nature, immensely complex but nevertheless orderly and capable of being understood if we wish to do so. For example, although the varying lighting conditions under which paintings by a given artist have been viewed over the years may seem to justify whatever type of lighting we may wish to use today, it is often possible to identify and evaluate the types of lighting under which the paintings in question have been seen at various times and places and thereby to make more thoughtful choices and to explain to the public just what they are seeing and why.

Set against the fact that these changes can be categorized and thereby, to some extent, dealt with as type problems, is the fact that every painting is unique. For Constable, each act of seeing, each act of drawing or painting, was a new experience, the occasion for a singular focus on the world and a unique creation on paper, board or canvas. Therefore, each painting by Constable presents a unique problem for us to understand, and we must strive to adjust our understanding and practice to this situation. We must strive to make our art history and our conservation object specific.

To accomplish this, we must also attend to the specific time, place, and conditions under which each object is studied and treated. It may seem obvious to us now, but it is amazing how often old conservation reports and photographs, even those in major photo archives, are not dated, and it is therefore often difficult to establish when even major physical changes took place. Some time ago I began noting the conditions under which I viewed each object as I was cataloging it, and in two recent catalogues,[61] I have indicated, as a regular part of each entry, the conditions under which each object was studied: in many cases "Fully examined out of frame by good daylight," but for some "Examined framed off wall by good daylight," and in one case "Entry based on excellent color transparency, photograph of back, and information provided by Sotheby's". Along the same lines, I have been attempting, for some years, to persuade museum curators to cross out the section on their catalogue sheets that reads "Condition" and to write instead "Physical History of the Object." What we should like, ideally, is surely not simply a report on the present condition (simply one stage in an ongoing process) but rather a full, chronological history of all physical changes in a painting from the time it was painted until the present. In my entries, I now always try to list when, where, and by whom a painting was relined, cleaned, or otherwise treated. Once we accept this as a category of information to be provided, as a regular expectation for all major catalogues, I think we will be surprised at how much of this information can be reconstructed, especially as the records of retired private conservators become more available.[62]

Other types of records would also contribute to our joint enterprise. As many of you know, an extensive record of Constable's work, based on thorough technical examination of a large number of his sketches and paintings, has been developed in recent years by Sarah Cove.[63] This study has already produced important results and, of course, such a large, systematic body of technical information will be invaluable as a basis of comparison for any Constables to be studied and/or treated in the future.

In addition, before any painting is treated, it would be helpful if the curator and conservator in charge could read any statements by the artist and contemporaries relevant to the artist's studio practice and to the appearance, technique and physical make-up of the artist's paintings, but we art historians have been very slow to provide this information. In 1984, I drew up for discussion at a colloquium at the National Gallery of Art, Washington, a sample of the type of record I should recommend we keep for any significant artist. I should be happy to provide at cost a xerox of the document ('A History of Technique: John Constable, A Trial Study') to anyone who would like one.

One of the central ideas that I assume we shall return to in various ways during this symposium is the interdependency of the three types of changes mentioned in the call for papers and adopted as the major divisions in my outline. Just as our judgment of a painting's authenticity is influenced by the physical state of the painting and the conditions under which it is seen, so the type of tonal coherency which a conservator attempts to achieve in cleaning a painting is influenced by the attribution of the painting and its relation to other paintings attributed to the same artist. Cultural and institutional norms for whether a portrait or landscape is valued more for its evidence of the artist's hand or for the image of the person or place represented (different, for example, in an art museum than in a portrait gallery or historical society) help determine how a painting is cleaned and the extent to which it may be restored. We do not consider physical changes in a painting first, then changes in the conditions under which it is viewed and finally changes in the paintings cultural and psychological context; nor do we proceed in the opposite direction. Whether we are aware of it

or not, all three types of changes are involved in every judgment we make, every action we take. This makes all of our art history and curatorial judgments, all of our conservation and conservation science, a great deal more complicated but also, I hope you will agree, quite a bit more interesting.

Publications cited in abbreviated form

GR Reynolds G, **The later paintings and drawings of John Constable,** YUP (1984) 2 vols.

H Hoozee, R, **L'Opera completa di Constable,** Rizzoli (1979).

JCC II **John Constable's correspondence ii: early friends and Maria Bicknell (Mrs. Constable),** R. B. Beckett (ed), SRS Vol.VI (1964).

JCC III **John Constable's correspondence iii: the correspondence with C. R. Leslie,** R. B. Beckett (ed), SRS Vol.VIII (1965).

JCC IV **John Constable's correspondence iv: patrons, dealers and fellow artists,** R B Beckett (ed), SRS Vol.X (1966).

JCC VI **John Constable's correspondence vi: the Fishers,** R. B. Beckett (ed), SRS Vol.XII (1968).

Leslie Leslie, C R, **Memoirs of the life of John Constable, composed chiefly of his letters,** J Mayne (ed), Phaidon (1951; orig. pub. 1845).

LP Parris, L, **The Tate Gallery Constable Collection,** Tate Gallery, 1981.

R Reynolds, G, **Catalogue of the Constable Collection,** Victoria and Albert Museum, 2nd ed, HMSO (1973).

Rhyne Rhyne, C S, "Constable's Drawings and Watercolors in the 1981 Collection of Mr. and Mrs. Paul Mellon and the Yale Center for British Art: Part I, Authentic Works," **Master drawings,** XIX2 (Summer 1981), pp 123-45, pls 1-17.

Rhyne Rhyne, C S, "Discoveries in the Exhibition," in **John Constable, 1988 R.A. (1776-1837),** Salander-O'Reilly Galleries (1988), pp 11-27.

Rhyne Rhyne, C S, "Constable First Two Six-foot Landscapes," **Studies (1990) in the history of art,** 24 (1990), pp 109-29.

References

1. Because this paper is to be given as a symposium lecture, I have written it as such, raising questions for discussion at the symposium and referring to details in Constable's paintings which in my lecture, will be illustrated with detail color slides. For illustrations of the paintings and drawings discussed, see the references given in parentheses after the title of each work in the text.
2. The identification of this scene is secured by correspondence of the detail of the windmill with the same detail, including the red roof immediately to the left, in Constable's 1815 painting, 'Golding Constable's Kitchen Garden' (Ipswich Borough Council 1955-96.2, H213).
3. GR 25.1-25.4.
4. JCC II p. 385.
5. Leslie p. 145.
6. Clark, K, "Constable; 'Study for The Leaping Horse', in his **Looking at pictures,** Holt, Rinehart and Winston (1960), pp110-121.
7. JCC II pp 385-87; see also JCC IV pp 100-101, 171, and 271.
8. I have discussed and illustrated some of these aspects of 'The Leaping Horse' previously in "A Slide Collection of Constable's Paintings: The Art Historian's Need for Visual Documentation," **Visual resources,** IV, 1 (Spring 1987). See pp 56-58, figs 3-4.
9. Jean Rosston, then Mellon Fellow in Conservation at the Museum, was especially helpful with 'The Lock'.
10. Strangely, the right edge of the canvas, in its present condi-

tion, does not appear to have been either cut or torn, but rather cracked off. See also Richard Dorment, **British painting in the Philadelphia Museum of Art, from the seventeenth through the nineteenth century,** PMA, (1986), no.11.

11. JCC VI 1968, pp 197-98.
12. JCC VI 1968, p 45.
13. JCC VI 1968, p 134.
14. GR 28.2.
15. JC: FDC 1975, p 133.
16. C. R. Leslie, **Life and letters of John Constable, R.A.**, R C Leslie (ed), Chapman and Hall (1896), p xiii.
17. Martin Hardie, "Constable's Water-Colours," in **The Old Water-Colour Society's Club: Twelfth Annual Volume 1934-1935** (1935), p 9.
18. H32. See also Rhyne-Studies, note 60.
19. GR 20.48.
20. Rhyne-1990. This article includes extensive technical information for this painting, based largely on examination helpfully carried out for me by Sarah Fisher and Charlotte Hale and paint samples analysed by Eugena Ordonez.
21. In 1985 at the Art Institute of Chicago, Rick Brettel showed me Picasso's "Blue Guitar", in which Picasso had painted directly over a figure below without an intermediate ground. Brettell pointed out that such a procedure required powerful control.
22. Rhyne-1988, pp 21-23, color plate 2.
23. Partially quoted in Rhyne-1988, p. 21.
24. See GR30.18.
25. Leslie, pp.227-28.
26. Rhyne 1981, no 25, pl. 9a.
27. Previously unpublished. Pencil on off-white laid paper, soiled and foxed, opaque hinges covering the left corners, stamped "LIVERPOOL CITY LIBRARIES"and HORNBY LIBRARY LIVERPOOL". 95 x 128 mm (trimmed). Verso of 'Flatford Mill from the Towpath near Old Bridge'. Coll: Hugh Frederick Hornby; by whom bequeathed to Liverpool 1899.
28. See the facsimile publication of three Constable sketchbooks (plus a fourth by Lionel Constable) at the Louvre (RF1870/ 08698, 08700, and 08701), in which most of the pages with drawings are stamped 'ML' inside an oval. **Constable and his friends in 1806.** 5 vols. Paris: Trianon Press; & Guildford Surrey: Genesis Publications, 1981.
29. Exeter Public Library, p42 (35). See Rhyne 1981, p142, note 18. See also GR23.75-79, 81; 25.16-17; 27:35-9; 34:53, 68; 35.20, 31; 36.12, with illustrations. More recently, the drawings in the Exeter Album have been expertly lifted from the sketchbook pages, treated and mounted by Heather Norville.
30. 'East Bergholt Common; View to the Rectory from the Fields Behind Golding Constable's House'. Rhyne-1988, p16, color pl on cover.
31. In 1988, Simon Parkes generously discussed with me his cleaning of a number of Constable sketches and paintings during the two or three previous years.
32. Shortly after its rediscovery, I informed other Constable scholars of the whereabouts of this painting and provided detail color slides showing the painting before and after the cleaning. I then used the painting as the centerpiece of a lecture, "The Substance of Constable's Art," given at the annual meeting of the College Art Association in America, San Francisco, 1981. This lecture was expanded as "John Constable: The Technique of Naturalism' and in 1981 given at the University of Oregon, Johns Hopkins, University of Delaware, Oberlin College, Metropolitan Museum of Art, and the Courtauld Institute of Art.
33. Hoozee lists it as a rejected work and describes it as an imitation of the sketch in the Phillips Collection (GR34.76).
34. GR36.19. Following this study, I presented a lecture, "Constable's Last Six-Foot Sketch," at the Art Institute of Chicago, bringing together for the first time all of Constable's representations of Stoke-by-Nayland and interpreting its meaning in Constable's art. The manuscript of a long article on the subject is on file at the Art Institute. I should be happy to make a xerox available at cost to anyone wishing a copy. The grounds for considering the Chicago canvas a sketch rather than an unfinished painting (or in one previous publication a finished painting) are presented in Rhyne

35. JCC IV 1966, p 129.
36. **The Reminiscences of Solomon Alex. Hart, R.A.,** A Brodie (ed), (1882), p 58.
37. John Walker, **John Constable** Abrams (1978), p 150.
38. LP, no. 41.
39. JCC IV 1966, p 122.
40. I have presented this view of 'The Valley Farm' in a 1982 discussion at the Paul Mellon Centre for Studies in British Art, London, and in a 1984 lecture, "The History of Technique: John Constable a Trial Study," at the Center for Advanced Study in the Visual Arts, National Gallery of Art, Washington.
41. A summary of the report is dated 14 Jan. 1960. For an especially informative technical analysis of another painting at the Tate, see Anna Southall, "John Constable 1776-1837, 'Flatford Mill (Scene on a Navigable River)' in **Completing the picture: materials and techniques of twenty-six paintings at the Tate Gallery,** Tate Gallery (1982), pp 34-38.
42. Leslie pp 176-77.
43. For Wolber's work on bitumen see R Wolbers, "Developing Fourier Transform Infrared I Spectroscopy (FTIR) as an Aid in the Selection of Asphalt-containing Paint Films," in **Papers Presented at the Art Conservation Training Programs Conference,** May 1/3, 1983, Cooperstown, New York, pp. 103-22.
44. For a discussion of several, see Rhyne 1988, p16.
45. His nude studies would have been painted by gaslight at the life classes of the Royal Academy schools. See JCC III 1965, pp35-36.
46. JCC II 1964, p 421.
47. JCC IV 1966, pp 137-38.
48. JCC III 1965, p 132.
49. JCC VI 1968, p 53. This agrees with Constable's own directions for the hanging of his "Barge Passing a Lock", in which the light falls from the left. In a letter of August 30th 1833 to Brussels, he writes: ". . . I should much prefer the light coming from the left of my picture, and if it were placed about level with the eye, should such a situation conveniently offer itself—" (**Constable the art of nature,** by Leslie Parris and Conal Shields, Tate Gallery [1971], p. 24.)
50. JCC VI 1968, pp 221-222.
51. JCC VI 1968, p 84.
52. Examined unframed by good daylight. Oil on canvas, cleaned, wax relined, and restretched by Lowy Co., Philadelphia, c.1987. 359 x 422 mm (stretcher). Label on back of frame: "P.A.B. Wiedner 508/94018/01" (that is sale 508, lot 01, Widener receipt no.94018). See LP pp72, 74, fig 7, and GR17.1, both published on the basis of black-white photograph.
53. Forrest R. Bailey, Paintings Conservator, was especially helpful during my visit in 1987. He shared with me his 1983 examination (No 83.02.15), x-radiographs and photographs, showing that (the cleaning revealed the partial image of a deer underneath the cow [in the lower-left of the painting]. Because "the reflection of the cow in the water appeared to be original paint', the 1830 mezzotint of the same scene also showed a cow', and "the cracks in the cow's nose conforms to the crack pattern in the painting", the partial remains of the deer were painted out and the cow repainted.
54. JCC II 1964, pp 109-10. In a letter of July 7th 1826 to Fisher in Salisbury, Constable writes: "Have you done anything to your walls? They were of a colour formed to destroy every valuable tint in a picture" (JCC VI 1968, p 222).
55. JCC IV 1966, p 129.
56. JCC VI 1968, p 124. Constable then identifies the painter as "G. de Vris, an artist contemporary with Rubens—& de Heem. . . ."
57. JCC VI 1968, p 185.
58. Although the words "reception theory" are never used, an information study has been published tracing Constable's multifaceted reception from his death until 1937: Ian Fleming-Williams and Leslie Parris, **The Discovery of Constable,** Hamish Hamilton (1984). See also my review in the **Burlington Magazine,** CXXIX (Feb 1987), pp 124-26.
59. Butlin and Joll, **The Paintings of J M W Turner,** YUP (1977) 2 vols, no 345.

1990, note 45.

60. Recounted by Robert C Leslie, in his edition of **Life and letters of John Constable, R.A.** by C R Leslie, Chapman and Hall (1896). See also JCC III, pp 69-70.

61. Rhyne 1988. I am told that the catalogue of the fifteen "discoveries" in this exhibition was the first published catalogue of works from diverse collections to indicate the conditions under which each object was studied. This information is included also for every object in **Constable and Dunthorne**, a catalogue produced for a small show of the work of John Dunthorne, Jr. that accompanied the Constable exhibition. This catalogue is scheduled for publication in 1990.

62. For example the papers of William Suhr, housed at the Getty Center for the History of Art and the Humanities, Santa Monica.

63. Cove S, "An Experimental Paintings by John Constable R.A., **The Conservator**, Vol 12 (1988), pp 52-56; "The Constable Project: Current Research into Materials," **Conservation today: papers presented at the UKIC 30th anniversary conference 1988**, pp 59-63.

This paper was received after the editorial deadline.
Except where noted, all photographs were taken by the author.

HANGING FRAGMENTS: THE CASE OF TURNER'S OEUVRE

Will Vaughan

All admirers of the art of Turner must feel grateful for the growing attention that he has received in the last two decades. Perhaps the most heartening events have been the appearance of a thorough and definitive catalogue - that by Butlin and Joll[1] - and the establishment of the Clore Gallery at the Tate, where it is possible for the first time to see the majority of the oil paintings bequeathed by Turner to the nation hung together.

Yet, while applauding these achievements, we must recognize that they present us with a further problem. For in bringing Turner further into view, have we not in some ways overexposed him? This is particularly a problem for the Clore Gallery. For what we have on the walls now are not just the works that Turner himself wished to have shown, but virtually every canvas that he had himself worked upon in any degree whatsoever that was in his studio at the time of his death. Some of these canvasses may well be works that he himself regarded as 'pictures'. Others are clearly the most rudimentary of beginnings. While few would wish to go as far as one critic of the Clore Gallery, who dismissed its contents as an aggregation of "studio sweepings"[2], it is not hard to see that the hanging together of pictures in states varying from finished to hardly begun presents a number of scholarly and aesthetic problems.

Before going further into this question, I would like to clear one potential misunderstanding out of the way. I am not suggesting that our appreciation or understanding of the work of a given artist should be restricted to an attempt to reconstruct his intentions. In the first place, such intentions are perhaps rarely if ever fully recoverable. In the second place, it is surely the case that any artist who puts his work into the market place has to run the risk of it being taken at the value that it then assumes rather than at the one that he had first thought of putting on it. As we are all aware, the massive changes in aesthetic preferences over the last century have created a different context for Turner's work. The taste for the informal and the abstract has led to a new appreciation of his 'unfinished' productions.

It would clearly be absurd to deny the admirers of such works access to them on the grounds that the artist had not exhibited them in his lifetime. On the other hand there is an onus, for historians at least, to attempt some sort of a reconstruction. For the understanding of a picture as a part of a culture of the past must involve some consideration of how it would then have functioned, and what meanings it could then be thought to have had.

Curators of collections are of course always having to face the problem of balancing demands for historical reconstruction against calls for displays that satisfy current aesthetic tastes. The task is not an easy one, and the present display at the Clore shows great ingenuity in addressing both sets of interests. My main purpose here is not to mount a critique of a particular hang. It is to consider the way in which display must inevitably involve compromise, and to see how such compromises do in themselves affect both taste and historical understanding. The case of the hanging of unfinished Turners - the 'fragments' of my title - has a long history. It is one that has played a significant part in the changes in the understanding of Turner's oeuvre over the last century. It is these changes that I would like now to consider, before coming back to reflect on the present situation.

The evidence that we are 'hanging fragments' is, of course, not hard to find. Indeed, there would be few who would challenge the literal truth of this fact. As is well known, the full contents of Turner's studio entered the National collection after the artist's death in 1851 as a result of confusion about the terms of his will. The will itself is complex in the extreme, largely because of the codicils that were added to it over more than twenty years. But what is clear is that in its final form Turner's will stated that it was his 'finished'

pictures that he wished to leave to the nation. This term first occurs in the codicil to his will of 2nd August 1848. As Martin Butlin suggests, the fact that it had not occurred before is probably because the idea of 'unfinished' works being included simply had not occurred to him[3]. The concept of 'finish' at this time was a highly important one. A 'finished' picture was one that had been worked through completely by an artist, as to meaning and effect. It did not necessarily mean a picture of high detail - as Turner's own exhibited works make clear; particularly those of his later years.

Following Turner's death in 1851 the interpretation of his will went through many stages. Its terms were hotly contested by his relatives, and this caused a Court of Chancery ruling which took possession of the full contents of his studio. Significantly, when an inventory of this was taken, by Sir Charles Eastlake (then Keeper of the National Gallery) and by John Prestcott Knight, the division between 'finished' and 'unfinished' was maintained. Their schedule, verified in an affidavit of December 1859 arrived at the following numbers and categories:

Finished pictures	100
Unfinished, including mere beginnings	182
Drawings, sketches, etc.	19,049

The wish expressed in the will that only 'finished' works should be shown was fairly strictly observed. Of the oils, only exhibited works and a handful of highly-worked unexhibited and 'unfinished' ones were put on view[4]. The total came to 105. They were exhibited first at Marlborough House and then at a number of other locations during the nineteenth century, ending up largely in the National Gallery itself. While watercolour sketches were included in exhibitions in this period, the only oils to be shown were those from the original selection. The rest of the Turner bequest remained without classification - beyond the rudimentary description of them that had been given in the schedule of 1858. They stayed in the vaults of the National Gallery, uncatalogued, uncounted and unconsidered. They do not appear in the first catalogue raisonne of the artist's ouevre - that published by Sir Walter Armstrong in 1902[5].

It was in fact in 1901 - the year before the publication of Armstrong's book - that the first signs of a reconsideration occurred. For in this year four more paintings from the unclassified part of the bequest were given accession numbers[6]. Yet over the next forty three years further sections of the unclassified part of the bequest were gradually given accession numbers until by 1944 the whole of it had been accounted for. It is not difficult to tell which works were accessioned in this way, or the sequence in which they were processed. This can be learned from the size of their accession numbers. Briefly, any Turner in the Clore whose accession number is between 458 and 562 is part of the original selection. All the other pictures from the Turner bequest have numbers running from 1857 onwards. Those with numbers between 1857 and 2707 were accessioned between 1901 and 1908. Those with numbers between 2857 and 4665 were accessioned between 1911 and 1932. Those with numbers from 5473 to 5546 were accessioned in 1944.

In other words, it is only in the twentieth century that many of the works that we regard as major productions by Turner actually became regarded officially as being pictures. More than this, they did not even become known until this century, for the reason that they were unclassified and unshown. Such striking pictures as 'Norham Castle'(Fig 1) and 'Interior at Petworth'(Fig 2), for example, fall into this category. Both were accessioned in 1905 and were first put on show in 1906[7].

The history of how these 'unfinished' Turners came to be catalogued and exhibited is hard to establish in detail. For although there is no doubting the broad fact that these pictures gradually became unearthed from the vaults of the National Gallery and

Fig 1. J M W Turner 'Norham Castle, Sunrise', 91 x 122 cm, oil on canvas, c.1844 (Tate Gallery No 1981)

were progressively moved across to the Tate Gallery - and ultimately into the Clore Gallery, there seems to be some uncertainty about the process whereby the decisions to effect these changes were made. In his succinct account in a preface to the Turner Oeuvre catalogue, Martin Butlin suggests that it was more or less a simple process of discovery: "the new discoveries being moved as they were unearthed"[8]. Yet some works were not transferred as soon as they were discovered. 'Rough Sea with Wreckage'[9], to take a specific example, was given an accession number in 1905. Yet it was not transferred until 1954. On the other hand, it is clear that many of the pictures in the Turner bequest were known - to curators at least - long before they received accession numbers. This is obliquely acknowledged by D S MacColl in his 1920 catalogue of the Turner Collection at the Tate when he remarks, after having quoted the figures of the Turner bequest that "of these 282 oil paintings, 199 are now framed and exhibited."[10] There were, it is true, a number of unframed pictures (sometimes several on a roll of canvas) found on occasions - notably those found by Lord Clark at the beginning of the Second World War and described by him as: "in a small and remote vault, some twenty rolls of canvas, thick with dust, which I took to be old tarpaulins."[11] But the occurrence of such finds should not obscure the fact that the accessioning of most of the 'unfinished' Turners in the twentieth century seems to have been a matter of deliberate aesthetic selection. Only in 1944 did the policy appear to have changed to that of accessioning and displaying every single piece of paper, wood, or canvas that had come from Turner's studio and that seemed to have been touched by his hand.

The process of selecting and accessioning 'unfinished' pictures from the Turner bequest was most active during the Edwardian period. Between 1901 and 1908 seventy one such works were accessioned[12]. After that there was a slower process. By 1932 a further 38 had been accessioned. Then there was a gap until the discoveries of Lord Clark completed the collection in 1944.

When viewing these accessions chronologically the impression is gained that there were two principles at work behind the selection. The first was a gradual tendency to accept more and more 'abstract' works as pictures. The Edwardian acquisitions focussed largely on works that were clearly 'studies' such as 'The Thames Near Walton Bridges'[13] and those that had recognizable locations, such as the 'Norham Castle, Sunrise' mentioned above. The aesthetic that guided such choices was clearly 'impressionist' in inspiration - as will be suggested in more detail in a moment. In the 1920s this taste gradually widened, until it was possible, by 1932, to see such glorious atmospheric and topographically impenetrable hazes as 'Sun Setting over a Lake' (Fig 3) as a picture. The other tendency was a greater tolerance towards those areas of Turner's art where he was not considered to have excelled, namely his figure compositions. Such a detailed and finished figure subject as 'George IV at St. Giles' Edinburgh'(Fig 4) was not regarded as being worthy of accession before 1911. Those pictures that had the double disadvantage of being both figurative and indistinct had to wait a lot longer. The ethereal 'Scene in a Church or Vaulted Hall'(Fig 5) - which is related in "style and general composition"[14] to the painting of 'George IV at St. Giles' Edinburgh' was not given an accession number until 1944, the point when, as I have suggested, anything touched by Turner was accessed without demur.

Behind these two tendencies we might discern the activities of two pressure groups. One is the 'aesthetes' , who found in the unfinished Turners evidence of that modernism that British art seemed to be lacking in elsewhere. The other group is the scholars, who wished more simply to keep a record of all the great man's productions.

It was the aesthetes who seemed to have been foremost in bringing about a call for a revaluation of the unexhibited Turners. Significantly, evidence of the appreciation of this side of the painter's art came first from works that had mysteriously 'disappeared' from his studio while his bequest was still going through the lengthy process of gaining probate. A notable example is the 'Landscape with a River and a Bay in the Distance'[15] now in the Louvre, which had arrived in Paris by 1890. Praised by Edmond de Goncourt and (it would seem) by Camille Pissarro [16], such works

Fig 2. J M W Turner 'Interior at Petworth', 91 x 122 cm, oil on canvas, c.1837 (Tate Gallery No 1988)

gained a new significance from the comparison that they suggested with the work of the French Impressionists. In a period when English art was undergoing a crisis, it was highly welcome to unearth works by artists that might suggest that there was a national tradition of Impressionism to set against that of the French. This tendency had already reached a high point by 1903, when the distinguished critic Charles Holmes edited a collection of essays entitled **The Genius of J M W Turner**. "Turner was the first of the Impressionists", wrote one of the authors, "and after a lapse of eighty years he remains the greatest."[17] As if to emphasize this point, the one picture reproduced in colour in this book - a 'Seapiece' in the collection of James Orrocks - was given the superscript "oil colour impression, late period, about 1842". As so often in the discussion of these unexhibited Turners during the Edwardian period, the assumption is that these were direct, plein-air paintings. It is significant, too, that to make this point about Turner being an Impressionist it was necessary at that time to go to the handful of unfinished works that had seeped out of Turner's studio before its contents were handed over to the nation. For by 1903, as has already been said, no more than a handful of the 'unfinished' oils in the Turner bequest had ever been on show[18].

Pressure for a revaluation of the unexhibited works of Turner was added to by the scholar E T Cook in his polemical **Hidden Treasures at the National Gallery**, published by the Strand Magazine in 1905. Cook - best known as one of the editors of the magisterial Library Edition of Ruskin's works[19] - published his book to expose the scandal of the "remarkable accumulation of Turners" which "had been allowed to lie for 50 years" in the basement of the National Gallery.

It is interesting to see that it was precisely at the time of these publications that the curators of the National Gallery began to look in their vaults again and start recounting their Turners. As has already been mentioned, the newly numbered works tended to be those which could most comfortably be fitted into an Impressionist aesthetic. Some were put on show in the National Gallery itself - the 'Thames Near Walton Bridges' was one of these. But most

were shipped off to the 'National Gallery of British Art' where they were housed in Gallery XVIII, the last of the rooms built by Henry Tate as part of the original foundation[20].

Undoubtedly the decision to move these Turners to the Tate was part of a familiar policy - active until the separation of the Tate from the National Gallery in 1955 (on St Valentine's Day, as it happens) - of moving pictures of insecure aesthetic status out of the main institution to the lesser one on Millbank. In fairness it must be said, too, that the National Gallery was suffering from hideous overcrowding and could not cope with the problem of finding space for the growing brood of Turners it was gradually discovering that it possessed. Whatever the reasons, however, the effect was clearly remarkable. For by having the traditional 'finished' Turners still on show at the National Gallery - where such tried favourites as 'The Fighting Temeraire' had long assumed the status of National institutions - and the new 'unfinished' works at the Tate, they were able to emphasize the distinction between the two.

"It is most interesting today to go to and fro between the two greatest Turner collections, that in Trafalgar Square and that near Vauxhall Bridge, " wrote the art historian Josef Strzgowski in the **Burlington Magazine** in 1907. "In the early period the idea of objective representation predominates; later the pronounced desire for a definite subjective effect."[21]

Strzgowski brought some unfamiliar central European psychologizing to the issue. Indeed, he is almost on the point of making Turner an expressionist when he calls 'Interior at Petworth' a "private confession of faith", adding " we moderns break down these barriers and seek the artist by preference in his intuitions." But his reaction is in other ways typical. Not only does he see the 'unfinished' Turners as being a distinct entity on their own. He also considers them to be quintessentially related to the latter part of Turner's career. The assumption is an interesting one because it has been so unquestioningly followed. Since Turner was productive up to the end of his life, it is hardly surprising that most of the unfinished works found in it would relate to his later years. But it is

Fig 3. J M W Turner 'Sun setting over a Lake', 91 x 122.5 cm, oil on canvas, c. 1840, (Tate Gallery No 4665)

worth pointing out that many of the unfinished pictures do come from early periods. Some of the most indistinct, indeed, date from the 1790s[22]. We should also remember that the dates currently ascribed to these works are largely arrived at from stylistic analyses based on the assumption of a growing haziness in his manner.

The argument that Turner was an artist who moved into a more and more indefinite 'late career' had of course been supported first of all by Ruskin. But Ruskin promoted the concept that such late work was still really deeply involved in the representation of nature. Ruskin himself did not countenance the idea that the 'unfinished' Turners were a serious part of his oeuvre - something that is clear in his activities in relation to the Turner Bequest[23]. But the idea that 'unfinished' Turner represented his apogee rapidly gained credence in the Ewardian period. Charles Holmes returned to this theme in an article in the **Burlington Magazine of** 1908[24], where he compared Turner to Rembrandt in this respect, and talked of him being one of those very great artists who manifests a 'late style'. But he also notes that Turner is less consistent in this than are other artists who achieve such a style. What bothers him is the fact that, while painting his broader works, Turner still went on exhibiting pictures of relative detail. He is scornful of such work, claiming that the 'Fighting Temeraire' was 'limited' by its subject matter.

The success of the room of 'unfinished' Turners at the Tate led to an important sequel. This was the funding of a suite of Turner Rooms by Lord Duveen and the removal of a far greater collection of Turners from the National Gallery to the Tate in 1910. The result of this was that 'finished' and 'unfinished' Turners were now hung together; though for a long time some division was made between the two categories. The Impressionist reading of Turner still gained credence in most quarters. Often this was to the detriment of the French, as when Clutton-Brock claimed in 1910 that: "'Norham Castle', compared with the most brilliant sun-piece by Monet, is like lyrical poetry compared with prose, that is to say it leaves a stronger image upon the mind because it is a more highly organized means of expression."[25] The high valuation of Turner against

the Impressionists was partly due to nationalism and partly to ignorance. While Impressionist paintings were turning up more frequently in the salerooms and galleries (not least, of course in Roger Fry's famous Post-Impressionist exhibitions) it was not until 1917, with the Hugh Lane bequest, that any such works entered the national collection. With this bequest, and with subsequent purchases, talk of Turner as the greatest of the Impressionists declined. It received its coup de grace with the onslaught meted out by Roger Fry in his celebrated attack on British painting in 1934[26].

But 'Impressionist' Turner was of course replaced by other Turners - notably 'abstract' Turner who received an impetus after the full accessioning of the contents of his studio at the end of the Second World War. In the aesthetic underpinning of this concept attention moved from the idea of Turner as the respondent to nature to Turner as the creator of 'equivalences'. This neatly got over the objection raised by the defenders of French Impressionism that Turner was not truly analytical in his work. There was even the attempt to suggest that Turner had been striving in his later works to create a public for his 'abstract' works ; something most ingeniously argued by Lawrence Gowing[27]. Gowing perhaps contributed more than anyone in the presentation of late Turner as a complex though coherent aesthetic entity. It is perhaps significant that this was argued most persuasively in his essay **Turner: imagination and reality** which accompanied an exhibition of Turner's works at the Museum of Modern Art in New York[28]. For this image of Turner as an expressive abstractionist emerged at the time and place where abstract expressionism had recently reached its apogee as a contemporary artistic movement. It is also interesting to note that many of the pictures around which Gowing based his arguments - for example the 'Yacht Approaching the Coast' (Fig 6) - were those that first went on exhibition in the 1920s and 1930s.

There is not space here to go further into the history of these later readings of Turner's unexhibited works. I would like to conclude , however, with a consideration of how this has interacted with policies for displaying Turner's work.

Fig 4. J M W Turner 'George IV at St Giles's Edinburgh', 76 x 91.5 cm, oil on mahogany, c. 1822 (Tate Gallery No 2857)

Since the opening of the Duveen Galleries it has become increasingly the practice to hang 'unfinished' and 'finished' works by Turner together. Even those scholars who have argued the case for a 'total' exhibition of Turner have had misgivings about this. Finberg, in his meticulous biography of Turner, first published in 1938, glumly noted - in his passionate plea for a total hanging of Turner's works that in the selection currently on show "a very decided preference is shown for his unfinished over his completed works"[29]. It is a preference that has grown rather than diminished.

The opening of the Clore Gallery has placed the issue of the hanging of Turner's work in the national collection on a new footing. For whereas before constriction of space could lead to the plea of necessary selection, now the ordering has to follow some concept of a total overview. It is an overview that gains even more acuity because of the position it must adopt in relationship to that textual overview of Turner's oeuvre - Butlin and Joll's magisterial catalogue. As Cecilia Powell noticed in her review of the Clore Gallery hang in 1987[30], the original plan was to hang the gallery in accordance with Butlin and Joll's arrangement. Butlin and Joll's arrangement is essentially chronological - with divisions being formed by Turner's major visits to the continent of 1802,1819, and 1828-9. Within these divisions (where an internal chronology is maintained as far as possible) there is a further distinction preserved between exhibited and unexhibited works. In the place of such a taxonomical arrangement, the present hang of the Clore has been ranged around a set of roughly chronological thematic concepts. The concept of the Sublime unites the early history paintings, the image of England that of the early topographical oils. Petworth, Rome, and the Classical ideal all have their day in subsequent rooms. Such hanging is successful in giving a vivid image of a set of artistic objectives. In the early rooms, too, there is some notion of the division of finished and unfinished work. For there is a section devoted to studies; and many further works of this kind are relegated to the 'reserve' collection on show in a separate part of the gallery. But in the last and largest room both thematic and pictorial distinctions are conflated. This is the room entitled 'Late Turner'.

On the whole, the thematic hanging has been well received. So, indeed, has the limited intermingling of studies and finished works in the earlier sections. Cecilia Powell finds this a good idea, on the basis that it 'enlivens' the artist.

"The presence of an excellent selection of oil sketches and unfinished pictures contributes a great deal to the principal display in a number of ways: they enliven the galleries visually; they contribute a human touch - the sense of 'work-in-progress'; and they are a marvellous demonstration of Turner's methods, variety, energy and complexity."[31]. Yet when it comes to the 'Late Turner' section even she has reservations about the concatenation produced. "Consciously or subconsciously we all know that Turner's late works are so complex and laden with meaning that it is idle to pigeon-hole them into categories," she claims. But at the same time, on aesthetic grounds alone she argues against the concatenation that comes from some of the hanging.

Aesthetically speaking there is much to support a greater partitioning of the finished and unfinished works. For there is undoubtedly a confusion caused by works that are intended to be responded to in terms of close reading of detail and those that exhibit broad effect being placed side by side. One might even, by

Fig 5. J M W Turner 'Scene in a Church or Vaulted Hall', 75 x 99 cm, oil on canvas, c.1820-30 (Tate Gallery No 5492)

Fig 6. J M W Turner 'Yacht Approaching the Coast', 102 x 142 cm, oil on canvas, c. 1835-40 (Tate Gallery No 4662)

inference, add the voice of the artist on the side of such a division. For, as we know from accounts of his behaviour when adjusting works on show at the annual Royal Academy exhibitions[32], he had an acute sense of the effect that a 'finished' work should have. We do not have any information on how he regarded his unfinished works, but as far as his finished works are in concern, we are in no doubt. He expected them to be exhibited in the company of other finished works, either at the Academy, in his own gallery, or in the gallery that he envisaged being erected to house them after his death.

Turner's expressed intentions can also lead us back to the other issue raised by Cecilia Powell. This is the nature of 'late Turner' as a concept. She refers to it as an immensely complex matter. So, indeed, it is. But does not a lot of that complexity come precisely from the reading in to the latter part of his career aesthetic intentions that only came into being long after his death? The foci of impressionist, expressionist and abstractionist interpretations of Turner have all been on that period. And each has left behind a set of assumptions that have had to be accommodated in the portmanteau concept of 'late Turner'. The present hanging of the Clore pays tribute to these concepts. And in doing so, it perhaps articulates best of all the conflict of interests involved. Nowhere, perhaps can it be seen more clearly how much the effect of a group of pictures can articulate the image of a style. A group of pictures goes as far beyond the sum of the individual works contained as a sentence goes beyond the listing of the words within it. Through its presentation of the preponderant part of Turner's pictures, the Clore has taken on the onus of being the locus for the definition of Turner's production as an oeuvre. It provides a crucial redefinition of Turner, interestingly different in emphasis from that provided by the more historically conscientious categorization proposed in Butlin and Joll's catalogue. The late Turner room, in particular, through its essentially 'promiscuous' hanging of finished and unfinished Turners has thrown down a momentous challenge. Is there such a thing as a coherent 'late Turner' style as an entity? Do the elements brought together here form a clear pronouncement? It is up to us, as spectators, to arrive at some conclusion about this. For once, now that Turner's art has become so totally an object of display, it may be possible for the works themselves to make their presence felt, and lead to a judgement that will reach beyond the partisan polemics of later aesthetic positions.

References

1 M Butlin and E Joll **The Paintings of J M W Turner**, New Haven and London (1977).
2 Brian Sewell on the **South Bank Show** on 5 April 1987. Quoted in Powell, C, The Clore Gallery Reviewed: the picture hanging, **Turner studies**, Vol 7 No 1 (1987) p 48.
3 Butlin and Joll, op cit, p xvii.
4 Gage, J, **J M W Turner: 'a wonderful range of mind'**, London and Newhaven (1987), pp 8-9. Gage stresses the interest taken by French artists and critics in Turner's sketches and lack of finish at this time.
5 Armstrong, Sir Walter **Turner**, London (1902).
6 'Caernarvon Castle' c1798 (Tate Gallery No 1867); 'River Scene with Cattle' c1809 (Tate Gallery No 1857); 'Christ and the Woman of Samaria' c1830 (Tate Gallery No 1875); 'Sunset' c. 1830-35 (Tate Gallery No 1876). The last three of these are in fact mentioned in Armstrong's catalogue.
7 MacColl, D S **National Gallery Millbank. Catalogue. Turner Collection**, London(1920) p 29.
8 Butlin and Joll, op cit, p xviii.
9 Butlin and Joll, op cit, No 455.
10 MacColl, op cit, p v.
11 Clark, K **Another part of the woods**(1974) pp 276-7.
12 A full listing of accession numbers is given in Butlin and Joll, op cit, pp 289-91.
13 Butlin and Joll, op cit, no 184.
14 Butlin and Joll, op cit, p 138.
15 Butlin and Joll, op cit, no 509.
16 ibid.
17 Robert de la Sizaranne, in **The Genius of J M W Turner** ed. Holmes, **Studio**(1903), p xxx.
18 The 'Seapiece' - now known as 'Off the Nore: Wind and Water' (Butlin and Joll, op cit, no 476) - may in fact not be a genuine Turner. As it has now disappeared, it is hard to say. But it is clear that many 'impressionist' Turners were faked in the late nineteenth century.
19 Cook, E T and A Wedderburn, **The Works of John Ruskin**, 36 Vols, London (1903-10).
20 MacColl, op cit, p.viii.
21 Strzgowski, J Turner's path from nature to art, **Burlington Magazine**, 12 (1906-7) p 336.
22 As, for example, 'Interior of a Gothic Church', c1797, oil on mahogany, 28 x 40.5 cm, (Tate Gallery No 5536).
23 Ruskin resigned his executorship of Turner's will before the selection of works for the national collection was made. However, he did advise on this, and published a commentary to the first exhibition of the works at Marlborough House and a catalogue of the watercolour sketches and drawing shown there. see Butlin and Joll, op cit, pp xx-xxi.
24 **Burlington Magazine** 14 (1908).
25 Clutton-Brock, A, The weaknesses and strengths of Turner, **Burlington magazine**, 14 (1910-11), p 23.
26 Fry, R, **Reflections on British Art**, London(1934).
27 Butlin and Joll, op cit, No 509.
28 Gowing, L, **Turner: imagination and reality**, Museum of Modern Art, New York (1966).
29 Finberg, A J **The Life of J M W Turner** (1938) p 454.
30 Powell, C, The Clore Gallery reviewed: The picture hanging, **Turner studies**, Vol 7 No 1 (1987) p 48.
31 Powell, C, The Clore Gallery reviewed:The picture hanging, **Turner Studies**, Vol 7 No 1 (1987) p.48.
32 Accounts of such incidents are numerous. A collection of them can be found in Reynolds, G, **Turner**, London(1969), pp 141-45.

LIST OF SPEAKERS

Anderson Jaynie
 Ruskin School of Drawing
 and Fine Arts
 70 High Street
 OXFORD
 OX1 4BG
 U.K.
Carlyle Leslie (Conference organiser)
 20 Church Row
 Hampstead
 LONDON
 NW3 6UP
 U.K.
Cove Sarah
 4 Hamilton Place
 Woodside Gardens
 LONDON
 N17 6UN
 U.K.
Cummings Alan J
 Course tutor (Conservation)
 Faculty of Humanities
 Royal College of Art
 Kensington Gore, London
 SW7
 U.K.
Gage John
 Department of History of Art
 1 Scroope Terrace
 Cambridge University
 CAMBRIDGE
 CB2 1PX
 U.K.
Hackney Stephen
 Conservation Department
 Tate Gallery
 Millbank
 LONDON
 SW1P 4RG
 U.K.
Hedley Gerry
 Courtauld Institute of Art
 Somerset House, The Strand
 LONDON
 WC2R 0RN
 U.K.
Hill Stoner Joyce
 Art Conservation Program
 University of Delaware
 303 Old College
 NEWARK
 DE 19716
 U.S.A.
Jirat-Wasiutynski Voytech
 Department of Art History
 Queens University
 Kingston, Ontario
 K7L 3N6
 CANADA

Jones Rica
 Conservation Department
 Tate Gallery
 Millbank
 LONDON
 SW1P 4RG
 U.K.
Kemp Martin
 Department of Art History
 University of St Andrews
 St Andrews
 KY16 9AL
 SCOTLAND
 U.K.
Leback Sitwell Christine
 Saracens House
 Corton
 Nr Warminster
 WILTSHIRE
 BA12 0SZ
 U.K.
Newton Travers
 Fine Art Conservation
 544 West 27th Street
 NEW YORK CITY
 10001
 U.S.A.
Rhyne Charles
 Reed College
 3203 Southeast Woodstock Blvd
 Portland
 OREGON
 97202
 U.S.A.
Saunders David
 Scientific Department
 National Gallery
 Trafalgar Square
 LONDON
 WC2N 5DN
 U.K.
Townsend Joyce H
 Conservation Scientist
 Tate Gallery
 Millbank
 LONDON
 SW1P 4RG
 U.K.
Vaughan Will
 Department of History of Art
 Birkbeck College
 43 Gordon Square
 LONDON
 WC1H OPD
 U.K.

Postscript

The paper entitled "Long lost relations and new found relativities: issues in the cleaning of paintings" by Gerry Hedley (pp 8-13) first appeared in the post prints for "Shared Responsibility: A Seminar for Curators and Conservators" co-hosted by the National Gallery of Canada and the Canadian Conservation Institute, in October 1989. It has been reprinted here by kind permission of the conference organisers with special thanks to Marion Barclay.